W9-CHQ-184

Reinventing Africa

The popular imagination has been touched by the varied story of the Dark Continent to an unprecedented extent . . . Frightful wrongs to be wiped out, deeds of high surprise to be achieved, virgin countries to be commercially exploited, valuable scientific discoveries to be made, myriads of people steeped in the grossest idolatry . . . these are some of the varied elements which have thrown a glamour and fascination over Africa and taken men's minds captive.

(*The Stanley and African Catalogue of Exhibits*, London 1890, p. 1)

One cannot reside for any time in England or in any part of Europe without discovering the strange but significant fact that in African matters, and as to the destiny of this race, Europe is a veritable 'Dark Continent', having much to learn, much suffering to undergo, and much suffering to inflict upon others, before the lesson will be acquired.

(John Payne Jackson, *Lagos Weekly Record*, 23 October 1897)

Reinventing Africa

Museums, Material Culture and
Popular Imagination in Late Victorian and
Edwardian England

Annie E. Coombes

Yale University Press
New Haven and London
1994

For my parents –
and Ihsahan and Roey wherever this may find them

Copyright © 1994 by Annie E.S. Coombes

Second printing 1997

All rights reserved. This book may not be reproduced, in
whole or in part, in any form (beyond that copying permitted by
Sections 107 and 108 of the U.S. Copyright Law and except by reviewers
or the public press), without written permission from the publishers.

Library of Congress Cataloging-in-Publication Data

Coombes, Annie E.
Reinventing Africa: museums, material culture, and popular
imagination in Late Victorian and Edwardian England / Annie E. Coombes
p. cm.
Includes bibliographical references and index.
ISBN 0-300-05972-8 (hbk)
ISBN 0-300-06890-5 (pbk)
1. Africa-Foreign public opinion, British. 2. Material culture-Africa.
3. Africa-History-1884-1918. 4. National characteristics, British
5. Public opinion-Great Britain. 6. Museums-Great Britain-History-19th century.
7. Africa-Relations-Great Britain. 8. Great Britain-Relations-Africa
I. Title.
DT32.1.C66 1994
960'.074'41 – dc20

94-767
CIP

A catalogue record of this book is available from The British Library

CONTENTS

ACKNOWLEDGEMENTS

A project of this kind can be accomplished only with the help and encouragement of many friends and individuals. To some I owe a special thanks. Ihsahan el Fahdel and her daughters Imman and Hannan shared their home and their friendship with me. I am especially indebted to them and to the staff and students at both Shendi and Kassala Secondary Schools for Girls in the Sudan. More than anyone else, their friendship and generosity has helped shape the direction of this book. Thanks to Dea Birkett who has always been on hand with valuable information and criticism. Her laughter has helped me through some sticky moments. Thanks also to my colleague at Birkbeck, Avtar Brah, for her careful reading of some of this material and her constant encouragement and commitment, and to other colleagues at Birkbeck for criticism and discussion: John Kraniauskas, Laura Marcus and Will Vaughan. To John Picton who, many years ago, without asking too many questions, let an interloper sit in on his MA in African Art, many thanks. To John MacKenzie for sharing his knowledge of British imperialism in Africa and his collection of exhibition ephemera, thanks also. Other friends have provided support, commentaries and references when they were most needed, especially Adrian Rifkin, Anna Davin, Alex Potts, Nélia Dias, Steve Edwards, Joseph Adande, Lola Young, Jane Beckett, Deborah Cherry, Karin Barber, Rob Nixon, Anne McClintock and Neil Lazarus. Pitika Ntuli's courage and generosity have been a source of inspiration. Thanks also to my students over the years at Portsmouth University, Middlesex University and Birkbeck College for their patience, persistence and enthusiasm. And thanks to Nancy Jachec for taking many of the final photographs.

While writing this book I have had the good fortune to be able to share work in progress with colleagues working in many other disciplines. It has always been an enriching experience and I am grateful to those individuals who gave me this opportunity: Lisa Tickner, Jean Jamin, János Riesz, Raphael Samuel, Francis Barker, Peter Hulme, Margaret Iverson, and Steven Mansbach.

The research for this book was aided enormously by the consideration and professionalism of many librarians and curators. Many thanks for their patience, efficiency and goodwill to the staff and archivists of the British Museum, the Bodleian, Cambridge University Library, the Royal Commonwealth Society Library and the library at the School of Oriental and African Studies. I especially want to thank Rosemary Seton, archivist at S.O.A.S., Elizabeth Aquilina at the Hammersmith and Fulham local history library, Elizabeth Edwards at the Pitt Rivers Museum and Lynne Williamson, who was the archivist there at the time I completed much of the research on the collections, and who tirelessly indulged my requests for documents and introduced me to new friends.

For the assistance of Yvonne Schumann at the Merseyside County Museum in Liverpool and David Allen at the Horniman Free Museum I am also thankful. Rosemary Keen, archivist at the Church Missionary Society, has been a fount of information and has patiently sought out obscure missionary literature for me on frequent occasions, many thanks. Thanks also to John Mack at the Museum of Mankind for advice and support in the early days of this research.

I am grateful to the J. Paul Getty Foundation for a Postdoctoral Fellowship in the History of Art and the Humanities for one year, which gave me time away from a busy teaching schedule to write and think.

Thanks also to my editors at Yale University Press, Gillian Malpass and Miranda Harrison, for their patience, perseverence and professionalism.

Two people deserve a very special mention. Frank Mort took time out of his own book to read mine in the final stages. His careful critical commentary was invaluable. Michael Orwicz has been a constant source of emotional and intellectual support and stimulation from the very beginnings of this project. Many thanks.

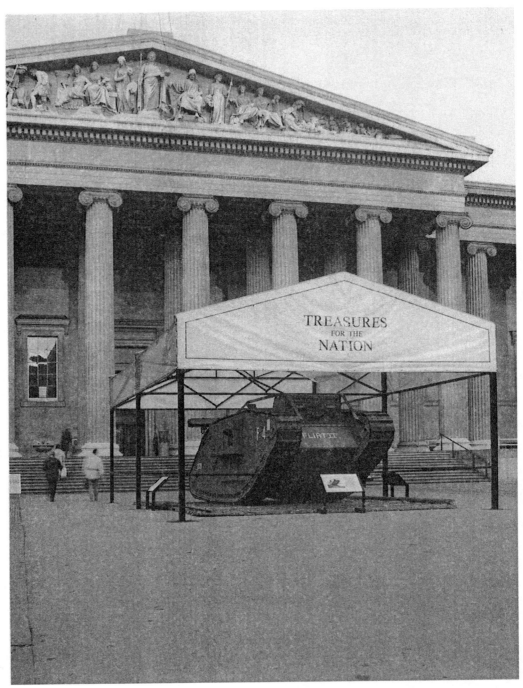

1. Photograph showing the main entrance of the British Museum, Bloomsbury, at the time of the 'Treasures for the Nation' exhibition in 1989. An armoured vehicle, 'Flirt II', can be seen positioned beneath the exhibition's canopy and in front of the museum's portico. Courtesy of the Trustees of the British Museum.

INTRODUCTION

'There is no document of civilisation which is not at the same time a document of barbarism.'[1]

Walking past the imposing but familiar façade of the British Museum some time in 1989, I was stunned by an altogether unfamiliar sight. There, in the forecourt of the Museum, was an armoured vehicle from the First World War, virtually blocking the main entrance of the building (fig. 1). Nestling beneath a canopy marked 'Treasures of the Nation', the 'exhibit' mirrored the pediment of the huge façade in what might now be seen as a knowing postmodern pastiche. Closer inspection revealed that the armoured vehicle was incongruously 'feminised' by the words 'Flirt II' written across its front. The image has stayed with me, in turn disturbing, intriguing and often hilarious. My reason for recalling it now is because it seems to me to be an image which perfectly dramatises the contradictory emotions conjured up by the sign of the Museum.

Regardless of the intentions of the curators responsible for this piece of inspired absurdity, the conjuncture of femininity, military hardware, neo-classical façade, national museum and 'heritage' is a profoundly destabilising image. It enacts a challenge to those cultural values mythologised and therefore naturalised as part of a shared heritage, while at the same time threatening to expose the spuriousness of such a notion by dramatising the encounters between the state, militarism, colonialism and the secular temple, which stakes its claim to representativeness on the very basis of its institutional and academic autonomy from such essentially paternalistic entities.

Two years earlier, I had been similarly struck, not this time by a discomforting juxta-position, but by the predictability and unsettling familiarity of the kind of conjuncture propounded by a feature in the science columns of a well-known liberal British newspaper. The extensive article, written by the medical correspondent, purported to be a scientific analysis of the incidence and conditions of the AIDS virus in Africa. Accompanied by a photograph of two smiling Kenyan women, the opening paragraph began, 'The best time to observe the Nairobi hooker is at dusk when the tropical sun dips beneath the Rift Valley and silhouettes the thorn trees against the African skyline. It is then that the hooker preens itself (*sic.*) and emerges to stalk its prey: the wazungu.'[2] The homophobic hysteria, that had characterised so much of the press reporting on AIDS and HIV, evidently now was being supplemented by the rabid attacks on another form of sexual transaction, whose deviance was confirmed by the racialisation and bestialisation of one of the parties involved, in this case, the Nairobi sex-worker.[3] Apparently responsible for the contamination of 'innocent' white western males, these women were now being held accountable not only for the spread of the HIV virus but also, by implication, for the demise of

western culture. Some paragraphs later, this familiar anxiety resurfaces more explicitly: 'The port, with its spicy mixture of Africans, Arabs, Indians and Europeans, and the hint of dangerous excitement lurking in every dark corner, provides a temporary home for thousands of visiting merchant seamen and U.S. sailors.'[4]

On the face of it, these two anecdotes bear very little relation to one another, but I would like to suggest that their distance is deceptive and that the assumptions they dramatise, and the social relations they invoke, are intimately linked to each other. In addition, together they signal two of the underlying concerns of this book. On the one hand, my aim is to understand a little more about the museum as a repository for contradictory desires and identities, and the means by which different publics have been implicated by the narratives of belonging and exclusion produced within its walls.[5] On the other hand, the book seeks to demystify the link (in the West) between those cultural values which could be said to reside in the museum and deep-seated attachments to a concept of racial purity, coupled with an equally tenacious anxiety about its contamination and degeneration by 'black' races cast in this scenario as the forces of evil. The context of my second anecdote – the science pages of the *Guardian* – makes it clear that any discussion of such an anxiety would also have to take account of the extraordinary licence given to those pronouncements made in the name of scientific inquiry or from the unapproachable distance of academic objectivity. I hope in this study to provide a better grasp of how such categories transform and produce knowledge beyond the bounds of their associated disciplinary remits.

Another reason for introducing this historical study with two incidents from the more recent past is that while the book forms an analysis of a particular moment in the history of British imperialism, and a particular aspect of the colonial encounter, it is also framed as a contribution to a much broader project of contemporary relevance. How do we account for the apparently endless currency of certain received notions about racial difference, and how do we make sense of the resurgence, transformation and subsidence of these representations at different points in time?

The image of Africa, as it was presented to the British public in the last decade of Victoria's reign and the first decade of the twentieth century, has often been historically reconstructed as the product of a monolithic imperial propaganda.[6] According to these accounts, Africa was uniformly reproduced through a series of tropes as a 'land of darkness', 'the white man's burden', peopled with savages of an inherently inferior order, both intellectually and morally, to the white coloniser. Consequently, the material culture that was brought out of Africa as a result of the 'civilising mission' of the white colonisers is usually understood in most historical accounts as being relegated solely to the demeaning category of 'trophy' or 'curiosity' over this period.

It would be absurd to claim that this was not the prevailing image, but I believe that rather than simply cataloguing the horrors of the British imperial/colonial psyche, it is only by coming to terms with the heterogeneity of responses to, and involvement in, Africa, that we can fully comprehend the insidious appeal of colonial ideology, even amongst those philanthropic and humanitarian liberals who were its most ardent critics.[7] Africa, as a concept as much as a geographical designation, had diverse resonances for different sectors of the British public from the last decade of the nineteenth century to the beginning of the First World War. The Africa that existed in the popular imagination was an ideological space, at once savage, threatening, exotic and productive,

inhabited by a population assigned a similarly disparate and ultimately contradictory range of racial traits. Representations of the African were, and are, evidently not 'fixed' but eminently recuperable and variable, depending on the political exigencies of any specific historical conjuncture.[8] As such, they necessarily tell us more about the nexus of European interests in African affairs and about the coloniser, than they do about Africa and the African over this period.[9]

This book is not intended, however, to be a lexicon of representations of Africa in visual culture over the period 1890 to 1913. Rather it focuses on a series of case studies which have been selected in order to articulate the complex and often contradictory relationship between aspects of what could be broadly termed 'popular' and 'scientific' representations of Africa. The word 'popular' is used here as a way of differentiating that knowledge which was not produced through the emergent disciplines claiming to be 'scientific', in particular, anthropology, eugenics and biology. More precisely, my use of 'popular' is to describe cultural vehicles which were accessible to, and consumed by, an educated middle and lower middle-class public with a general interest in the colonies, or with professional stakes in the colonial administration, but who remained outside the academic establishment. It is not, as is so often the case with historical studies of popular culture, a shorthand term for working-class culture, although questions about the involvement of different class sectors in aspects of colonial ideology form an integral part of this analysis.[10] In this sense, the use of 'popular' here comes closest to Tony Bennett's definition of an 'area of exchange' between classes.[11]

There are two themes which structure this book: firstly, the analysis of the role of 'spectacle' in the constituting of racial difference, in relation to Africa, and secondly, the definition and scope of the public domain of anthropological knowledge of Africa from 1890 to 1913. In a period of burgeoning leisure opportunities for both the middle and working classes, two particular cultural arenas effectively disseminated knowledge of Africa and other colonies to a wide-ranging public.[12] The display and classification of material culture from Africa in ethnographic collections in local and national museums, and the use of this material culture together with the spectacle of Africans themselves in a variety of large-scale national and regional exhibitions, ensured that, as one commentator remarked in 1890, 'Africa in one or other of its phases [was] on everybody's mind and in everybody's mouth'.[13] By focusing on these cultural institutions, each of which became associated in the public consciousness with 'scientific enquiry' or entertainment (and usually both), the analysis which follows explores the relationship between that knowledge of Africa and the African claiming to be 'objective truth', through the discourse on African culture and society produced within the emergent anthropological establishment, and that image of Africa sustained in the popular consciousness as 'received' knowledge. In other words, it examines the relationship between so-called scientific knowledge and popular imagination.

It is also my contention that any analysis of how exhibitions and ethnographic museums defined and addressed their constituencies, and the question of their effectivity, has to be seen in relation to the rise of anthropology and its struggle for recognition in Britain, both as an academic discipline and in terms of its usefulness to the imperial state. Most histories of the development of anthropology have a tendency to characterise the emergent discipline either as the liberal conscience of the colonial administration or as a government lackey.[14] It is clear from what follows that this is an unhelpful polarisation of

what is a necessarily ambiguous and shifting partnership with imperialism. In this respect, the professionalisation of anthropology in Britain provides a special case. In North America, France and Germany, the science's relationship to the state was less tentative and could rely on its direct patronage. This period sees the emergence of ethnographic curators and ethnography as a newly professionalised sector within the museums establishment. In Britain, however, despite developments in the stratified hierarchies of the museum bureaucracy and administration which today would signal a separate, if related, sphere of activity, ethnographic curators were drawn almost entirely from the membership of the Anthropological Institute. Indeed, many curators were also presidents of the Institute between these dates. Consequently, each sector had vested interests in the public recognition of both. What this meant, of course, was that precisely because of the lack of government recognition for anthropology as a serious academic subject (until the 1920s in Britain), and the lack of government funds for the development of ethnography, the domain of museums, curators sought to make their area of expertise indispensible in the broadest possible sphere. Their strategy was to propose anthropology as both 'popular' *and* 'scientific', appealing to and relevant for the general public, school-children and the serious academic who recognised anthropology and ethnography as a 'science' and a discipline with its own domain of study. This was primarily accomplished through the medium of the ethnographic collection.

The heated debates from within the membership of the Anthropological Institute clearly demonstrate shifts and complexities in the paradigms produced as an aid to understanding cultural production from different African societies. One of the contentions of this book, however, is that these complexities are rarely registered directly in what was arguably the public face of anthropology – the museum. While the history of anthropological theory within the discipline, and the shift from 'armchair' to fieldwork methods, has been thoroughly treated, little attention has been paid to the relation between anthropology's academic and public image over this period.[15] It is this interface, and what I perceive to be a disjuncture between the anthropological theory promulgated in the public domain through museums and that produced for circulation within the aspiring academic community, that primarily concerns me here, rather than rehearsing the intricacies of anthropological theory from 1890 to 1913. This disjuncture mitigates against using the ethnographic collection as a barometer of the latest developments in anthropological thought. On the contrary, there is no easy correlation between the two. The ethnographic collection or museum instead represents the material intersection and negotiation of state, institutional and professional politics and policy over this period.

A central and related concern of this book is to elaborate the process whereby material culture functioned, metonymically, to stand in for various African societies. 1890 is the historical starting point, since this marks the period of concerted British imperial and colonial expansion in Africa, one of the consequences of which was the subsequent influx into Britain of material culture from different regions of the African continent. Since British expansionism tended to concentrate on territories in Sub-Saharan Africa, these are the communities which are most frequently subjected to the ethnographic and exhibitionary gaze. 1890 is also the moment which signals a renewed interest in ethnographic collecting generally, together with a shift towards a more expansive policy with regard to the hitherto neglected African sections in most national collections.

Art history has consistently dealt with the rise of European collections of material culture designated as 'ethnographic', in terms of the European avant-garde's projected spiritual or formal affinities with African, Oceanic or latterly Inuit material culture. In other words, research has focused on that development defined by the modernist catchphrase 'primitivism'.[16] The best of this acknowledges anthropological discourse as a contributing factor in the widespread acceptance of certain criteria for establishing the cultural and aesthetic value of non-western culture in the West.[17] With some notable exceptions, however, such empirical tracking serves primarily to indicate when and who amongst the European avant-garde 'discovered' the material culture of Africa and other colonies as an aesthetic category.[18]

This book works to expand the horizons of such scholarship, by indicating the extent to which discussions on the aesthetic and other values of material culture from the colonies were, in one way or another, familiar to a far broader middle-class public than is generally recognised. It also demonstrates that this public was directly implicated in the production of ethnographic 'meaning', and was sufficiently aware of the categories through which this was constructed, even while they may not have been aware of the more subtle nuances of meaning in the differentiation that they described, to recognise the ethnographic collection as something more than a mere jumble of 'curiosities'.

Certainly it is abundantly clear that attributing aesthetic value to material culture from the colonies was not something confined to, or initiated by, modernist artists working in Britain, France or Germany in the first decade of the twentieth century. Rather than charting, once again, the European avant-garde's appropriation of African and Oceanic culture as a more or less opportunistic adventure in self-renewal (which none the less always puts the European in the privileged position of seer and visionary), it seems to me that more can be gained from exploring the ways in which such discussions around aesthetic criteria and the artistic categories of art and design from the colonies contributed both to definitions of 'race' and to the ideology of a national culture within Britain itself. My interest, then, lies in exploring the ideals of social effectivity and the narratives of identity produced through public ethnographic displays. In this respect, I am concerned to elaborate the symbolic status of collections as a form of social transaction which tells us more about the colonial process and the subject positions occupied by the main players in the colonial drama.

What follows is conceived as a contribution to the work of excavating the imperial and colonial consciousness, through an archaeology of certain institutions of colonialism. As such, I am primarily concerned with British perceptions of Africa and African culture. However, to analyse any aspect of the colonial encounter is to recognise it as just that, as an encounter. It is to recognise that the colonial community was not just the community of the coloniser, but was also made up of those communities subjugated under imperial rule. It is to realise, as Terence Ranger and others have so adeptly demonstrated, that any encounter, while not necessarily one between equal partners, is nevertheless a dynamic meeting.[19] Consequently, while my primary preoccupation lies with unravelling the intricacies of the imperial state and the ways in which class and gender, together with the vagaries of party and institutional politics, mediated the available representations of Africa in Britain, I am also concerned to indicate some of the more ambiguous and strategic exchanges in the dialogue between coloniser and colonised. In recent years important work, much of it in the domain of literary studies, has theorised various aspects

of the colonial encounter.[20] It is my hope that the reader of this account will recognise, in the materialist history which follows, the traces left by these insights. I have deliberately avoided expository passages laying out theoretical premises which are then 'illustrated' by empirical data. The book has rather made use of critical and political theory to underpin such material and to lend it meaning.

Some aspects of Michel Foucault's analysis of the dynamics of power and Antonio Gramsci's political writings on the concept of hegemony have been helpful in providing a theoretical framework for exploring the possibility of an interactive and mutually transformative relationship between these communities, both of which were necessarily heterogeneous rather than easily unified and straightforwardly oppositional entities. I have tried to signal some of the ways in which different African communities and individuals were able, sometimes of necessity and sometimes by choice, to make creative and strategic use of the colonial encounter. Since the focus of this book is on the impact of that encounter in Britain rather than on the African continent, I have chosen examples which dramatise the contradictions between expectations and lived experience on this front and between Europeans and Africans from the continent, rather than the African diaspora in Britain over this period.

Foucault's concept of discursive formation has also enabled me to think through the possible relations between different scientific and popular rhetorics and debates concerning race and culture, and the way in which they can be said to have produced Africa for different sectors of the British public through their own regimes of truth.[21] Nevertheless, any dialogue said to occur between coloniser and colonised is already circumscribed by the all too tangible violence of imperialism. Consequently, I have found the materialist account of Antonio Gramsci indispensable as a corrective to the sometimes slippery relation between representation and lived experience, and the subsequent lack of opportunity for the recognition of dissent or resistance, which could be said to characterise Foucault's analysis.[22] In particular, Gramsci's concept of hegemony as maintained through constant bargaining and negotiation between different social groups, rather than imposed forcibly from above, is a model which not only allows for a more dynamic and differentiated relationship between classes and between subaltern and dominant groups, it also enables a more productive rethinking of the power and suggestibility of cultural activity.[23] The dialectical relation suggested by Gramsci's thesis helps to explain the ambivalence of anthropology's position in the early twentieth century in Britain, and the reasons why public exhibitions of material culture from the colonies were such a potent means of maintaining the myth of Britain as a powerful and unified colonial force in the popular consciousness of those early years, and why they can still generate controversial discussions about the nature of belonging and history today.

MATERIAL CULTURE AT THE CROSSROADS OF KNOWLEDGE: THE CASE OF THE BENIN 'BRONZES'[1]

> The discovery of these treasures resembles that of a valuable manuscript. They are a new 'Codex Africanus', not written on fragile papyrus, but in ivory and imperishable brass.[2]

> Although little authentic knowledge of the Benin people is current, the main characteristics of the surrounding tribes are thought to be theirs also in an intensified degree, finding expression in habits of disgusting brutality and scenes of hideous cruelty and bloodshed, ordained by the superstitions of a degraded race of savages.[3]

Between them these two statements, both written in the late nineteenth century about different aspects of Benin culture, encapsulate the essential ambivalence of the European colonial response to material culture from West Africa and other colonies. These commentaries confusingly register an admiration of Benin culture according to western European aesthetic criteria, while simultaneously inscribing the indigenous producer within a racialised discourse of degraded savagery.

In 1897, a series of events took place in Benin City, in what was then the Niger Coast Protectorate, which ended in the wholesale looting of royal insignia from the court of Benin. These incidents, and the resulting loot, gained instant notoriety across a range of British journals and newspapers which serviced both a mass popular readership and a professional middle class. They also received coverage in the more specialist journals serving the emergent 'anthropological' professionals. Such a spread of coverage provides the basis for mapping the configurations of interests in Africa – at once scientific, popular, geographical, administrative and cultural – and the possibility of understanding the interrelation of knowledges produced in what were often presented as discreet spheres. In addition, this particular passage of history is a marker of how early, and to what extent, questions of aesthetics and cultural value, in connection with material culture from the colonies, appear as central issues on not only art historical and anthropological agendas, but to a much larger public with no particular specialist investment in African affairs.

If the valourisation of cultural production has any impact on a reassessment of the general culture and society of the producer, then the influx of sixteenth-century carved ivories and lost wax castings from Benin City onto the European art and antiquities market, together with the subsequent proliferation of popular and 'scientific' treatises which their 'discovery' generated, should have fundamentally shaken the bedrock of the derogatory Victorian assumptions about Africa, and more specifically, the African's place in history. Yet, as we shall see, this was certainly not the case. In fact, what the Benin

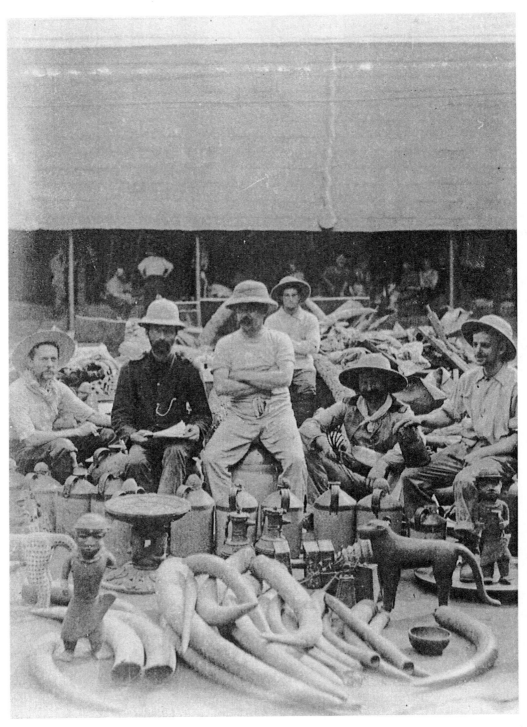

2. British officers of the Benin punitive expedition with bronzes and ivories taken from the royal compound, Benin City, 1897. Courtesy of the Trustees of the British Museum.

example demonstrates is precisely the extent and the ways in which such contradictory beliefs could be maintained. This chapter is about the conditions which made possible the coexistence of the apparently mutually exclusive observations expressed in the opening citations.

I

The details of the historical circumstances surrounding the raid which led to the looting of Benin City, provide useful insights into the way in which the colonial process was presented to the British public, and into the shared assumptions regarding race which lay at the basis of both Conservative and Liberal justifications for the intervention (fig. 2). This is an important narrative all too readily expunged, except as a seriously truncated version, from most discussion of the Benin bronzes. More importantly, the dialogical relationship between the terms and language through which these events were relayed, via a broad cross-section of the British press *and* in certain proto-nationalist papers in West Africa whose coverage was often available in Britain through radical and humanitarian journals, supplies the key to understanding the possible range of significances of the bronzes and other artifacts.

The history of British relations with Benin City prior to, and including, the punitive expedition of February 1897 is essentially a narrative of claims over trading rights, and frustrated British efforts to break the back of the monopoly on palm oil and various other commodities held by Ovonramwen, the Oba (or king) of Benin and of the Edo peoples. With the onset of trade competition from Dutch and German firms in the 1880s, it was deemed expedient to confirm the British government's claim to a proportion of the trade by the formation in 1893 of the Niger Coast Protectorate.[4] This effectively extended the British government's sphere of direct influence from the Oil Rivers region in the Niger Delta area (what is now southern Nigeria) to the hinterland, so that Benin now fell wholly within the jurisdiction of the Protectorate. Earlier peaceful incursions in 1891, into the area traditionally under the Oba of Benin, by Henry Gallwey as the first Vice-Consul of the Benin River area, had already resulted in the establishment of a vice-consulate at Sapele to the south of Benin. The Itsekiri and the Urhobo peoples in this area were increasingly aware of the encroaching British interest in what had hitherto been their unchallenged territory in the interior. By 1890, European trade was certainly thriving around Sapele and Warri. Furthermore, persistent protests from an increasingly influential body of traders about the Oba Ovonramwen's ban on the sale of palm kernel and other trading restrictions, imposed on the death of his father Adolo, encouraged further initiatives by the British to protect their interests and to increase their sphere of influence in the area. In March 1892, Gallwey made an attempt, accompanied by a consular agent and trader, J.H. Swainson, to persuade the Oba to sign a treaty recognising British sovereignty which would effectively sign away Benin's independence. This Gallwey succeeded in doing. Article VI of the document drawn up stipulated that trade should be open to all nations throughout the Oba's territory. The ensuing bloodshed which has since been attached to the name of Benin was largely the result of various attempts by the British to enforce this clause of the treaty. What is significant in this lead up to the punitive raid of February 1897, particularly in relation to the present inquiry,

is the basis for the arguments used to either justify or exclude the use of force to effect the treaty.

While Gallwey himself advocated a peaceful means of approach, Claude Macdonald, in his capacity as Commissioner and Consul-General of the Oil Rivers Protectorate, urged aggression as the most effective means of enforcement.[5] For Macdonald, the justification for his solution hinged on the need to eradicate the practice of human sacrifice among the Edo.[6] Gallwey's case also focused on the custom of human sacrifice, but to a different purpose. He argued that, with the use of force, the Edo would only retreat to greater 'savagery' than before by fleeing the city, characterised in his discourse as the seat of a relative state of civilisation. This emphasis on the necessity of 'civilisation', which meant saving the 'savage' from apparently continuing on the road to self-destruction, was an important component in the presentation to the British public of the necessity for a permanent European, and preferably British, presence in Benin as a moderating force. It also served to remind the reader of the very temporary nature of what is portrayed as essentially a veneer of civilisation. According to popular belief, the Africans would revert to their 'true' nature – the untamed savage – as soon as the colonial agent, and thus civilisation, was out of sight.[7]

Other economic considerations underlay this representation of the African. The desire for an urgent resolution to the problem of the treaty's enforcement was because the revenue yield for 1892 was not appreciably larger than it had been in the 1850s, due to the Oba's effective monopoly on the lucrative items mentioned above.[8] The situation was aggravated further by another incident which involved Nana, the influential Governor of the Benin River region. Nana was one of the most powerful trade chiefs of the Itsekiri. A man of considerable business acumen, he was a force to be reckoned with by both British traders and the government, who resented his authority in the Benin River and were looking for a way to minimise his power. In 1894, he forbade trade with Benin. As a result, skirmishes occurred between different factions of Urhobo and Itsekiri which brought Nana into conflict with the British authorities, who eventually captured his city of Ebrohimi on 25 September 1894. The incident was to lead, that same year, to Nana's demotion and exile by the British government. Fired by this success at quashing Itsekiri resistance, Ralph Moor, the Deputy Consul-General of what had been the Oil Rivers Protectorate but which in 1893 was renamed the Niger Coast Protectorate, became intent on taking over Benin City as well. However, repeated applications to the Foreign Office for permission to take Benin by force met with rebuttals in favour of a peaceful solution.

Meanwhile, after initial aquiescence by the Oba agreeing to certain concessions regarding the relaxation of trade restrictions, the situation was reversed again in November 1896 when he closed all markets to outside trade.[9] During the crucial period of this latest development, Moor had gone to England on leave. In charge, as Acting Consul-General, was an inexperienced official by the name of Phillips. Finding the situation thus worsened, and with Moor away, Phillips seized the opportunity for self-aggrandisement and determined to solve the dilemma in Moor's absence. He wrote to the Foreign Office, advocating the swift implementation of Moor's strategy of offensive. While Moor supported this plan and prepared to return to Benin for the fray, the Foreign Office again opposed such action. This time the telegram did not reach Phillips before he had taken the matter into his own hands. He had already gone forward to Benin City, however

inexplicably, not with an armed force but an unarmed party and ostensibly on a peaceful mission. Despite repeated warnings to the party to retreat, both from the Oba's messengers and others, it continued to advance. As a result the entire party, bar two, was killed before it reached the city.

If the Oba had been anxious about the prospect of war with the British on the occasion of Gallwey's last visit in 1892, an anxiety which had encouraged him to sign the treaty, by 1897 grounds for such concern had escalated. Ovonramwen's prestige amongst his own people, and his confidence in their support, had waned after several incidents and disputes resulting in murder and reprisals. Further local rebellions compounded his problems on the home front. In addition, the British government's exile of his vassal Nana had already indicated how far he could trust the British. Despite these considerable grounds for the Oba's suspicion as to the motive of the consular mission, there is evidence to suggest that the Oba made persistent attempts not only to stall the Phillips party, but also to stop the war party organised from Benin.[10]

Reprisals for the killings were extremely speedy. The District Commissioner at Sapele received word of Phillips' death on 7 January 1897, from Chief Dogho, an Itsekiri chief who had attempted to warn the party of the impending danger. Three days later news had reached London. By the beginning of February, some 1,500 men were readied for the attack on the city, and by 18 February Benin City was taken by the British punitive forces.

II

The British public were regaled, in the national and illustrated press, with details of the gruesome events leading up to the punitive expedition, and with a minute account of the manoeuvres of the expeditionary force. Following the death of Phillips' party, the *Illustrated London News* ran a series of stories on Benin which built up an ever-increasing store of depravities.[11] Certain features recur throughout the narratives on Benin in the middle-class illustrated press. These are summed up in the following statement, quoted at the beginning of this chapter:

> Although little authentic knowledge of the Benin people is current, the main characteristics of the surrounding tribes are thought to be theirs also in an intensified degree, finding expression in habits of disgusting brutality and scenes of hideous cruelty and bloodshed, ordained by the superstitions of a degraded race of savages.[12]

The emphasis on Benin as a 'degraded' race is an important feature of the representation of certain peoples prior to and during colonisation. It was a concept already familiar in Britain, in relation to the representation of what was euphemistically referred to as the 'Orient'.[13] The terms 'decay', 'deterioration' and 'degradation' were mobilised in the Benin context partly because they were a convenient means of undermining the all too substantial evidence (both through historical accounts and the tangible evidence of the bronzes and other items) of an ancient and thriving society in Africa, which displayed all those signs associated with European definitions of civilisation. To enhance the idea of Benin as a degraded society, both the narratives in the illustrated press and 'firsthand' accounts of the punitive expedition made use of an effective juxtaposition of text and

image. Though not often explicit, the correspondence between text and image in the middle-class illustrated press had the effect of implicitly reinforcing this sense of Benin as degraded and degenerate. Two aspects of this far-reaching preoccupation with 'degeneracy' are worth recounting in some detail: the representation of Benin women, and of Benin City itself.

Immediately after Benin forces ambushed and killed the Acting Consul-General Phillips and most of his entourage, the *Illustrated London News* of the 23 January 1897 published an article denouncing Benin society as having 'a native population of grovelling superstition and ignorance', together with an apparently unrelated photograph entitled 'A Native Chief and His Followers', showing a group of women sitting around the single figure of a man (fig. 3). The group of figures seem, from a contemporary European perspective, to be impassive and static. In the foreground, two women are literally arranged to frame the image. While the 'native chief' is the central figure compositionally, it is the women who predominate and who arrest the eye. The nudity of the foreground women is both masked and accentuated, because their objectification is reinforced by the fact that this is clearly not a natural posture. They have evidently been 'put' there. To cement this objectification, their bodies signify as the human equivalent of the 'trophy' display which was so popular at this time with both ethnographer and big-game hunter alike (fig. 4).

This is a recurrent feature of representations, not only of the Edo but other African women, in the British illustrated press. Similar compositional devices were used in many different contexts. For example, a photograph in the *Reliquary*, a serious antiquarian publication with a readership of archaeologists, ethnographers and folklorists, employed the same motif ostensibly to illustrate bells on Benin women's girdles (fig. 5). The

3. 'A Native Chief and his Followers', *Illustrated London News* (23 January 1897).

4. Detail from fig. 28: Tanganyika exhibit from the Stanley and African Exhibition, an example of the 'trophy' method of display (London 1890).

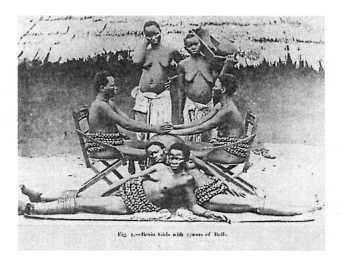

Fig. 1.—Benin Girls with aprons of Bells.

5. 'Benin girls with aprons of Bells', *Reliquary*, vol. VI (October 1900).

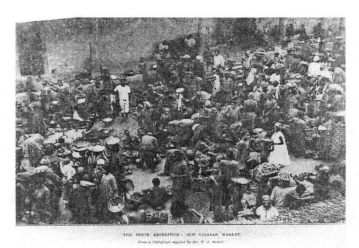

THE BENIN EXPEDITION: OLD CALABAR MARKET.
From a Photograph supplied by Mr. W. J. Sackett.

6. 'The Benin Expedition: Old Calibar Market', *Illustrated London News* (27 February 1897).

bells seem a rather precarious alibi for voyeurism since they are difficult, if not almost impossible, to make out.[14] It is again the body which is actually held up for inspection. The 'scientific' aegis of the journal operated here in a specific way in relation to the image. Together with the same compositional framing device as the previous illustration, this photograph's additional status as 'document' rendered even more respectable such overt nudity and any sexual connotation implied, in much the same way that the familiar convention of mythologising the nude in western fine art supposedly masked the sexuality of the sitter sufficiently to render nudity inoffensive to bourgeois sensibilities.

In the context of the representation of Benin as a degenerate society, it is as significant as it is banal that all the women in these close-up photographs are only partially clothed, while photographs in the illustrated press of those West Africans who had acknowledged British sovereignty were pointedly shown fully clothed (fig. 6).[15] In another article in the

Illustrated London News, for example, this time extolling the virtues of the British held Old Calabar and its prosperous transformation under British 'guardianship' (as opposed to the apparent dissolution further up river in Benin), all the women in the photograph of 'Old Calabar Market' are notably fully clothed. This is not necessarily to suggest that the camera was not reproducing what was visible in this instance. Rather, that this also served as a reiteration of the old adage that while nakedness signified 'uncivilised', clothing was an obvious appurtenance of 'civilisation'. Consequently, such juxtapositions reinforced this distinction. The fact that such assumptions could be made visible through the medium of the photograph lent a veracity that the old lithographs, until recently the mainstay of the illustrated press, could not compete with.

Similarly, although the title of the first illustration suggests nothing about the relationship of the women to the central male figure of the chief, it was presumed that they were his wives. While that favoured topic of orientalist paintings, the harem, was a familiar sign linking Islam and degeneracy, the practice of polygamy in African societies did not evoke a specific genre. Yet as a sign it was irrevocably tied to the concept of African degeneracy. Debates and discussion on the topic of polygamy in African society were common in a variety of arenas. An attack on polygamy, for example, was often at the heart of arguments against the slave-trade from the Anti-Slavery Society and the Aborigine Protection Society, particularly when Arab slavers were involved, since this provided the perfect alibi for a dual assault on slavery and Islam. Similarly, the various missionary societies with interests in Africa (or indeed in India) never missed an opportunity to launch an offensive on Islam, or in the case of India, Hinduism, and polygamy was a key pawn in their defence of Christian values.[16] At the same time, others with the ear of different publics were busy defending the practice of polygamy. Mary Kingsley, inveterate traveller, champion of British trading enterprise in West Africa, entomologist and self-styled ethnographer, was adamant about the cause of any 'degeneration' on the West African coast. In a statement which echoed many West African patriots' criticisms of the colonial government, she claimed: 'I know perfectly well that there is a seething mass of infamy, degradation, and destruction going on among the Coast natives. I know, humanly speaking, what it comes from . . . for it is the natural consequence of the breaking down of an ordered polygamy into a disordered monogamy.'[17] I will return to a discussion of the implications of this debate in the next chapter. For the moment, it is enough to point out that the representation of polygamous relations frequently functioned as an unspoken indictment of certain African societies. The comment accompanying the photograph in the *Illustrated London News* article which stated that 'the women develop, as usual in these regions, at a very early age', positioned the African woman ambiguously in the category of both victim of pagan practice, and libidinous degenerate. Thus, from the complacent vantage point of moral high ground, the colonial gaze could scrutinise with impunity.[18]

Another feature of firsthand accounts is the way in which a degenerate topography is mapped for Benin City itself. T.B. Auchterlonie's narrative of a voyage to the city on New Year's Day 1890, delivered to the Liverpool Geographical Society in the wake of the 1897 expedition, starts by pointedly clarifying his use of adjectives such as 'New' and 'Old', or alternatively, 'Black', to describe different aspects of Benin.[19] 'Old' or 'Black' Benin was distinguished from 'New', chiefly because of its refusal to establish trade links with Britain. In common with most accounts of Benin City directly after the punitive raid, Auchterlonie introduces the sights and smells of human sacrifice early in the narrative,

and refers to Benin City as being in a state of crumbling decreptitude.[20] On the other hand, Old Calabar, Warri and Sapele, in what is called 'New Benin', were held up as examples of the prosperity which supposedly followed British trade. The use of the adjective 'black' is of course an historically familiar device for emphasising the malevolent character of 'Old' Benin.[21] That it also happens to be the colour ascribed to the African's skin, carried with it consequences which ensured the derogatory connotations of the term. The full implications of this use of the adjective become clear in the light of Auchterlonie's remarks that, since the Oba's skin was not as black as most coastal tribes, he did not look like a killer![22] The *Illustrated London News* followed up Auchterlonie's account with a report on the city which described it as: 'A cluster of native huts of the usual West African type . . . with the King's house in the centre. This is reached through a number of enclosed squares, in each of which a space is reserved for fetish observances at various pagan altars.'[23] As if to complete the picture, the piece was accompanied by drawings of a British ship, 'the Hindustan government hulk at Benin', together with the

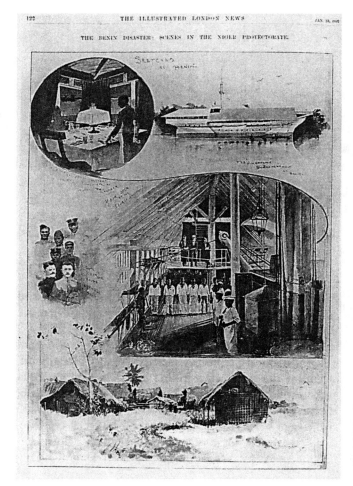

7. 'The Benin Disaster: Scenes in the Niger Protectorate', *Illustrated London News* (23 January 1897).

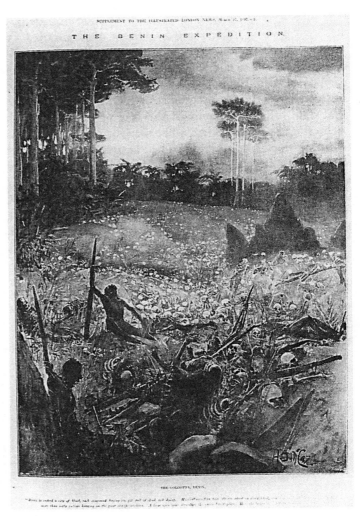

8. 'The Golgotha, Benin', *Illustrated London News* (27 March 1897).

ordered ranks of 'loyal' African troops on the main deck of the 'George Shotton', and at the British trading post 'Old Calabar'. These bastions of order and civilisation are juxtaposed with an image of a clearly rambling and delapidated local town (fig. 7).

Meanwhile, this image of a hopelessly degenerate society was enhanced by a different kind of documentation, which drew its authority from the fact that it was a 'firsthand' depiction of the horrors of Benin and of the attack on Phillips' mission. Captain Alan Boisragon, one of the two survivors, lost no time in writing his memoirs of the ambush. They were published the very same year.[24] His text repeats the same narrative of a grand civilisation relapsed into a state of savage barbarism as a result of being cut off from European influence. As proof of the inevitable logic of such a hypothesis, Boisragon offered the reader the examples of the powerful West African states of Dahomey and Ashanti, where he had been involved in settling the western boundaries of the Gold Coast

in 1892.[25] Despite a generous reception of 14,000 men to welcome them, Boisragon observed that, 'still, with all this reception there were no signs of any civilisation, and the Coomassies (*sic*.) had relapsed into most of the usual customs of savages, which had at one time been stopped – particularly of human sacrifices.'[26] It is important, here, to emphasise that the Ashanti capital of Kumasi, to which this passage refers, was another region where the skill and excellence of cultural production was incompatible with certain of the more derogatory racial stereotypes of the Ashanti held by the British. Their material culture, much of which consisted of *cire perdue* gold casting subsequently secured for British ethnographic collections, was of a complex manufacture requiring a high degree of skill comparable to the material from Benin and, crucially, not usually associated with Africa.[27] Consequently, it is interesting that the same discourse on degeneracy emerges in accounts of Kumasi and its inhabitants as a way of undermining any challenge which such material culture might have represented to British perceptions of the African as a wayward savage.

The comparison of the Edo with the Dahomeyans and the Ashanti becomes a recurrent feature in the attempts of writers of various categories of text, broadly classified as either 'popular' or 'scientific', to locate Benin in the popular consciousness within an African context. They specifically chose other African societies which had already acquired public notoriety, through association with resisting colonisation and also with the practice of human sacrifice, but who significantly had also succumbed to European sovereignty. Consequently, the comparison had the effect of emphasising the inevitability of this process.[28]

Boisragon's book, which begins with details of cannibalism, twin-killing and the health hazards of the mangrove swamp, ends with a eulogy to those Britons killed in Benin because of their 'glorious work of rescuing the native races in West Africa from the horrors of human sacrifice, cannibalism and the tortures of fetish worship.'[29] The same sentiments regarding the moral obligation to 'civilise' in the face of such unspeakable (but volubly and often repeated) horrors, is also a feature of the *Illustrated London News* reporting on the incident, and, predictably enough, of most other reporting of the event in the British press. Discussion of trade monopolies is notably absent from almost all accounts of the punitive raid. Any British interests in Benin are presented as purely altruistic.

On 27 March 1897, the *Illustrated London News* published a supplement devoted entirely to the Benin expedition, supported by supposedly documentary evidence in the form of eyewitness illustrations. The reporting is easy to anticipate. Much detail is given over to recounting the numbers of men and arms deployed, and the inevitable encounters with the remains of human sacrifices and mutilated bodies, as well as the fetish altars covered with human blood at the entrance to the city. All are meticulously described. Any examples of the material culture that are mentioned, even the bronze memorial heads and carved ivory that eventually formed the basis of the displays in the British Museum, are dismissed in most accounts of the actual punitive expedition with phrases like, 'having the most grotesque appearance.'[30] Again, the illustrations that accompany the narrative reinforce this without the need for explicit reference in the text. Various full-page illustrations continue to serve as reminders of the more morbid details of the punitive expedition, such as 'The Golgotha, Benin' (fig. 8), which represents a huge field of human skulls and skeletons with a central figure in a contorted crucifixion pose. However, a

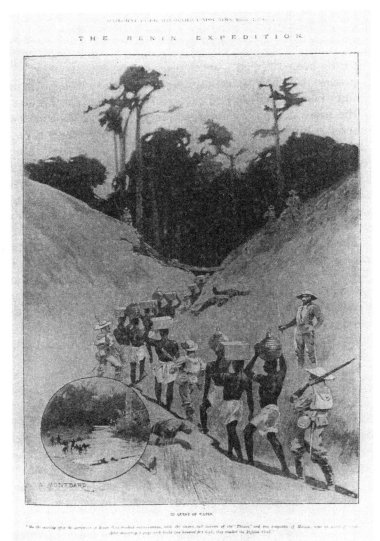

9. 'In Quest of Water',
Illustrated London News
(27 March 1897).

number of other images which extend the philanthropic sentiments of Boisragon's memoirs are also included. In the illustration 'In Quest of Water' (fig. 9), the artist has not missed the opportunity to sprinkle the ground liberally with cadavers and dismembered limbs. While the ostensible subject of the picture is a file of muscular black carriers interspersed with white armed guards in search of water, the imminent danger signalled by the dead bodies reinforces the message of care and concern apparently shown by the British protecting those black carriers in their retinue. In 'Captain Campbell's Brigade Bringing up the Rear in the Advance on the Town' (fig. 10), the majority of carriers are shown to the far right of the image. One has his hands over his ears to shield them from

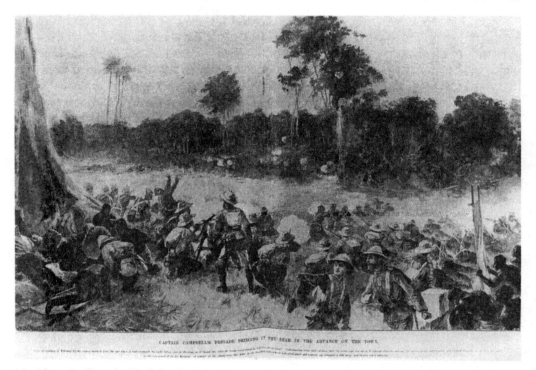

10. 'Captain Campbell's Brigade Bringing up the Rear in the Advance on the Town', *Illustrated London News* (27 March 1897).

the repeated gun blast. Although they represent stretcher-bearers, their main function in the picture is as passive onlookers to the British action. (The British apparently have no time for the luxury of protecting *their* own ears from the blast!)

Another feature of the coverage of incidents which took place in Benin in 1897, and one which lends even more significance to the kinds of illustrated material which accompanied it, is that many of those images that appeared in the illustrated press had a far wider circulation than simply the readership of magazines such as the *Illustrated London News*, the *Graphic* or *Black and White*. The same artists produced illustrations for other written accounts, and occasionally different versions of the same illustrations were used in contexts which crossed over into different categories of text, termed 'documentary' or 'firsthand'; 'ethnographic' or 'scientific'; or 'general interest'. Because of this repetition they gained a particular currency as apparently objective visual documentation. Consequently, such images played a special role in providing a context for those objects later displayed to a British public who had already consumed Benin through such texts.[31]

One such account to reappropriate illustrations from the middle-class illustrated press was *Benin, City of Blood*, published in both London and New York in 1897 by R.H. Bacon, intelligence officer to the punitive expedition.[32] Many of the illustrations in the book correspond directly to a series of photographs of Benin, taken at the time of Gallwey's 1892 mission to the city to secure trading rights from the Oba. These were

taken by J.H. Swainson, who had been the resident agent in Benin for the Liverpool merchant James Pinnock and had assisted Gallwey's negotiations with the Oba. The trajectory of these photographs is a good example of the kind of multiple uses to which such visual material was put. Initially exhibited by Pinnock at the Exchange Rooms in Liverpool just prior to the punitive expedition, they were subsequently published in the *Graphic*.[33] Pinnock later recycled the *Graphic*'s version of Swainson's photographs in a lecture on Benin which he delivered before a number of the regional geographical societies including those of Liverpool and Newcastle-upon-Tyne, and which was published in 1897.[34] In turn, Swainson's photographs form the basis of many of the illustrations in Bacon's book. The same book also recycled other images from the illustrated press. 'Drawing a Plan of Benin City' (fig. 12) is essentially a revised segment of an illustration which was produced in the *Illustrated London News*, entitled 'Chief Dore

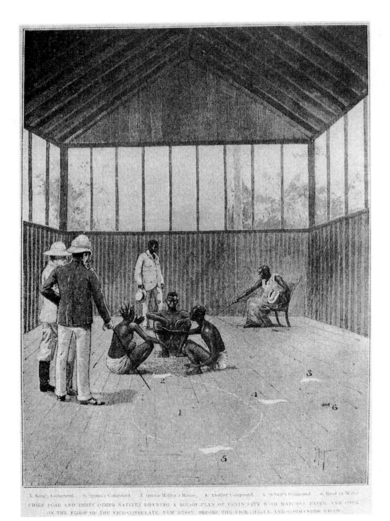

11. 'Chief Dore and Three Other Natives Drawing a Rough Plan of Benin City with Matches, Paper and Cork on the floor of the Vice-Consulate, New Benin, before the Vice-Consul and Commander Bacon', *Illustrated London News* (27 March 1897).

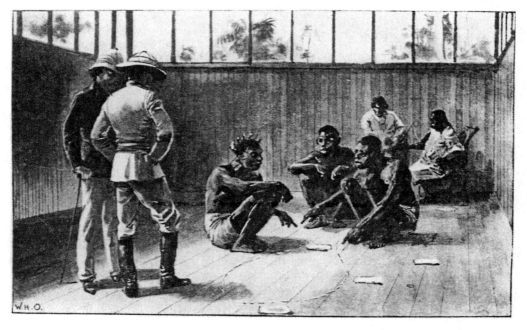

DRAWING A PLAN OF BENIN CITY.

12. 'Drawing a Plan of Benin City', illustrated in Commander R.H. Bacon, *Benin the City of Blood* (London and New York 1897).

and Three Other Natives Drawing a Rough Plan of Benin City with Matches, Paper and Cork, on the Floor of the Vice-Consulate, New Benin, Before the Vice-Consul and Commander Bacon' (fig. 11). The original has been substantially altered to conform more neatly to a series of stereotypes of the African. The figures of the two Europeans have been enlarged so that they take up a larger proportion of the foreground. In addition, the Africans, who are all in some marginal way differentiated one from another in the *Illustrated London News* version, have become grotesque approximations of a formulaic ape. Furthermore, the African figure in the background dressed in European clothing has disappeared from the composition. He was a confusing signifier as an African who was also clearly working in the British colonial service, and as such he had no place in Bacon's narrative. Chief Dore has become a bedraggled version of the commanding figure in the magazine illustration.

Bacon's book, produced for a general readership, was also cited by the 'scientific' community as expert eyewitness evidence. It remained a source of supposedly reliable information at least until the publication of H. Ling Roth's *Great Benin* in 1903. When Bacon's book was reviewed in *The Times*, the reviewer stated that the book was of much more importance than simply a narrative of well-known events. He went as far as to suggest that it was also important 'for the light which it throws on the habits of the native Savage'. In a sense, then, it was hailed as an ethnographic document by the general middle-class reader.[35] Even Ling Roth, author of several publications on the material

culture and society of Benin which are completely at odds with the histrionics of Bacon's book, frequently cites Bacon as a trustworthy and non-sensationalist documentor. Indeed, Bacon goes to some lengths to claim this quality of 'truth' for himself, prefacing his narrative with the statement that, 'All tendency to enlarge has been carefully avoided, and the reader must kindly accept the baldness of the narrative as surety for its lack of exaggeration.'[36] Notwithstanding the minutae of the manoeuvres and the tireless elaboration of the kit of each soldier on the force (which ran to four appendices), Bacon's narrative is certainly not coy in dealing out generalisations about the Edo people's character and other observations which passed as ethnographic field work in relation to the 'native'. In common with most such accounts, this emphasis on empirical data was often an excuse for a rehearsal of the most basic racial stereotypes. Consequently such statements come as no surprise:

> An average nigger or low type lies without compunction if there is the slightest thing to be gained by it, and often, when nothing can be gained one way or the other, out of absolute indifference to telling a lie or the truth . . . [and] the brain of the black man is also very slow . . . they are not, therefore, easy people to manipulate from the intelligence point of view.[37]

However, it was just as likely that such passages would be followed by a completely contradictory statement. The British officer himself had little compunction when it came to ensuring that the narrative reinforced his own self-esteem. Consequently, while the Edo may have been 'liars' and mentally 'slow', both Bacon and Boisragon were adamant about the Edo's courage and tenacity in battle, even though Gallwey, who had little investment in either quality, had pronounced them irredeemable cowards.[38] It is interesting that it was those men who wished to be remembered for posterity as brave fighters who emphasised the same qualities in the Edo. Fighting 'cowards' with such a sizeable punitive force would not likely have impressed the British readers. In this context, as was so often the case, the contradictory references to the Edo's 'character' tell us more about the speaking subject than they do about the African.

III

The treatment of Benin society is not the only confusing and contradictory aspect of these accounts. The discussion, in each of these narratives, of the bronzes, ivories and other artifacts made for the royal court of Benin is just as incoherent. Alan Boisragon's memoirs contain descriptions which are perhaps the most consistent with the rest of his narrative. His account of the royal compound merely provides an opportunity to expand on the gruesome details of 'crucifixion trees' and human sacrifice that run throughout his book. According to him, the compound housed

> sacrificial altars, on which were placed the gods – carved ivory tusks, standing upright, on hideous bronze heads. In front of each ivory god was a small earthen mound on which the wretched victim's forehead was placed . . . When the expedition took Benin City they found these altars covered with streams of dried human blood, the stench of which was too awful, the whole grass portion of the Compounds simply reeking with it.[39]

On the other hand, Auchterlonie, in his talk to the Geographical Society in Liverpool, goes into some detail over descriptions of blacksmiths who had evidently been productive at the time of his visit in 1890:

> We saw blacksmiths at work. They make images, ornaments of various kinds for the hair, bracelets, anklets, knives out of hoop iron, etc., and, considering the appliances they have, they certainly turn out wonderfully good workmanship. And these were not the only craftsmen working in the City. There are also in the town good carvers in ivory and wood.[40]

Auchterlonie even goes as far as to acknowledge the 'splendid' carving of some of the tusks, one of which he had received as a gift from the King.[41]

While Bacon described the smell of human blood and decaying flesh as one of the most memorable impressions of the city, he too had few qualms about describing the tusks and bronzes in glowing terms:

> Buried in the dirt of ages . . . were several hundred unique bronze plaques, suggestive of almost Egyptian design, but of really superb casting. Castings of wonderful delicacy of detail, and some magnificently carved tusks were collected . . . silver there was none, and gold there was none, and the coral was of little value. In fact, the only things of value were the tusks and bronze work . . . of other ivory work, some bracelets suggestive of Chinese work and two magnificent leopards were the chief articles of note; bronze groups of idols and two large and beautifully worked stools were also found, and must have been of very old manufacture.[42]

Unlike Auchterlonie, however, Bacon insists that nothing of a similar calibre of workmanship existed at the time of the punitive raid; 'in the majority of cases the ivory was dead from age, very few of modern date were to be seen, and those mostly uncarved'.[43] As if to reinforce this statement, he concluded that only one blacksmith's shop was visible.[44]

The various categories of text discussed above are littered with such inconsistencies, in relation to descriptions of Benin City and its peoples, and to their material culture. None the less, there is a pattern that emerges in the kinds of discourses reproduced around Benin City and its cultural life, both in the middle-class illustrated press, and in the books written by survivors of the Phillips expedition or those participants in the punitive raid. That Bacon was able to articulate such praise for the bronzes and ivories which he encountered, while at the same time being compelled to register the impossibility that such work could be produced by the Edo in 1897, is perfectly consistent with the concept of a degenerate society. This concept was made all the more potent by relegating any evidence of such cultural excellence to an increasingly ancient 'past', and by denying the continuing contemporary production of bronzes and ivories.

Those museums whose collections were enriched as a result of the punitive raid on Benin received their share of public attention in both the 'scientific' press and in the local, national and illustrated press. The Benin collections acquired by Liverpool's Mayer Museum, the Pitt Rivers Museum in Oxford, and London's Horniman Free Museum and the British Museum, all featured prominently in the press over this period. What relationship does the knowledge of Benin produced through the accounts discussed above (written by colonial officials engaged in military reprisals for the death of their colleagues, by British traders interested in developing profitable trade routes in the Niger

Delta, and by journalists in the illustrated press) have to the knowledge produced through the writings on Benin material culture written by aspiring 'professionals' working within the museums establishment? To varying degrees, the scientific press coverage shared, elaborated on, and transformed aspects of the discussion on Benin culture that have already been found in the popular narratives and accounts.

A report in the official *Bulletin of the Liverpool Museums*, written by the director, H.O. Forbes, sets the scene with familiar references to 'the barbarous massacre . . . of the members of an official mission pacifically proceeding'.[45] While Forbes pays more detailed attention to aspects of Benin culture which are not mentioned in Bacon's account in *Benin, City of Blood*, his own observations are heavily dependent on personal correspondence with Bacon.[46] In addition, Forbes authenticates his claims for any particular interpretation by reference to a substantial number of early travel documents and contemporary eyewitness reports from members of the punitive expedition. The supposedly objective accounts by Richard Burton (1862) and later Bacon (1897) are those sources most frequently cited. Theirs is the authority which, for Forbes, ultimately lends weight to his reiteration of the conception of Benin as a decaying civilisation, even while his own observations regarding the objects in the Mayer Museum's possession are uniformly praiseworthy of skill and craftsmanship, and his descriptions focus on this aspect and on faithfully reproducing iconographic details. The confusing conjuncture of praise and appreciation for the artifacts with the adamant refusal to accredit any cultural and social value to the Edo themselves, often resulted in convoluted and self-defeating arguments.[47]

13. Bronze memorial head from Benin in the Liverpool Mayer Collection, *Nature* (7 July 1897).

14. Bronze figure from Benin in the Liverpool Mayer Collection, *Nature* (7 July 1897).

One glaring example of this phenomenon concerned the nature of the nudity of a cast bronze figure of a woman in the Liverpool collection. A statement by Forbes, that on the face of it suggests a positive appraisal of Benin culture, claimed that nudity in Edo casting was not offensive in the way that other African figure carving was found to be. However, this was then qualified by a quote from Bacon which goes to some lengths to turn this observation into evidence of a primal and bestial culture. He suggests 'that they were not sufficiently civilised to carry indecency into their ornaments; that they were rather "the animal" than "the sensualist" '.[48] Of course, this suggestion taken to its logical conclusion would weaken any argument about the degeneracy of Benin society. The fact that the Edo did not apparently worship any form of idol also failed to count in their favour in this reckoning. According to Bacon (Forbes' source), this indicated that they were not 'far enough advanced to worship any person or figure.'[49]

Along with other commentators, Forbes was preoccupied by questions of how these works, 'indicating skill born of long experience', should have remained unknown to Europe for so long, of who the manufacturers were, and how they came to acquire the knowledge to produce such objects. These are the questions which come to dominate the museum and ethnographic establishment in general. The journal *Nature* also devoted an article to the Liverpool Mayer Museum's Benin collection. Written for a broader middle-class readership interested in the natural sciences, rather than the more exclusive and internal readership of the Mayer Museum's *Bulletin*, it nevertheless borrowed sub-stantially from Forbes' report. Of course, a by-product of such recycling was that the authority of Forbes (and Bacon also, since Forbes leaned heavily on his account) was further strengthened. Together they became an authority which was mutually reinforced by the separate spheres (scientific and military) from which they inherited their preroga-tive to speak. The article in *Nature* reiterated the astonishment of the museums establish-ment:

> The wonderful technical skill displayed in the construction of the metal objects, their lavish ornamentation, much of which is deeply undercut, and in nearly every case, the high artistic excellence of the completed subjects, have been a surprise and a puzzle to all students of West African ethnology.[50]

The items from the Mayer collection discussed here consisted of a small brass plaque, one of the brass head-stands for the carved tusks, and a brass statuette of a soldier holding a flint lock firearm.[51] The text focuses in particular on the manufacturing process involved in the making of the head (fig. 13) and the figure (fig. 14), examining their 'realism', together with a careful delineation of the iconography of all the pieces.

Ignoring earlier travel narratives which had marvelled at Benin culture, the author of this piece cavalierly declared that none of the European travellers who had visited Benin City within the past three hundred years actually mentioned such metalwork as being of any special interest. But how, continued the writer, could travellers have failed to notice such fine work had it existed then in anything like the quantities that had by this date (1898) been either sold at auction in London and the provinces or exhibited at the British Museum?[52] Preferring to dismiss any idea that these objects were of African manufacture, the writer none the less conceded that the 'artist' who had made such objects would have had to have been at least well acquainted with the Edo and their social structure, had probably lived for some years amongst them, and that 'his skill and patience are

beyond question'.[53] Consequently, while the article is notable for the total absence of any reference to human sacrifice or torture and mutilation, the writer reiterates Bacon's assumptions and repeats the suggestion that no contemporary Edo was capable of producing any work of similar quality.[54] Therefore the conclusion was that the art had been introduced by a European traveller or trader, prisoner or resident, who, recognising a facility for modelling in clay amongst the Edo, had taught them how to apply this to metal casting.

The objects acquired by the Horniman Free Museum in London were among some of the earliest examples of artifacts from the expedition which claimed any attention in the general, as opposed to the scientific, press. Almost immediately after acquiring the Benin artifacts, Richard Quick, the curator of the Museum, began to expose them to a variety of publics, developing what was to become a very efficient publicity machine for the Horniman collection.[55] Photographs of items in the Horniman collection appeared in the *Illustrated London News*, and other illustrated journals in both the local and national press.[56] These were not the carved ivory tusks or bronze plaques which had already received so much acclaim, but consisted of a carved wooden 'mirror-frame' with two European figures in a boat, a hide and goat-skin fan, and two ivory armlets rather poorly reproduced (fig. 15). Described by the *Illustrated London News* reporter as 'relics of a less savage side of the native life', and noted for their 'fine carving' and 'antiquity', they were

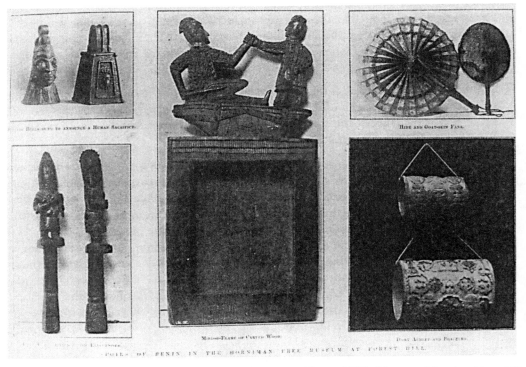

15. 'Spoils of Benin in the Horniman Free Museum at Forest Hill', *Illustrated London News* (10 April 1897).

none the less accompanied by the inevitable descriptions of 'hideous sacrifical rites'. Also illustrated were bronze bells cast in high relief with motives of human heads figured on them, together with two staves labelled 'ivory idols carried by the executioner' and surmounted by two carved figures wearing coral bead regalia. Such sentiments, and the expression of regret concerning what was perceived at this early date as a dearth of relics from a lost 'civilisation which dates back far beyond the Portuguese colonisation of three centuries ago, and probably owes much to the Egyptian influence', are common in the early coverage of material culture from Benin.[57] Quick's own publications on the collection favour the argument concerning Egyptian influence, which he goes to some lengths to substantiate.[58] Significantly, at this early date of 1897, there is less astonishment or curiosity over the origin of the objects than emerges in later writings from the 'scientific' or museums establishment. Their primary value for Quick at this time lies in their commemorative function as relics of the death of Phillips and his entourage, and the ensuing punitive raid.

One of the factors which transformed the terms of discussion of Benin material amongst emergent museum professionals, and which fired the interest in the origin of the bronzes, was the exhibition in September 1897, at the British Museum, of over three hundred bronze plaques from Benin City. By 1899, it is clear that the British Museum exhibition, together with the publications of Charles Hercules Read and O.M. Dalton (those curators at the Museum responsible for ethnographic material) and of H. Ling Roth, had extended the significance of the Benin artifacts beyond their original association with the bloody events leading up to their acquisition. Ironically, one of the results of this was to open up the possibility of an African origin for the bronzes.

To corroborate this, we have only to compare some of Quick's earlier statements with the radical changes of opinion and increased significance concerning the Benin material that appear in his writings published *after* the British Museum exhibition and publications. By 1899, he felt confidently able to describe the objects in the Horniman collection as 'valuable works of art'.[59] Their now detailed appraisal focuses on features of ornamentation such as the *guilloche* (or interlace border) on the previously named 'executioners' idols' now transformed into 'Two carved ivory maces or staves of office from Benin'.[60] Although the same facial features in the carvings are still compared with Egyptian drawings, Quick is now keen to attribute the items to Edo manufacture. Similarly, whereas one of the two bells in the Horniman collection was originally mooted as being made in England, he is now able to specify that 'bells of this form are peculiar to the West Coast of Africa. They are what are termed rivetted bells, and were wrought by the native blacksmith in iron.'[61] Significantly, Quick also acknowledges the skill of contemporary Edo artisans, as he calls them, although the spectre of degeneration is not far behind, since contemporary examples should not, he suggests, be compared with the older examples.[62]

Furthermore, Quick hoped that by demonstrating any similarities between some of the iconographic details of the objects in the Horniman collection, and those in the possession of the British Museum, he would register their importance and consequently increase the public profile of his own museum. This instance should signal the institutional allegiances and strategic negotiations that were partly responsible for the shift in terms used to describe and categorise Benin material, and, more specifically, its transformation from the status of 'relic' to 'work of art' in museum circles, with repercussions in other less specialised spheres. Quick's opportunism should also alert us to the complex professional

and personal negotiations which were partly responsible for the aestheticisation of Benin culture in the nineteenth century.

However, even in 1898, there remained another option which could not be completely ignored:

> It is possible, on the other hand, that their knowledge of founding was derived from purely African sources. The ancient Egyptians knew how to cast in Bronze . . . It seems not improbable therefore, as another explanation of the presence of such high works of art in Benin, that many centuries ago the city may have been occupied by an offshoot of the same central Soudan race, with the leaven of Abyssinian or Egyptian influences among them, as now occupies Nupe, a few hundred miles further North.[63]

That an African origin for the Benin material could be posited so early on in the debates of the scientific press may seem an enlightened conclusion in the context of the rabid xenophobia expressed in the popular press. Indeed in many ways it was, although, as we shall see, such a proposition was not as rare as history has so far led us to believe. None the less, it should be recognised that, even here, any challenge presented by this hypothesis was tempered by the fact that it remained inscribed within that familiar discourse shared by the popular press: the discourse of racial degeneracy augmented by the concluding statement that, 'the metalwork discovered in the city may, therefore, be the relics of a former higher civilisation.'[64]

CHAPTER 2

VOICES IN THE WILDERNESS: CRITICS OF EMPIRE

In 1897, James Pinnock, a trader and merchant on the Benin River for over thirty-five years, published his pamphlet *Benin, the Surrounding Country, Inhabitants, Customs and Trade*.[1] Originally given as a lecture to various regional geographical societies, it is an important document for several reasons. Evidently, Pinnock's primary interest in the events of 1897 in Benin lay in the fact that they presented the possibility of breaking the Oba's trade monopoly once and for all, which, when accomplished, would enable him to consolidate his own investments in the region. In many respects, his publication repeats the well-rehearsed sentiments of savagery and degeneration shared by most of the popular and firsthand accounts of the expedition and the raid that followed. However, his case for the necessity of British trade in the Benin River area is characterised in terms that shed a more concentrated light on the significance of the discourse on degeneracy.

Pinnock's argument hinges on the degree to which the West African can acculturate into European 'civilisation', and the extent to which this is dependent on daily contact with the coloniser or 'civiliser'. To make his point, he cites the case of a youth, a slave of Nyomerie, the Chief of Warri, who was given to Pinnock as a 'gift'. Pinnock apparently 'lent' the twelve year-old child to the actress Mrs Bancroft, to carry the train of her dress in a production of Sheridan's play 'The School for Scandal'. According to Pinnock, 'he became a great favourite and thoroughly Europeanised'.[2] On returning to Benin with Pinnock, however, he was taken back by Chief Nyomerie's sons, whereupon from being, 'one of the most interesting little negroes ever seen, he ultimately degenerated into the unsophisticated slave'.[3] This is the familiar scenario of instant reversion to savagery, once away from the benevolent influence of 'civilisation'. It was a tale designed to serve as a cautionary rider to the next part of his thesis, which was at pains to promote the African's malleability as a pupil of European civilisation.

Chastising the readiness of his compatriots to think ill of the African, Pinnock continued, 'the world at large is too prone to think and speak of the African as the personification of idleness and laziness, it is a gross libel on the race; my experience is the reverse'.[4] Then followed a series of examples from West Africa in an effort to impress upon the listener or reader the value of the West African as a reliable source of cheap labour. In true trader's logic, the process of transforming the African required only that the European encourage the growth of capitalism: 'Cultivate and create wants in him, and you will find he has all the ambition of the white race to live on a par and be equal with his neighbour.'[5] Bishop Samuel Crowther, the first African Bishop of the Church Missionary Society, and the Hon. Sybil Boyle from Sierra Leone are the models that clinch Pinnock's hypothesis, 'proving the comparatively easy possibility of raising the

native of Africa to a high social level.'[6] To maintain the moral high ground here, Pinnock reminded his audience of Britain's debt to Africa as a result of participation in the slave-trade, pointedly emphasising Liverpool's primary role. Such a debt should, he continued, be paid through investing in the development of Africa's resources. The real beneficiaries of such a programme remain diplomatically ambiguous in Pinnock's discourse.

However, while Pinnock's argument may have emanated primarily from an opportunistic desire to carve out a larger slice of Benin River trade for himself, such sentiments concerning British culpability for the slave-trade, expressed as they were by a prominent trader, were not without value for West African and other critics of the British colonial government. A sizeable West African press was already well established by the late 1890s, and many newspapers, including the *Gold Coast Leader*, the *Lagos Weekly Record* and the *Sierra Leone Weekly News*, were recognised forums for West African dissent and censure of the colonial government.[7] On this occasion, the editor of the *Sierra Leone Weekly News* (a newspaper known for its ascerbic criticism of British government policy) was able to use Pinnock's speech for his own ends. The paper went as far as to publish substantial extracts from Pinnock's speech, introducing it in the leading article with the pointed observation that:

> In these days when it is becoming fashionable to hazard opinions prejudicial to the interests of the Negro Race . . . we could not but admire the manliness and courage of Mr. Pinnock, in reminding his hearers of the enormous debt Great Britain owes to Africa, and we are the more thankful to him for associating our savagery and degradation to the accursed slave-trade carried on by England and notably by some of the Liverpool merchants in the past.[8]

It went on to take further advantage of Pinnock's speech, and of his trading connections, to air Sierra Leonean grievances over the colonial government's imposition of the Protectorate Ordinance, which they felt presented severe drawbacks for the development of Sierra Leonean trade and commerce.[9]

From other quarters, however, critics of colonial policy within Britain itself had earlier recognised Pinnock's bellicose tendencies, barely masked by the humanitarian call for atonement in his 1897 pamphlet. In 1895, Pinnock had been less diligent about the terms in which he couched his desires to expedite trading rights to the Benin River region. In a letter to Sir Claude Macdonald, the Commissioner and Consul-General of the Niger Coast Protectorate, Pinnock, in a stream of frustrated invective against the Oba of Benin, pronounced him an 'outrageous savage' and a 'demon in human form'.[10] He finally insisted that the only way to 'deal with him' was to depose or exile him so that trade (and in particular, we might suppose, Pinnock's own trading concerns), which was severely curtailed by the Oba's recalcitrant monopoly, could proceed without let or hindrance.[11] *The New Age*, a predominantly socialist review whose masthead proclaimed it as, 'A Journal for Thinkers and Workers', drew its readers' attention to the fact that, in February 1896, Pinnock had written to the African section of the Chamber of Commerce suggesting that while British troops were in Ashanti they should go to the Oba and compel him to do business with the Europeans, and at the same time to suppress the practice of human sacrifice.[12] While by no means a large circulation weekly, *The New Age* none the less had a considerable reputation as a forum for critical political debate, and a history of eminent contributors from amongst Christian liberals, radicals and socialists, including

Ramsay MacDonald.[13] The paper exposed the hypocrisy of Pinnock's statements, insisting that his second point was merely a convenient alibi for ensuring his first. It cited an anonymous critic of British government policy in Benin who summed up their feelings on the matter:

> He says that it will be quite time enough for us to look after the King of Benin when we have stopped our too numerous and abhorrent human sacrifices at home. 'Our numerous factory workers,' he says, 'living on considerably less than starvation wages, working something like 15 or 16 hours per day in a close and unhealthy workroom, and dying off like rotten sheep, are most conveniently looked over'.[14]

Another example serving to highlight the way in which critics of the colonial government were able to turn unpromising copy to their own advantage, appears in the *Lagos Weekly Record*. Edited from 1891 to 1914 by the African nationalist John Payne Jackson, and one of the most influential and consistent critics of British policy in West Africa, the newspaper published an interview with the Hon. George W. Neville, who had accompanied the expeditionary force to Benin City.[15] Ostensibly, it was a discussion about whether there would be increased prospects of trade with Benin in the aftermath of the punitive expedition. But it also provided an opportunity to raise the thorny question of the political and commercial wisdom of the British policy of deporting native chiefs who were implicated in any insurgent activity against the British. Despite Neville's attempts to remain conscientiously obscure on the issue of the recent deportation of the Oba's ally Chief Nana, his interviewer's persistence eventually prompted the sympathetic observation that:

> Chief Nana was a remarkable organiser, he kept his large following well together and well employed and since his deportation they have been like sheep without a shepherd and a considerable loss of trade to the River has in consequence resulted.[16]

Neville had been a long-term resident in the Niger Coast Protectorate, having arrived in the region in 1880 as the agent of both the British and African Steam Navigation Company, and of the African Steam Ship Company, and had established a bank there in 1891. He should be differentiated from Pinnock in so far as he was clearly seen as a different category of colonial, even by those whose views were associated with early nationalist tendencies. The *Lagos Weekly Record*, for example, described him as 'one of the few Europeans who conceived and strove to carry into effect the idea that the interests of the natives and those of the Europeans were identical'.[17] Neville's restrospective account of the Benin incidents, although deploying its share of picturesque and sensationalist language, none the less bears out the suggestion that he was a more sympathetic commentator on the plight of the Edo peoples:

> While no words can be too strong in condemnation of such terrible waste of human life, I am convinced, from long residence and intercourse with the natives in West Africa, that lust of blood is not the inciting cause but rather a deep-seated belief in the principle of propitiation, for which authority is not wanting in the Old Testament.[18]

Indeed, the final page is an indictment of Phillips' lack of tact and foresight in not heeding either the warnings of the Oba's messengers, or of the Foreign Office, and is the occasion for Neville to express his concern that administrators and colonial officials

should undergo some form of preliminary training in what he calls 'the characteristics' of the colonies.

In fact, the colonial government's indiscriminate policy of exile for any African leaders who came into conflict with it had already caused considerable controversy in the British press, and embarrassment to the government itself. Two of the more recent instances, involving Jaja of Opoba and Chief Nana of the Itsekiri, had already provoked criticism from within the British colonial service. Vice-Consul Gallwey's retrospective comments on the exile of Jaja in 1887 are revealing, particularly as an example of how even its British critics often reproduce, unthinkingly, the derogatory metaphors that were so much a part of the bureaucratic language of a colonial government, populated in its higher echelons by an administration steeped in the public school ethos. While Gallwey expresses disenchantment with the colonial government in no uncertain terms, his disapproval presents the colonial government's economic sabotage of Jaja's trading base as an embarrassing 'foul' on the 'playing field' of colonial intervention, and Jaja himself as a recalcitrant stallion:

> The removal of Jaja from Opobo was not an act of which the British Government could be proud. It is readily allowed that Jaja was a headstrong man and had to be kept up to the bit, but the manner of his capture was unfortunately very contrary to our ideas of fair play. In other words 'it was not cricket'.[19]

In February 1899, the Aborigine Protection Society took up the deportation issue, and published correspondence between the Society, Lord Salisbury and Chief Nana. It is clear from this that the Society were firmly of the opinion that Nana's only offence had been to block British trade. Nana himself had appealed to the Aborigine Protection Society to take up his case and petition the Foreign Office on his behalf, whereupon the Society discovered that it was

> admitted that he has been harshly treated, but the apology for this is that his deposition was considered necessary in the interests of trade, and it is held that a new order of things being established, it would be inconvenient and embarrassing to re-instate him.[20]

Before their amalgamation in 1909, there existed in Britain two major humanitarian societies protesting at any excesses of jingoistic zeal and the subsequent abuses of power that all too frequently accompanied the colonial process. Bernard Porter has described both the Anti-Slavery Society and the Aborigine Protection Society in the 1890s as outdated organisations, labouring under the legacy of the somewhat antiquated arguments for justice, humanity and charity, belonging to the old reformism of the 1830s and to an earlier era of colonial intervention.[21] Nevertheless, it is important to remember here that the two societies were still an active forum that had the ear of a sizeable group of white liberals and radicals, and that often took the initiative of liaising with and publicising the nascent African nationalist associations that were formed in Britain over the first decade of the twentieth century. As pressure groups, they tirelessly published pamphlets and journals, engaged in copious correspondence with the Colonial and Foreign Offices, organised public meetings and rallies, and lobbied Parliament, often inaugurating long-standing Parliamentary debates.

While neither society in the 1890s can be said to have had any misgivings about what they confidently assumed to be the ultimate benefits for the colonies accruing in the wake of British imperialism and colonisation, it would be a simplification to suggest that both were interchangeable in their policies and in their attitude to the colonial government. A crucial point of departure between the two organisations was in their attitude to trade. Initially, they were both firmly convinced that fostering a desire and taste for legitimate trade in the African would be the one sure way of rendering redundant the heinous traffic in slaves, by providing the African suppliers with a legitimate and more profitable alternative.[22] Such a development would incidentally, of course, bring with it the additional advantage of providing new opportunities for British trade. The pages of the *Anti-Slavery Reporter* are consistently filled with news of the various chartered companies in Africa, and repeatedly canvass support for the development of new companies. The Aborigine Protection Society, on the other hand, seems, by the 1890s and certainly by 1900, to have abandoned unqualified support for such trade enterprise.[23] In 1900, their president, Henry Fox Bourne, issued the policy statement: 'The Claims of Uncivilised Races.'[24] Here he elaborated a case for the acknowledgement of the right of indigenous peoples to their own land, together with the practice of their own customs and institutions. Fox Bourne also advocated a share for indigenous peoples in any wealth created as a result of colonisation, and that no land, goods or any other property should be taken from these peoples without legitimate and intelligent consent, and certainly not by force. In particular, he was highly critical of the punitive expeditions which so often accompanied trading and expansionist initiatives. The Aborigine Protection Society was directly opposed to the Anti-Slavery Society's support of the British policy of using chartered companies as a form of government in the colonies. The former society did not, however, go so far as to endorse one West African critic's opinion that, 'the sooner all territories administered by chartered companies are placed under direct Imperial control, the better will it be for Britain, for Africa, and for humanity.'[25] Nevertheless, the Aborigine Protection Society made no bones about what they saw as one of the central contradictions of using chartered companies as governing bodies – namely the contradiction of maintaining a 'just' government while at the same time being necessarily constrained to make all decisions on the basis of achieving the highest dividend. The Society's journal, the *Aborigine's Friend*, frequently carried vigorous criticisms of traders. Fox Bourne's own expansive letter published in the May 1897 issue, regarding the Royal Niger Company's abuse of power in the Brass region and calling for the colonial government to restrain and regulate the Company's powers, is a case in point.[26] It is perhaps a measure of the different standing of the two societies amongst radical opinion in Britain, that while the Anti-Slavery Society was not actively eliminated from the pages of *The New Age*, it is an interview with Fox Bourne, and not with the president of the Anti-Slavery Society, which takes over the columns where that review's editorial comment would usually have been.[27]

In November 1897, Oba Ovonramwen was put on trial by the British government. The occasion served as an excuse, if any were needed, to revive the catalogue of horrors that had earned Benin the title of 'the City of Blood' in the eyes of the British patriot. However, it also gave rise to a number of dissenting voices, sometimes from unexpected quarters, who championed the Oba's cause against the tide of such righteous indignation.[28] The trial also proved to be the catalyst which provoked challenges to the hegemony

of the concept of a bloody and degenerate society. One West African correspondent to *The New Age*, who was a medical student from Lagos studying at Edinburgh University, provided perhaps one of the most spirited invectives against the tyranny of Empire. Writing to the newspaper, Moses da Rocha intended his letter to be 'a native expression of opinion on the Benin War.'[29]

Asking the reader to 'take into consideration the spirit of hatred and contempt for the negro manifested by some European officials . . . [and] the atrocities committed in Matabeleland and Mashonaland in the name of civilisation, by the Chartered Company Authorities', Da Rocha proceeded to make an eloquent defence of the Oba on the grounds of the ignorance and arrogance shown by Phillips' disregard for the Oba's warnings.[30] He condemned the British and European traders for their hypocrisy in remaining silent about human sacrifices when it suited their trade purposes, and their equally opportunistic 'revelation' of such practices when it proved more expedient:

> The Human Sacrifices which public opinion in Britain has denounced in the case of the African 'savages' are not the spontaneous suggestions of cruelty; they are prescribed in their ritual . . . Britain once had its Druidism, but Druidism was swept away by the onward march of militant civilisation. So also it may be hoped that human sacrifices may soon become a thing of the past in the whole of Africa.[31]

Da Rocha had already expanded on this thesis in the *Edinburgh Evening News* as part of a defence against aspersions cast on the African by Sir Harry Johnston in a recent publication. On this occasion, his attack was reinforced by reference to the British government's current policy of non-intervention in both Armenia and Crete. In 1895, the Turkish Sultan, encouraged by the passivity of the European colonial powers, had ordered the massacre of an estimated 80,000 Armenians. Likewise in Crete, in April 1897, the Sultan had inflicted a crushing defeat on the Greek army. Both incidents generated intense public indignation in Britain, and heated criticism of the government's inactivity. Da Rocha was in good company with his pointed attack:

> Human sacrifices with which they [Africans] stand charged, have been practiced by even the most polished nations of antiquity. In my opinion there is no material difference between these human sacrifices and the massacres which have taken place in Armenia and Crete.[32]

Furthermore, the overzealous bloodshed, apparently advocated by the Oba at the time of Phillips' mission should, he argued, be understood in the context of anxieties created as a result of the way in which the British had dealt with Ovonramwen's erstwhile ally, Chief Nana.[33]

Da Rocha was to become a familiar correspondent on African affairs during the late nineteenth century, not only in the British progressive and socialist press and the leading Edinburgh dailies, but also in a number of leading West African newspapers. His importance may be measured by the extent to which his commentaries were often published in one newspaper and then reprinted in a series of others, both in West Africa and across Britain. There was, at this time, nothing unusual about the policy of exchanging copy between liberal weeklies and dailies within Britain. What is perhaps more significant for us is the degree to which this exchange took place between these papers and national West

African weeklies edited by West Africans, known for their often outspoken criticism of the colonial government. This, then, is another example of the political and intellectual exchange between different factions of the liberal, and radical, colonial communities, and an indication of a vocal and audible West African voice, not only in the colonies, but also at the very centre of the British Empire. Moses Da Rocha's choice of *The New Age* as a sympathetic forum for his critical views is symptomatic of the esteem in which the newspaper was held by members of nascent African nationalist organisations in Britain, and for that matter in West Africa itself. Consequently, Da Rocha's final paragraph in his 1897 letter voiced sentiments shared by a number of other radical anti-imperialist organisations and movements in Britain when he said:

> I have been impelled to write this letter, mainly by the custom which prevails in some British circles, of painting Africans in the blackest colours imaginable – in colours almost Tartarean in conception. I have addressed the letter to you owing to the sympathetic manner in which you have always referred in *The New Age* to subject races and to the spirit of brotherhood which pervades all your leading articles.[34]

The editor, A.E. Fletcher, was associated with the newly formed African Association which was founded in October 1897 under the guidance of the Trinidadian Henry Sylvester Williams, because of the 'absence of any body of Africans in England representing native opinion in national matters affecting the destiny of the African.'[35] Although it was a rule of the Association that only those of African descent could be members or have any share in its management, certain members of the Aborigine Protection Society, plus a few select individuals including Fletcher, were made honorary members.[36] Fletcher's editorial in the issue of *The New Age* featuring Da Rocha's letter appealing for clemency for the Oba, clarifies the paper's allegiances in relation to the issue of Benin. He commented on Da Rocha's statement, saying that it 'can hardly fail to convince right-thinking people that the black man has a future, and that it should be our aim not to crush him but to co-operate with him.'[37] By October 1897, the Oba had already been exiled, despite protestations from many quarters including those inside the colonial administration. *The New Age* lost no time in challenging the government's decision:

> The policy of banishment has been pursued with cruel persistency in Africa. Cetawayo, after Ulundi, was deported. Dinizulu, for asserting his ancestral rights, was deported. JaJa, for claiming certain oil districts, was deported. Prempeh, for failing to comply with unjust demands, was deported. Behanzin, for fighting in defence of his country, was deported. Nana, for arraying himself against the British, was deported. Arabi, for leading a revolt against vile oppression, was sent to Ceylon.[38]

The *Sierra Leone Weekly News* also published extracts from Da Rocha's *New Age* correspondence, praising the paper for 'defending the weak'. The *Lagos Weekly Record* reprinted it in full, together with an editorial which endorsed Da Rocha's commentary as possessing the 'vigour of truth and force of eloquence.'[39] John Payne Jackson shared Fletcher's disapproval of what he identified as Britain's indiscriminate policy of deportation. His own editorial was couched in an argument which was cleverly designed to appeal to the very trading interests which had resulted in the deportations in the first place: 'The

deportation of JaJa led to an unrecoverable paralysation of the trade of Opobo, while Nana's deportation practically extinguished the trade of Benin . . . Then where is the profit?'[40]

West African 'patriots' like Da Rocha were not the only voices raised against the selective and opportunistic British outrage at the practice of human sacrifice. Liberal humanitarian and philanthropic institutions in Britain joined in criticism of the colonial government. The Aborigine Protection Society, referring to the punitive expedition in the Niger Coast Protectorate a year earlier, went so far as to state that 'in most cases, if not invariably, no punishment for human sacrifices is thought of unless or until trade is interfered with, and the only "good behaviour" required of the blacks is compliance with the demands of white traders.'[41]

On the 16 September 1897, *The New Age* published a letter responding to a leading article entitled, 'The Future of the Black Man'.[42] Signed 'A Black Man', the letter congratulated the paper on its support for those black races demanding equality with the white coloniser:

> In spite of all experiences to the contrary, some white men still believe in the inferiority of the blacks . . . They forget, or do not know, that whatever difference there is at present between the white and black races of the world, is one of degree, and not of kind.[43]

To prove the point, the writer cited a scholar of ancient history, a certain Dr Pritchard, who reportedly provided evidence which suggested that the Gauls and Britons had the 'most sanguinary rights', comparable in fact, to Ashanti, Dahomey and other West African societies:

> The system of suppression under which African races suffer renders it imperative on their oppressors to allege some reasons as plausible as they are able, in their own defence. To give colour to the various wars that England has undertaken in Africa, specious reasons are never wanting, one time it is the suppression of human sacrifice. At another, the African potentate whose land has been previously marked for plunder is hostile to friendly tribes.[44]

Such a response to the punitive raid and the 'official' justification for the attack on Benin City was not an isolated instance, not least because Da Rocha's letter was reprinted in the journals of both the Anti-Slavery Society and the Aborigine Protection Society, as well as a number of West African newspapers including the *Lagos Weekly Record* and the *Sierra Leone Weekly Times*.[45] On the 6 November 1897, the *Lagos Weekly Record*, in a lengthy leader, took on the issue of human sacrifice in connection with the recent events in Benin. It reproduced a report from *The Times Weekly Edition* on a speech given by Bishop Taylor Smith in Norwich, on the anniversary of the local branch of the Church Missionary Society. The speech took the form of a catalogue of human mutilation and torture in Benin, enumerated in detail. In line with most reports of the incidents in West African run newspapers, the *Record* was careful to condemn any actual atrocities which had occurred by order of the Oba. It also, however, reiterated Da Rocha's earlier appeal to the British to recall not only its own historical indulgence in the practice of human sacrifice, but also to remember that, 'as every schoolboy knows, [it] has been practiced in

all countries by all races.'[46] Thence followed an erudite exposition of the occurrences of such practices from the ancient Romans, Greeks, Gauls, Swedes, Danes, Saxons and early Christians. Passages from the Old Testament were cited as further evidence that there was nothing exceptional in the practices at Benin and Kumasi, which Bishop Taylor Smith had referred to as 'astounding revelations to prove that the African is such an inexcusable and unmitigated savage'.[47] Moreover, continued the *Record*, recent history was repeating the trend:

> History everywhere and at all times has proved how narrow-minded enthusiasm even if exercised for spiritual ends, may lead to the most revolting and degrading enormities. The burning of witches and the horrors of the Inquisition have taken place under Christian government . . . What is the lynching of Negroes in the United States but human sacrifices? . . . Aye and what do we hear from South Africa?[48]

The concept of 'history' in fact played an important role in the West African critiques of British intervention in Benin. While the British commentators often seem to have conveniently 'forgotten' the long history of European travel and trade relations with Benin dating from the sixteenth century, and the extent of the power and control wielded by that kingdom, some West African commentaries invoked an even more ancient past for Benin. The *Lagos Weekly Record* went so far as to claim that Benin had at one time been the seat of power and influence for the whole of West Africa.[49] Consequently, it was no accident that the editorial chose to reaffirm the historical significance of Benin by citing C.C. Reindorf's *History of the Gold Coast and Asante* (*sic*.) written in 1889. The Reverend Reindorf conceived his 'mission' in terms of rewriting the history of West Africa from the perspective of 'true native patriotism, written by one who has not only studied but has had the privilege of initiation into the history of its former inhabitants.'[50] As a mission-educated West African, Reindorf's history displayed much of the ambivalence towards European colonisation of many others from such an educational background. Desiring what he perceived as the benefits of European, and specifically Christian, civilisation on the one hand, he was also wary of the dangers of a complete cultural assimilation which would destroy the cultural values and traditions of certain West African societies without offering a meaningful alternative suited to the specific conditions of the African context. The editor of the *Lagos Weekly Record* cited that section of Reindorf's history which posited an Egyptian link to the ancient kingdom of Benin and reminded the reader that it was on the advice and experience of the king of Benin, as a result of his contact and association with Egypt and Abyssinia, that the king of Portugal was able to 'discover' a sea route to India in 1497 through Vasco da Gama. Jackson drew the reader's attention to the irony of the coincidence that the fall of Benin was on the 400th anniversary of the 1497 achievement, which had proved so beneficial to the Europe which was finally responsible for Benin's dissolution.

As far as the *Lagos Weekly Record* was concerned, it was the bronzes and ivories which verified any hypothesis on the long-standing historical significance of Benin City, and not just within West Africa, but also for the development of European civilisation. Furthermore, the discovery of the bronzes proved, for the *Record*, that the kingdom of Benin had existed for at least four centuries or more, and 'consequently possesses a tradition and history worthy of study'.[51] Moreover, the newspaper pointed out that 'if they prove to be an Egyptian origin, the question of the connection of West African Negroes with the

ancient Egyptians will be placed beyond all doubt.'[52] It was by this time that George Neville's collection of ivories and bronzes had already attracted speculation in the West African press. The carved figures on the ivory tusks were then compared in the *Record* with armour familiar from Greek and Roman sculpture, and other figures were said to resemble those from Egyptian mythology. In particular, the reader was asked to consider the head of a man whose 'features are distinctly Negro.'[53]

It is important to recognise, at this point, that while part of the strategy of recovery entailed recalling patriotic histories written by West Africans earlier in the century, a corollary to this was a recognition of the way in which historical hypotheses could be reinforced through cultural ascendency and valourisation. This was an important strategy, both for an emergent nationalist political agenda in West Africa, and amongst the West Africans in Britain. There is obviously a very complex structural relationship here, between the narratives of terror and barbarism on the one hand, and the surprised recognition by the British of a cultural form which spoke of great skill and refinement on the other. It is equally clear that while West African 'patriots' may have been able to mobilise the existence of the bronzes and ivories as a means of reinforcing a historical thesis which proposed an ancient and noble trajectory for Benin, the British acknowledgement of the importance of the bronzes as sophisticated cultural artifacts did not replace the image of Benin as a violent and bloody society. In fact, the tales of blood-lust and savagery, that abounded in popular British narratives of Benin after the Phillips expedition and in the aftermath of the punitive raid, persisted, yet this was despite, and perhaps even because of, a consistent acknowledgement of the cultural and artistic output from the city.

As we have seen, the ideology of Benin as a degenerate society, in the sense in which this was perpetrated in the popular British press, was one means of side-stepping any untenable contradictions in the discourse on savagery which underwrote and produced the Benin narratives. However, here too the discourse on degeneracy which fuelled the vituperous antagonism against the Edo had a counterpart in West African commentaries, many of which were available, and indeed popularised, in Britain. It seems not unlikely, therefore, that one of the reasons why the discourse on degeneracy circulated with such persistency in Britain was precisely because, during the same period, it was being launched as the basis of a critique of European colonisation in West Africa by West Africans. Crucially, their critique was one which had exponents who not only travelled to Britain over this period, but had the ear of the press and of large gatherings of colonial administrators and traders as well as the more predictable humanitarian lobby. Opinions about the cause and nature of degeneracy in West African society were common even amongst those who like Da Rocha, Carl Reindorf, Edward Blyden and John Payne Jackson were always at pains to acknowledge the selective benefits of British colonisation. It should also be mentioned at this point, however, that such admissions might well have been the result of expediency, since to many West Africans it seems that the British colonial administration represented the lesser of three evils. Whatever criticisms Jackson may have had of British colonial rule, he evidently saw the German and French colonial regimes as 'harsh and absolutist' by comparison.[54]

While James Pinnock was busy reiterating the all too familiar sentiment that any educated African's air of civilisation was merely a veneer that only went skin deep, ready to be jettisoned as soon as Europe's nurturing presence was out of sight, West African

historians, scholars, journalists and traders were theorising this apparently inherent tendency to degeneracy from a rather different perspective. The same year as the Benin incidents in 1897, the influential West African merchant and editor of the *Lagos Times*, Richard Beale Blaize, visited Liverpool for some weeks.[55] It was by all accounts a busy period for him, filled with many social and public engagements. An interview in the *Liverpool Courier* praises Blaize's 'energy, ability and . . . high intelligence and comprehension of matters far beyond the region of commerce.'[56] The substance of this interview is concerned with what Blaize perceived as the lack of trading opportunities for indigenous merchants on the coast since British law made it impossible for manufacturers to sell direct to native traders.[57] The other section of the interview, however, recorded Blaize's opinions on European colonisation in Africa, and to what extent he had found this to be beneficial for the African. His response is one that is symptomatic, to varying degrees, of feeling amongst West Africans sympathetic to certain aspects of British colonial rule, but disaffected by the evident prejudice and discrimination they encountered at the hands of the administration:

> Civilisation has its advantages and its disadvantages, but on the coast when weighed in the balance, it is always disadvantageous to the African race. It is easier to copy the vices than the virtues of civilisation . . . It would have been far wiser if we had . . . retained so much of our old customs as was suitable to our climate and physique, and utilised anything in your methods that would have been beneficial to us . . . Instead of becoming Europeanised Africans we want to become native civilised Africans.[58]

When asked what he thought would become of the African race, a subject which the interviewer deemed to be of racial and 'ethnological' interest, Blaize reaffirmed the African's resiliance, saying that the only instance of deterioration of the race was mainly around the coastal areas. The reason Blaize gave for this was that those peoples had all been subjected to prolonged contact with Europeans. The *Lagos Weekly Record* was quick to exploit Blaize's notoriety and his sentiments. In particular, his remarks about 'the influence of so-called civilisation' were emphasised, and Jackson stressed the danger of 'heedless imitation of Europeans'.[59] His next statement neatly turned on its head the Europeans' familiar metaphor for the African continent:

> One cannot reside for any time in England or in any part of Europe without discovering the strange but significant fact that in African matters, and as to the destiny of this race, Europe is a veritable 'Dark Continent', having much to learn, much suffering to undergo, and much suffering to inflict upon others, before the lesson will be acquired.[60]

Such views on the insidious and dangerous way in which wholesale adoption of European culture led to racial deterioration and degeneration, were propounded by other West Africans who had considerable standing amongst those organisations in Britain which were critical of aspects of the colonial administration. Earlier in the nineteenth century, Bishop Samuel Crowther, appointed in 1864, had insisted on the importance of recognising the value of indigenous African institutions and customs. Despite his allegiance to the British evangelical society and its policies in Africa, he argued for the preservation of African culture and preferred to make use of these in the evangelising process rather than to destroy them indiscriminately. Edward Wilmot Blyden was perhaps one of the most effective West African writers and speakers on the political and philosophical implications

of acculturation. A resident of Liberia and Sierra Leone, Blyden had a varied career as a minister of the Presbytery of West Africa, a professor of Greek and Latin at Liberia College, and a spokesperson for the Liberian government in North America. By the 1890s, Edward Blyden was promoting his own brand of nationalism to an international audience, as an invited speaker to prestigious groups in the United States, Britain, and various West African colonies. While acknowledging the benefits of certain aspects of European contact, he developed a sophisticated, if at times contradictory, thesis which not only refuted point by point racist allegations perpetrated by European science and history but also constructively proposed the basis of a new order, elaborating plans for both government and education run for Africans by Africans:

> It is a truth at which not only we ourselves but thinking foreigners are arriving, that Africa is to be civilised and elevated by Africans – not merely because of the physical adaptation but on account of the mental idiosyncrasies of Africans. Not only on account of the colour of the Negro but because of his psychological possibilities and susceptibilities.[61]

Blyden also shared Blaize's opinion that contact with Europeans led to weakness and degeneration. He pointed to those peoples in the hinterland who had not been subjected to such contact, and whose isolation made them neither 'spurious Europeans, bastard Americans nor savage Africans, but men developed upon the base of their own idiosyncrasies, and according to the exigencies of their climate and country.'[62]

While such ideas smack of racial purity and a romantic dependence on the concept of originary unity, they are also evidence of a long-standing debate amongst West Africans that clearly identified European contact, *transculturation*, as the basis of racial degeneration.[63] It is important to point out here that the links made between European contact and race degeneration, in the writings and lectures of Blyden and other earlier and contemporary West African scholars and historians, differed substantially from the philanthropic and humanitarian societies' outcry against the European slave-trade and liquor traffic as the cause of degeneration in West Africa. While the West African commentators, as has been seen, were not averse to strategic recourse to such an argument, theirs was, for the most part, a more sophisticated contention concerned with the problems of assimilation and the possibilities of a productive and selective use of any resultant hybrid culture.[64]

In September 1897, *The New Age's* leading editorial, 'The Future of the Black Man', seriously challenged the inherent superiority of the white coloniser, using terms that reflected a discourse already popularised, in other quarters, by some who were not exactly known to be ardent antagonists of Empire. The important point here is that such a debate was fought out on terms that were extremely familiar to a British public interested in African affairs, even if the protagonists of the language of degeneracy were not necessarily motivated by the same objectives, and were in most instances diametrically opposed to one another. 'The black man's turn is coming,' wrote A.E. Fletcher, in *The New Age*:

> Already the 'colour' question is becoming a serious political problem in the United States, and there is forcible evidence to show that it is quite possible the white man will some day be played out, and that the black man and the yellow man will divide the world between them.[65]

This, added Fletcher, whose paper advocated Christianity as a corollary to effective socialism, was always providing that both races become Christianised. Anticipating panic even from his readership after such a pronouncement, he added by way of reassurance that there was no cause for alarm, 'because it does not matter what the colour of a man's skin may be if his conduct is right.'[66] It was, nevertheless, essential that the white man remember

> that the African native is not dying out before the advance of the white man but is actually increasing in numbers, and, moreover, is as a rule bright and intelligent, and susceptible of educational influences. Therefore our policy should be to keep on good terms with the black man, and not to bully and cheat him.[67]

In the 1880s, even spokesmen and women from the different humanitarian organisations often propounded the view that by a process of natural selection, extinction was the inevitable fate of colonised races. After all, what other alternatives existed in the face of the failure of native races to adapt to European habits?[68] By the 1890s, many recognised that a thesis that might be successfully applied to Amerindian and Aboriginal societies could not be applied to the African. By 1900, Mary Kingsley, for example, arguing for the adoption of indirect rule in West Africa, based her case on a thesis not dissimilar in substance (though quite different in its objectives) to Fletcher's observations in *The New Age*. Kingsley was adamant that, unlike the indigenous races of the Americas and the Pacific, the African negro was 'a great world race – a race not passing off the stage of human affairs, but one which has an immense amount of history before it.'[69] While neither Kingsley nor Fletcher necessarily calculated to generate anxiety through such opinions, the suggestion that the African was reproducing at a rate which ensured that extinction was an impossibility could not be disassociated from sexual metaphors. These were easily absorbed into more general fears concerning the African's potency and virility, and were ultimately transformed into an anxiety about miscegenation. As will be seen in the following chapters, such nervousness about inter-racial union and marriage surfaces in many different guises over the period covered by this book. The advocation of polygamy by self-publicists like Kingsley and Blyden, coming as it did from both sides of the political divide, could only fuel such a fear.[70]

In the 1890s then, degeneration, generation and regeneration, particularly in connection with Africa, were evidently familiar concepts in a debate which was taking place in a number of politically diverse arenas with interests in African affairs. These ranged from Tory to Liberal and radical opinion within Britain, through to those like Kingsley and Pinnock, whose party political affiliations remained ambiguous, but whose concerns with colonial policy in West Africa were vocal and persistent and had the ear of a number of influential politicians and businessmen. They were debates that took place in the pages of popular narratives, daily and weekly national newspapers, and reviews. It is equally clear that such concepts were part of a discourse on European colonisation, and its effects on West Africans, generated by West Africans with diverse political agendas within the continent itself, and that opinion from this quarter was disseminated via the liberal and radical press in Britain, and also via the lecture circuit to influential bodies directly involved in the colonial administration. It is also evident that the discourse on degeneracy, as it evolved in Britain, was produced, in part, as a response to the way in which such a term was fast becoming indivisible from the nascent 'patriotic', nationalist discourse

produced by West African and other critics of the colonial regime. Because of such exposure, terms like 'degeneration' became common currency amongst a broad public in Britain. Its association with the inherent properties of a race, and its relation to the concept of regeneration and reproduction, had fundamental implications for the evaluation of culture from Africa and other colonies.

CHAPTER 3

AESTHETIC PLEASURE AND INSTITUTIONAL POWER

In the 1890s, debates on the origins of art and the nature of ornament constituted a considerable proportion of both ethnographic *and* art historical discourse. 'Degeneration' was a key concept in such discussions.[1] While the popular narratives and firsthand accounts of the Benin punitive expedition tended, for the most part, to use the notion of degeneration to reinforce a series of predictable stereotypes, the term took on a different gloss in the aesthetic treatises concerning Benin and other African societies' culture which were produced by the anthropological community. Here, degeneration played a more ambivalent role in the representation of Africa. However, it was a role which was no less symptomatic of vested political interests, but this time was of an institutional and disciplinary nature. In order to grasp fully the implications of this concept, in relation to emerging definitions of race and culture, we need to consider the ways in which degeneration and other racialised assumptions underpinned the categories and descriptive processes for classifying ethnographic collections, and thus their consumption by the museum-going public.

In addition to reporting in the local and national press, both in Britain and West Africa, the British public's interest in material culture from Benin was stimulated by the British Museum's own massive 1897 exhibition of carved ivories and three hundred bronze plaques from Benin City. This display occasioned a series of 'learned' publications by the Museum's own staff and others connected with the museums establishment inside Britain. By charting the trajectory of these accounts produced within the museum and academic establishment, and the way in which they drew on and developed a series of aesthetic assumptions and theories, this chapter explores the paradox which resulted in a thriving market response to Benin culture on the grounds of aesthetic merit and antiquity, while simultaneously fostering the spectacle of a bloody and senselessly cruel society. How, if at all, was such material incorporated within a critical apparatus for the appraisal of material culture, not only from Benin but from other parts of Africa, while it so obviously represented a fissure in the conventional evolutionary paradigm for dealing with ethnographic material, applied by most museums at the time? How did museum curators encourage their publics to negotiate the complex and often dissonant meanings attached to these exhibits?

Museum collections of material culture from the colonies were far more effective as constituents of an imperial ideology than has hitherto been acknowledged, but, crucially, this was not accomplished through a simple reproduction of imperial propaganda. Indeed, in certain respects, as we shall see in chapter six, the curators of ethnographic material cast themselves in the role of benevolent educators, dispensing rational and more particularly

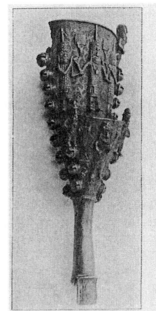
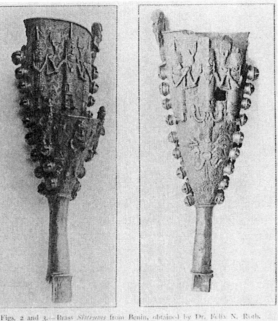

Figs. 2 and 3.—Brass *Sistrums* from Benin, obtained by Dr. Felix N. Roth. Length 30 c.m.

Fig. 1.—Brass Staff Head from Benin, obtained by Dr. Felix N. Roth. Length 24 c.m.

16 (right). 'Brass Sistrums from Benin', *Reliquary*, vol. IV (July 1898).

17 (far right). 'Brass Staff Head from Benin', *Reliquary*, vol. IV (July 1898).

'scientific' knowledge about the colonies and their indigenous peoples. As a self-image, this relied on distinguishing a set of referents and terms which qualified their contribution as 'scientific', and which differentiated knowledge defined as 'anthropological' or 'ethnographical' from other forms of knowledge of the colonies. To this end, the effectivity of the ethnographic collections depended on promoting the material culture in its custody, as, simultaneously: fodder for purportedly disinterested scientific and comparative study of culture; as 'proof' of racial inferiority (and therefore as justification of colonial intervention), but also in their capacity as objects of exotic delectation; aesthetic pleasure and, more frequently in the case of Africa, as spectacle.

The subsequent aestheticisation of material culture brought to England, as a result of the Benin punitive expedition, for example, has to be understood both within the specific context of British interests in that part of Africa and the dialogical relation between the Benin that was produced in the British press, and the Benin of the 'patriotic' West African press, and also within the context of the historical conjuncture that saw the rise of anthropology as a professional domain with the establishment of ethnographic departments in major British museums. In other words, it has to be understood in the context of both national and institutional policy and politics.

In 1898, the same year in which H.O. Forbes (director of the Liverpool Mayer Museum) published his piece in the Museum's *Bulletin*, H. Ling Roth, director of the Bankfield Museum in Halifax, and an individual who figured prominently in the history of interpretations of Benin culture, published his 'Notes on Benin Art' in the *Reliquary*.[2] The article is notably devoid of any reference to, or embellishment of, the 'cruelties of

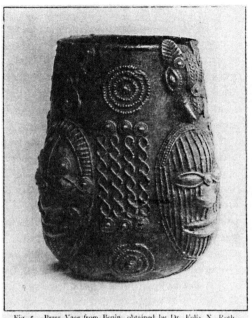

Fig. 5.—Brass Vase from Benin, obtained by Dr. Felix N. Roth.
Height 14 c.m.

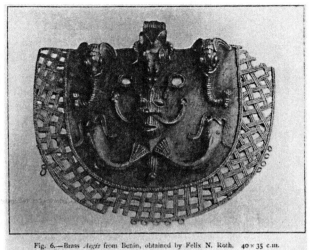

Fig. 6.—Brass *Aegis* from Benin, obtained by Felix N. Roth. 40 × 35 c.m.

18 (above). 'Brass Aegis from Benin', *Reliquary*, vol. IV (July 1898).

19 (left). 'Brass Vase from Benin', *Reliquary*, vol. IV (July 1898).

these "custom days"' on which, according to Forbes, 'has chiefly rested, during later times, the celebrity of Benin'.[3] Ling Roth's chief contention was that it was possible to define two phases or periods of Benin casting. Two objects, a brass sistrum and a brass staff-head, are used to strengthen his hypothesis (figs 16 and 17). These he compares with a brass vase and aegis (*sic.*) (figs 18 and 19). Ling Roth was not interested in setting up a hierarchy, since both phases were credited with equal workmanship and skill. He was more concerned to show 'that either there was a period when the workmanship and design underwent considerable modification, or that a different class of artist may have been introduced'.[4] Ling Roth makes clear his admiration for the work of both proposed periods, on the grounds of technical skill, elegant and thorough detailing, clarity and sharpness of design, and variety of illustration and ornamentation, together with what he perceived as an artistic sense of the balance between foreground relief and decoration, and background ornamentation. He specifically admired what he called 'the adept and bold evolution' from a naturalistic or realistic representation to a conventionalised version.[5] In addition, Ling Roth also established a long history, from an early date, of iron smelting and gold casting amongst different African societies. Furthermore, while emphasising that there was a world of difference 'between the crude castings of the average native African and the beautiful results' from Benin, he emphasised that there was no evidence extant to suggest that there was any such 'high-class art' in the Iberian Peninsula at the end of the fifteenth century, and certainly not elsewhere in Europe.[6] This, therefore, called into question the argument of a Portuguese origin for the bronzes.

Finally, he advanced a hypothesis completely at odds with the ethnographic curators at the British Museum, Read and Dalton (writers of the other major monographs on the subject by this date). Ling Roth suggested that, because the Portuguese figures were later additions attached to the surface of many of the bronze plaques, this method of casting must have pre-dated the Portuguese colonisation of Benin.[7] Since the first Portuguese arrived in 1486 and there is a representation of a European dating from 1550, a date arrived at because of the costume and weapon, Ling Roth argued that the lapse of only seventy years from the introduction of a totally new art form in 1486 would have been far too short a period to arrive at such a perfection of technique. The unsettling conclusion he arrived at, in 1898, was that this sophisticated art existed in Benin prior to the advent of the Portuguese, and was therefore entirely of African origin.

Lieutenant-General Pitt Rivers, whose substantial collection Ling Roth used to illustrate much of his article and his later book, *Great Benin: Its Customs, Arts and Horrors*, supported Ling Roth's hypothesis in private. In a letter to the eminent Oxford anthropologist, Edward Burnett Tylor, in August 1898, Pitt Rivers suggested that, 'It does not follow that because European figures are represented that it all came from Europe. Most of the forms are indigenous, the features are nearly all negro, the weapons are negro'.[8] The recurrence of specific features such as the spear and sword blades with the ogee sections, and the similarity between ancient Benin weapons and modern Congo implements with regard to inlay work of copper and brass, seemed, in his opinion, to support this argument. In public, however, Pitt Rivers expounded a rather different version. In his book, *Antique Works of Art from Benin*, privately published in 1900, he put forward another thesis.[9] While, on the one hand, he reiterated Ling Roth's judgement that the true value of the artifacts lay not as 'relics of a sensational and bloody episode but . . . in their representing a phase of art – and rather an advanced stage – of which there is no actual record', he nevertheless concluded by asserting that 'we cannot be far wrong in attributing it to European influence, probably that of the Portuguese some time in the sixteenth century'.[10]

By 1898, Read and Dalton had already lectured at the Anthropological Institute, exhibiting some of the banker George Neville's carved ivory tusks and also photographs of the brass plaques in the British Museum's collection. Two publications resulted: an article in the *Journal of the Anthropological Institute*, and a published book.[11] The arguments put forward here are worth recounting, especially since, together with Ling Roth's accounts, they form the body of apparently authoritative and scientific opinion that was used to legitimise certain interpretations of the Benin material. The earlier version in the *Journal of the Anthropological Institute* makes it clear that Benin was one of the first important African kingdoms to come to European attention through the accounts of travellers and traders. It testifies to a once prosperous city which, by 1600, was falling into the state of decay and degeneration described by the famous traveller Richard Burton, and, later on, by Bacon and Boisragon.[12] Echoing the sentiments of the missionary and anti-slavery lobby, it is the slavery on which the social order was thought to rest that is held up as further evidence of such degeneration. Such 'home truths' are supplemented by a plethora of details concerning Edo life, society, and a detailed description of the architecture of the royal city and the palace compound, taking care to delineate the various motives and animals represented here. The hierarchy and structure of government and the royal court is set out, emphasising, for the first time, the seminal role played by the

queen mother. Her brass memorial head was one of the most prized items in the British Museum's collection, although by this date it was described simply as the 'head of a girl' (fig. 20).[13]

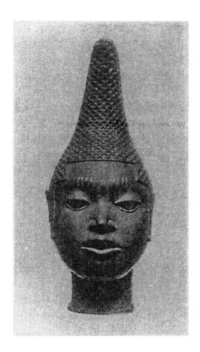

20. Bronze memorial head of the queen mother, Benin City. In the collection of the British Museum.

According to Read and Dalton, enough similarities existed, both in social custom and in cultural practice, between the Edo and the Dahomeyans and Yorubans (not least because of the shared practice of human sacrifice), to be able to use contemporary evidence from these other peoples to supply the missing details in Benin's historical record. The fact that, according to Read and Dalton, 'the African negro is everywhere very much alike' seemed ample justification for this procedure.[14] The full implications of such a solution are treated later in this book. It is sufficient to say, at this point, that this argument was based on the evolutionary premise that these societies existed in a timeless vacuum, and when they did change in any way, such change was much slower than in a more 'sophisticated', and by this was meant European, society.

One thing that Read and Dalton share in common with other commentaries already mentioned is an acknowledgement that these complex and detailed figures, cast with such skill and expertise, 'were produced by a people long acquainted with the art of casting metals'.[15] The authors go so far as to compare their mastery of the *cire perdue* process to the best work of the Italian Renaissance, not only in relation to the plaques but because of the demonstrated facility for casting in the round.[16] Read and Dalton's dating of these brasses corresponded to the dating of the costume and weaponry found on those items

representing Europeans (that is, from the mid-sixteenth century), and conceded that, at the opposite end of the scale, some might well be of considerably later manufacture since many of the items represented on the tablets were in current use in Benin in the nineteenth century. Any question of the bronzes actually being contemporary, however, was immediately dismissed with reference to the inferior quality of contemporary casting. There was no danger here of transgressing the image of Benin as a degenerate culture.

Significantly, the point at which ethnologists decided to intervene in the debate over the origin of the Benin bronzes was precisely the moment when the paradox of technical sophistication versus social savagery threatened a break with the evolutionary paradigm, which up to that time had also supplied the classificatory principles under which most collections of material culture from the colonies were organised. Consequently, the concept of degeneration was summoned up as an aesthetic principle, to appease anxiety over these recalcitrant objects which refused to conform to comfortably familiar taxonomic solutions. It is this articulation of the concept of degeneration, as part of a systematic evolutionary schema for explaining the origins of all art, that provides a nuance for the concept that exploits but also belies its immediate association with racial denigration.

<center>I</center>

In Britain, Henry Balfour, Alfred Haddon, and Charles Hercules Read were the earliest anthropologists who, operating in the more general public sphere as curators of large public ethnographic collections, also promoted the degenerationist thesis, as it came to be known, as a system for aesthetically evaluating material culture from the colonies.[17] The thesis, however, had a broader following. An English doctor, H. Colley March, was cited by Haddon as an important contributor to theories on the origin of art. Dr Hjalmar Stolpe, the Swedish biologist and museum curator, whose work was translated in 1892, was also acknowledged by Haddon as one of the first to tackle seriously the subject of the ethnological aspect of the decorative arts.[18]

The theories laid out by these anthropologists were in direct opposition to most previous attempts to explain the origin of art. These usually expounded a formal development, beginning with geometric abstraction and culminating in naturalism. The best known of these, and one familiar to all three researchers concerned here, was the work of Gottfried Semper. Semper's two volume *Der Stil in den Technischen und Tekonischen Künsten, oder Praktische Aesthetik*, published in 1863, was still extremely influential in the 1890s. One of the most ardent and prominent exponents of his theories was William Henry Holmes, curator of anthropology at the American National Museum in Washington, who translated a version of Semper's ideas into a system for displaying and organising the ethnographic material in the Washington collection, and thus helped to prolong its relevance as a system for understanding the origin of form in North America.[19] At the basis of Semper's theory is a profound functionalism, whereby architectural structures were evolved through necessity in order to protect the sacred fire of the hearth. This resulted in the construction of a roof against rain, a raised earthen surround to protect against flooding, and a plaited enclosure as protection against wind.[20] It is this enclosure which acquires a seminal significance in Semper's treatise, as an architectural

structure which divides the 'life inside' from the outside world. As a consequence, plaiting becomes the primary technique from which weaving, and subsequently all ornamentation, derives. From the use of natural plant fibres to a spun fibre, patterns initially emerging through accidental variation of the natural colouring were later deliberately produced by applying dye beforehand. Weaving was thus perceived as the process which ultimately gave rise to the earliest form of ornament.[21] From the development of woven fabric, and the resultant pattern, followed other necessary utensils such as pots. According to Semper, the decoration of these items was a direct transference of the ornamentation already familiar from the process of weaving, and now extended to the surface of pottery. In other words, the earliest designs were geometric abstract forms derived from functional necessity.

In contrast to this theory, the protagonists of the degenerationist school believed that through carefully plotted sequences and series, they could prove the opposite: the linear development of ornament from naturalistic to geometric and abstract.[22] Their method was characterised by a systematic analysis of the formal or stylistic elements of different objects, in order to prove culture contact by the aid of resemblances in style and to demonstrate diffusion of cultural elements. Their analysis, however, did not stop with formal considerations. From the outset, Haddon and Balfour were also concerned to elaborate the meanings and significances of objects for their indigenous producers and consumers.[23] The distinctions between Semper and the degenerationists, in terms of the practical implications of their theories, are explained by Philip Steadman in his history of theories of design, where he compares Semper's proposed layout for his ideal museum to that specified by Pitt Rivers for the display of his collection in the Bethnal Green Museum and later in the museum which bears his name in Oxford.[24] According to Steadman, 'The two schemes are obviously direct reflections of the transition of interest . . . from the "environmental" influences emphasised in Semper's classification by function and materials, to the "evolutionary" connections stressed in Pitt Rivers' chronological series'.[25]

On the one hand, the degenerationist thesis represents a clearly overdetermined evolutionist account. On the other, the degenerationists were also at pains to point out that, while the move to abstraction might be the result of unconscious variation (following the Darwinian model of 'accidental' evolution), this tendency might also be due to the conscious decision and invention of the producers. This is something which Henry Balfour introduced in his book *The Evolution of Decorative Art* of 1893, and which is conceived of as three stages, which he defined as appreciative, adaptive and creative. In the first stage, conception for the work is derived from natural phenomena, which may evoke a resemblance to something familiar, or which are the result of an appreciation of 'the unusual in nature'. This was followed by a stage where the result was achieved artificially from beginning to completion, and the effects copied by succeeding generations.[26] Balfour proposes these as sequential stages in the early history of art. It is the final stage that he elaborates, however, since this is the phase which supposedly provided the most variation of result. At one level, this was thought to be due to a lack of requisite skill on the part of the maker, the different demands made by the material and tools used to produce the work, reproducing from memory, or careless copying.[27] Together, these four possible reasons for finding a variation in the same or similar design or ornamentation were called 'unconscious variation'. These are compared to variations arising from what

Balfour designates as intentional changes, made, he suggests, as a mark of ownership, or to embellish an ornamental effect, to serve a functional purpose, or to emphasise a special element in a symbolic design.[28] Balfour named these 'conscious variations', and defined this stage as the 'creative stage' where, 'once man found that he could produce at will decorative effects or representations of objects, the real starting point of art industry was reached'.[29] According to Balfour, the design thus becomes conventionalised in order to provide ornamentation. Significantly the implication here is of volition rather than accident.

As Pitt Rivers had before him, Balfour attempted to provide proof for his thesis of degeneration and variation, through a controlled experiment involving repeated copying

26 *Evolution of Decorative Art.*

21. Plate showing the gradual 'degeneration' from realism to abstraction as a result of successive copying. Illustrated in Henry Balfour, *The Evolution of Decorative Art* (London 1893).

without recourse to the original. Balfour employed a series of individuals to collaborate in an exercise of successive copying. In the results of this experiment, published in his book, the final copy looks very different from the original (figs 21 and 22).[30] In his lecture to the Society of Arts, he provides an example of this process with two illustrations of Ikengas from West Africa, described as 'two little carved wooden human fetish figures with long horns'. The process of 'degradation' supposedly demonstrated here, is from

> one showing body and limbs complete, the left hand holding the bowl of a pipe which is being smoked, and the other figure showing the same design in a more conventional form, the body and limbs fused into a mass below and the pipe hanging centrally between the mouth, or rather chin, and this body mass.[31]

ORNAMENTATION OF NEW IRELAND PADDLES. SHOWING THE TRANSITION OF FORM.

22. Plate showing the transition from realism to abstraction on the ornamentation of paddles from New Ireland. Illustrated in Augustus Lane-Fox Pitt Rivers, *The Evolution of Culture and Other Essays* (Oxford 1906).

This thesis was further enhanced in Balfour's text by examples taken from anthropology and archaeology.[32] It is with respect to these experiments that the Darwinian concept of 'natural' selection is most obviously inapplicable, since it is difficult to assess the 'fitness' of a decorative design solely on the basis of the functional criteria demanded of the Darwinian analogy. Crucially, Balfour's paradigm, unlike a strictly Darwinian analogy, allows for a degree of autonomy and intentionality on the part of the producer, and this in turn accounts, at some level, for the variation of design. Consequently, since both Balfour's and Haddon's examples were drawn from African and Papua New Guinean societies, their arguments obviously offered the possibility of acknowledging an alternative aesthetic motivation usually denied to these societies at the time they were writing.[33]

The other feature of Balfour's argument worth considering here, and one which had a particular impact on the shape and development of African ethnography in museums up and down the country, is that section relating to the distinction between 'graphic' or two-dimensional art, and 'plastic art'. Balfour suggests that, although there is only circumstantial evidence to support his hypothesis, graphic art was a later derivation from plastic art, since, 'We know that solid shapes appeal more readily to the lowly cultured mind, than do designs representing the same objects in the flat'.[34] This rather inadequate explanation for his hierarchical distinction between plastic and graphic is as far as he takes us. What is significant about such a distinction, however, is the fact that the one is prioritised over the other, in terms of the evolutionary paradigm. In relation to African material culture, it may perhaps explain the degree to which Kuba, Edo and 'Bushmen' work (from the then Congo, West Africa and South Africa respectively), while not necessarily constituting the largest proportion of African material in the holdings of the major ethnographic collections in this country, was consistently singled out as amongst the most prized and interesting possessions. Such work shares in common a high degree of surface decoration. Similarly, the 'Bushmen' paintings are explicit examples of 'graphic art' by Balfour's definition. Likewise, the cut-pile raffia fabric of the Kuba is a particularly good example of the consistent preoccupation with rectilinear surface design which covered all the objects, carved, woven or moulded, that this group produced. This might also account for the fact that while the innumerable carvings brought over from areas of West Africa rarely featured in any 'decorative art' exhibit, objects with similar functions from the Congo region would almost certainly have been incorporated into such a category.[35]

Another and important instance of the more progressive potential of this idiosyncratic thesis, was the way in which it effectively challenged the prevailing art historical view of art as a work of individual, inspired genius. It was a challenge that did not go unnoticed. One of the prestigious venues where such concerns were fought out was in the hallowed halls of the Royal Society of Arts. The Society had, from its foundation, been concerned with the promotion and encouragement of trade and production in the British Empire. From the early days it had seen itself as a source of information on almost all aspects of life in the colonies, and as a source of custom for the colonies by publicising colonial produce, often displaying specimens in the Repository. (This was a function later taken over by the Imperial Institute Galleries.)[36] The Society's most concentrated period of engagement with colonial issues, however, began in 1869 with the formation of the Indian section. This was followed in 1874 by the African Section, which became, in 1879, the

Foreign and Colonial Section, changing its name again in 1901 to the Colonial Section, which title it kept until 1921. Most of the people mentioned in this book were contributors at one time or another to the debates in the Royal Society's colonial meetings. The roll-call of those involved forms a list of all the most prominent industrialists, administrators and cultural managers with an interest in the colonies. What is worth noting here, is the extent to which the topics reflect a concern with aspects of material culture from the colonies, and the question of how such production, mostly seen as the product of a 'primitive' people, should and could be interpreted and made significant to an audience back in Britain.

In a presentation to the Society in 1903, Sir George Birdwood, a well-known scholar of Indian culture, could already claim that 'much attention has been directed during the past thirty years to "primitive art", by which its specialised students and expositors mean the so-called "art" of contemporary savages'.[37] Birdwood's own rather verbose lecture is clearly unsympathetic to the notion that the work of peoples so classified should in any way assume the category of 'art', since they

> by no charity of aesthetic sensibility can be regarded as embellishing . . . and decorative . . . and by no elasticity of technical definition can be classed as artistic objects; while they can be characterised as ornamental . . . only in the primary and strictly etymological sense, and, in the nomenclature of the arts, a strained sense, of that word.[38]

The lecture is an interesting tirade on several counts, and worth examining in detail for the insight it provides into the objections to what was identified by the art historical establishment as 'ethnographical' analysis. The antagonism expressed in Birdwood's lecture is in many ways representative of the terms of opposition encountered by Henry Balfour and Alfred Haddon, two of the anthropologists most concerned with popularising anthropology and probably the best known outside of specialist anthropological circles. The debate sheds new light on the impact made by their theses on the 'origins of art'.[39] It is also interesting as an early example of a continuing debate between anthropologists and art historians regarding the most suitable frames of reference within which to discuss non-European cultural production. In this case, the stakes were even higher since Haddon and Balfour were arguing for a system which they considered appropriate for the analysis of both European and non-western material culture.

Birdwood's reputation as a scholar and promoter of Indian art and culture, in addition to his constant presence in the debating rooms of the Royal Society of Arts, earned him the posthumous honour in 1921 of a lecture series dedicated to his memory by the Society.[40] He was, therefore, no mean opposition for Haddon and Balfour. His paper provides, on the one hand, a glowing account of the literature available from those professing to analyse the development of decorative art by 'scientific' means, while on the other hand being scathingly sceptical about the implications of their research. Pitt Rivers, Henry Balfour, and Alfred Haddon all came in for criticism. But they were nevertheless acknowledged as being 'of profound interest to all students of ethnography, and human culture', and it was recommended that the information collected in their monographs on the evolution of decorative art should be 'possessed by every student of art, and even cherished'.[41] Birdwood goes on to make the case that while

the sense of art is universal among mankind . . . there is no . . . art in the mechanical figurations of primitive man and contemporary savages, or even of men who have advanced to barbarism . . . and most of the conventional 'designs' . . . of savages, are but meant to serve either as charms, or as crude hieroglyphs for the conveyance of information.[42]

Clearly, the concept of evolution in art applied to ethnographic material was not acceptable to Birdwood. The work of art was a work of individual, inspired, genius, for 'in art there is no such thing as evolution, but more or less isolated and veritable "creations" – for their law cannot by searching be found out – by men whose genius is a true divinity.'[43]

Haddon's response was an argument which would not be out of place in a contemporary critique of formalist art history:

There are two ways in which decorative art may be studied; these may be briefly defined as the 'aesthetic' and the 'scientific'. The former deals with all manifestations of art from a purely subjective point of view, and classifies objects according to certain 'canons of art'. These may be the generally recognised rules of the country or race to which the critic belongs, and may even have the sanction of antiquity. Or they may simply be due to the idiosyncracy of the critic himself.[44]

Haddon and the other degenerationists proposed instead a comparative analysis of all decorative art, both European and non-western, as a branch of biology mediated by environmental factors. Indeed, in his conclusion Haddon states categorically, on the relation of art to ethnology, that 'the same processes operate on the art of decoration, whatever the subject, wherever the country, whenever the age – another illustration of the essential solidarity of mankind'.[45] Like his contemporary Henry Balfour, Haddon worked from the premise that whereas the final or contemporary result might suggest otherwise, 'the decorative art of savages is originally almost entirely realistic or suggestive, and that usually natural forms were copied.'[46] Haddon assumed that since the decoration is based on nature, what resulted would therefore be a direct consequence of the artist's environment. Such a conclusion demanded a considerable knowledge of the physical conditions of the region. It was also impossible to carry out such an analysis without regard for the 'arts and crafts' of the group under discussion, since to a certain extent the nature of the object to be decorated, and its function, dictated the form of the ornamentation, although the shape of the object had a history independent of its decoration.[47] Such a job, argued Haddon, was of course more suited to the emerging skills of the anthropologist than the art historian or connoisseur.

The cultural relativism implied by the suggestion that all art was subject to the same determining factors of environmental conditions and material circumstances of production, did more than simply undermine the myth of individual genius that was so dear to the art establishment. It threw into disarray the principle of racial purity which underlay so much art historical writing in Britain over this period. George Birdwood's own defence of individual intuitive genius, for example, relied heavily on the necessity of racial purity. His ultimate criticism against the Papua New Guinean work, that formed the bulk of both Haddon and Balfour's examples in their respective publications, is that this was a 'depraved and sinister deformation of aboriginally Indian types, transmitted in the train of Buddhistic missionaries, Mahometan (sic.) traders, and Portuguese and Dutch navigators, and fillibusters, voyaging to and fro, through the centuries'.[48] On the other

hand, the Eskimau (*sic.*) as a pure race, supposedly a direct 'survival' of Paleolithic man, were accredited with 'all the truth to nature and all the artistic verve and flare of Landseer'.[49]

Not only did this debate self-consciously qualify anthropology's, as opposed to art history's, particular contribution to the study of material culture from the colonies, it also had consequences for the study of art and culture at home.[50] In fact, the theory of degeneration had important implications for more specific debates around the nature of the Englishness of British art which were currently resurfacing in the writings of art historians and critics. As such, it brought the work of anthropologists like Haddon and Balfour, the very people who were concerned to broaden the public awareness of the value of anthropology, to the attention of a far larger public than they were currently able to attract. At a moment when anthropologists were fighting for recognition as a scientific and academic discipline with a wide range of applications and use values, this was an important bonus, even if such attention took the form of a heated controversy.

Back in the 1850s, certain prominent critics and art historians, among them John Ruskin, had already proposed that naturalism was somehow a precondition, if not an inherent property of true English art; a property which was taken as irrefutable proof of the moral health of the nation.[51] Conventional or abstract tendencies, on the other hand, were evidence of moral decline and degeneration. In this scenario, the morally degenerate examples were drawn from the decorative art of various colonies, or from the celtic Irish tradition. By the 1890s, the revival of such a tradition was firmly established as part of the cultural nationalist movement within Ireland.[52] The relation of such xenophobia to the anxiety over resurgent Irish nationalism needs no rehearsal here. The potential threat to the moral integrity of English art posed by that aspect of Haddon's and Balfour's thesis which suggested a more positive espousal of a non-European geometric idiom, coupled with the indisputable naturalism in the Benin bronzes themselves, is also clear in this context.

However, the degenerationist thesis had other features which further complicated its relationship to the idea of racial purity. In order for the theory to work, and to fulfil the ultimate objective of most anthropological treatises on aesthetics at this time – the elucidation of contemporary 'man's' creative drive or 'psychic urge' to artistic expression – it was deemed necessary to focus on those societies which conformed to E.B. Tylor's earlier concept of a 'survival'. These were described as 'processes, customs, opinions and so forth which have been carried on by force of habit into a new state of society different from that in which they had their original home, and they thus remain as proofs and examples of an older condition of culture out of which a newer has evolved.'[53]

In Balfour's essay, such societies are further defined as one of two categories of 'survival'. While some are described as 'lowest in the scale of civilisation, whose condition of culture is in the most primitive of existing states', others are termed specifically degenerate races. These are societies which having 'in former times enjoyed a higher civilisation', now reside in a state of retrogression or degeneration – although interestingly enough this was a condition laid squarely at the door of the coloniser in this instance.[54] Aboriginal Australians and Tasmanians, for example, were by these definitions truly 'primitive' rather than 'degenerate', since they had remained outside of the contaminating sphere of white contact, until what is described in Balfour's treatise as 'their ruthless extermination by the savage methods of intruding civilisation, which resulted in their

complete extermination.'[55] By such definitions, Benin was the quintessential 'degenerate' society.

Such nostalgic reverie for the lost sanctity of originary unity was not always accompanied by so explicit a critique of colonial intervention. Haddon, for example, suggested that 'impurities' in race led to regrettable impurities in form: 'It will often be found that the more pure or the more homogeneous a people are, the more uniformity will be found in their art work, and that florescence of decorative art is a frequent result of race mixture.'[56] Consequently, a thesis which in the context of art historical debates had the power to rupture the xenophobic association of naturalism with moral stability, as an intrinsic property of the English, could, in the context of the discussions around the Benin bronzes, be mobilised for other rather less progressive ends. Back at the British Museum, as we have seen, the thesis provided Read and Dalton with the opportunity of safely comparing the Benin mastery of the technically complex *cire perdue* process with the work of the Italian Renaissance, and conceding that the castings were probably produced by a people long acquainted with the art of metal casting, while at the same time continuing to assign the Edo to a state of savage degeneration.[57] The apparent absence in most eyewitness accounts of any contemporary Benin work of similar naturalism, coupled with the apparent tendency towards 'florescence' of surface ornament in what were deemed later examples, ensured that there was no danger of their interpretation transgressing the theory of degeneration in either its 'scientific' and aesthetic aspect, via anthropology, or the specifically racialised aspect already disseminated in the middle-class illustrated press.

One of the reasons why the more progressive aspects of the degenerationist thesis could be disregarded, was precisely because of the way in which notions of racial purity had already acquired a particular currency in another area of public culture. The terms 'primitive' and 'degenerate' were familiar through their use not only in the discourse of West African 'patriots', whose writings, as we have seen, would have been known to philanthropists and humanitarian and radical groups in Britain, but also in a context far closer to home. Discourses on health and racial purity, produced through medicine, philanthropy and eugenics in the work of Francis Galton and later, Caleb Saleeby and Karl Pearson, ensured the topicality of such theories. In this context, the focus on racial purity was a symptom of anxiety over the degeneration of the 'imperial' Aryan race. It was an anxiety which surfaced more visibly in 1902 in the aftermath of the Boer War, when the need for soldiers had pointed up the ill health of working class recruits. By the 1890s, an alarming decline in the state of health of the working classes was becoming a major concern, which later medical research and social surveys confirmed.[58]

The ensuing debate, however, around the question of deterioration versus degeneration was exacerbated by the eugenists, who were still mostly convinced of the inherited, rather than environmental, determinants of such a decline in the nation's health. Consequently, while the findings may have provided the impetus for preventative health initiatives, they also provoked a public campaign for the surveillance and categorisation of those considered racially degenerate and unfit.[59] Alfred Haddon, one of the major proponents of the degenerationist thesis applied to aesthetics, had already supplied expertise, in physical anthropology and anthropometry techniques and statistics, for Galton's work on systematic race regeneration and population control within the British Isles. Evidently, then, such terms as 'degeneration' had a particular resonance for certain ethnic, class and gender constituencies within Britain. It was this contradictory intersec-

tion of anthropological, medical and aesthetic discourse around the issue of degeneration, coupled with the exigencies of the demands for a professional status for ethnography, that precipitated the question of the origin of the Benin bronzes in the late nineteenth century into a national concern, and transformed the bronzes themselves into a symbol of national pride within Britain.

II

In 1899, Read and Dalton published a special presentation book entitled *Antiques from the City of Benin and other Parts of West Africa in the British Museum*. This contained several significant shifts from their earlier 1898 argument regarding the origin of the bronzes.[60] It also introduced a new order of knowledge in the form of oral history as a valid category of historical evidence. Together with the earlier travelogues and eyewitness accounts produced by Europeans, this new order of evidence was mobilised partly as an opportune means of authenticating the antiquity of the Museum's Benin collection. Firsthand accounts of Edo society from various chiefs in the deposed Oba's retinue were collated by Captain E.P.S. Roupell, a member of the expeditionary force. Those individuals with the titles of Court Historian, Juju Man, Master Smith, Master Wood Carver, and Master Ivory Carver gave testimonials which became the foundation of the Edo history narrated in Read's text.[61] Such witnesses established the existence of an ancient history, and their use as authorities by none other than the British Museum helped validate such oral tradition as a legitimate source of evidence. According to these accounts, the knowledge of brass casting came in the reign of King Esige with a man named Ahammangiwa, who arrived with the Europeans. For Read and Dalton, this corroborated their earlier guess of a date for the bronzes from around the middle of the sixteenth century. They had initially rested their case on a Portuguese or Egyptian origin for the bronzes. However, by 1899, Read felt obliged to warn the reader that one of the dangers of this hypothesis was that, since Europeans were better acquainted with Egyptian material, there would inevitably be a tendency to compare other lesser known cultures with Egyptian civilisation. More importantly, Read and Dalton were now both prepared to concede what Ling Roth had suggested in 1898, that although certain aspects of the ornamentation might still be attributable to the Egyptians, the Benin castings may well have preceded, or at any rate come into being independently of, Egyptian predecessors! What does this sudden admissability of an African origin signify at such a moment? Why were the two spokespeople from the national collection prepared to concede such a thing, when by this date there was effectively very little additional empirical data available than the previous year?

I would argue that the degree to which the Benin aesthetic is assigned an African origin corresponds partly to the stepping up of pressure from ethnologists and anthropologists in the museum for government recognition and financial support. Furthermore, the course of Read and Dalton's argument for an African origin is inextricably linked to the fortunes of the Ethnographic Department within the British Museum itself.[62] Unlike the already thriving department of Egyptology (the other tentative 'home' for the bronzes if an Egyptian origin were proven, and an autonomous department within the Museum by 1886), ethnography was only granted the status of an autonomous department in 1941.[63]

The fact that so many commentaries could so confidently claim an Egyptian source for the Benin bronzes was not at all surprising, given the extent to which Ancient Egypt had made something of a comeback in the popular imagination of nineteenth-century Europe. The mysteries of embalming, mummification and other rites associated with death were kept alive by the reissue of the Egyptian *Book of the Dead*, a guidebook for the soul's journey after death.[64] Other manifestations of this association of Ancient Egypt with funereal rites included the increase in funerary sculpture in France and Britain, which borrowed from the architecture and structures (pyramids and 'needles') most resonant of Ancient Egypt to the more general public.[65] This penchant for Ancient Egypt, and indeed Egyptology, amongst an educated lay public was clearly a consideration for Read and Dalton, and resulted in the cautionary note in the conclusion of their book on the British Museum's Benin collection.[66] It was also no secret that the British Museum relied heavily on the drawing power of the Egyptian mummies to ensure the popularity of the Museum.[67]

On a more serious academic front, one of those who did much to bridge the gap between the mysteries of archaeology and ancient history, and the more generally educated layperson with an interest in Egypt and the Middle East, was William Matthew Flinders Petrie, who had already lectured at the Society of Arts on Egyptian decorative art.[68] By 1895, he had published his book on the same subject. The thesis of the book is interesting for the light it sheds on the popularised version of Ancient Egypt's place in world history.[69] In terms of the question of the origin of patterns, Flinders Petrie does not mince words: 'Practically, it is very difficult, or almost impossible, to point out decoration which is proved to have originated independently, and not to have been copied from the Egyptian stock'.[70] More to the point for him, 'the general descent of classic ornament from Egyptian, and of Indian and Mohammedan from the Classical, and even of Eastern Asian design from the Mohammedan sources, is undeniable'.[71] Martin Bernal, in his important study of the afro-asiatic roots of classical civilisation, *Black Athena*, argues that by the late nineteenth century the fact that Ancient Egypt could no longer be denied as part of the African continent presented a paradox rather similar to that presented by Benin culture, because of the evidence of an ancient civilisation. According to Bernal, European scholarship dealt with this by either denying that the Ancient Egyptians had been black, that is African, or by denying that Ancient Egyptians had a 'true', that is racially pure, civilisation, or both.[72] What is significant here is the fact that Flinders Petrie, one of the earliest and most vocal promoters of the glories of Ancient Egyptian civilisation, and to a certain extent one of the public figures responsible for spreading his enthusiasm amongst an interested educated middle class in Britain, evidently held neither of these views. In this book on the decorative art of Egypt, his closing paragraph – the summation of his thesis – clearly reinforces the hybrid nature of Ancient Egyptian society by what he then perceived as 1552 BC: 'Another design came into fashion during the great foreign wars of the XVIII Dynasty, representing two captives, one negro, one Syrian, bound back to back against the sam.'[73] The sam had already been identified by Petrie as the decorative feature of a column which he interpreted as the Ancient Egyptian sign for union. For Petrie, then, 'it symbolised not only the union of upper and lower Egypt, but also of the northern and southern races outside Egypt. Later on four or even six such racial types are figured as bound together.'[74]

In the British Museum, however, no such ambiguities were possible in the display of

what were, and remain, two separate departments. Thus the knowledge of Ancient Egyptian culture as it was structured in the Museum, even on the basis of its separation from the African material housed in the Ethnographic Department, reinforced a view of the relation of both regions which was not necessarily the current view of those at the forefront of the discipline of Egyptology. It is within this context that the possibility of claiming an African origin for the bronzes becomes a viable strategy in ethnography's bid for recognition within the Museum and conversely for the Museum's bid for more government funds.

In September 1897, a series of some three hundred brass plaques from Benin were put on public exhibition in the British Museum. The provincial and national press almost unanimously described the exhibits as remarkable and extraordinary examples of skilled workmanship, often repeating the opinion that such work would not discredit European craftsmen, while simultaneously rehearsing the gruesome and by now familiar details of the punitive expedition's experiences.[75] In the British press, coverage of the exhibition positions the significance of the Benin bronzes as primarily relics of the punitive expedition and as reminders of the horrors experienced by Phillips' party. The same obsession with the origin of the exhibits and their alleged antiquity repeats itself here, although the most frequently posited solution is an Egyptian origin.

There is, however, another set of discourses running through both popular and scientific reports which suggest controversy of a different order to that which, on the face of it, seems to be a debate around the possibility of assigning an African origin to the Benin bronzes. Initially, it was assumed that the vast hoard of brass plaques, temporarily on loan to the British Museum, would eventually become the property of the Museum through the Trustees' acquisition of the artifacts. The Foreign Office had agreed to the loan after official representation had been made to the government on behalf of the British Museum to secure some specimens.[76] The series arrived at the Crown Agents and subsequent provision was made for their public exhibition. While the government halted the impending sale of the plaques at the West African coast before embarkation to England, they did not make the same proviso regarding the tusks, many of which were thus procured and later disposed of at a sale in the City. Read and Dalton, who narrate these events, end with a plea: 'The British Museum could not at the time buy more than one of them, from lack of funds, and two or three more would be welcome additions.'[77] By the next year, it was clear that a much smaller proportion of the loot remained in the possession of the Museum than had been originally hoped. In fact, over a third of the bronze plaques had already been sold off as revenue for the Protectorate. The ensuing public auction of items from Benin aroused much bitterness amongst those museum staff with an interest in the affairs of the Ethnographic Department.

To compound this frustration, a visit to Germany resulted in Dalton publishing a report, in June 1898, on large-scale acquisitions being made in the area of African ethnography, especially in Berlin, with the financial and moral support of the Kaiser.[78] Financial resources for ethnographic work in German museums seemed to Dalton to be boundless. An annual government grant of about two thousand pounds was reportedly shared between only five departments at the Berlin Museum für Völkerkunde alone, and this was supplemented by a committee of wealthy men interested in ethnology, called the Hülfscomité.[79] With this income, the same museum was thus also able to fund scientific expeditions. Further details regarding other facilities available for the development of

ethnography in German museums, together with a list of initiatives in display techniques, were followed by the observation that, unlike the British, Germans of all classes found ethnography of great interest.[80] Dalton felt moved to observe about the Museum für Völkerkunde in Berlin that 'in almost every section . . . it leaves the Ethnographical Gallery at the British Museum far behind.'[81] Finally came the crushing news that the Director of the Berlin museum had already spent one thousand pounds, chiefly in England, on the very Benin material for which the British Museum was unable to get funds from its own government.

The cry of 'national heritage' was taken up by the British press, which similarly couched its arguments in terms of British competition with Germany – a strategy calculated to inspire a sense of nationalist indignation. As an ironic consequence, national pride became intimately linked with the fate of the Benin bronzes, which now came to symbolise the triumph of British manhood over Edo barbarity. How could the government allow valuable loot from the punitive raid, the reprisal for so many British deaths, to go to that other repository for British xenophobia, the Germans? The public auction of Benin artifacts was clearly presented in the press as no less than a loss to the nation, and details of the few 'fine bronze heads' (as they were now described) that remained in the British Museum collection were compared with the thirty or forty acquired for Berlin through the Kaiser's patronage.[82] The German threat was a card consistently played by anthropologists over the period under discussion in their bid for popular and government support. The insistence with which this competition was opportunistically enlisted in aid of anthropology is commensurate with the perceived threat posed by Germany to Britain's imperial supremacy – a threat which steadily increased over the years leading up to the First World War.[83]

The extent of the bitterness and longevity of such grievances against the government is summed up in a statement, made six years later in 1903, in Ling Roth's book on Benin:

Not only was the national institution thus deprived of its lawful acquisitions, but at the same time another government department sold for a few hundred pounds a large number of castings which had cost thousands to obtain, as well as much blood of our fellow countrymen . . . and it is especially annoying to Englishmen to think that such articles, which for every reason should be retained in this country, have been allowed to go abroad.'[84]

The location of the Benin material on view to the public at the British Museum in 1898 reinforces the fragility of the Ethnographic Department's status within the institution of the Museum itself. The ethnographic section was at this time part of a larger department of British and Medieval Antiquities and Ethnography, and in fact the actual ethnographic galleries were only open to the public on certain days of the week, and then for only two hours in the evening.[85] One reviewer of the Benin exhibition recalled the inconvenience of having to travel the sizeable distance from the Assyrian Saloon in the basement to the ethnographic gallery on the first floor, in order to see the display which had been split up between these two rooms.[86] It should perhaps be pointed out that the Assyrian Saloon was the room set aside for lectures at the British Museum. Here, in this converted space, temporarily arranged on screens, the three hundred brass plaques deposited on loan by Sir Ralph Moor were displayed to the public. Meanwhile, in the ethnographic gallery, the African section was rearranged in order to accommodate the carved tusks and a portion of

the bronzes in a large central case.[87] By 1899, the plaques had been removed from the Assyrian basement and placed in the middle of the African section, but only after many of the objects already on display had been removed from view in order to provide room for them.[88]

In conclusion, it is clear that, for all its idiosyncrasies, the 'degenerationist' thesis was immensely influential both in Britain and in other European countries. Contemporary criticism of the thesis made little impact on the popularity of the concept as a way of 'explaining' African and other colonies' culture in Britain, precisely because the main exponents of the concept were all curators of major public ethnographic collections. Consequently, these curators were able to give tangible and, most importantly, *public* visibility to the thesis through the organisation and display of their ethnographic collections. As we have seen, the degenerationist thesis had an even more fundamental structural impact on the general development of ethnography in Britain. It resulted in the prioritising of certain geographical areas over others, and it ensured the importance of the category of 'decorative art' in displays of material culture from the colonies.

Equally clear is the fact that the influx of Benin material culture into nineteenth-century Britain made an important impact in several ways. It generated debate amongst different communities of interest in Africa, which had the potential to shift certain popular pre-conceptions regarding the African's lack of competence to produce complex, technically sophisticated, art work. The attempts by those who saw themselves as part of the scientific community to provide an alternative context in which to interpret these finds, other than as 'curio' or 'relic' of past misdemeanours, drew public attention to a hidden history of long-established and affluent African societies. Even though the museums establishment's use of early travel accounts and oral histories may have primarily served to establish the antiquity, and therefore increase the value, of their Benin holdings, such sources nevertheless introduced a historical dimension which had previously been denied to the peoples of the African continent. Crucially, though, despite the promise of a revisionist history that such initiatives presented, whenever Benin material is discussed over the period 1897 to 1913, the writer invariably exhibits complete incredulity that such work could possibly be produced by Africans. While certain aspects of the anthropological knowledge on Benin suggested definitions and values which contradicted some of those stereotypes promulgated in the popular middle-class illustrated press, the fact that Benin was consistently treated as an anomaly of African culture by anthropologists ensured that the more racialised sense of the term 'degenerate', popularised by the press accounts, was always inherent in descriptions of Benin culture. This incredulity at the African's skill should also alert us to the fact that the degree to which the European credited a society with making 'works of art' (technically, conceptually and in terms of design) was not necessarily commensurate with any reassessment of their position on the evolutionary ladder. Indeed, the value of the brasses and ivories was considerably enhanced by actually reinforcing their origins as African and by stressing their status as an anomaly in terms of other examples of African carving and casting. Through such a procedure their notoriety was assured. Their value as 'freak' productions in turn enhanced the status of the museum in which they were held.

In addition, while the ethnographic communities' hypotheses on the origin of the bronzes effectively produced knowledge that threatened to disturb the equilibrium of racial superiority, which legitimised the colonial process, such knowledge was mediated

by its function in the struggle for professional and institutional validation for the new 'science' of anthropology. The ethnographic curators were able to capitalise on the heightened public awareness of the Benin bronzes as symbols of British manhood, Edo barbarity and artistic anomaly, in order to claim their retention by the British Museum, for example, as a matter of national urgency. This had the additional benefit of enhancing the department's own status in the eyes of both the government and the Museum. The ethnographic curators' decision to assign an African, as opposed to Egyptian, origin to the bronzes placed these contested and now highly desirable objects squarely in the domain of the ethnographic department, rather than ambiguously positioned between Egyptology and European Antiquities. This highlighted the importance of ethnography as opposed to the already well-endowed Egyptology department in the Museum. How far such a hypothesis was a deliberate strategy for more recognition on the part of the ethnographers, remains a matter of conjecture. Yet one thing is certain: this history is instructive of the kinds of negotiative processes by which 'scientific' knowledge of the culture of the colonies was produced, and gives the lie to a simplistic empirical account which takes such narratives at face value, without acknowledging the institutional and other political factors at play.

Most extraordinary, in the end, however, is the fact that considerable evidence supporting the view of an African origin for the bronzes certainly existed even in the nineteenth century. Literature expounding such arguments was clearly available, even if primarily amongst the academic or museums establishment, only a year after the punitive raid to Benin. Yet no trace of even this tentative questioning was passed down to later generations. The network of institutional, professional and popular discourses, and political interests (both in institutional and state terms), which made and make such silences possible, is of course a major concern of this book.

THE SPECTACLE OF EMPIRE I: EXPANSIONISM AND PHILANTHROPY AT THE STANLEY AND AFRICAN EXHIBITION.

> It is quite evident that the spectatorial lust is a most serious factor in imperialism. The dramatic falsification, both of war and of the whole policy of imperial expansion required to feed this popular passion forms no small portion of the art of the real organizers of imperialist exploits, the small groups of businessmen and politicians who know what they want and how to get it.[1]

The 'spectatorial lust' that John Atkinson Hobson defined as an indispensable corollary of imperialism reached its apogee in a phenomenon which had its beginnings in the Great Exhibition of 1851. By 1890, national, international and colonial exhibitions became the arena for renewed entrepreneurial ingenuity. By 1907, the Society of Arts was still confident about the usefulness of such public exhibitions, recognising that they offered 'opportunities for the transaction of business, and, judging from their success, such opportunities are much appreciated and generally utilised'.[2] It was a statement vindicated the same year by the addition of a new purpose-built site in London, later christened the 'White City', to compliment the already well-established exhibition grounds at Olympia and Crystal Palace, and dedicated to the pursuit of spectacular pleasures and edification.

The effectivity of these events as components of a discourse of imperialism resided, as Hobson had perceptively remarked, in their lust for spectacle, but crucially it was a spectacle constituted as simultaneously scientific exegesis and as mass entertainment. By means not only of static displays of produce, raw materials and technology, but also of a variety of dramatic interludes and staged re-enactments, these exhibitions mobilised what passed in the popular consciousness as sociological investigation, historical objectivity and anthropological knowledge. The latter was an assumption facilitated by the fact that the discipline was only just beginning to acquire a new professionalised status. Here, then, is another instance where public spectacle was enabled by (and in turn actively encouraged) the dissipation of the already tenuous boundary that divided the scientific from the popular. As a result, those exhibitions which featured any representation of the colonies were a powerful means of ensuring the longevity of a residual scientific racism long after this had been discredited in academic scientific circles.

The following chapters examine the rhetorical and specular devices by which a variety of public exhibitions – colonial, national, international and those organised under the aegis of Africa-interested learned societies – produced a set of obsessively repeated characters which were made to stand in for the multiplicity of cultures comprising the African continent. They analyse the terms on which the official literature, published in

connection with these events, produced an Africa for popular consumption by mobilis-ing a series of well-worn tropes able to masquerade as authenticity and a neutral and academically sanctioned objectivity, through their association with emergent disciplines. Most histories of exhibitions have concentrated on the international, and occasionally the colonial, exhibition. However, it is only by recognising the extent to which the exhibition format served as publicity for an extraordinary range of organisations, with often diametrically opposed agendas, that we can begin to understand the familiarity and therefore 'legibility' of such events, and the impact which they might have had on a heterogeneous public. In addition, we should appreciate that as a form of leisure activity whose ostensible purpose was usually the promotion of trade, exploration or other business interests as well as facilitating international relations, it is significant that almost all exhibitions of whatever scale or pretension featured colonised races as an integral part of the proceedings. Their inclusion provided the points of differentiation around which to reinforce, whether consciously or through more subtle means, the certainty of European imperial superiority.[3]

Together with a number of astute businessmen, Thomas Cook had already taken advantage of the Great Exhibition of 1851 to publish a journal dedicated to promoting the potential for trade and travel which the exhibition had presented. Throughout 1890 to 1913, the company published a steady stream of magazines which were designed to tap into the burgeoning prospects for increased tourism, as a result of the numerous exhibitions held nationally and internationally. Indeed, by 1890, one enterprising individual felt confident enough to launch a magazine devoted solely to 'giving authentic advice in relation to Exhibitions throughout the world, but especially British and Colonial'.[4] *The Universal Exhibitions Guide and Industrial Review*, launched on the 20 June 1890, 'for general circulation throughout the world', was optimistic enough to guarantee the sale of at least ten thousand copies to its advertisers. According to its editorial, the magazine was aimed not only at the exhibitor but also at the consumer, and obviously conceived of itself as filling a particular gap in an ever increasing market. The magazine provides a useful index of the aims and aspirations of the organisers of colonial and other exhibitions at the beginning of the period under consideration here. The editorial signals the two aspects most consistently put forward as the special domain of such exhibitions: in much the same way that the museums establishment sought to promote its collections, the organisers of exhibitions advertised them as 'a valuable opportunity for amusement or self-improvement.'[5]

The first issue of the magazine was at pains to emphasise the serious side of the exhibition as a long-established tradition. Consequently, it contained a history of exhibi-tions which traced the evolution of the practice in England from the 1756 Industrial Exhibition, held in those hallowed rooms of the Society of Arts in London, to the Paris exposition of 1889. In this way, it effectively validated the exhibition as a legitimate enterprise by constituting it as part of a tradition initiated by a professional and academi-cally accredited body; the Society of Arts.[6] The review conveniently lays out, in the first few pages, many current assumptions and ideals about the practice of 'exhibiting' propagated by the entrepreneurs responsible for these events. The perceived advantages of the exhibition, and in particular the International Exhibition, which are shared throughout the period 1890 to 1913, are expressed in terms of four main aspects: benefits to commerce (private enterprise), recreation for that class of participant described as 'the weary toiler', educational advantages, and as a means of maintaining peaceful relations

between nations. This last was to be attained through the event's promotion of the policy of Free Trade.[7] Significantly, it is on the educational note that the editor ends his summary: 'In fact, in some corner of one or other of the Exhibitions from time to time opened, the seeker after knowledge of almost any kind, if he knew but where to go, might do not a little to allay the pangs of his hunger and thirst after information.'[8]

Unlike their French and American counterparts, most of these exhibitions in England were not directly funded by the state, but were the result of private backing by the 'small groups of businessmen and politicians' of Hobson's critique.[9] Between 1889 and 1908 there were only five exhibitions held in Britain which were considered by contemporaries to have been truly 'international' in character. Only two of these, the Bradford exhibition of 1904 and the Wolverhampton exhibition of 1902, were actually held in England.[10] There were, however, a number of trade and special interest exhibitions held in London and the provinces that included significant contributions from the colonies and other European countries, as well as Japan. Despite little official support from the British government at home (a constant bugbear of the organisers), such events were often held with the tacit consent and financial aid of the contributing countries' respective governments. Two of those entrepreneurs who were responsible for many of the larger exhibitions on the Earl's Court and White City sites are John R. Whitley and Imre Kiralfy. Kiralfy, who was a compulsive organiser of such events, formed a company in 1895 dedicated entirely to this purpose, called London Exhibitions Limited. One of the consequences of private investment in exhibitions was that there were a number of competing organisers fighting over the same exhibition grounds and for a similar public. Their survival depended on their successful implementation of various strategies in order to attract both traders and customers, and to expand and diversify the range of consumers. To this end, most exhibitions were thematic, and novelty was also a prerequisite. Early accounts by those men responsible for the organisation on the larger London sites also mention the pressures of conforming to particular codes of decorum at the exhibition. This was especially the case where the proximity of white women and subject peoples threatened to extend 'the colonial encounter' beyond the safe confines of the perimeter fence of the 'Native Village'. Consequently, the desire for 'respectability' was another dimension of the constantly reiterated authenticity of whatever was on offer.[11] Furthermore, the ambivalent relationship of the exhibitions to the state and their apparently independent organisation, was an important factor in facilitating an easy engagement and participation in the mythology of shared citizenship which underpinned such events.[12] Unencumbered by the heavy hand of state intervention, and enticed by the rhetoric of pleasure and edification, heterogeneous crowds consumed the spectacle of the exhibition and revelled in their own involvement as an integral part of that spectacle.

There is a special appropriateness in using the temporary exhibition as a site of investigation for assessing the interrelation between spheres of scientific and popular knowledge about Africa and 'colonised' peoples in general. The exhibition format was unlike certain other representations of Africans during this period, such as white Europeans posing as their colonial counterparts in minstrel shows, or black performers in theatrical and music-hall productions.[13] While it had pretentions to certain standards of excellence with regard to the criteria outlined above, the exhibition had no cumbersome conventions in the literary or dramatic sense that it had to adhere to, or at least be seen to address. This is not to say that none existed, but that one of the significant distinctions

between a theatrical conceit and the dramatic performances of the exhibitions was that the latter's organisers went to great lengths to deny the mediating effect of narrative in its presentation of colonised subjects. While capitalising on the drawing power of the prospect of a spectacle, the exhibition organisers and contracted showmen were, in fact, at pains to distinguish their contribution from their theatrical counterpart. They emphasised at any available opportunity that their dramas, rather than being fiction, were authentic re-enactments of an event which had occurred, often being performed by those who had participated in the actual event. To the exhibition organiser, it was a question of different degrees of those well-worn touchstones, 'truth' and 'objectivity'. However, the dramatic interludes and re-enactments constituted in effect a genre in their own right, as bound by convention as any dramatic entertainment found on the stages of London or the provincial capitals. The nature and structural effectivity of these tropes, as a mechanism which produced a particular set of definitions of Africanicity for a British public, and the way in which African material culture contributed to the dramaturgy of the exhibition, form the core of this chapter.

I

Some types of exhibition laid claim to ideals of truth and objectivity by sheltering under the aegis of one of the many Africa-interested academic, philanthropic or scientific bodies. The Stanley and African Exhibition provides a particularly relevant example of this type, since it comes, conveniently, at the very beginning of the period under review, being staged in 1890. An analysis of this exhibition makes it easier to appreciate fully the degree to which supposedly scientific data was used in exhibitions, organised simultaneously under the banner of 'scientific enquiry' and the flag of 'entertainment'. Specifically, it is an instance of how a popular literary genre, this time the travelogue, informed the presentation of African society and material culture in another sphere of public culture designated as scientific, and signals again the conflicting interests that produced a more heterogeneous Africa than has previously been acknowledged.

1890 was the year of Henry Morton Stanley's return to England after his trek to the Nile, through the Congo in Central Africa, in search of Emin Pasha, who had been appointed as Governor of Equatoria by General Gordon. Stanley led a private expedition to attempt to 'rescue' Emin Pasha back to England after General Gordon's defeat by Mahdist troops in Khartoum in the Sudan (fig. 23). On March 24th of that same year, an exhibition opened at the Victoria Gallery in Regent Street, London, to commemorate the man lionised in the middle-class national and illustrated press as the representative of the 'new journalism', and the 'intrepid explorer' who was to receive the ultimate accolade of a wedding in Westminster Abbey. Despite the proliferation at this time of a variety of exhibitions, many of which included some reference to Africa, few of these received the same degree of attention to detail in the national press.[14] The coverage of the Stanley and African Exhibition in *The Times* was exhaustive. It began with a blow by blow account of the progress for the preparations, listing the committee members responsible for the organisation. Evidently, it was an event of considerable importance, and certainly international in the scope of the collections it deployed; these coming from different parts of the African continent via Paris, Germany and Brussels. *The Times* was moved to proclaim that 'never has there been an Exhibition on anything like the scale of the present'.[15]

23. Map of Africa showing Henry Morton Stanley's route (thick line running across the Congo) produced for the Stanley and African Exhibition at the Victoria Gallery (London 1890).

Arranged by a committee, presided over by a host of dignitaries and eminent travellers including the Duke of Fife, Chairman of the British South Africa Company; Sir William Mackinnon, Chairman of the British East Africa Company; Sir Samuel Baker and Sir Richard Burton, the exhibition was a gathering that epitomised that sector of the British aristocracy and middle class with disparate, and not always mutually compatible, vested interests in Africa.[16] Together, the committee and the executive committee represented exactly the pattern of interests that was to become responsible in the next two decades for the effective dissemination of a set of images of Africa to a diverse British public. It was a combination of trade interests, government officials, missionary, scientific and non-denominational philanthropic bodies. Indeed, the executive committee published their objectives in the *Illustrated London News* as engaging

> the sympathies of the English Public in opening up Central Africa to commerce and civilisation, by showing objects explanatory of the geography, geology, botany and natural history of that region, its produce and manufacture and the conditions of its native races, also of the good work of the missionary, religious, educational and anti-slavery societies employed there.[17]

Apart from the Colonial Service and representatives from the Armed Forces, the contributors comprised two learned societies, the Royal Geographical Society and the Anthropological Society; missionary societies in the form of the Church Missionary Society and Universities Mission; a representative from the national ethnographic collection, Charles Hercules Read of the British Museum; and Frederick Horniman, the tea merchant and founder of the Surrey House Museum (later to become the Horniman Museum).[18]

The list also included the humanitarian pressure group, the Anti-Slavery Society. Charles Allen, secretary of the Anti-Slavery Society, was one of Emin Pasha's long-standing supporters in Britain, and initially the organisation had been fully behind Stanley and the expedition.[19] Indeed, Stanley promoted himself to considerable effect as the selfless servant of the Anti-Slavery Society in a speech in the Free Trade Hall in Manchester, just prior to setting off on the expedition in 1889.[20] It was a gesture not lost on the Anti-Slavery lobby and won him valuable support, until it became increasingly evident on his return to England in April 1890 that the issue of slavery was of very little concern to him, and that in fact the expedition was embroiled in rather dubious dealings with one of the most notorious slavers in the region, Hamid Ibn Muhammad, known to the British as Tippoo Tib.[21] Initially, however, the pages of the Society's journal, the *Anti-Slavery Reporter*, fuelled the interest of the liberal and philanthropic community with romantic eulogies to 'the Great African leader, who has once more proved himself unquestionably the very paladin of explorers'.[22] The language of fiction and romance described the expedition:

> From the untracked depths of one of Nature's densest and most deadly forests, saturated with the tropical rains of countless ages, and alive with malignant pigmies, skilled in the use of poisoned arrows, Stanley like a hero of Romance, has once more emerged into the light of civilisation.[23]

It was this same language which informed the dramaturgy of the exhibition, when it opened just prior to Stanley's return in March 1890.

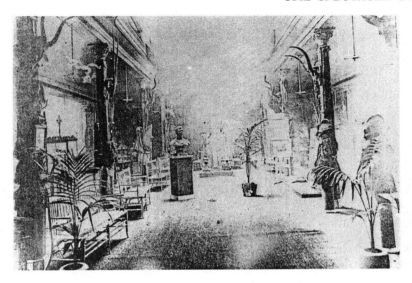

24. General view
of the Stanley and
African Exhibition
(London 1890).

A report in *The Times* makes abundantly clear the manner in which the viewer was expected to consume the Stanley and African Exhibition. The spectator was in fact constructed, through the narrative of the exhibition, as an explorer. Through a vicarious intrepidation, they were thus able to gain the 'experience' of the seasoned traveller. *The Times* reporter reinforced this concept by borrowing the narrative devices of the writer of adventure fiction, suggesting that once at the exhibition, the visitor would find 'himself' 'in the heart of Africa'.[24] The entrance to the exhibition was through a 'pallisade of . . . tree stems . . . ornamented with skulls' which led into a simulated explorer's camp, surrounded by a composite landscape supposedly representative of the key features of Central African territory as 'discovered' by the European.[25] Recognising incongruities in the homogenous image constructed by the painted scenery for the exhibition, *The Times* felt it necessary to excuse such discrepancies as the artistic licence needed to produce 'typical African scenery'.[26] That such an apology was thought pertinent is telling. It suggests a recognition on the part of *The Times* reporter of the extent to which the supposed public for the exhibition was already saturated with detailed accounts of Africa, not only through Stanley's own exploits but through numerous others by this date.[27] Africa was being produced as both particularised and as a homogeneous fictional entity. It is, in fact, the tension between these two 'accounts' which made such exhibitions so potent as imperial myth.

Once past the camp, the exhibition voyager encountered portraits of the monarchs of those powers most active in the colonisation of Central African territory; Britain and Belgium. Beside these were portraits of Stanley, the great explorer himself, with associated objects, against what was emphasised as an authentic African backdrop with 'tastefully arranged and appropriate drapery; for even the drapery is African . . . while here and there will be seen some wonderful grass fabrics, soft and rich as plush or even velvet, with patterns exhibiting taste and ingenuity' (figs 24 and 25). The writer went on to affirm, in case of a disbelieving public, that 'these are from the Kasai River, in the very

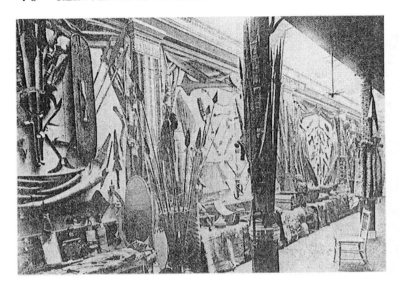

25. General view of the exhibits at the Stanley and African Exhibition. It includes one pillar on the far right, draped with cut-pile embroidered raffia fabric from the Kuba peoples from what was then the Congo.

heart of the Congo region and may be relied upon as of purely native manufacture'.[28] Here was 'taste' in the Heart of Darkness! It was no accident that the first section encountered by the visitor, having experienced the camp, was a series of historical maps illustrating the progress of European expansion in Africa, some of which dated back to the sixteenth century. Alongside these were two maps demonstrating the advances of specifically British explorers on that continent and their routes. At this point, and directly above the visitor, was a comprehensive portrait gallery of European travellers to Africa, including Speke, Grant, du Chaillu and Mrs Conger. The combination of the two exhibits force-fully declared the hegemony of the European presence as a continuous and progressive tradition. This was reinforced in the catalogue, which actually acknowledged 'native exploration' only to undermine its value by dismissing the information acquired through such channels as 'useless for cartographic purposes'.[29]

The exhibition was divided into five major sections dealing primarily with zoology and exploration, a large section of which was devoted to the role of the Royal Geographical Society who were the most heavily involved in the different consultative and organisa-tional capacities of the exhibition. Another section provided space for missionaries' portraits, and relics of the most prominent workers in the field, as well as for what were called 'idols' and 'other objects connected with the religions and superstitions of Africa (fig. 26).'[30] The slave-trade was another aspect of African society that was represented in detail; commemorating those Europeans who had worked toward its suppression, but also showing objects associated with the slave traffic itself. The 'Native Section' had an emphasis on raw materials and locally manufactured goods, but also contained a range of 'weapons, implements, dress, ornaments, etc., in use among the various tribes', together with model figures whose function is specified in the catalogue as having, 'apart from their value as showing the manner in which the negroes live . . . an added interest in having been . . . collected by well-known travellers and missionaries during famous expeditions'.[31]

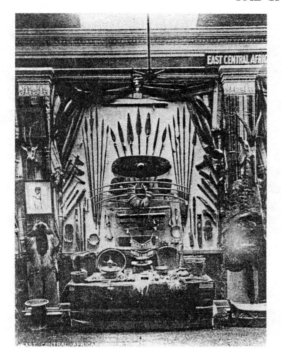

26. The Stanley and
African Exhibition
display from East
Central Africa.

The visitor was directed to the catalogue and advised to plan a systematic viewing of the exhibits. The careful scrutiny of objects on display, both in the catalogue and in the newspaper reporting of the exhibition, is an important indicator of public as opposed to 'professional' taste and preference in African material culture in this country. The objects that received the most attention in *The Times* reviews were the spears, whose forms were described variously and in descending order of preference as 'graceful', 'rude', and 'frightfully barbed'.[32] As we might expect, apart from this summary description of the spears, their significance lies more with the identity of their collectors than in any function they might have had in their original African context, and this is a feature of most of the material on display. Other criteria used to describe the objects of indigenous African manufacture were 'quantity' and 'variety', both of which were attributed specifically to Zulu shields and, generally, to all of the pottery and utensils. The personal ornaments were deemed 'extraordinary', but the only objects qualified as 'beautiful' were the leatherwork horse furniture from Sokoto, and the Ashanti gold ornaments which were consequently singled out as worthy of the ladies' attention.[33] The trophies of the hunt and of warfare were the men's prerogative, those of the domestic and personal ornaments were predictably women's domain.

The official catalogue lists almost every item in the show and while most of these generally adhere to geographical classification, the other organisational principle was to arrange them according to particular and known collectors, so that the already dominant 'trophy' method of display functioned precisely as such: as trophies to the glory of those Europeans associated with them (figs 27 to 32). It may well be that the predominance of this trophy method of display also facilitated an appreciation of the decorative potential of

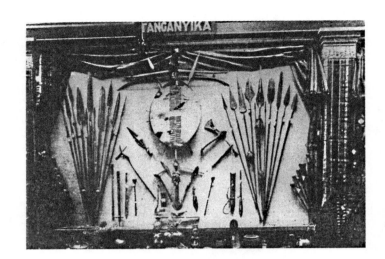

27. The Stanley and African Exhibition display from Tanganyika.

28. The Stanley and African Exhibition display from Lower Niger Region.

29. The Stanley and African Exhibition display from the Congo Basin.

30. The Stanley and African Exhibition display from 'Nyassaland'.

31. The Stanley and African Exhibition display from Central South Africa.

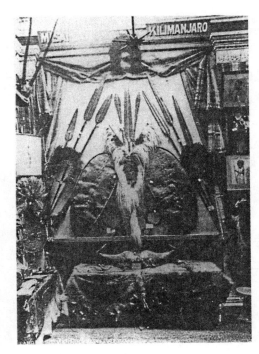

32. The Stanley and African Exhibition display from 'Masailand, Kilimanjaro'.

Panel. 13. (on table)

Calabash or Gourd Vessel.
Ilorin -
Yoruba).

Lat. 8°.30' N : Long. 4°.30'E.

Colour of groundwork very pale vandyk brown - Pattern = light burnt sienna & chrome yellow mixed. decidedly darker than groundwork - all engraved scratch lines are color of ground work.

The hair pillow on panel 13. is used by the Asaba Kings.

33. Page from the sketchbook of William Steains illustrating the decorative details of what he calls a 'calabash or gourd vessel from Ilorin', Nigeria, displayed on the table beneath panel 13 at the Stanley and African Exhibition. Courtesy of the Trustees of the British Museum.

African material culture in what could be described as a safe environment, since the context of its display did nothing to disrupt the complacent assumption of European superiority. Certainly, the official catalogue itself made the pointed distinction that the arrangement was 'artistic' rather than 'scientific'.[34] While descriptions of the African objects displayed around the walls of the exhibition introduce a series of criteria which immediately suggest a more complex system of appraisal than is usually accredited to this period of ethnographic collecting, the dominant narrative of European exploration, and the hagiography of those figures involved in mapping the continent according to

34. Page from the sketchbook of William Steains illustrating the details of decorative carving on two weapons and a travelling stick exhibited at the Stanley and African Exhibition. Courtesy of the Trustees of the British Museum.

European principles of visibility and geography, certainly reinforced the initial impact created by the mock explorer's camp at the entrance to the exhibition.

The same tension between particularity and homogeneity is reproduced in the descriptions and organisation of the material culture on display. William Steains, a Fellow of the Royal Geographical Society, was assigned the task of detailed documentation of the exhibition. In fact it seems likely from the Steains correspondence that he was to provide a limited edition, colour version of the catalogue for the 'Stanley and African', another indication of its important status.[35] A copy of this is not known to exist, although another document in the British Museum collection contains Steains' prototypes for the plates of this colour catalogue.[36] It is clear from this document that certain objects were favoured over others for inclusion as illustrations in this special edition. Steains assigns a more important place to some categories, often singled out from larger display panels or tables which included various classes of objects. Many examples focus on decorative features (fig. 33). The categories most frequently illustrated are carvings of figures and furniture. Even where Steains drew weapons, there is obviously a selection process at work suggestive of an aesthetic criteria. The focus is on the decorative carving and metalwork of the object (fig. 34). While these different levels of appreciation are discernable from the

35. Page from the sketchbook of William Steains illustrating an Ikenga and Ibeji figure from Nigeria exhibited at the Stanley and African Exhibition. Courtesy of the Trustees of the British Museum.

prototype catalogue, it is only within the context of the broader exhibition layout that they can be fully understood.

The predominant arrangement comprised spears and fighting equipment on the wall panels, with miscellaneous objects on a small chest or table below these. All were labelled according to provenance and function. Notably, the objects illustrated in the photographic souvenir of the exhibition that was on sale to the public do not include the West African exhibits. It was this section that contained a more substantial number of masks and carved figures than any of the other panels or accompanying tables.[37] In the Steains

manuscript, however, this panel – number 16, entitled 'West Coast of Africa, (Yoruba)' – is given special attention precisely because the projected emphasis for the colour catalogue was to be on figures and carvings. Interestingly enough, while certain figures are indeed referred to as 'idol' or 'fetish', this is not indiscriminately applied to all figure carvings (fig. 35). In the published official catalogue, also, it is clear that some sort of distinctions exist between different categories of figure carvings.[38]

Another form of differentiation which occured in the display of material culture here, is that those sections with loans of predominantly missionary material (East Central Africa, Tanganyika and the Congo Basin, for example) contained a more varied selection of objects. Instead of concentrating on the indigenous arsenals, the missionary contribution focused, as one might expect, on the religious aspect, but also on the element of craft, despite the fact that at this date material culture from East Africa in particular was usually dismissed in rather disparaging tones in anthropological circles.[39]

II

Besides the pursuit of progress through travel and exploration, the British were keen to project their expansion as philanthropic and humanitarian. The exhibition's focus on the slave-trade within Africa was calculated to achieve this and, to a certain extent, to give a sense of urgency to the colonial mission now that the 'scramble' for territory in that continent was well underway. The Anti-Slavery Society itself consistently attacked what it denigrated as 'German adventuring', and had supported Stanley's expedition in search of Emin Pasha partly because he was seen as someone capable of securing British trade routes in East Africa, this time in the name of the Imperial British East Africa Company, against the incursions of the Germans. *The Times* echoed the Society's sentiments about the virtue of trade, and optimistically praised Stanley's abilities as an emissary of British imperialism:

> It is pretty certain that Mr. Stanley has been made acquainted with the real position, and that with his usual shrewdness and determination he has brought much of this sphere within the influence of the Company . . . One thing may be taken for granted that Mr. Stanley will not return without doing all in his power – and that means much – to secure the interests of the Company, which are really identical with British interests.[40]

On his return, Stanley himself, of course, was only too happy to feed anti-German sentiment, and in his speech to the London Chamber of Commerce in May 1890 he rebuked the British government for being too ready to relinquish territory to German competitors.

Different sections of the press agreed that those aspects of the exhibition dealing with slavery were the most popular. The *Universal Exhibition and Industrial Review* covered this side of the event in the form of an imaginary conversation between women visitors at the exhibition, designed to expose European consumption of ivory as the root cause for the continuing slave-trade. In the dialogue, one speaker is berated for her hypocrisy in buying ivory goods whilst expressing her horror at the results of the slave-trade.[41] The *Illustrated London News* also made a prominent feature of those objects at the exhibition associated with the slave-trade.[42] *The Times* confidently predicted that it would be the

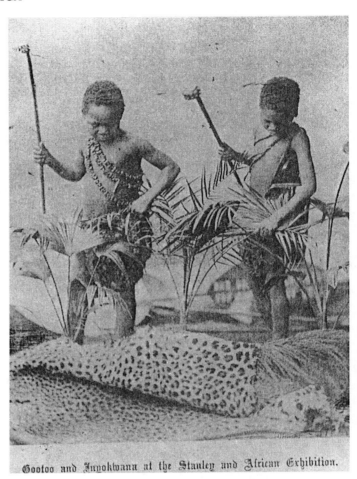

36. A postcard of the two South African children, Gootoo and Inyokwana, who appeared at the Stanley and African Exhibition.

Gootoo and Inyokwana at the Stanley and African Exhibition.

slavery section which was likely to prove the most popular with the public.[43] The paper went on to say that 'the great sensation of the exhibition has been constructed on a space behind the gallery'.[44] This consisted of an artist's impression of, on the one hand, a village scene with women peacefully at work and, on the other side, an Arab slave raid on a neighbouring village 'with all its horrible accompaniments', some of which included whips, manacles and masks, together with photographs and other graphic illustrations of the horrors of the trade.[45] Britain's self image as an active combatant of the slave-trade, projected through such displays, was evidently designed to enhance the credibility of paternalistic claims of providing for the best interests of the colonies. There is, however, something more at stake in the press's confidence in the crowd-pulling potential of the spectacle of slavery. The voyeuristic fascination in the objects of torture and degradation, so much in evidence at the exhibition, was fostered by the tone of many reports of slavery in the pages of the *Anti-Slavery Reporter* itself at this time. The following section from an article on the slave market at Galabat in the Eastern Sudan embodies (quite literally) the

37. A photograph showing Gootoo and Inyokwana at the Stanley and African Exhibition in profile and full-frontal portraits.

prurient obsession with certain of the more sexualised aspects of the slave-trade, and gives perhaps the clearest indication of the specular nature of this section:

> Only two or three travellers have been able to describe the busy and piteous spectacle in the slave booths of Galabat, which is all the more interesting and deplorable because the victims are girls, torn from their mountains to live like caged birds behind the lattices of harems from the Nile to Mecca.[46]

The rest of the piece details those aspects of travel writing that dwell on minute descriptions of the victims, often reading like a promotion, and which tellingly reproduces exactly the kinds of considerations one imagines were entertained by the prospective customer: 'Many of these young girls are beautiful. Their colour is often not darker than that of a Spanish gypsy, their features are small and delicate, their form proportioned like a Greek statue, and their eyes large and lustrous.'[47] From vicarious explorer to vicarious slaver, the exhibition-goer was interpolated through different mechanisms of

desire and fantasy, and each individually and collectively reinstated as the purveyor of Empire, exonerated from any guilty association with the forces of 'evil' by the rhetoric of philanthropic concern generated by the Society.[48]

It was not only the body of the African woman that was offered to the visitor's curious gaze. The incorporation of an 'act' that prefigured the standard inclusions of Africans in many exhibitions, here was designed to fuel the viewers' repugnance at the concept of slavery. Two boys, known as Gootoo and Inyokwana, and said to be from Swaziland, were displayed at the exhibition.[49] Orphans apparently fallen prey to despotic acts at the hands of their respective chiefs, the boys had then become their property. It is unclear from the catalogue what the children actually did in the exhibition, although their significance would have been rather less ambiguous. As children, and therefore essentially innocent beings, they would have served as living examples of the depravity of slavery. The two photographs that exist show them with knobkerrys beating their way through a 'jungle' of two palm plants, toward a leopard skin, and standing with shields and spears in poses redolent of the vogue for anthropological scrutiny (figs 36 and 37).

If any doubt remained regarding either the timeliness or 'naturalness' of the British colonial mission, the one exhibit apart from the slavery section guaranteed to reassure the visitor of Britain's right to make such a claim, was the sculpted group of figures in the main hall that greeted the visitor, unavoidably, in the centre of the space which opened before them. This consisted of a bust of Stanley and a quarter-size version of the original African group modelled by Theed for the Albert Memorial. To avoid any misunderstanding on the part of the spectator, the figures were interpreted in the catalogue:

> The central figure represents Egypt seated on a camel, on the right an Arab merchant, on the left a figure of a Troglodyte, formerly dwellers on the Nile, at the back a figure of civilization instructing a negro, who is trampling on his broken chains indicative of freedom.[50]

Directly behind this group was a specimen of a gorilla, supposedly du Chaillu's (but, in fact, borrowed from elsewhere). The paradigm of progress is too plain to ignore here, and certainly would have been appreciated by an audience with any peripheral involvement or interest in the work of any of the societies represented at the exhibition.[51] In this context, the position given to the gorilla is also significant, and completes the paradigm. Instead of being featured along with the other wildlife in the diorama especially constructed for the exhibition 'The Lion's Den', which was used to demonstrate the extent of both the British naturalists' discoveries and the hunters' prowess, the gorilla appears directly behind a group illustrating different African racial 'types'.[52] The context smacks of an evolutionary connection in which the black African is perceived as the lowest variant of human development through association with the primate. Consequently, while the material culture on show was not laid out in either the catalogue or in the main display itself in any systematic 'evolutionary' classification, this thesis was reinforced through a variety of means in the exhibition.

Together with the concern about slavery, the central figure group, with its resonances of evolutionism, would have compounded the necessity and inevitability of Britain's role as a leading colonial power. By 1890, evolutionism was thoroughly popularised amongst the middle-class audience which was fully conversant with the controversies generated by

the thesis and its widespread applications.[53] At a time when it was still pertinent to convince the British electorate of the expansion of British interests in Africa, the emphasis on the philanthropic nature of the project would have been politically expedient. The Africans produced through this exhibition were victims of circumstances beyond their control; exploited by neighbouring Arabs acting in collusion with despotic African rulers who, through their greed, would sell even their own subjects to the highest bidder.

The 'Stanley and African' is yet another example of the ramifications of the category of 'decorative art' or 'craft' as a component of colonial discourse. The material culture here succumbed to the overwhelming paternalism of the rhetoric which surrounded so much of the reviewing, and indeed the official ephemera connected with the exhibition. Consequently, it served to reinforce the notion of these races as unwilling victims of heathenism and despotism, but ultimately salvageable and succeptable to training, already equipped with a modicum of 'taste', but needing the firm guidance of those races more fortunate than themselves.

The image of Africa provided through the Stanley and African Exhibition, then, is the result of the intersection of different spheres of interest, producing knowledge of that continent promoted as 'objective' and 'scientific'. The proliferation of maps and detailed charts, specifying geographical and orthographical information, rainfall, population, religions, and mineral distribution, was calculated to reinforce this authority and to increase the sense of European controllability over such a vast terrain, that is, its 'knowability'.[54] At the same time, it is evident from the introduction in the exhibition catalogue that the organisers were prepared to make some capital out of one particular aspect of the Africa of 'popular imagination', the concept of mystery and romance:

> The popular imagination has been touched by the varied story of the Dark Continent to an unprecedented extent . . . Frightful wrongs to be wiped out, deeds of high surprise to be achieved, virgin countries to be commercially exploited, valuable scientific discoveries to be made, myriads of people steeped in the grossest idolatry . . . these are some of the varied elements which have thrown a glamour and fascination over Africa and taken men's minds captive.'[55]

This insistence on the interdependence of the scientific and the popular conception of Africa was acknowledged and deliberately exploited, and subsequently fostered an increasing conflation of such knowledges. Yet such readings, while certainly dominant, were confounded by the opposition which arose against certain aspects of the exhibition and against Stanley himself, and conversely are rendered more explicable by the tortuous negotiations which took place between the different parties. From the moment of his return to England in April 1890, and to a more concerted extent after the publication of his book on the Emin Pasha Expedition, *In Darkest Africa*, controversy surrounded the expedition, fuelled by the competing accounts (sometimes amounting to little more than opportunistic disclaimers) of the various officers and retainers accompanying Stanley.[56]

Two issues preoccupied Stanley's critics: the abandonment and subsequent massacre of many of his rear column left to starve at Yambuya, and the revelation that he had engaged six hundred Zanzibaris. These were euphemistically referred to as 'carriers' in the official documents, 'as a concession to English prejudices' as the *Aborigines' Friend* put it. It transpired, however, that they had been 'procured' in the manner of slaves by one of the most notorious slavers in Central Africa, Hamid Ibn Muhammad, known as Tippoo

Tib.[57] Antagonism in the pages of the Anti-Slavery Society journal took the form of more oblique but none the less pointed criticism of conditions of labour in the Congo. The Aborigine Protection Society, on the other hand, who had never had the same degree of investment in the affair or in promoting Stanley's endeavours, produced outright attacks on what it condemned as his participation in, and condoning of, the slave-trade in Central Africa.[58] Despite such devastating and highly public condemnation, together with criticism from leading political figures and those who had accompanied Stanley, the Anti-Slavery Society was none the less capable of suspending disgust long enough to support an initiative which was the direct outcome of one of Stanley's own propositions. Consequently the exhibition was launched in his honour, to the ostensible glory of the philanthropic concern supposedly underpinning British imperialism.

It was the Anti-Slavery Society that was represented on the committee of the Stanley Fund, inaugurated by the promoters of the exhibition at Stanley's suggestion in order to raise public subscriptions for a steamer to be placed on the waters of Victoria Nyanza. The committee met in June, in the very heat of the public controversy over Stanley's conduct and leadership, to discuss how best to raise funds for the venture. Putting to one side, one imagines, any of the acrimonious criticism of Stanley which his own Society had propagated, Charles Allen, secretary of the British and Foreign Anti-Slavery Society, supported the proposition. The Society, traditionally long-standing supporters of chartered companies and of trading initiatives as a prelude to Christianity, firmly believed that introducing steam traffic on inland waters was 'one of the most powerful civilising agencies that could be introduced.'[59] Evidently, moral indignation was mediated by political expediency if the price was right. It is perhaps a measure of the complex web of intersecting interests in the colonial process that the curator of ethnography at the British Museum, Charles Hercules Read, was also on the board of trustees for the proposed steamer fund, perhaps in the interests of securing passage for the Museum's ethnographic collection.[60]

Meanwhile, another controversy had arisen as a result of the exhibition, this time unconnected to Stanley himself, and once again threatening both to disrupt and to confirm the text of the exhibition. The two Swazi children in the exhibition had stimulated considerable interest amongst the public and some concern as to what would become of them after the 'Stanley and African' closed. It transpired that the two boys had been the 'property' of a white trader who had fallen ill and been nursed back to health by a Mrs Thorburn, an Afrikaaner woman married to an Englishman and living in Swaziland. As thanks for her nursing, the children were given over to her. Allen, surmising that the children had been brought to England without the authority of any relative or guardian and that if they were taken back to Africa they would probably remain there in a state of slavery, brought proceedings against Mrs Thorburn. Although the judge found in her favour in so far as he could find no evidence of ill-treatment of the boys on her part, Allen was not satisfied and the hearing became a showcase to prove the existence of continuing slavery in Swaziland. It was also, perhaps, a way for the Society to regain the moral high ground which it may have lost over its support for Stanley, once his involvement in the slave-trade had been publicly exposed. Finally, at considerable cost to the Society, it was agreed to place the boys in the care of the Roman Catholic Bishop of Natal for education in a Trappist monastery. (Mrs Thorburn had had the children baptised into the Catholic church, much to Allen's chagrin.)

The debacle over the two children is interesting for several reasons. Along with the controversy over Stanley's implication in the slave-trade, it disrupted any neat reading of the exhibition as an integrated imperial text, by questioning the integrity of the motives of those responsible for exhibiting Africans at such events (although such criticism was perhaps less threatening to the hegemony of British righteousness, particularly at the outset of the Boer War, since it was directed at someone pointedly described as 'Afrikaaner'). On the other hand, the imperial text was confirmed by reasserting the presence of the ever watchful philanthropic eye, in this instance of the Anti-Slavery Society. At the same time, the Society was careful to link its concerns with the broader benefits to be gained from British imperial expansion – as the Society pointed out in the pages of its journal:

> Mr Justice Stirling's decision will form a precedent in all cases where native African children are brought to this country from districts where Slavery exists, and will render it easy to prevent their being taken back without guarantees that the freedom which they have acquired by touching British soil shall run no risk of being violated.'[61]

WRESTLERS.

38. 'Wrestlers.' Official Libretto and Programme for 'Briton, Boer and Black in Savage South Africa' (Olympia 1899–1900).

THE SPECTACLE OF EMPIRE II: EXHIBITIONARY NARRATIVES

The relationship between popular and scientific domains of knowledge relating to Africa, in exhibitions not under the aegis of a specifically accredited scientific body such as the Royal Geographical Society, is even more complex.[1] Here, black performers appear in a variety of settings, billed as 'Africans', usually from a particular society that held a topical interest for a British audience because of their notoriety through recent conflicts with British expansion.[2] These were sometimes simulated villages where the 'Africans' supposedly lived out their daily lives as they would have done in Africa (fig. 38). The other context in which Africans appeared was in dramatic interludes which often took place on a grand scale in huge arenas on site.

I am not concerned here with the story of the performers themselves, although there are certainly many to tell, as the work of Peter Fryer, Jeff Green, Bernth Lindfors and Ziggy Alexander has already demonstrated.[3] My concern in this section is rather to explore the structural and dramatic means, the tropes, by which the British constituted a mythic Africa in an extraordinary range of spectacles designed to appeal to the broadest possible public. Integral to the effectivity of almost all of these public displays was the rhetoric of 'objectivity' and 'authenticity'. At the same time, however, the promoters were only too keenly aware of the amusement value of these kinds of exhibits and their potential as a massive crowd-stopper, a potential lacking in most other exhibits at these events. Ironically, this appeal relied on precisely those qualities which the literature, emphasising authenticity, went to such lengths to negate.

The discourse of authenticity took several forms between 1890 and 1913, and had a number of different implications for the construction of racial stereotypes. The French Exhibition of 1890 at Earl's Court provides an example of a usage frequently applied by the organisers in their publicity notices, citing in this instance the troupe of Arabs who performed 'with their steeds', billed as the 'Wild East'. The Arabs here were co-opted as 'Africans' for a programme of events, many of which revolved around antics with Arab horses, and included races, duelling, and the kidnap of a distressed white maiden. It also featured ' "Treachery", an Incident in the African Rebellion', which capitalised on recent events in East Africa to produce a suitable collage of incidents. These comprised disassociated and unchronological elements of the political upheavals there, put together to provide a composite image. Time and history were reordered and remade in the image and likeness of an unstoppable British supremacy. Most of the events made specific reference to various aspects of the 1880s war against the Mahdi in the Sudan, which ended with a British victory in 1898. The same exhibition also included events based on the incidents in Somalia and the resistance of the celebrated leader nicknamed by the British

the 'Mad Mullah'; the struggle continued from 1887 to 1913. The whole Arab troupe was apparently led by an individual billed as 'one of the most powerful and popular tribal leaders in Eastern Africa', a certain Sheikh Larbi Ben Kess-Kess who, according to the official programme, had been an informer for the French authorities during the 1870 African Rebellion.[4]

The term *life-picture*, used to describe the act, together with the supposed inclusion of an actual Arab political leader, is an indication of the extent to which the organisers would go to promote these events as re-enactments, rather than fictional accounts:

> The intention of the Executive Council has been to give a real and truthful representation of African life as it exists. Nothing is merely imitation. What is presented to the public is not a "circus" or a "show", in the modern acceptance of the words – but a faithful, though obviously a condensed, illustration of "Life in Africa".[5]

An 'Ashanti' troupe made successful appearances in France, and were employed in Liverpool and at the Crystal Palace in London, where the same guidebook was produced in both cases. Both contained similar claims that 'Everything which might have given a theatrical appearance was strictly avoided . . . Everything is just as real as in their country'[6] The libretto and programme for 'Briton, Boer and Black in Savage South Africa', for the winter season of 1899 to 1900 at Olympia in London, carries an advertisement on the first page for 'the only Eskimo Village. The first ever exhibited in Europe.' The billing continues with eight items, all preceded by the adjective 'real', and a further five prefixed with 'genuine'. Likewise, the Zulus in the same event are described as 'simply enacting before the people who go to see them, certain facts in the past history of their country.'[7] In fact, of the 'Drama' itself – 'Briton, Boer and Black' – the guide claimed that 'never before, in the history of the world have the resources of the stage been used to anything like a similar extent to teach to a nation the most heart-stirring episodes of its own contemporary history.'[8] The guide then goes even further in its attempts to drive home the degree of authenticity, and what is fast emerging as the promotion of its educational potential:

> The historical drama, dealing with the events of long-past history, has, of course, been common to all nations and all times in which the theatre has been a familiar institution . . . [the difference being that] the scenic representation of the contemporary history of a people, the reproduction upon the stage of events in which every spectator might have been an actual participant, is a purely modern idea, and one of which it would be difficult to exaggerate the educational value.[9]

Not only were these demonstrations or dramas in the exhibition context emphasised as distinct from a theatrical experience, they were also publicised as an experience creating a different and more lasting impression than the vivid accounts of the same events in the national press, on the basis that 'things seen are mightier than things heard.'[10] This is not to say, however, that the image of Africa produced through coverage in the national press was not recognised as a powerful force in this process of visualising the Empire. Indeed, the Military Exhibition at Earl's Court in 1901, conceived at the height of the Boer War, had a special section dedicated to those press correspondents from the front, of whom it was said that 'the perils of the field and of disease were encountered with the bravery of

the professional soldier, whose vicissitudes and hardships they shared without murmur or complaint.'[11] More importantly, in some instances it was these same war correspondents who were responsible for writing the libretto for the performances themselves.[12]

Despite the organisers' denial of their product as fiction, it played as significant a role in the construction of the colonies to the British exhibition public as it did to the avid readership of the burgeoning market in colonial romance and adventure.[13] This was not only in the more banal sense of the actual and rhetorical distinction between 'fact' and 'fiction', but in terms of a more structural affinity. For example, the official guidebook of the 'Briton, Boer and Black' exhibition compared the inhabitants of the 'Zulu Kraal' to the characters in a Rider Haggard novel. The Arabs in the French Exhibition of 1890 are referred to in one report as acting up to 'their book reputations, they are dignified, sad, silent and aristocratic looking.'[14] The women are dismissed with another literary analogy, since 'there isn't an atom of sentiment or the merest outline for the foundation of an old-style sentimental story in the whole caravan-load of them.'[15] The frequency of references of this kind encourages the view that there was a considerable degree of dependency between the literary and exhibition constructions of racial 'types' and identities, and that it was a correspondence that was exploited by the exhibitions, even while they set themselves up as the more immediate experience.

The degree to which references to ethnography and anthropology, if not their theoretical premises, were also exploited as a means of ensuring that the event would be credited with at least a veneer of authenticity, is also significant. This is particularly the case because it occurred even in spectaculars and entertainments such as Barnum and Bailey's Great Show at Olympia in 1897, which had less pretentions to educational excellence and a much more overt acknowledgement of the entertainment aspect than many of the other exhibitions put on before 1913. The dual emphasis on entertainment and scientific edification was present here even in the 'Freaks and Animals' section, and by 1897 was a tactic evidently considered expedient by the most dedicated showmen.[16] The dramatic performance in Barnum and Bailey's Great Show, entitled 'The Mahdi: or For the Victoria Cross. A Realistic Reproduction of Life in the Soudan', by Bennet Burleigh, was an occasion produced, according to one guide, 'with historical truth and accuracy to the minutest detail' and was accredited in the same breath with being 'a most momentous new departure in ethnologic, spectacular, equestrian, gymnastic, Oriental and warlike exhibition and display.'[17] And if this was not enough, it was also 'unequivocally of considerable educational value', able to 'convey to the mind in an hour or so, whole volumes of information which could not be so quickly or graphically conveyed to the mind through the reading of books.'[18] The 'scientific' paradigm encouraged one commentator (referred to euphemistically as one of Mr Bailey's 'editors') to describe the Africans and Arabs in the drama as 'a weird and curious sight in themselves as an ethnological exhibit.'[19] This is a particularly telling description, since it indicates that the Africans and other colonised races taking part in these enactments, already designated 'in role' as themselves, were doubly defined by such productions as ethnological specimens and representatives of the 'race', and were never able to exist outside of 'spectacle'. They simultaneously fulfilled the role of 'curiosity' and 'specimen', as both objects of amusement and scientific scrutiny. An advertisement in the pages of the official programme of the Naval and Military Exhibition of 1901 at the Crystal Palace makes this connection explicit. In the list of daily exhibits and attractions, sandwiched in between 'Pompeii as It Was and as It

Is' and 'The Palace Wild Sports Rifle Range', was an item under the collective title of 'Ethnological Groups' which comprised 'Groups of Indians, graciously presented by His Majesty the King; also Bushmen, Zulu Kaffirs, Mexican Indians, Hindoos, [*sic*.] Tibetans, etc.'[20] The 'Ashanti Village' guide, mentioned above, went to the extent of incorporating an entry from the Encyclopedia Britannica, calculated to provide a note of accuracy and scientism and to emphasise the value of the 'Village' as an educational asset.[21]

Both the Sudanese and the Zulu encampments at the 'Briton, Boer and Black' exhibition are singled out for similar attention. In the case of the 'Sudanese' – who were in fact Senegalese – it was remarked that it was to:

> M. Gravier that the thanks of the European student of Anthropology are principally due, for this unequalled opportunity of studying the customs of our dusky fellow-subjects in their homes and habits, as they could formerly be observed only by the African traveller.[22]

This appeal, made as it is to the 'armchair anthropologist', as the majority were at this time, is interesting since it reinforces the ambiguous domain of anthropology. It had long been considered appropriate, on an *ad hoc* basis in the very early days of anthropological inquiry, to use colonised peoples in such mass exhibitions as human 'specimens' for 'scientific' case studies. The fact that it continued over this period, and was seriously advocated by emergent professionals in the new 'discipline', is corroborated in a statement by the Cambridge anthropologist whose name is synonymous with the development of diffusionist social anthropology in Britain. W.H.R. Rivers, in an address to the Anthropological Institute in 1900, called for more use to be made of the opportunities for such scrutiny presented by the plethora of exhibitions. He went as far as to suggest that the Anthropological Institute should seek special permission from the exhibition proprietors in order to 'inspect' these people prior to the exhibit's opening to the general public.[23]

A similar appeal to the visitor as a serious observer rather than simple pleasure-seeker is found in passages relating to the Zulus in the same exhibition. But here, another method of validation is deployed – testimonials from accredited scientific authorities, confirming the 'reality' of the exhibit, are quoted at length.[24] On this occasion a letter from Henry Morgan Stanley is used to endorse the Zulus' authenticity: 'Your "savages" are real African natives, their dresses and dances, equipments and actions are also very real, and when I heard their songs I almost fancied myself among the Mazamboni near Lake Albert once again.'[25]

The persistent emphasis on the authenticity of the displays of colonised races operated in several ways as a mechanism in the construction of an image of these peoples. A frequent feature of this discourse is the claim that the verisimilitude of the scene is so complete that the occupants themselves fail to recognise that they are living in a simulated environment. It is a short step from the Zulus in the kraal of 'Briton, Boer and Black' who, apparently, 'easily recognised the different landscapes' painted by the scene painter as specific locations from their own country, to those 'Ashanti' at the Crystal Palace who were 'absolutely indifferent to the customs of foreign countries', and, apparently unable to distinguish the artificial environment from that of their own home environment, lived 'a very simple African life.'[26] From here, it becomes easier to make the final leap where,

in a 'living tableau' entitled 'The Amorous Negro' at the 'Woman's Exhibition' of 1900 at Earl's Court, the character Sambo

> has been sent to dust the bric-a-brac, but is unable to keep his eyes from the statue of a smiling lady. Charmed and enraptured, he cannot resist declaring his passionate love but alas! her heart throbs not, she is cold, and his appeal is made to stone deaf ears.[27]

Such figurative devices may no longer come as any surprise in the exhibition context. However, their legitimacy was endorsed through the prevalence of a similar discourse in the guidebooks of many public ethnographic collections, including the national collection at the British Museum. Here, as late as 1910, Charles Read in his *Handbook to the Ethnographic Collections* could confidently claim that:

> The mind of primitive man is wayward, and seldom capable of continuous attention . . . His powers of discrimination and analysis are undeveloped, so that distinctions which to us are fundamental, need not be obvious to him. Thus he does not distinguish between similarity and identity, between names and things, between the events which occur in dreams and real events, between sequence of ideas in his mind and of things in the outer world to which they correspond.[28]

This focus on the African's inability to distinguish between the representation and the 'real' at exhibitions, served three functions. It provided living proof of the scene's verisimilitude, but crucially, while the white audience needed to be convinced of this, the black performers were seen to be completely duped. As well as increasing the exhibition's credibility in terms of its 'truth to life', and reinforcing the gullibility of the African, this also served as a reply from the management against any criticism by those who found the use of indigenous peoples from the colonies offensive in such contexts.

The use of testimonials in connection with the 'Zulu Kraal' in 'Briton, Boer and Black' is a case in point. As well as the functions discussed above, these were partly designed to counter the controversy that erupted when the same group had been brought over to perform in the 1899 Greater Britain Exhibition at Earl's Court before transferring to Olympia. To this effect, the Reverend Charles Johnson (who, according to the guide, had lived at Rorke's Drift for forty years as a missionary amongst some of the same Zulus) is quoted at length from a report he made of his impressions of the exhibition. The testimonial established the exhibition organisers' consideration for the Zulu's spiritual well-being and, more importantly, their moral welfare, by making provision for a Sunday service to be held on the exhibition grounds. As far as the Reverend was concerned, they were 'simply enacting . . . certain facts in the past history of their country', a statement which endorsed the organisers' publicity regarding their claims to a distinction between theatre and the exhibition dramas.[29] According to Johnson, their performance was in no way seen to compromise their faith, although he did admit that:

> They are, no doubt, brought in contact with special temptations; but temptation does not necessarily mean that they must fall, and each place, whether here, in England or in South Africa, has its own special temptations . . . I am sure it is better that they should come in this way to England, where they are really taken care of – well fed and looked-after – than face the awful temptations and go through the terrible experience of all natives working in the mines at Johannesburg or Kimberley.[30]

Early in the exhibition a dispute arose over the importing of the group of Zulus, and was rigorously followed by *The Times*. The Colonial Secretary, Joseph Chamberlain, speaking in the House of Commons, objected to their transportation (as did the governments of the British colonies and the Dutch Republics) on the grounds that, having been given passes ostensibly to travel to the Kimberly mines, they had been brought over on false pretences, and that their participation would be 'injurious to themselves and the South African population.'[31] We could also surmise that the Colonial Secretary's concern lay rather less with the injuries which the Zulus might incur to themselves, and rather more with the fact of a prospective cheap labour force being employed in a different capacity and one not so directly associated with the economic wealth of the colony. The Duke of Cambridge, who was to provide a royal sanction for the event by opening it, was duly contacted and the minister's disapproval conveyed. His way around this issue was to argue for the separateness of the different parts of the exhibition. 'Savage South Africa', the drama incorporating the Zulus, was, after all, under separate management. The rest of the exhibition was a commodity showcase to demonstrate the commercial desirability of colonial produce and industries, organised with the full co-operation of the various colonial governments themselves. Cambridge saw his role as 'strictly confined to the commercial exhibition, and . . . that his withdrawal at the last moment would cause great disappointment.'[32]

The Colonial Secretary and other M.P.s were not the only ones to take issue with the importation of South Africans for such purposes. The Aborigines Protection Society was among those who were also vocal in their condemnation of the scheme, although their criticisms were of a rather different nature and motivated by somewhat different concerns.[33] The correspondence between Edwin Cleary as managing director of 'Savage South Africa', Earl Grey and Fox Bourne, the secretary of the Aborigines Protection Society, is an illuminating example of the convoluted and contradictory interests invested in concessions featuring Africans and other colonised peoples, and also of the kinds of interventions available to and solicited from certain humanitarian organisations. The acknowledgement of such interventions, while often underwritten by deep-seated paternalism, also helps dispel the tendencies to monolithic histories of colonial oppression. In April 1899, just before the opening of 'Savage South Africa' at Earl's Court, Grey contacted Fox Bourne with a view to obtaining the Society's 'co-operation and support for [the management's] endeavours to secure that the natives shall be treated in such a way as will enable them to return to Africa not the worse, but the better, for their visit to London.'[34] The management's request was, of course, precipitated less by altruism than by a series of attacks in the London press, ostensibly about the conditions under which the Africans were being kept at the exhibition. A closer analysis of the criticism reveals a deep concern about what is described as the Africans' 'moral and physical welfare'.[35] The use of the phrase 'safe custody' for the Africans is telling in this instance, and signals the real anxiety underlying the attacks in the press. This was an anxiety over the pollution, not of the Africans in the 'Kraal', but of the imperial race through the lax morals of European women 'subjected' to close contact with the performers. This fear of racial pollution was ultimately expressed as a disgust over miscegenation, which is elaborated later in this chapter.

Whatever the motives of the management of 'Savage South Africa' or indeed of the Aborigine Protection Society, Fox Bourne's letter to Earl Grey in May 1899 gives

us important information about the actual conditions of employment of many of the performers in such events:

> I have been shown the contracts under which the [Zulus, Swazis and others] have been brought to England, and which are contracts, not with the natives themselves, but with their custodians, who are alone responsible, both to them and to the managers of the 'Savage South Africa' Exhibition, for their proper conduct and treatment. They are practically in a state of bondage, apparently cheerfully submitted to, and made as easy and pleasant to them as is practicable, but of a sort that would probably not be recognised in an English Court of Law . . . The contracts on their behalf which I have seen are for twelve months [not seven as Cleary had testified] and, if valid for that term, are open to indefinite extension, without the intelligent consent of the natives themselves being obtained.'[36]

In addition, the controversy also provides an example of the voluble and effective dissent of those performers who have so often remained mute bystanders at the enactment of their own demise in other histories dealing with international and colonial exhibitions of any kind.[37] After the closing of the Olympia version of 'Savage South Africa' in January 1900, some of the Zulus had apparently stayed behind in London with a view to being sent to Paris for the Worlds Fair for a contemplated 'Transvaal and Savage South Africa' show. The headman of this party of seven, described in the *Aborigine's Friend* as 'an "educated" Zulu from Ladysmith', contacted the committee of the Aborigines Protection Society to complain that the contracted weekly lodging allowance had only been paid for two weeks, and that he had not been able to obtain the arrears already due. As a result, solicitors were instructed to take legal action to secure the fulfilment of the contract.[38]

Notwithstanding these criticisms, made on different grounds and by parties with very distinct and differentiated interests in South African politics, the 'show' went on. From most accounts, it received considerable critical acclaim.[39] However, by the time the programme had been drawn up for the Olympia version in December 1899, the Reverend Johnson's letter had been inserted into the revised text. While some of the reasons for its inclusion are now clear, it is only having explored such a change in the programme in the context of the reasons for the move to Olympia, that the full implications of Johnson's references to temptation and the Zulu's moral welfare are comprehensible.

I

In his article 'Showbiz Imperialism', Ben Shephard emphasises the changing press response to 'Savage South Africa', the dramatic performance aspect of the show, before it had moved to Olympia.[40] He traces the decline, from July 1899, from critical acclaim to outrage. As has been outlined, the seeds of such outrage were already sown some months earlier. The period after this date, however, is significant since it corresponds with the engagement of the 'star' performer, who was billed as the son of Lobengula, the recently subjugated leader of the Ndebele, to a Miss Kitty Jewell. The proposed marriage seems to have been a trigger for a spate of articles raising, overtly now, the thorny issue of miscegenation.[41] In order to save face after a barrage of criticism from the press, the proprietors of London Exhibitions Limited ultimately brought legal action against

Frank Fillis, the South African showman responsible for the section on 'Savage South Africa'. As a result, on August 28 1899, the 'Zulu Kraal' at Earl's Court was closed to women. Only male visitors were admitted. The action of Kiralfy's company represents a complete turn-about on its earlier position regarding the franchise, and the defence it had been prepared to launch after the initial debacle over the importation of the Zulus.[42]

The statement which Fillis now issued in defence of this latest attack neatly turned the tables on his defamers by treating the attack on the show as a slur on British womanhood, and an attempt to cast the show's organisers as irresponsible. *The Times* reported that 'The management feels strongly that English women who have visited the 'Kraal', and the natives, have been grossly maligned.'[43] The managing director, Mr Edwin Cleary, added that the 'Kraal' had been shut 'in the face of reputable English women who are brought by their fathers, husbands and brothers to see what they themselves tested and have found, as they write to us, eminently reputable.'[44] This last being the final seal of approval to counter any criticism.

As if to reinforce the suggestion that any attraction from the black occupants of the 'Kraal' was in any case totally 'unnatural' and therefore an anomaly, many of the dramatic re-enactments now included scenes where the white heroine died, rather than be left to the hands of the black 'savage'.[45] Another device, often used in such exhibitions, was to make the narrative revolve around the heroic efforts of the white men to retrieve the women from the clutches of an apparently unattractive and wholly undesirable black foreigner.[46] It was considered necessary to bring home to the viewer the inconceivability of a white woman actually entertaining the notion of a romantic liaison with a black man, while, paradoxically, the reverse was actually anticipated.[47] Such strategies were of course familiar as a literary conceit in many colonial novels of the period.[48]

In the context of this 'moral panic', the Reverend Johnson's references to the 'temptations' that might meet the Zulus and other African performers most certainly refer to the temptations of the flesh.[49] Even before Frank Fillis and his troupe had left Cape Town, one dissenting voice had already warned that once they had been exposed to all the vices of a large city, 'nothing but vice in a white skin would satisfy [them] thereafter. How many times have I not had it thrown in my teeth by natives that they can get as many white women as they like?'[50] Press hysteria over social, if not sexual, intercourse between black tenants of the 'Zulu Kraal' and white women visiting them increased throughout August 1899. By this time, in a last desperate attempt to disavow the reality of miscegenation, the blame lay not only with the African inhabitants, but explicitly with the European women as well:

> All of her race take care that in Africa, an English woman shall be respected . . . English people having female relatives in South Africa might well feel some anxiety for the women who live in close proximity to natives who are worse that brutes when their passions are aroused. Colonists know how to keep these passions in subjection by a wholesale dread of the white man's powers and that dread is being dissipated daily by familiar intercourses at Earl's Court.[51]

This shift from concern for the African in a strange environment far from home, to anxiety over the white woman's proclivity for intercourse with the black man, is redolent of fear and antagonisms towards the independent and articulate 'new woman', as Ben

Shephard suggests.[52] It is also indicative of the paranoia of 'pollution'. If European women, 'apparently of good birth', were to become tainted by sexual contact with black Africans, the imperial race would not survive. One of the significant features of much of the criticism levelled at those women apparently guilty of encouraging physical contact between themselves and the Africans at the Earl's Court version of 'Savage South Africa', is that it is consistently the middle-class woman who is singled out for censure in this respect. As Anna Davin has pointed out, these were the guardians of the imperial race and were the class selected in the growing literature of the eugenics movement in Britain for the proliferation and strengthening of the breed.[53] It follows, therefore, that the anxiety and paranoia around the maintenance of racial purity focused specifically on this class of 'mother'.[54] While this was one of the only occasions on which the issue of inter-racial marriage was raised as a direct result of events connected with participants in an exhibition display of indigenous Africans from the colonies, the theme of racial purity lurks fairly close to the surface in both those texts designed to guide the public on their journey through the various exhibition sites, and also the press reviews of these events. In other words, it existed on both a conscious and deeply unconscious level. It was, however, a concept which was applied discriminatingly and from which the white male emerged curiously unscathed.

The discourse on racial purity surfaced in other ways at such exhibitions. In the earlier French Exhibition of 1890, much is made of the negotiations by those officials of the committee to secure 'a company which should be thoroughly representative of the Tribes from which it was selected.'[55] To further prove the point, it was stressed that when the Arabs saw the sea 'for the first time' at the dock for embarkation to England, they were said to have been reluctant to leave. The guide confirmed that, with the exception of a few members, 'none of the present company have ever before been out of their native land, and it need hardly be said, therefore, that they are strange to the ways of civilised countries.'[56] Unlike their black counterparts from Africa, though, these 'splendid specimens of humanity, tall, bronzed, wiry and upright . . . [have] nothing savage about them.'[57] It should be remembered here that while the Arabs in this context are designated 'African' rather than 'Oriental', they are nevertheless distinguished from their black brothers by their 'intelligence'. Even this is not a fixed racial characteristic, however, and at certain historical conjunctures it was obviously more expedient to transform these adjectives into 'sly' and 'cunning'.[58]

<p style="text-align:center">II</p>

Notwithstanding what is clearly emerging as an intense fear of miscegenation over the period, one aspect of the discourse on racial purity and civilisation that remains remarkably constant throughout the years 1890 to 1913, is the emphatic concentration on minute details of the African's physicality. While this might also be a feature of descriptions of other colonised races, when mobilised in relation to specifically black Africans it often had the effect of undermining their intellectual capability. In this way, although the Zulus of the 'Kraal' in 'Briton, Boer and Black' may be regretted as no longer being 'unspoilt savages' of the noble savage ideal, their redeeming feature is that 'they are physically fine specimens of a race of warriors who taught us at Isanlwana the error of employing loose

formation against masses of bold men.'[59] While the British can muster strategic military skills to their aid, the Zulus have only brute strength ('boldness') on their side, despite, or because of, the military evidence of tactical warfare deployed by the Zulus in their campaign against British incursions.

Consequently, even where the African was presented as essentially 'civilised', as in the 'International Horticulture Exhibition', the show included the requisite 'combat'. In the example of 'Briton, Boer and Black', the men are compared to 'young athletes, laughing, singing, and dancing.'[60] So pervasive is this image that it persists, despite the contradictions to it which are provided by the very photographs inserted into the text of the official guide. The men are described as being like

> the true native who formerly possessed the lands between the Zambesi and the Limpopo rivers. Some have kilts of Zanzibar cat tails or tails of wolves or foxes, with a skin caross thrown over the shoulders. Others wear a leopard skin loin cloth (mutcha), with strips of the same fur round their calves, and ornaments of beads on their necks and arms.[61]

The photographs of a 'scene in the kraal' and 'cooking in the kraal' show three black men huddled together by an open fire, wearing blankets or, in one instance, an old army greatcoat against the cold and drizzle of a London winter. In both cases, they are surveyed by white army officers in the background (figs 39 and 40).

A considerable amount of detail is given over to what are presented as empirical physical descriptions of specific individuals. In 'Briton, Boer and Black', for example, the Zulu chief Mphlupo is described as 'a finely built man of middle age, looking every

39. 'Scene in the Kraal.' Official Libretto and Programme for 'Briton, Boer and Black in Savage South Africa' (Olympia 1899–1900).

SCENE IN THE KRAAL.

inch a warrior . . . and a suggestion of tense, muscular vigour and activity which is extra-ordinary.'[62] The inhabitants of the 'Soudanese Village' in the same exhibition, despite displaying, in contrast to the Zulu occupants, 'an extraordinary desire for the higher side of civilisation as we know it' are accredited with

> the true ebony colour, their skin being jet black and highly polished, their faces are unrelieved by the customary red lips, and like the majority of African natives, they are as a rule quite beardless. As a rule, the men are finely made, their shoulders and arms being of the most magnificent proportions and their muscular development quite extraordinary.[63]

There are three noteworthy features in the descriptions deployed in this paragraph and the statements directly preceding it, in the context of the exhibition as a whole. Firstly, it is evident that there is some comparative assessment taking place between the 'Soudanese' (who were in fact from Senegal) and the Zulus from Southern Africa. On the scale of 'civilisation', these Senegalese have achieved a status which the Zulus are only close to, in terms of their potential. It was their potential as converts that the Reverend Johnson was only too happy to suggest should be exploited.[64] As the programme almost immediately pointed out, the Senegalese had largely abandoned 'ju-ju' worship and witchcraft in favour of Christianity and Mohammedanism. Confirmation that the readers' attention was indeed being drawn to this comparison comes on page thirty-five of the guide, where one was informed that, 'It is in their methods of culinary and domestic duties that the tribes of West Africa show themselves so infinately superior to the South Africans and Cape boys.'[65]

COOKING IN THE KRAAL.

40. 'Cooking in the Kraal.' Official Libretto and Programme for 'Briton, Boer and Black in Savage South Africa' (Olympia 1899–1900).

41. 'Wrestlers in the Dahomey Village.' Official Programme for 'The Dahomey Village' at the Imperial International Exhibition' (White City, London 1909).

The illustrations set into the text are further confirmation of the differentiation made, in this instance, between Africans. Almost all those concerning the Senegalese illustrate specific work activities. Others consist of family and group pictures and another depicts the inevitable 'wrestlers'. The illustrations in descriptions of the 'Zulu Kraal' consist of the two small photographs mentioned previously, and show virtually the same scene with perhaps different participants: a group of three men round a cooking pot on a rudimentary camp fire. They sit huddled together, their backs or profiles to the camera, inactive. Here it is also important to note the implicit critique of the Zulu contingent as unhygienic. Not only are they apparently less diligent and productive, but they are also dirty.

A second aspect of the physical descriptions which appear in the text of the guide is the detail in which they are carried out. In the context of the hue and cry over the physical contact between black men and white women, some special device was necessary in order to avoid this reading like an open invitation to indulge in a sexual liaison. Consequently, the degree to which the men have been literally 'objectified' through the persistent use of a sculptural analogy, deploying such terms as *ebony*, *jet black* and *polished*, is a common feature of the physical descriptions of black men.[66] As with those photographs of African women used in an ethnographic context and discussed in chapter one, the text was used here as a device to objectify and distance the viewer from the African and his dangerous but exciting physicality. The 'wrestling matches' held in almost all 'African Villages' of such exhibitions, did nothing to alleviate this dominant image. In 'Briton, Boer and Black', Ashanti and Senegalese battle it out in a series of matches described as 'interesting and manly'.[67] The 1903 International Fire Exhibition at Earl's Court had Arabs in an 'Assouan Village', engaging in a fight with long sticks, while an acrobat and conjurer performed feats and tricks for the public.[68] In Barnum and Bailey's Great Show of 1897, 'daily life' in an Arab encampment included 'sports, games, acrobatics, native military exercises . . . and all phases of native life reproduced with faithfulness and truth . . . the natives are contesting in their games and revelries, others are watching the gambols of their dusky children'.[69] (See figs 38 and 41.)

In the 1904 International Exhibition at Bradford, the Somalis who in that instance peopled the 'village' were featured as wrestlers and spear-throwers.[70] The guide to the 'Ashanti Village' reinforces this physicality as an inherently African quality, by pointing out the 'flexible limbs' of the men and women.[71] Significantly, these physical antics take place in exhibitions on the slightest provocation, and at times when 'typical scenes from daily life' are supposedly being enacted. It is a short step from producing such physical prowess as an apparent aptitude, to a 'naturalised', 'fact' of blackness. The concept of 'natural' racial characteristics, biologically determined, is consistent with the emphatic preoccupation with the body in anthropology over this period, and details of black physiognomy were a feature, as we shall see, of ethnographic displays in museums. It is also in line with popular received notions of 'scientifically' verifiable facts, through the popular assimilation of certain features of anthropological theory by this date. Such an interest also corresponds to the developing obsession with eugenic theory prevalent from the 1890s in England.[72]

Consequently, a string of physical characteristics produced as racial traits recur in the official guides to these events. Arabs are graceful, but sly and cunning.[73] Negroes generally exhibit a love of home and a fear of the unknown. The Sudanese have uniformly happy dispositions and innately courteous manners.[74] Zulus exhibit chivalry and no malice, but are averse to steady, continuous work.[75] Basutos are generally diabolic, but teachable.[76] The Ashanti, despite their contact with the civilised world, remain possessed of a natural childlike gaiety.[77] Their 'natural' characteristic is one of valour in defence. The Somalis at Bradford are also, ultimately, just so many children.[78] Of course it is not only the African that comes in for this treatment, although when applied to them it is of a rather more consistently derogatory cast. When the same practice is applied to the Eskimo group who share the limelight with the Senegalese and the Zulus in 'Briton, Boer and Black' of 1899, the 'natural' characteristic attributed to them is a sense of justice, morality and truthfulness.[79] The outstanding feature of so much of the discourse around the physicality of the African, be they specifically Somali, Ashanti or Senegalese, was that such an emphasis implied the inherent capacity and, in fact, the driving need, to perform some feat of physical skill or brute force.

III

Neither did the women in the troupes manage to escape particular mention in the guidebooks. Consequently, in the exhibitions the writer's attention was also focused on the physical aspect of the women represented. The female equivalent to the juggling, wrestling negro is the dancing, black woman. She makes an appearance in almost every context where Africans form a part of these spectacles. In that part of the French Exhibition entitled 'The Wild East, or Life in the Desert', a group of women supposedly from El-Ahab-Biskra perform dances. While the men are described as 'splendid specimens of humanity', the women are objectified in terms which share not a little of the language of the *Anti-Slavery* report on the slave market at Galabat, as 'for the most part, well-shaped and pretty, with large dark eyes of the Eastern type.'[80] The second section of the 1892 International Horticulture Exhibition even has the Zulu Choir enacting a series of scenes, four out of nine of which involve some women dancing. The paradigm is taken

to an extreme in the example of the Ashanti village, where life is presented as a continual dance which 'accompanies the Ashanti from the cradle to the grave.'[81] Particular attention to detail is given to certain physical qualities of the women, despite the fact that men were also taking part in this activity. The writer talks of the performers as 'young, slender girls, with their white teeth and their pretty eyes . . . the most graceful dancer of all is Akole, who especially develops much grace in the fiery and original "Shilling-Kome".'[82] Other paragraphs detail the hairdressing process among the women, and other aspects of personal adornment.

Significantly, in the case of 'Briton, Boer and Black', although the perennial 'dancers' are still present, the emphasis is rather on roles which are less resonant of an unregulated

A FAMILY PARTY.

42. 'A Family Party.' From the section on the 'Soudanese Village' in the Official Libretto and Programme for 'Briton, Boer and Black in Savage South Africa' (Olympia 1899–1900).

sexuality. The most prominent of these is motherhood. 'Each new baby as it arrives is carried on the mother's hip, being held firmly and safely in place by a broad strip of cotton stuff.'[83] Furthermore, 'she never disencumbers herself of her burden, even while she is grinding the millet seed, cooking or washing' (fig. 42).[84] As if to reinforce this image of the 'good' mother, the illustrations contained in the guide include two photographs of mothers with their children (figs 43 and 44). The frequent references to the women's position in many African societies as analogous to the conditions of slavery, includes extraordinary statistics such as 'the king has had a regular allowance of 3,333 wives'. Comments like 'the women are little better than slaves, and a young girl, until she is married, is the absolute chattel and property of her father', may here be as significant in

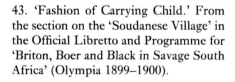

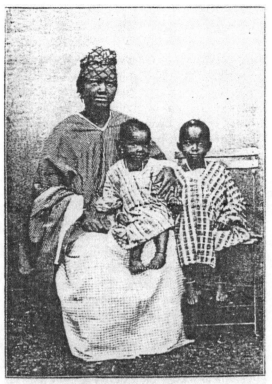

43. 'Fashion of Carrying Child.' From
the section on the 'Soudanese Village' in
the Official Libretto and Programme for
'Briton, Boer and Black in Savage South
Africa' (Olympia 1899–1900).

44. 'Mother and Children'. From the section on
the 'Soudanese Village' in the Official Libretto and
Programme for 'Briton, Boer and Black in Savage
South Africa' (Olympia 1899–1900).

its implications for white middle-class women in Britain by this date, as it was supposed
to be an indication of the status of the black African woman in her own society.[85]

By 1901, the Military Exhibition at Earl's Court was more explicit about the sorts of
lessons to be learnt by British middle-class womanhood from such dedication to 'duty' in
the face of an adversity such as polygamy. Having stressed the soldier's need for self-
respect when returning home from active service, the guide declares that, 'It lies with
responsible persons in every locality and specially with the women of the Nation to make
him so [respect himself]. The words "Mother", "Home", and "Duty", are those that
appeal the strongest to his heart and philosophy.'[86] With such clear directives reinforced
as a discourse throughout the national press, the implications of the relations set up
between the representation of black womanhood – oppressed, but nevertheless fulfilling
her maternal and wifely obligations – takes on a special meaning. The symbol of the
African woman served as a means of chastising feminist tendencies amongst white British

women, in the face of their apparent dereliction of wifely duties. Such a representation also effectively denigrated the black male as lacking in consideration and respect for his own womankind. This was important, since he was perceived as more of a hindrance to the progress of the white coloniser than the African woman. In fact, the representation of African woman as an oppressed group within her own society functioned, in part, as an advertisement for the necessity of colonisation and the European and specifically Christian version of civilisation. It also had unmistakable implications for those British women making demands for their rights within British society, since it emphasised their privileged status in relation to their male counterparts.[87]

By 1900, Imry Kiralfy had already realised the financial potential of the representation of women in his Woman's Exhibition at Earl's Court. The emphasis was on the role of woman as 'civiliser and purifier', and ostensibly to demonstrate 'the remarkable progress women had made in the past hundred years.'[88] Committees of venerable titled Ladies were set up, with the Lady Mayoress of London acting as president of the honorary committee. These bodies were responsible for a historical section, a large British and Irish Silk section, and, among others, those dealing with art, applied art, music and nursing. The most popular event associated with the exhibition was the display entitled 'Women of all Nations'. The Empress Theatre at Earl's Court was converted at considerable expense to accommodate the spectacle. A series of sets of 'typical' and notably 'domestic' environments served as a backdrop for women of different nationalities who were apparently engaged in 'their own particular work.' This resulted in Danish women making lace, Italians in a carnival Venetian scene, 'doll-like Japanese' playing 'quaint instruments', and English 'types of womanhood' (the only group credited with diversification within a national identity) 'occupied in making articles for the soldiers at the front.'[89] In the context of the present study, one of the most striking features of this spectacle was that out of the list of twenty-four national groups represented, not one of them was African.[90] The representation of African womanhood was confined to an exhibit entitled 'The Dinka Village'. This was found in the queen's court, along with the 'Great Canadian Chute', 'The Swan Boats', the 'Camera Obscura' and 'Miss Sono's Sea Lions'! In other parts of the same programme, the 'village' is confusingly described as 'The Fashoda and Dinka Village', and as 'A Fashoda, Dinka, Amazon Village'. The inhabitants are likewise confusingly described as both 'brought from the desert of Africa' and 'a vivid, realistic reproduction of a village of the almost inaccessible and barbarous region of the Soudan, and peopled entirely by women.'[91]

The autobiography of Harold Hartley, a colleague of Imry Kiralfy, is interesting for its descriptions of this exhibition, particularly since it reproduces the same stereotypes already witnessed in the texts accompanying the other earlier exhibitions. He credits the women in the 'village' as being 'remarkable for their industry and devotion to their homes and [their] fearless courage'.[92] A sort of composite image of the 'good' mother emerges. Again, a hierarchical evaluation is made through his statement that 'the huts of the Dinkas were very superior dwellings compared to those other Africans.'[93] To some extent then, this comparative device, also seen at work in 'Briton, Boer and Black', might be understood as a strategy which allowed for a positive image of the African, but only in so far as this was presented ultimately as an anomaly, and consequently as a 'positive' image which failed to rupture the more frequently repeated derogatory stereotypes. The programme continues in familiar vein, emphasising the reputation of the Dinkas 'amongst other

savage African tribes, of being the handsomest natives of the Dark Continent.'[94] The women in this 'village' apparently also gave several dance performances during the day, and public demonstrations of hairdressing. However, because the African representatives were excluded from the 'Women of all Nations', it also meant that they had no participants in the ensuing competition, in which visitors to the exhibition were encouraged to take part in order to select the country considered the most 'representative' in this part of the show. This is even more significant when it is pointed out that the results were evidently important enough as a feature of national interest to be reported in *The Times*.[95]

The 'Irish Colleens' received the first prize and an award of one hundred pounds. They received 32,095 votes while England finished second with 24,029 and Scotland came third.[96] The British Isles swept up all the prizes in a barely disguised nepotism. The programme's descriptive labels which accompanied the titles of the different national groups all contain adjectives drawing attention to either the contestants' beauty, charm or attractiveness. While it was evidently acceptable practice to attribute certain physical attractions to African women, therefore, they were of a kind not to be confused with the 'real' beauty of the white women contestants in the exhibition. It was an attractiveness that existed in a different league.

<div align="center">IV</div>

A corollary of this emphatic reference to the bodily, physical attributes of either black males or females is the frequent inference in the guidebooks that this physicality is a quality more closely connected with animals than humans. Paradoxically, one means by which this is established is through references to the African's treatment of animals. In the 1890 French Exhibition, the positive image of the Arab is enhanced by the statement that 'a noticeable feature is the affectionate relations existing between the men and their animals . . . They allow all sorts of liberties to be taken with them and, like their owner, appear to be very intelligent.'[97] Conversely, the negative image of the Ndebele in the 1899 'Briton, Boer and Black' is reinforced by the gratuitous violence on the mules of the Gwelo Coach, when, for no apparent reason, they were all shot or stabbed by the Ndebele after the white occupants of the coach had already fled.[98] In the 1899 Greater Britain Exhibition, the language used to describe the spectacle entitled 'Spessardy's Tigers and Bears' is too similar to earlier references to the Zulu contingent taking part in 'Savage South Africa' to avoid mutual identification. In relation to the animals, the audience is reminded that:

> Here we may witness a wonderful exhibition of the perfection of training to which the wild beasts of the field may be susceptible, when unlimited patience, kindness and perseverence are the means employed . . . but really as we watch their trainer's command, one can scarcely help regarding such a precaution as superfluous.[99]

Compare this with the description of the Zulus in the exhibition as 'wild, untutored savages', but likewise tamed by, in this instance, the superior force of the British army: 'No troupe . . . could be more perfectly disciplined or more absolutely under control . . . the whole display constituting a revelation of savage warfare in Africa.'[100] As with

the animals, there is no danger of these 'savages' getting out of control since 'the attendant exhibition of British military power and the British method of dealing with the savage hoards of the Dark Continent' was an important accompanying feature of the exhibition.[101] If in any doubt about the connection here between the African and animality, it is made more explicit on page twenty-six of the guide, where we are told that Frank Fillis 'has achieved some wonderful results in the training of the troupes of savages and, incidentally, of the horses also.' The section describing the 'Kaffir Kraals' further collaborates with this analogy, by emphasising that in the pool at the centre of the village, 'the elephants of the show and the savages indiscriminately perform their ablutions.'[102]

Local press reports of the 1904 Bradford International Exhibition describe the panic that understandably ensued after fire broke out in the 'Somali Village', in language reminiscent of descriptions of a herd of unruly animals: 'Men, women and children dashed about the enclosure almost wild with excitement, shouting and screaming at the top of their voices . . . several times they broke through the entrance and rushed in among the crowd, and it was impossible to keep them within bounds.'[103] A commentary on the Zulus in the 1899 exhibition five years earlier, but written some years after the event, makes a similar inference: 'For their accommodation it was necessary to repeat as nearly as possible the conditions under which they lived in their native country.'[104] The writer adds that because the space allotted to them backed onto the District Railway Line and was enclosed by a high fence, they 'escaped' over the top of it, onto the line and into some tunnels. 'Fortunately the signalman saw them and held up all the trains until we had them all back.'[105] The unmistakable impression here is of wild, frightened animals. Furthermore, the paranoia over the issues of racial purity and miscegenation finds expression again at these moments through the idea of escaping containment, reinforced now by this discourse on animality.

Nevertheless, the easy stream of bestial metaphors which represented performers from the various colonies as chaotic and undisciplined was often interrupted by events which demonstrated an unnerving capacity for organisation and determination. On one occasion, at the Bradford International exhibition of 1904, the Somalis who had populated the 'village' marched on Bradford Town Hall and refused to board their train. The fire which had broken out in the 'village' had destroyed not only the buildings, but also many of the performers' personal belongings. Distressed by such an occurrence and angered by their losses, a delegation of Somalis took their grievances to the Mayor of Bradford. They demanded compensation for the damages they had sustained through the fire and full payment for their services, which, they claimed, the concessionaire, Victor Bamberger, had neglected to pay. As a result of negotiations, the Somalis finally left with no compensation for the fire damage, but with assurances that they would be paid in full under the terms of their contract.[106]

<div align="center">V</div>

Throughout all the exhibitions from 1890 to 1913 is the feature which shows Africans locked in battle, either with each other or against a white, usually British, defendant. Despite the fact that there were many conflicts with British imperialism over parts of the Empire, the re-enactments of fights or battles are invariably African.[107] The focus of the

event was the 'inevitable' subjugation of the Africans involved. The choice of specifically contemporary events enhanced this end, since they had the added authority of the image already constructed by the national press. Evidently, the discourse on physicality and animality which has already been mapped out intersects with those on war and combat.

The essential contemporaneity of the dramatic interlude also accounts, to a certain extent, for some of the apparent contradictions or shifts in the representation of certain African groups. At one time it might be considered more expedient (as was the case of 'Briton, Boer and Black') to credit some sort of differentiation between the Senegalese and the Zulus, while the Arabs in the French Exhibition of 1890 are presented in a positive light perhaps despite their classification in this instance as 'African'. By 1897, other less attractive aspects of the racial characteristics attributed collectively to them all are being emphasised. In 1892, at the height of the Zulu wars, such a battle feature including Zulus was a significant propaganda exercise to demonstrate the complete subjugation of a race that had been credited with considerable fighting stamina and courage, if not skill. To the exhibition-going public, the Zulu Choir at the International Horticultural exhibition of 1892, was the living example of this pacification. At this event, fifteen Zulus, apparently mission-educated, were employed to sing selections from Rossini and Sullivan.[108] By 1899, the more pressing menace was that of the Ndebele so that by this date, while the Zulus are definately represented as a lower order of life in comparison to the Senegalese, they are still presented more favourably than their Ndebele compatriots.[109] The point of distinction now becomes an issue of the benefits of peaceful behaviour, so that the Senegalese who are claimed to be 'the most peaceable of the Black Tribes of Africa', are also, therefore, rewarded by the labels 'civilised' and productive.[110] The Zulu, by comparison, is a warrior credited with outstanding bravery – an honourable characteristic, according to the ethics of the male British public school spirit – but doomed none the less to the category of 'uncivilised' because of the society's war-like resistance to the 'civilising mission'.[111]

While there may be points of similarity between the Zulu and the Ndebele, the latter is constructed as a complete animal by 1899. There is no talk of 'evangelising' him as there is in the case of the Zulus.[112] By this date, however, the Boer is fast approaching an equivalent to the Ndebele, although this is not yet directly stated. By 1901, the Military Exhibition turned the Boer into the prime butt of British antagonism, in the feature 'Boerland', and a cardboard model of the 'unkempt army of De Wet and that of the President, offer irresistible temptations to seize a rifle and perform deeds of valour oneself.'[113] Typical of this timely appropriation of contemporary struggles in Africa was the 1897 to 1898 production of 'The Mahdi', or 'For the Victoria Cross', (once again an example of a libretto written by a war correspondent, this time from the *Daily Telegraph*) as part of Barnum and Bailey's Great Show at Olympia. Here a point is made of the alliance between the British and the Egyptian forces which join together to defeat the Mahdi's armies.[114] Very little reference is made to the particularities of the struggle in the Sudan. It is enough to know that the Mahdi represented the evil forces. In case the audience were for one moment unclear about their allegiance, a romantic plot is introduced in the form of a Mahdist abduction of white women 'tourists' with whom the Mahdi's supporters are said to be 'infatuated'. The 1904 Bradford exhibition, while not presenting a re-enactment as such of some military confrontation as a means of providing

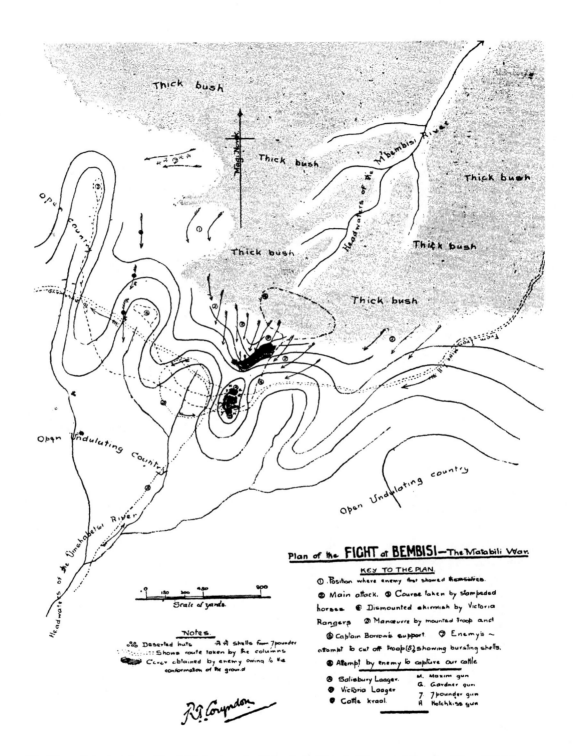

45. Plan of the battle at Bembisi during the 'Matabele Wars', *Illustrated London News* (10 March 1894).

a contemporary reference, in its programme refers to the war with the individual de-
scribed by the British government and the national press as the 'Mad Mullah'.[115]

The persistent inclusion of this dramatic feature and the representation of the Zulus,
for example, as fierce and evidently effective fighters, worked in the colonial government's
interest on an immediate but also a more subtle level. In most instances, the inevitability
of conquest is evident to the audience through frequent references to the chaotic,
unsystematic fighting of the opponents, as opposed to the military science displayed in the
strategic devices deployed by the British forces. The illustrations in the various guides
where battles are depicted bear this out. The superiority of the British force is made
obvious by the evidence of 'new technology' warfare, such as steamships and trains, and
the language used to describe various battle scenes reinforces this image of the Africans'
disorganised chaos. This was an image that was corroborated through graphic illustra-
tions in weekly newspapers and travelogues. The coverage of the Matabele Wars (sic.)
of 1893 to 1899 in the *Illustrated London News* is a case in point (figs 45 to 47).
Those articles providing documentation of military campaigns were aimed at produc-
ing a diagrammatic statement of the African's inability to organise militarily, and, by
implication, politically, despite the protracted and bloody campaigns that in fact took

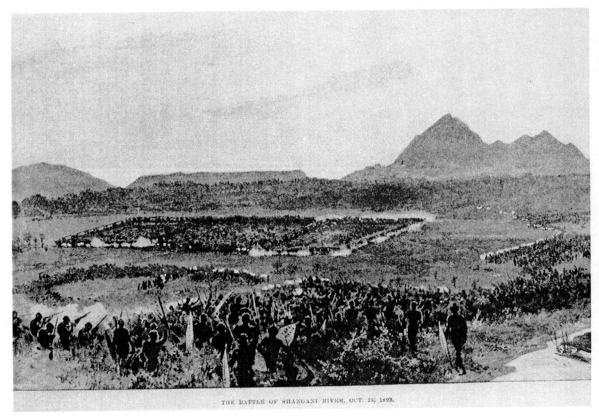

THE BATTLE OF SHANGANI RIVER, OCT. 25, 1893.

46. Artist's impression of the battle of Shangani River during the 'Matabele Wars', *Illustrated London News*
(17 March 1894).

place and cost the British dearly. Those that took the form of narrative illustrations of battles emphasised the same point, but without the supposedly scientific authority invested in the more diagrammatic format of the former. The literate exhibition public was therefore no stranger to this type of representation, having already encountered it through a variety of readily accessible texts. The implications are unmistakable; ultimately the intellectual strength of the British soldier would inevitably triumph over the brawn of the African.

The sheer number of diverse organisations who saw the exhibition format as the most appropriate means of publicising their cause or selling their product, testifies to its popularity as a form of leisure and suggests its effectivity as a profitable form of promotion. Clearly, exhibitions which contained an African section, whether as a simulated 'village' or in some dramatic 're-enactment', were much more widespread than has previously been acknowledged, and certainly not confined to international or even national exhibitions. 'Africans' represented in one form or another were a familiar sight in most provincial centres in Britain over this period, and primarily as spectacle. Such events evidently disseminated a series of racial stereotypes which acquired credibility partly through the frequent references to the authenticity of the performances and their

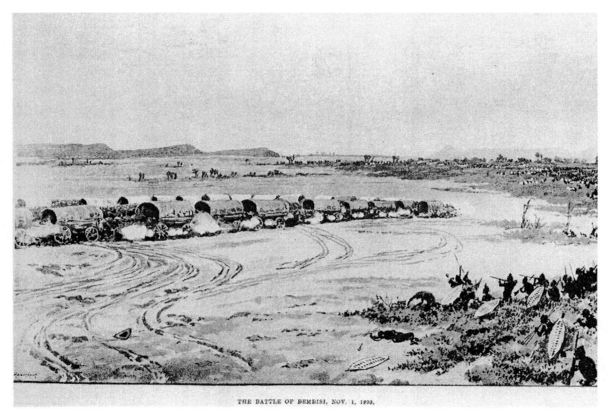

THE BATTLE OF BEMBISI, NOV. 1, 1893.

47. Artist's impression of the battle of Bembisi during the 'Matabele Wars', *Illustrated London News* (17 March 1894).

relevance to students of anthropology. Anthropology may still have been struggling for recognition on the academic front, but it was achieving a fairly high profile in the burgeoning leisure industry of late Victorian and Edwardian England. The relationship between what was represented as scientific and popular knowledges of Africa was further complicated at these exhibitions by the appropriation of popular fiction to enhance the veracity of certain supposed racial characteristics, and to reinforce the pleasurable leisure aspects of the exhibition. Such devices were so pervasive that even those exhibitions held under the aegis of 'scientific' bodies, such as the Royal Geographical Society where Africa was presented in an essentially serious context, could not escape association with their fictional counterparts from the romantic colonial novel, and neither did they necessarily desire it. Significantly, however, the racialisation perpetuated through such events was not immutable. The presence of the African, both male and female, served different ideological ends, depending on which representation was more politically expedient at any given time.

Yet it is also the case that those Africans employed at the exhibitions, usually in the 'amusement' sections, were not necessarily victims of an imperial plot in any simple sense and were quite capable of acting 'out of character' as it were, and resisting some of the more unpleasant repercussions of this type of 'employment'. As we have seen, those Zulus employed as part of the 'Savage South Africa' concession at the Greater British Exhibition took the initiative to make representation through the courts by way of the Aborigine Protection Society in order to claim fairer conditions of employment. Similarly, the Somalis who inhabited the 'Somali Village' at the 1904 Bradford International Exhibition and who had been described in the press in terms reminiscent of a herd of unruly animals, organised a strategic demonstration to demand negotiations over compensation for losses incurred due to the fire and for back pay.

Perhaps one of the most extraordinary things to arise from this chapter's research, however, is the extent to which these representations of Africans are reiterated in the official and unofficial exhibition despite the considerable educated African presence in Britain over this period. Many Africans were in positions of power as advocates or visiting statesmen, and certainly took it upon themselves to write volubly for the national and local press, independent publications and books. Perhaps one of the best known and more popular examples is the humorous, but often scathing, satire on British society written by A.B.C. Merriman Labor, published in London in 1909 and entitled *Britons Thru' Negro Spectacles* or *A Negro on Britons*.[116] Merriman Labor was a mission-educated Sierra Leonean, a trained high-school teacher who worked in the Colonial Secretary's office in Sierra Leone. Author of a number of official publications as well as fiction, Merriman Labor's 1909 satire, under guise of humour, is a serious commentary on class and race prejudice amongst the British. Many of these spokespeople, as we saw in chapter two, provided serious indictments of the colonial government and of imperialism in general. In addition, diplomatic visitors to Britain from various West African countries were no rarity in the Edwardian period, and their visits to the country and audiences with the king are covered extensively in the press and also publicised by the statesmen themselves in books or articles published in Britain.[117] Terence Ranger and others have produced research which supports the idea that many of these individuals knowingly exploited a presentation of self and identity which reappropriated and transformed anticipated western assumptions about the African and Africa and which was

calculated to have a particular effect in Britain.[118] This strategic adoption, by Africans, of different 'masquerades' for political ends is an example of what Karin Barber and de Moraes Farias have described as 'power-broking' in the formation of early cultural nationalism in Africa.[119]

Such examples make even more extraordinary the longevity of those derogatory tropes deployed at the numerous exhibitions throughout Britain from 1890 to 1913. They also make all the more urgent an understanding of the conditions which enabled these to persist.

TEMPLES OF EMPIRE: THE MUSEUM AND ITS PUBLICS

It is clear from the previous chapters that certain assumptions about race and racial characteristics, in relation to Africa, were already common currency among at least a substantial middle-class public. That such assumptions were also associated at some level with the rise of anthropology as a professional domain is crucial to my argument, for it is through this association with 'science' that such assumptions derived their credibility and longevity.[1]

At this point, it is important to look more closely at the issues which preoccupied the official bodies for both anthropology and museum ethnography, particularly in terms of the ways in which they constituted their ideal public. The debates around the role of ethnography in relation to the state, and the public it was supposed to address, are central issues for anthropologists from 1890 to 1913 and are concerns markedly absent from histories of the development of anthropology in Britain.[2] Such debates are an essential key to gauging the effectivity of museum displays of material culture from the colonies in the construction and dissemination of a set of common sense beliefs about Africa and the African.

Throughout the entire period under discussion, anthropology as a discipline was still making its debut and was courting opinion on three fronts: the state, the general public and academia.[3] Consequently, the professional mouthpiece for academic anthropology, the Anthropological Institute, had for some time been at pains to justify its existence as readily accessible on a broadly based popular educational level, a rigorous scientific level and on a practical level as the helpmate of the state. In 1904, anthropology was promoted as necessary because 'the proper understanding of native races and their relationship to each other is a matter of vital interest to us, if we are to govern justly and intelligently.'[4] By 1908, the journal of the (now Royal) Anthropological Institute is even more pragmatic in its desperation to appear indispensable to the colonial government, by rationalising the benefits of anthropology in the interests of the state:[5]

> Several of our distinguished administrators, both in the colonies and in India, have pointed out that most of the mistakes made by officials in dealing with natives are due to the lack of training in the rudiments of ethnology, primitive sociology and primitive religion. Numerous instances of the troubles arising from this cause can easily be adduced.[6]

It is important to emphasise here that both the earlier humanitarian sentiments, and the idea that anthropological knowledge would facilitate passive consent from subject races for British colonisation, coexist in the official discourse of the Institute over the first

decade of the twentieth century. This uneasy alliance was further complicated by the desire to maintain a degree of professional autonomy through the production of 'objective' scientific knowledge as well as a public profile that encouraged the definition of anthropology as a popular science, with the Institute claiming that 'it is necessary to try to spread the conviction that anthropology is not merely an academic science appealing to a few experts.'[7] By 1901, a lecture series had already been introduced by the Institute that was designed to be 'of a character readily understood without any special acquaintance with the mysteries of anthropological science.'[8] The necessity of academic credibility, however, prompted the rejoinder that this popularisation should not constitute 'an interference with our more specialised communications, which must always remain the foundation of our knowledge . . . There will be two kinds of audience as there will be two kinds of lecture.'[9] Furthermore, anthropologists' appeals for support for the discipline continued to be framed as a response to the competition posed by what was to become a serious threat to British imperial supremacy: Germany. Consequently, the spate of anthropological texts that came out after 1906 sporting the motto 'accurate but readable', and written by such eminent representatives of the science as Alice Werner, T.A. Joyce and Northcote Thomas, frequently railed, even at this relatively late date, against the British government's indifference in comparison to the German government's expansive support and recognition of German anthropologists.[10] The rancour of O.M. Dalton's early report on the wonderful conditions at German ethnographic museums continues throughout the years 1890 to 1913 in anthropological discourses, both for 'popular' and 'academic' audiences.[11]

In order to understand developments in the management of material culture from the colonies between 1890 and 1913 more clearly, it is important to acknowledge the degree of contact that took place between curatorial staff in different museums. Frequent communication between these institutions was a feature of museum bureaucracy, even if the museums concerned were not members of the Museums Association. Other publications and organisations existed for the exchange of ideas and progress reports, not only on a national but on an international basis, and in particular in relation to developments in North America and Germany.[12] Dalton's visit to Germany in June 1898 was reciprocated by German curators.[13] Such exchanges were commonplace during this period. Relations with museum staff in these countries were often premised on a highly competitive interchange, which also served as leverage to put pressure on their respective governments for more active financial support. Between curators within Britain itself however, the atmosphere, while not without an element of competition, was more mutually supportive. The annual reports of the three museums which are the focus of this analysis are evidence of the degree to which each took an active interest in the other's development. As curator of the Pitt Rivers Museum, Henry Balfour was a frequent visitor up and down the country, as was Alfred Haddon in his capacity as advisory curator to the Horniman Museum.

The objective of such exchanges was to make a comparative assessment of the organisational and more logistical and practical design features of the various displays. This meant that nationwide there were more features which museum ethnography sections held in common than in distinction. The degree of consistency adopted in the broad organisational principles, whether the main divisions of the display were geographical or morphological, had a particular consequence in terms of the representation of those

cultures on display. The 'knowledge' produced was more efficiently and thoroughly disseminated to the museum-going public in Britain because of the mutual reinforcement that resulted from the similarities in each display's organisation. This is not to suggest that together these institutions presented a seamless hegemonic construction of colonised peoples, but rather that the resolution of any contradictions in their representation in the museum imposed a uniformity that did not exist. Crucially, such attempts at uniformity did not always succeed.[14]

While it is apparent that during this period all large museums found it judicious to redefine their public image in terms of an educational prerogative, the ethnographic collections can be seen to have played a very particular part in this public relations exercise. It seems to me that an analysis of the way in which these collections produced, and continue to produce, knowledge through their physical arrangement is predicated on an understanding of the museums' self-conception of their function, and of the types of public that they claim to address at any given time.

I take the year 1902 as my starting point, when the Education Act announced the policy of 'Education For All'. The Act was an initiative which resulted in transformations in the educational system that had far-reaching consequences. More specifically, the 1902 Act also made provision for schoolchildren, accompanied by their teachers, to count visits to museums as an integral part of their curriculum; this, then, is an early indication of government recognition of the educational potential of such institutions. Another effect of the Act was to generate a series of debates within a professional body which is still the official organ of the museums establishment today: the Museums Association.[15] The focus of these discussions was threefold: concern with the problem of attracting a larger and more diverse public; proving the museum's capacity as a serious educational resource; and, in the case of the ethnographic collections, presenting the museum as a serious scientific resource. While the existence of such debates cannot be taken as a measure of the efficacy of any resultant policies, it does give a clear sense of the self-appointed role of museums within the state's educational programme at this moment.

1902 was a significant year in other respects since it marked the renewal of concerted strategies, by both contending parliamentary parties, to promote the concept of a homo-geneous national identity and unity within Britain. Imperialism was one of the dominant ideologies mobilised to this end. The Empire was to provide the panacea for all ills, the answer to unemployment with better living conditions for the working classes and an expanded overseas market for surplus goods. Through the policy of what was euphemis-tically referred to as 'social imperialism', all classes could be comfortably incorporated into a programme of expansionist economic policy in the colonies, coupled with the promise of social reforms at home. It was in this context that museums, and in particular the ethnographic sections, attempted to negotiate a position of relative autonomy, guided by a code of professional and supposedly disinterested ethics, while at the same time proposing themselves as useful tools in the service of the colonial administration. The degree to which the museum, as a site of the production of scientific knowledge and as the custodian of cultural property, can claim a position of relative autonomy from the vagaries of party politics and state intervention remains an issue central to an under-standing of the ethnographic collection's actual and possible role even today.

Anthropology's ambivalent position as simultaneously critic *and* advocate of govern-ment policies in the colonies, was reproduced in some measure in the ethnographic

collections at home. These trod a similarly forked path, as purveyor of objective scientific knowledge on 'neutral' territory on the one hand, and as propagators of an overtly imperial ideology on the other. The domain appropriated by ethnographic curators as their special contribution to the national education initiative of 1902 is indicated by their use of particular categories to define their public. All curators claimed that their public was representative of all classes, but the finer distinction of a scientific or unscientific public is a qualification reserved mainly for ethnographic or natural history collections. The specific roles assigned to ethnographic collections in the discourses on museums and education, produced from within the fairly catholic membership of the Museums Association, can only be fully understood in relation to that other public site producing knowledge of the colonial subject: the national, international, trade and colonial exhibition. Particularly relevant here is the fact that these extremely popular and well-attended events, held on massive purpose-built exhibition sites, nationwide, often mobilised the same heady rhetoric of education and national coherence which was to become the hallmark of the museum's appeal to the public at this time. The exhibitions become, in fact, a crucial element in gauging and comprehending the terms on which the ethnographic curators sought to define their domain, and to establish their distinctive contribution to the national education programme after the 1902 initiative. In the face of the much greater popularity of such exhibitions, differentiation was only expedient.[16]

The obstacles that faced museum ethnographic curators in their efforts to acquire the same mass audience as the exhibitions, without relinquishing any academic credibility, are exemplified through contemporary debates concerning the problems posed by the museum building. Through the internal organisation and classification, in conjunction with the inevitable restrictions imposed by the architecture itself, the museum guided its public through its collections in a specific though not always linear narrative, encouraging implicit, if not explicit, associations. In view of the claims of ethnographic curators regarding the popular, albeit 'scientific', accessibility of the presentation inside the building, it is significant that the exterior – in the case of the larger municipal and national collections – was often of the temple type design. The imposing and distancing connotations of this type of public building were fully appreciated by many contemporary curators, and resulted in a series of novel architectural schemes (mostly never realised) which were designed to overcome this obstacle.[17]

The colonial, national and international exhibitions, on the other hand, were notable for precisely the absence of such a monolithic structure and an apparent lack of any rigorously imposed control over the viewing space. This semblance of endless choice and unrestricted freedom was an important factor in the effectiveness of these exhibitions in obtaining a broad basis of consent for the imperial project. Through the rhetoric of 'learning through pleasure', the exhibitions achieved the sort of popular appeal that the museum could only dream of. Far more successfully than the museum, whose exhibits could only signify the colonised subject, the exhibitions literally captured these potentially dangerous subjects and reproduced them in a 'safe', contained and yet accessible and supposedly open environment. Together with the various dramatic re-enactments, the exhibition had the additional attraction of mock villages which were always favourites for press attention. Railway and other transport networks within the exhibition grounds had the effect, reinforced by the text in the guidebooks, of allowing the visitor to travel metaphorically from one country to another without ever having to

leave the site.[18] Consequently, they cultivated, at one and the same time, a sense of the availability and the containability of those societies represented. The 'villages' successfully fostered a feeling of geographical proximity, while the sense of 'spectacle' was calculated to preserve the cultural and physical divide.[19] The possibility of possession, as well as a sense of being an active participant at an event rather than simply a passive observer, was another aspect of the exhibition that was lacking in the museum experience. The vicarious tourism on offer was available to all who passed the turnstile at the entrance to the exhibition site, providing they had the sixpenny fee that allowed them access to the so-called villages. The ensuing competititon for the same broad public necessitated the implementation of certain policies in order for the ethnographic curators, in their capacity as museum administrators, to distinguish their appeal from that of the exhibition. Such strategies served not only to differentiate the two institutions but, more importantly, to legitimise the museum as the domain of the 'authentic' educational experience in the face of the 1902 initiative.

The debate around the use of *curio* and *curiosity* as generic terms for ethnographic material is a case in point. Throughout the first decade of the twentieth century, these terms were a bone of contention amongst museum ethnographers and early acknowledged by them as one of the major hindrances to any effective educational use of ethnographic material. As evidence of the severity of the problem, the *Journal of the Museums Association* published the following comments by an early visitor to the Liverpool County Museum's ethnographic rooms.[20] The visitor contended that one of the main troubles lay in the unfortunate fact that the public 'regard it as a storehouse of curiosities arranged to please and amuse. Certainly there are curiosities in every museum . . . though the fact may be insisted that their original and foremost purpose is to educate.'[21] The solution advised by the influential body of the League of Empire in 1904 was the 'orderly arrangement and the transformation of mere curios into objects of scientific interest by appropriate classification.'[22]

The early history of the Horniman Museum in London provides a colourful illustration of the eclectic display policy that the Association was up against. The Horniman is in fact a useful example of a museum founded from the start with a commitment to involving the local community, and to attracting a broad public which incorporated different sectors of the working classes. Apart from this feature of the Museum, it is significant in another respect. It was a collection which derived from one man's obsession for 'curio' hunting but was subject to the drive for ordered taxonomy, which subsequently transformed the idiosyncratic display into a systematic classification, once it passed out of private ownership and into the hands of the London County Council in 1901. As a private museum it was housed in the home of its founder and benefactor, the tea merchant, Frederick John Horniman. Initially opened to the public only on bank holidays and by appointment, increased demand resulted in its opening on three days of the week in December 1891, and the collection's dimensions expanded enough to warrant the construction of two extensions in 1893 and 1895. Attendance figures for Surrey House Museum until its inauguration as the Horniman Free Museum in 1901 clearly demonstrate the popular appeal of the collection from an early date. Numbers of visitors rose from 42,808 in 1891 to a phenomenal 90,383 in 1897.[23]

To a certain extent, then, the Horniman represented a cultural institution shaped in the mould of the Victorian philanthropic ideal, set up for the use of both the middle classes

48. An article on the munificence of Frederick Horniman in handing over to the public his collection at Surrey Mount. Horniman Museum Cuttings File 1888–1901. Cutting dated February 1891.

(the main inhabitants of the leafy, prosperous Forest Hill suburb), and the working classes, but with a special concern for encouraging working-class interest and access (figs 48 and 49). Early annual reports prior to its opening to the public as the Horniman Free Museum provide ample evidence of the range of societies and parties, most of which were local, who made use of the collections. The annual reports for 1891 to 1892 mention Horniman giving over the Museum to the Committee of the Metropolitan Association for Befriending Young Servants.[24] Representative of the period up to 1913, the Lads' Rest (Dulwich), South Place Institute Ramblers Club, Nunhead Passage Board School, Girls Industrial Home (Forest Hill), private, church and board schools, the Worshipful Company of Bakers, and the Working Men's Club and Institute (Clerkenwell and Deptford) as well as the Dulwich Scientific and Literary Association are examples from the annual report of 1893.[25] These details are less interesting as a catalogue of philan-

49. Detail of fig. 48 showing the interior of the Horniman Museum.

thropic largesse than as an indicator of the frequency with which the Museum was evidently seen as an appropriate site for either edification or leisure, or both, by a considerable working-class community.[26] That the Horniman was one of the earliest museums to produce a series of public guidebooks to the collections is another factor which corroborates the Museum's concern to generate interest in the collections amongst a broad public. Despite some success in attracting the kind of public advocated in the various policy statements from both the Museums Association membership and the Anthropological Institute, it is none the less evident that the character of the collection and the focus of its displays conformed in most respects to precisely the sort of arrangement that the Museums Association was fighting to suppress.[27]

Prior to the Museum's transferral into the hands of the London County Council in 1901, descriptions of the Ethnographic Gallery focused on either the slave-trade or material culture from societies like the Dahomeyans or the Zulus, both of whom were identified in the popular consciousness as aggressive African fighters with a penchant for human sacrifice and gratuitous violence.[28] Such exhibits functioned in a similar way to the Spanish 'Torture Chair' from the Inquisition. The terms of the description are exactly equivalent, and in the guides themselves there is little ambiguity concerning other items of African material culture. Spaces that do exist for a possible re-evaluation of the popular mythology constituting the African as a mindlessly violent savage, would seem from the guide to be closed over by the reiteration of descriptive terms such as 'curio' and the persistence of the 'trophy' form of display.[29] Before entering the African and Japanese Room, the visitor would have passed through the Annexe where a collection of 'deities' from China, India, Scandinavia and Peru were on offer, together with a Buddhist shrine and 'a Chinese banner fixed on the wall', as also a 'skeleton in the cupboard, the bones and ligatures all shown and named; it is labelled: – "the framework on which beauty is founded".'[30] Glass table cases in one room contained Swiss, African, Eskimaux (sic.) Indian, Japanese and Chinese ivory carvings and a collection of Meerschaum pipes, while on top of such cases 'are ranged glass Jars, containing Snakes, Lizards, Chameleons and a strange looking spiny lizard from Australia, together with a chicken with four legs and

four wings but only one head, hatched at Surrey Mount' (the museum's earlier name).[31] The visit culminated with a walk through the Zoological Saloon and a meeting with the much publicised Russian bears, Jumbo and Alice, and the Sal monkey, Nellie! (See figs 50 and 51.)

What is perhaps most significant about this example is that even here, where it is clear that little could be claimed by way of classification in any sense that might be deemed scientific, the middle-class viewer was too thoroughly steeped in evolutionary doctrines in relation to such material to avoid their association with any interpretation of the displays. The arrangement was neither geographical nor typological at this point but the paradigm is implicitly apprehended, if not explicitly applied, so that the author of a series of twenty-

50. *Guide to Visitors*, Surrey House Museum (16 January 1890).

51. Poster advertising the Surrey House Museum prior to its inauguration as the Horniman Museum in 1901.

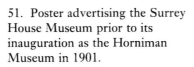

one articles on the Horniman Museum, published in the local paper, could confidently assume when treating the African collections that:

> Although these have very little fascination from a picturesque point of view, yet they are attractive to us because they portray the vast difference that exists between the civilised and uncivilised races of the world. The dress, the weapons used, the domestic utensils and other articles seem so peculiar to the Western eye that it is almost impossible for us to imagine that at one time in the annals of Great Britain a similar state of affairs existed.[32]

Such evolutionary assumptions were apparently not incompatible with other sections of the same series where the author could write of the ivory carvings in the centre of the Long Gallery: 'African exhibits consist chiefly of elephants tusks carved with figures in high relief, bracelets, anklets, war horns etc., from the interior and a beautifully carved tusk of a hippo.'[33] Futhermore, as early as 1894 some reviewers were claiming that while 'a few years ago museums were looked upon as musty places containing only curious and odd curios: that idea is now fast dying out.'[34] The Horniman and the Pitt Rivers Museum in Oxford were then held up as the two model institutions 'where specimens of the industrial arts of all nations are classified and grouped . . . under their various headings.'[35] Evidently, anything taken as a form of organisation was often perceived through the prism of evolutionism.

The debates in the Museums Association over the classification of ethnographic material in this country were considerably more complex and comprehensive than the resultant displays. The proposals revolved around the choice of a geographical or a typological organisation, and the relevance of either for different types of anthropological museum. The general consensus delegated the former as the responsibility of the national collections and the latter as that of the local museums. The material at hand was generally recognised as falling into the two categories of a biological unit and a cultural unit. Ideally, since 'man's physical evolution and anatomical structure related directly with all his activities', race and culture were assumed to be 'intimately connected', and the objective for the curator was to demonstrate the relationship between these two aspects.[36] Sub-divisions, according to tribe and nation, provoked discussion that provides us with a particular insight into the function of ethnographic collections in Britain. In this case, colonies as a category acquired the status of a homogeneous 'nation', as part of the British Empire.[37] Evidently, 'nation' by this definition was too large a category to be practically implemented in the museum! Nevertheless, the fact that a territorial possession of the British Empire had no recognised status as a nation outside the Empire as a whole, evidently had particular ramifications for any colony represented in the displays. Clearly, material culture from these countries functioned primarily as signifiers of British sovereignty. Above all, in this search for the perfect classification system, there was the certainty that somewhere there existed a 'natural' grouping. Since culture was seen to vary according to geographical and regional factors, and since environmental factors created regional affinities within the same groups, the 'natural' choice was thought to rest with a geographical classification. This was the arrangement selected by most large British collections.[38]

The other system advocated for smaller, local collections was the morphological or typological; the most exemplary then, as now, being the Pitt Rivers Museum in Oxford.

The theoretical premise that the past could be found in the present was explicitly laid out here, by the inclusion of archaeological exhibits, mainly weapons and implements, from the Stone, Bronze and early Iron Ages, alongside series of ethnographic material. It was this type of organisation that was thought to illustrate more specifically the evolutionary nature of man. It concentrated on series of objects from all over the world, grouped according to function, and divided into small exhibition groups, with the aim of suggesting an evolutionary progression by placing those forms classified as more 'natural' and organic at the beginning of a series, and culminating in more 'complex' and specialised forms.[39] A feature of the Pitt Rivers collection which sets it apart from others originally the property of one collector, such as Frederick J. Horniman, was that it was widely acknowledged as being 'no mere miscellaneous jumble of curiosities, but an orderly illustration of human history; and its contents have not been picked up haphazard from dealers' shops, but carefully selected at firsthand with rare industry and judgement'.[40] The classification system employed was the touchstone of the collection, and it was this aspect that recommended it as a model for so many other museums.

The principle on which the collection was based was described as: 'akin to that employed in the arrangement of most Natural History Museums, the objects being grouped according to their, as it were, morphological affinities and resemblances, all

52. Plate showing the evolutionary relationships of Australian weapons. Augustus Lane-Fox Pitt Rivers, *The Evolution of Culture and Other Essays* (Oxford 1906).

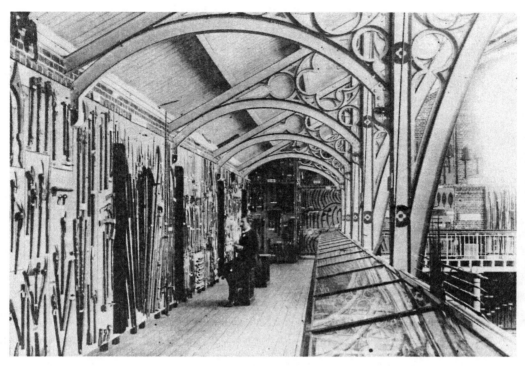

53. Henry Balfour in a gallery of the Pitt Rivers Museum, showing typological classification *c*.1895. Courtesy of the Pitt Rivers Museum, University of Oxford.

objects of like form and function being brought together into groups, into genera and species.'[41] Pitt Rivers' intended function for his collection was to provide what Balfour went on to call a 'Natural History and Phylogeny of the various arts and industries of mankind.'[42] In view of the sensitivity over such labels as 'curios' and 'curiosity', the Pitt Rivers Museum represented a welcome development to the newly established professional caucus of the Museums Association. In line with the morphological emphasis of the arrangement, synoptic series of objects sharing the same function or form were grouped together. These came from all over the world, and were thus also designed to elaborate the geographical distribution of any class of implement, to show local and regional variations and to show the possible diffusion of different objects typologically similar (fig. 52). The inference from this was that it was also apparently possible, through an analysis of probable 'lines of dispersal', to chart the migration of races themselves.[43] Furthermore, these series were arranged in such a way as to set up a specifically evolutionary paradigm, beginning with 'those objects which appear to be the most 'primitive' and generalised of their class, and leading gradually up to the higher and more specialised forms' (fig. 53).[44]

While the original collection (assembled by Pitt Rivers and given to Oxford University in 1883) consisted of both archaeological and ethnographical material, it was the rationale that attached so much importance to the ethnographic elements which concerns us here. This was summed up by the collection's first curator, Henry Balfour:

There can be little question that in the various races of modern savage and barbaric peoples we have instances of 'survival' from early conditions of culture, as also of physical development; that many of these races are, in fact, not only low in the culture scale, but also essentially primitive; that their upward progress has from various causes been arrested or retarded, and that they have thus dropped behind in general advance towards civilisation.[45]

From this follows the, by now familiar, thesis that through a study of the ethnographic material presented as living survivals of our European prehistory, it was possible to supply the missing link that the archaeologist needed in order to provide a complete history of European man. The insistence on the singular importance of ethnography for archaeology is particularly characteristic of Pitt Rivers' hypothesis.

This comparative and evolutionary system of classification, which placed the value of anthropology as 'tracing the gradual growth of our complex systems and customs from the primitive ways of our progenitors', through the use of material culture from extant peoples all of whom were colonised, was the chosen taxonomy throughout this period.[46] Despite academic anthropology's increasing disenchantment with evolutionary theory at this time, it remained the most prevalent means of displaying ethnographic material.[47] Even where this was not necessarily the case in museums, it is clear that this principle had acquired considerable currency amongst many members of the museum public. In 1902, for example, the British Museum erected an exhibition in the Pre-Historic Room to demonstrate the use of tools and weapons prior to the use of metals. A review of the exhibition, in the *Standard*, draws the reader's attention to the ethnographic galleries 'which should be visited, in order to study perishable objects still in use among races in a stage of culture corresponding more or less closely to that of the prehistoric races by whom the objects in this [the Pre-Historic] room were made.'[48] It is important to recognise that whether or not it was intended by ethnographic curators at the British Museum, it is symptomatic of the conjuncture that existed in the public consciousness that the reviewer was able to make such a comparison between the two rooms. Moreover, there is also evidence that the evolutionary paradigm served as a direct means of promoting support for that concept of class unity which was so essential to the ideology of social imperialism. Once accepted by Oxford University, the Pitt Rivers collection was subsumed under the overall conception of the function of the larger University Museum. Unlike the Mayer Museum in Liverpool, the University collection did not see itself as primarily a 'popular' public institution although this was grudgingly accepted as one of its functions.[49] Rather, 'the first and main purpose is undoubtedly to assist in the educational work of the University by illustrating the teaching of the professors and lecturers.'[50]

However, although the primary objective of the Oxford museum was to facilitate academic research, Pitt Rivers was no newcomer to the concept of the museum as an institution with a broad educational role, appealing to a diverse public. Indeed, he actually saw himself as one of the main progenitors of this initiative. The early history of the collection included a short sojourn in 1897 at the Bethnal Green Museum in London's East End. It is not insignificant that it was located in an area of social deprivation and class conflict. In line with other similar institutions during the 1870s, the exhibits were used as an aid in the task of 'improving the masses'. Pitt Rivers's own intentions towards the working classes were quite explicitly set out in relation to the use of his collection.[51] His

lecture to the Royal Society of Arts in 1891 makes it clear that not only was it important that the schema of the display conform to a scientific classification, but that it was designed to educate 'the masses' to accept the existing order: 'The masses are ignorant . . . the knowledge they lack is the knowledge of history. This lays them open to the designs of demagogues and agitators, who strive to make them break with the past . . . in drastic changes that have not the sanction of experience.'[52]

In the light of this statement, the persistent preoccupation with evolutionary theory takes on new and more explicitly political overtones. Through its tangible exposition in the physical arrangement of ethnographic collections, it was a paradigm which emphasised the inevitability and indispensibility of the existing social order and its attendant inequalities, while also stressing the need for a slow move towards technological advancement.[53] The opportunity which such a thesis provided for a dig at the 'new woman' was not lost on Pitt Rivers. Describing a series of crates shown carried by women from various countries he went on to remark that these were 'collected expressly to show the women of my district how little they resemble the beasts of burden they might have been if they had been bred elsewhere.'[54]

Where Pitt Rivers is explicit in his political affiliations in relation to class interests (while still maintaining, of course, that science was essentially objective and non-partisan), later uses of evolutionary theory and of its exposition in his collection were less overtly concerned with social control. Nevertheless, it was one of the most long-lived paradigms for the organisation of displays of material culture from the colonies, and there are certain features of later applications which reproduce the political assumptions of this earlier model. In both typological and geographical arrangement, for example, cultural elements characterised in the Museum's literature as 'the intrusive, generalised elements of civilisation' of the non-European cultures were deliberately eliminated. The curator was well aware that 'modern civilisation has broken over all natural limits and by means of railroads and ships carries its generalised culture to the ends of the earth.'[55] The resultant transformation brought about by this contact, however, was not the designated domain of the ethnographic curator.[56] For the material in these displays then, and by implication the cultures they represented, time stood still.

As a means of validating the expansion of ethnographic collections, the rhetoric often employed was one of the necessity of conservation and preservation in the face of the inevitable extinction of the producers of the material culture in their custody.[57] Paradoxically, of course, anthropology's desire for government funding in the museum context, as in the academic sphere, necessitated its aiding and abetting this extinction by proposing itself as the active agent of the colonial government. By speeding the inevitability of such destruction, anthropologists encouraged the expansion of a market in ethnographica, and boosted the already multiple values assigned to the discipline's objects of study. Thus the status of anthropological knowledge was enhanced, while simultaneously ensuring that those societies who produced such material culture maintained their position at the lower end of the evolutionary scale, since they were destined not to survive.

Unlike the international and colonial exhibitions, the colonised subject was not available in 'the flesh', and had to be signified by some other means. By 1902, the principle that physiognomic characteristics were accurate indicators of intellect and morality, early ingested as a tenet of certain anthropological theses, acquired new potency through its association with the eugenics movement, now marshalled to the aid of the state. If

evolutionism had ever looked like wavering, it was now here to stay. Consequently, in museum displays of material culture from the colonies, it was common practice to include photographs, casts of the face or of the figure, or even skeletons and skulls, to enhance the exhibit. These were supposed to demonstrate more nearly the relationship between the inherited and cultural features of any race since, 'the man himself as he appears in his everyday life, is the best illustration of his own place in history, for his physical aspect, the expression of his face, the care of his person, his clothes, his occupations . . . tell the story with much clearness.'[58]

In 1903, the Physical Deterioration Committee had recommended the setting up of an Imperial Bureau of Anthropology, whose anthropometry section was to be responsible for the collating of data on the physical measurements of those races coming under the jurisdiction of the British Empire.[59] Despite the fact that by 1908 the Royal Anthropological Institute was still fighting for some government support for the scheme, anthropometry had already been put to considerable use by anthropologists working within the British Isles.[60] The Physical Deterioration Committee, under whose aegis anthropometry came into its own in the following years, had originally been set up in response to medical reports on the poor state of health of the working classes.[61] While this generated concern about the social circumstances of the mass of the population, the ensuing debate around the issues of deterioration versus degeneration was fuelled by the eugenists, who were still mostly convinced of the biological and inherited, rather than environmental, determinants of such a deterioration. If this complex 'scientific' philosophy had ambiguous implications for the working classes, its implications for colonised peoples were no less insidious.[62]

The ethnographic curator's insistence that a person's physiognomy and the expression of the face could designate their position in history takes on particular significance in the context of this preoccupation with, and popular visibility of, the 'science' of anthropometry. The emphasis on the body as a feature of museum display would have made it difficult to avoid an association with the work of Francis Galton or Karl Pearson, especially at a time of increasing government advocation of eugenics (often in conjunction with anthropological investigations), as a means of strengthening the national stock. Evidently, the Museums Association was fully aware of eugenics policies and the means by which the ideology of selective breeding was implemented as part of a policy of national regeneration. That the 1907 presidential address of the Association reads like a eugenics tract, therefore, now comes as no surprise. At this meeting, a proposal was put forward for an Institute of Museums where once again the emphasis was educational, but where, significantly,

> of equal importance would be a regard for heredity teaching, seeing that the teaching of evolution must be based upon it. Here the endeavour would be to instruct the public in the part that inherited traits, character, virtues, vices, capabilities, temper, diseases, play in the destinies of men . . . and to popularise such branches of the subject of heredity as selection, variation and immunity.[63]

Because of the currency of such thinking in the museums establishment, and by the anthropological contingent in particular, it is my contention that ethnographic displays would have reinforced certain aspects of eugenic philosophy. The fact that this practice of scrutiny, so close to the prevalent eugenic ideology, is present to such a degree in

the discourse of the Museums Association is another indication of the museums' willingness to participate in the state's concern for national regeneration, and points to a further complex of meanings for the objects in their collections that was far closer to home.

One means of gauging the potential of the ethnographic collections, both as vehicles for a nationalist ideology and as sites for the proliferation of contradictory and possibly productive knowledge concerning the colonial subject, is through an examination of the discourses around education in the literature of the Museums Association for the period 1902 to 1913. It is through these discourses that museums constituted their 'ideal' public, and consequently the ideal function of the collections in their custody. Much of the discussion was formulated as a result of renewed interest in a concept known as the 'New Museum Idea'. The primary objective of this was to 'afford the diffusion of instruction and rational amusement among the mass of the people' and only secondly 'to afford the scientific student every possible means of examining and studying the specimens of which the museum consists.'[64] The museum was thus designated as provider of both 'rational amusement' and 'scientific study' for two distinct publics while prioritising one. What is particularly telling here is that the 'New Museum Idea' was anything but new by 1902. Between 1902 and 1913, however, the need to attract what was loosely referred to as the 'mass of the people', is revived as one of the central concerns for museum curators. How then was this purportedly liberal extension of the democratic principle of 'education for all' transformed, through the institution of the museum, into a discourse inextricably implicated in imperial ideologies?

The notion of an educational practice based on the careful observation and study of museum collections had already been integral to both the Victoria and Albert Museum and the National Gallery from their inauguration in the 1850s. Here, also, the policy was designed to attract a certain sector of the working classes.[65] Although this early initiative came primarily from a left-wing middle-class intelligentsia, demands from within the working classes for effective educational provision were later met by workers themselves through the Social Democratic Federation and other socialist organisations.[66] The fact that 'rational amusement for the mass of the people' was reintroduced as a focus of debate amongst curators within the museums establishment in 1902, by which time the composition of the working classes had altered considerably, suggests a new function for this concept. With the rise of socialism and the subsequent organisation of a large proportion of the working classes, they presented enough of a constituency to be a major target in the electoral campaigns of both the Liberals and the Conservatives throughout the period under discussion. If the museums wanted to carve out a role for themselves compatible with either party's campaign, it was essential that they were seen to address a broad sector of the public.

By 1902 it is possible to determine more precisely the public that was sought by the museums. The Education Act of this year had made provision for time spent in museums by children accompanied by their teachers to count as time spent in school. The *Museums Journal* of the same year expressed the hope that museums could occupy a territory 'neutral' enough to provide a common meeting ground for children from 'different class backgrounds' in so far as those from private, board and voluntary schools were seen to benefit from the Act in this respect. Furthermore, in conjunction with such adjectives as 'neutral' and 'objective', the museum was proclaimed as

the most democratic and socialistic possession of the people. All have equal access to them, peer and peasant receive the same privileges and treatment, each one contributes in direct proportion to his means to their maintenance and each has a feeling of individual proprietorship.[67]

The notion of the museum as an institution that transcended class barriers is particularly significant, not only in the light of the persistent claims for class unity made by organisations dedicated to juvenile education reform, but also in view of the constancy with which this rhetoric was applied in organisations dedicated to the 'ideal' of Empire, who also mobilised the pedagogic apparatus. One such organisation was the Primrose League. This was a group that specialised in popularising Empire through lectures in rural districts and was founded in 1883 with the objective of 'joining all classes together for political objects . . . to form a new political society which should embrace all classes and all creeds except aetheists and enemies of the British Empire.'[68] By 1900, the League claimed to include in its membership one and a half million workers and agricultural labourers. The Empire Educational League was another such group dedicated to lecturing 'for the benefit of the wage earner.'[69] By 1909, 2s 6d could procure annual membership and a free copy of *Our King and Empire!*[70] The special role of the museum for that sector of society described as having no life 'but this life of making money so that they can live', was 'to elevate people above their ordinary matter-of-fact lives.'[71]

By 1904, both the Horniman and the Manchester Museum were making claims for the conspicuous presence of both school groups and working-class participation. An exchange in the *Museums Journal* of the same year indicates the degree to which this was now a sensitive issue, in this instance, in the case of ethnographic collections. Free public lectures by A.C. Haddon had come in for sharp criticism, since, 'The time for delivery . . . is 11.30 am which showed that they were not altogether intended for the labouring classes.'[72] The Horniman felt this rebuff keenly enough to respond that despite this unfortunate time schedule 'large parties of workmen from various institutions . . . visited the museum.'[73] Other initiatives were devised to increase the allure of the museum. The Liverpool Museum, for example, was one of the earliest free public museums to establish a tradition of mobile cabinets filled with museum specimens and circulated to schools in the area as part of a systematic educational policy.[74] By 1890, pastors, teachers, and others lecturing locally on topics related to the Museum's collections were making full use of the service.[75] News of the scheme's success travelled as far afield as Australia and North America and by 1904 various education authorities in these countries were writing for more information.[76]

The Pitt Rivers collection was also at the centre of a similar controversy regarding its public. Once the collection had moved to Oxford in 1883, there were immediate conflicts of interest amongst those bodies responsible for its management. Some groups lobbied for a more direct relevance for the general public, while others were intent on mobilising the collection as a means of pressing the University into a commitment towards, and investment in, the discipline of anthropology. The struggle in Oxford for recognition of the subject from the University bureaucracy parallels the struggle between the ethnographers and anthropologists responsible for the ethnographic collection at Cambridge and their University administration.[77] In Oxford, the institutional emphasis persisted, and occasioned the recrimination from Pitt Rivers himself that his choice of Oxford as the

final resting place for his collection had been made as a last resort through the necessity of completing unfinished business before illness made activity impossible.[78]

Such conflicts of interest are a feature of the correspondence between those involved in the running and curating of the Museum, which was Balfour's domain from 1891, and those responsible for the use of the collection for University teaching, which was the prerogative of Edward Burnett Tylor. The debates in Oxford and Cambridge are symptomatic of the dilemma of promoting such museum collections as both a popularly accessible storehouse of interesting 'facts' about the colonies, and a scientific repository whose mysteries could only be unlocked by those initiated into the new science of anthropology. These debates were one of the hazards encountered on the long road to the establishment of anthropology as a recognised component on the academic curriculum at degree level.

The history of the acceptance of anthropology onto the curriculum at Oxford is well-known, but is worth setting out briefly here in order to emphasise the slow pace at which such developments occurred.[79] The diploma course in anthropology was founded by statute as late as 1905, the first of its kind to be inaugurated in the country. This was despite the fact that Tylor had been Reader in Anthropology since 1884, and Keeper of the University Museum since 1883, and had immediately made use of the ethnographic collections for demonstrations, supplemented by lantern slides and large wall charts.[80] The annual reports testify to the use made of the Pitt Rivers collection by those students on the diploma course, and to the existence of a lecture series especially designed for the probationers for the Sudan Civil Service.[81] This was not achieved, however, without a considerable battle in order to maintain the Museum in any form at all, and to obtain some type of regular funding. The early history of the collection in its new home at the University was dogged by debacles with those committees responsible for the funding of the institution.[82] The first examinations for the diploma took place only in 1908, and it was not until 1914 that there was actually a Department of Social Anthropology with administrative and financial autonomy.[83] Tylor's campaign to see anthropology established as a *bona fide* subject at Oxford attracted attention and support for academic anthropology, and for the Pitt Rivers collection, which thus received a considerable amount of public notice in Britain and abroad.[84]

If Tylor's concern lay primarily with the development of anthropology within the university system, Balfour's interests lay in promoting a wider usage for the collection. In this respect, despite the rather belligerent correspondence between himself and Pitt Rivers, Balfour was one of his staunchest supporters. Indeed, in 1891, Balfour drew up a proposal for a public guide to the collection. Significantly, it was never published, but it is interesting as a policy document. The guide identified the ideal public which Balfour envisaged for the collection. It was to be 'for the use of the general unscientific public, and as such should not be of a detailed character but dealing with the leading points of the various series, so as to convey a general idea of the object of each series.'[85] In addition, Balfour thought that any series might benefit from placing the relevant text from the guidebook alongside the exhibit in the Museum 'for the benefit of those who do not purchase the guidebook.'[86] Sketches, photographs, maps and diagrams were incorporated into the display in order to increase the educational value of the series exhibited and in order to 'explain the nature of the exhibited specimens' to the more general public.[87]

That the demand for such information came from the Museum's visitors themselves is evinced through their criticism of its overdependence on the presence of an 'expert' in the form of either Tylor or Balfour in order to render the collection pleasurable and instructive. Balfour indignantly refuted the charge with the comment that the collection had 'come to be one of the most popular exhibitions in the University. I have considerable opportunities of studying the "museum visiting public" and find that it derives both considerable and much instruction from the greater portion of the collection.'[88]

Written in the first year in which the whole building was open to the public, it is a measure of the Museum's success that Balfour felt confident enough to expand, at the earliest opportunity, on what he claimed to be the already considerable popularity of the collection with both a scientific and a general public.

Obviously, one should not take intention as a measure of effectiveness, but it is important to point out here that the fact that both museums and other public displays of material culture from the colonies felt in some way obligated to define their public as having a large working-class component, *and* in terms of an educational priority, is significant in itself, whether or not it was successfully implemented. This priority can be understood more easily in the context of the dominant political strategy of social imperialism, a policy designed to unite all classes, in the defence of nation and empire, by focusing its campaign on convincing the working classes that their interests were best served by the development and expansion of empire.[89] It is evident, as early as 1902, that the museum's concern with constructing its image as an organ for popular education was indeed specifically calculated to ensure that it had a recognised part to play in what was acknowledged at the Museums Association annual conference that year, as the 'one great national work, the building up of the Empire through the elevation of the communities and the individual.'[90]

In 1903, this declared allegiance was compounded by the formation of the League of the Empire, founded with the aim of bringing children from different parts of the Empire into contact with one another, and 'getting them acquainted' with parts of it other than those in which they lived, through correspondence, lectures and exchanges.[91] The museums played a crucial role in this organisation, and one which was clearly signalled by the distinguished line-up of museum directors and officials heading a sub-committee entitled 'School Museum Committee'. By 1907, the Museums Association was congratulating itself on the rather ambitious and dubious achievement of 'splendid success in educating and refining the masses of the population.'[92] The assumed role of the museums as specifically popular educators, concerned with encouraging working-class participation, received a further fillip of approval through a symposium organised under the aegis of the Empire League Educational Committee.[93] This eight-day conference, held in London in 1907, had a special interest for those involved in museum work. A section was inaugurated specifically to deal with museums and education. Even outside of the parameters of its own professional caucus, it should now be clear that the museum was recognised as an important element in furthering the objectives of the Empire.

Any interpretation of this educative principle advocated by both Leagues as simply a benevolent paternalism making use of Empire as a potential 'living geography' lesson, should be dismissed by 1908. By this time it had been transformed into a more specific call for the recognition of the superiority of the European races:

> The progress of colonisation and commerce makes it every year increasingly evident that European races and especially those of our own islands, are destined to assume a position in part one of authority in part one of light and leading, in all regions of the world.[94]

Consequently, since the British assumed the position of the world's teachers, it was essential that they were themselves well taught. As late as 1909, the relevance of education, especially through the use of ethnographic collections, was as persistent a theme in general museums discourse as it was in the discourse of the professional body of academic anthropology, the Royal Anthropological Institute. Where the emphasis shifts somewhat is in relation to that public which it constitutes as its object. Despite the fact that the membership was often the same in both official bodies, the Museums Association discourse is more class specific:

> Heaven-born Cadets are not the only Englishmen who are placed in authority over native races . . . There are Engine Drivers, Inspectors of Police . . . Civil Engineers of various denominations . . . to mention only a few whose sole opportunity of imbibing scientific knowledge is from the local museum of the town or city in which they have been brought up.[95]

It can now be appreciated that a certain sector of the working and middle classes were an indispensable component in the museum establishment's promotion of an image of itself as the site of consummation of a seamless and unproblematic national unity. Furthermore, the fact that the terms of this Museums Association address are borrowed in no small measure from a 1907 speech by that ardent exponent of social imperialism, the Liberal M.P. Viscount Haldane, places it firmly within the network of interests that have just been delineated.[96]

Within these ideologies, the ethnographic curators negotiated a special role for themselves. In an educational capacity, they operated in the conjuncture between popular and scientific theories of race and culture, and thus acted as an agency for often competing imperial ideologies. There is, however, an ambivalence underpinning the relationship of the ethnographic curators to the colonial government. By declaring that their aim was to provide 'objective' education on 'neutral' territory, those anthropologists working within the museums establishment claimed a degree of independence from specific government policies. The emphasis on the 'scientific' nature of the knowledge produced through the classification and organisation of their collections was calculated to reinforce their role as purveyors of 'objective truth'. At the same time, as a strategy of survival, the new academic discipline of anthropology relied on the argument that anthropological knowledge, as produced through museum collections, was an essential training for the colonial civil servant and an indispensable facilitator in the subjugation of the colonies. Furthermore, the social Darwinist focus of the evolutionary paradigms for representing material culture from the colonies to the British public, reinforced some of the worst aspects of those racial stereotypes disseminated through the more overtly propagandist international and colonial exhibitions. In fact, the popularisation of anthropology as a means of attracting the broadest possible public resulted in a highly selective and doctored version of anthropological theory being appropriable by parties with distinct vested interests in colonisation. Paradoxically, the science's accessibility speeded the disintegration of a

division between the 'scientific' and the 'popular' which it sought to maintain. At the same time, this accessibility ensured that the often derogatory images of African culture and society, that we have already encountered, were able to derive more credibility through their relationship to the supposedly separate specialist sphere of scientific knowledge.

CHAPTER 7

CONTAINING THE CONTINENT: ETHNOGRAPHIES ON DISPLAY

What place did the African continent occupy within the broader schemes of the 'new museum idea', promoted by that relatively new breed, the professional museum curator? What kind of knowledge was generated from the impetus to use ethnographic collections as the basis of an 'objective' education, and was such knowledge completely over-determined by the burden of Darwin's legacy? This chapter focuses more extensively on the three ethnographic collections discussed previously. Each exemplifies a different aspect of museum ethnography, and the conditions which facilitated its development in Britain. In addition, moving away from a concentration on London creates a better picture of both the diversity and homogeneity of regional and local representations of Africa.

The Horniman Museum provides an example of a collection which transferred out of private hands into the public domain, changing from a rather idiosyncratic to a more systematic collecting policy. The Pitt Rivers Museum, although constrained by the conditions for its maintenance and display set down by its founder, is a collection partly developed in response to the needs of the zoological, and later the anthropological, departments at Oxford University. It represents the tension between the academic and the more popular domain. The curators of these museums, Haddon and Balfour, were very much representative of those committed to the 'new museum idea' and concerned with popularising their collections through the medium of their respective museums. The Liverpool County Museum, or the Mayer Museum as the ethnographic collection was then called, had a particular stake in things African, due to its geographical and economic location in a major port with a history of trading relations whose ignominious beginnings went back to the slave-trade. Because of this, its collection was one of the largest and fastest-growing in Britain from 1890 to 1913, second only to the national collection at the British Museum. All these museums reflect the contemporary interrelation between natural history and ethnography, and, unlike the national collection which was a universal survey museum, the majority of their entire exhibits fall within these broader categories. Their proximity encouraged an analogy between the objects of both ethnography and natural history.

I

The present Merseyside County Museum in Liverpool was launched on the strength of two collections: Lord Derby's natural history collection, opened to the public on 18th October 1861, and Joseph Mayer's donation in 1867 of a large collection of material ranging from Anglo-Saxon, Egyptian and Assyrian origin to carved ivories from Africa

and local pottery.[1] As a demonstration of its standing nationwide, it could claim by 1898 to have had more visitors to its collection than the British Museum.[2] The Museum obviously saw itself in some senses as the British Museum's regional competitor, and the annual reports are full of comparative jibes to this effect. The curatorial staff were ambitious in their desire for national recognition, and dedicated to pursuing policies which would promote such a status.[3] By 1906, the much envied German ethnographic museums establishment clearly considered that the Liverpool Museum had achieved its objective. Dr Meyer, director of the Royal Museums at Dresden, was sufficiently impressed with the collection to remark that the newly opened ethnographic section was, 'next to London, the most comprehensive, and in all respects one of the best in Great Britain.'[4]

The fact that so much of the material in the collection was provided through the munificence of local shipping firms and their employees, contributed in no small measure to the degree of local interest and pride rarely shared by many other collections. The Elder Dempster Shipping Line is a case in point. By 1898, its director, Sir Alfred Jones, had already provided money for the founding of the Liverpool School of Tropical Medicine, and was later a chairman of the Institute of Commercial Research in the Tropics, founded in 1900. One of the most powerful Liverpool shipping magnates, he had a high public profile in connection with West Africa as, among other things, founder of the Bank of British West Africa in 1894 and the Empire Cotton Growing Association in 1902, with interests in both the Sudan and Nigeria. By 1902, he was a frequent contributor to the African collections of the Liverpool Museum. As director of Elder Dempster, he not only allowed free passage for African objects but also provided the same service for certain individuals. One of Jones' most renowned guests was Edward Blyden, who was frequently given free passage between Britain and West Africa and was entertained by Jones in Liverpool whilst lecturing on African issues to the city's extremely lively geographical society or the local Chamber of Commerce.[5] This was despite the fact that Jones later became the *bête noir* of Edmund Dene Morel's Congo Reform Association, because of his tacit condoning of the atrocities in the Congo through his involvement with trade in the area as a Congo concessionaire and as Consul in Britain for the Congo Free State.[6]

To consolidate the company's investment in the cultural life of the city, Elder Dempster had an agreement with the Museum which enabled Arnold Ridyard, a chief engineer with the firm, to arrange for free transportation to Liverpool of any items he donated to the Museum.[7] The fact that Ridyard was already fully employed in a demanding occupation is interesting in so far as it indicates a particular dedication and personal interest in ethnography. This was no passing commitment, but a long-standing agreement between Ridyard and the Museum. Throughout the period 1893 to 1916, Ridyard remains the single most prolific contributor to the West African collections. Almost without exception, the annual reports on the progress of the ethnographic department culminate in a vote of thanks to him. His diligence is a perfect vindication of the sentiments expressed in Viscount Haldane's speech of 1907, and the Museum Association's advocacy of the same in the 1909 presidential address.[8] Here indeed were the 'Engine Drivers . . . and Civil Engineers of various denominations' virtually single-handedly maintaining a whole department!

While many of the items were collected personally by Ridyard, others were collected

by government officials and, interestingly, by West Africans themselves, donated via Ridyard for transportation to the Museum.[9] Evidently, the support and constant collecting activities of government officials or merchant employees, from at least 1897, was an essential ingredient in the success and expansion of Liverpool's Mayer collection.[10] Had the support from this sector not been as consistent, the frequent comparisons with the national collections would very likely have seemed ridiculous. The extent and range of Ridyard's contacts, and the co-operation he received from government officials, colonial administrators, missionaries and local African inhabitants, is an exemplary demonstration of the diverse interests invested in the traffic in ethnographica in the late nineteenth and early twentieth centuries. To a certain extent, of course, it represents a personal triumph in terms of Ridyard's own powers of persuasion. However, it is also clear that those who collected for him in the field revealed unusual perseverence in the face of often quite considerable obstacles. This suggests that something other than a purely altruistic desire to further the cause of science motivated their commitments to the Museum's collection.

Ridyard's correspondence forms an interesting inventory of the perceived hazards involved in obtaining such material, and also provides an insight into some of the suppliers' motives. One collector describes the function of two 'fetishes' from Landana as enabling

> the offender to shuffle off this mortal coil, with the aid of a lingering throat disease . . . I had thought of attaching a label addressed to Mr. Ridyard, but fortunately remembering the law of [life] I refrained from doing so . . . These fetishes are like the Spanish fleet, i.e. becoming very rare.[11]

On another occasion, Ridyard was advised that:

> Great care should be taken in handling these fetishes as cases have been known of the above diseases [dropsy, sleeping sickness, rheumatism, syphilitic sores and fevers of the brain] attacking persons merely through placing their hands on them. I supply gloves, owing to the medicine with which they are covered.[12]

References to the costliness and rarity of items, and the difficulties involved in obtaining them, are frequent in the correspondence.[13] Other items were taken as a result of the colonial government's intervention when the death tolls exacted by a certain 'fetish' rose beyond what was deemed by the colonial authorities as an acceptable level.[14] That the objects collected were supposed to demonstrate the effectiveness of such timely interventions, was not solely the wish of the British administrator, however. It is clear that some of the African contributors who had accepted and become part of the colonial administration also entertained the hope that their presentations would illustrate the eradication of 'the unwholesome superstition of the past.'[15] Something less likely to be uppermost in the minds of the British coloniser, however, is the proviso in the same letter that the objects should also be recognised 'as an important link in the great chain of events of the African in their past history.'[16] While these remarks suggest the donor's desire that a particular context be provided for the object once it was displayed in the collection, they also serve to illustrate the distance between the donor's expectations, the concerns of the museum curators, and the context provided for the object through the museum. The popular fallacy of an Africa with no history to speak of until the colonisers' naming of the continent was perpetuated by most museum displays.

The Ridyard correspondence also reveals the degree to which the donors supply fairly meticulous details, naming and explaining the local function and significances of the objects. A sign of the ways in which ethnographies and other anthropological texts circulated amongst different sectors of the colonial community, was that where information about the objects' use and function was lacking, the donor was often able to refer Ridyard to some other source. On one occasion a Mr Showerless advised him:

> Mr Dennett will very likely be on board you in Loanga as he wishes to take a photo of 'Mungarka' [one of the donor's 'fetishes'], for reproduction in his new book. He is a great student of folk-lore amongst these natives, and I am sure he will only be too pleased to give you some reliable information about it.[17]

Many collectors in correspondence with Ridyard were themselves eager to discover new sources of knowledge regarding the country and peoples in their area, and while not pretending to any great scientific analysis or academic excellence, were keen to find new material to supplement their own researches. The Eastern Divisional Commissioner for Southern Nigeria, A.A. Whitehouse, provides a good example. Having by 1904 already published a short piece on Ibo M'bari houses in the *Journal of the African Society*, he was enthusiastic about receiving his first copy of the Anthropological Institute's journal, *Man*, from Ridyard in 1905.[18] While these contributors may still be using words such as 'curio' and 'fetish', which carried derogatory connotations, the care and interest taken to supply details of an indigenous significance and in some instances, manufacture, is resonant of a more complex relationship to their subject and to the activity of collecting. Indeed, it would not be going too far to suggest that by about 1904, many colonial administrators, for better or for worse, assumed that collecting ethnographic 'specimens' for British museums, rather than as personal 'trophies', was an intrinsic part of the job.

Ridyard's correspondence evidently demonstrates a close relationship between ethnographers in Britain and those colonial adminstrators, traders and missionaries in the field. In addition, while various museums were dependent on contributions from these sectors of the colonial community in order to swell their stocks, the association between museum and donor was mutually advantageous. Certainly, despite the lack of formal or academic qualifications of the donors, it is clear that the ethnographers back home were none the less happy to accept such information as they received from them as documentary 'evidence' of a sort. It is also entirely possible that the practice of 'amateur' ethnography and anthropology conferred a certain cachet of distinction on some of the more monotonous and often unrewarding aspects of a civil service appointment. Thus the employees of the colonial government, and the protagonists of the 'new' science of anthropology, were both beneficiaries of this arrangement.

Perhaps one of the most famous instances of such a symbiotic relationship for British ethnography was that between Emile Torday (a Hungarian in origin who was an agent for the Belgian Kasai Trading Company), and T.A. Joyce, Keeper of Ethnography at the British Museum at the time of their liaison.[19] Like Ridyard's links with the Liverpool Mayer Museum, the relationship between Torday and Joyce is paradigmatic of that between 'armchair' anthropologists and those in the field before 1920.[20] From 1905, Torday and Joyce together produced a series of commentaries on a variety of societies encountered by Torday on his trips to the Congo Free State. The manner in which these were produced tells us much about the way anthropological knowledge was structured

around an obsessive empiricism which the lay-person in the field was encouraged, and in fact directed, to follow to the letter. It also explains why anthropologists back in Britain felt reasonably confident about accepting the information provided by those amateurs in the field.

Guidance was at hand in the form of a special questionnaire, drawn up in Torday and Joyce's case by the British Museum's Ethnographic Department, but which was similar in conception to another series of anthropological questionnaires, *Notes and Queries on Anthropology*, which was widely used throughout this period.[21] The first edition was naively ambitious in its aim 'to promote accurate anthropological observation on the part of travellers, and to enable those who are not anthropologists themselves to supply the information which is wanted for the scientific study of anthropology at home.'[22] Before systematic fieldwork became an established anthropological apprenticeship, during the period of 'armchair' anthropology (which, with a few notable exceptions, lasted in Britain from 1870 to 1920), the same questionnaire underwent only four editions.[23] This fact alone goes some way towards explaining the lag between the relative sophistication of the kinds of developments made in theoretical and structural analysis in academic anthropology, and the insistent empiricism of most ethnographic museum displays in Britain over the same time-span. By 1920, British anthropology had moved away from a primary engagement with various versions of evolutionary theory to an interest in diffusionism and functionalism. Such developments were rarely signalled in the ethnographic narratives of the public museum. From the 1880s, questionnaires were already familiar tools as an aid to sociological investigations on health and demography. Other similar statistical aids were used by different interest groups to illicit and collate information from outside a particular and often self-styled, professional group.[24] Some of these were more directly related to the anthropological version of the questionnaire. In 1890, the Folklore Society published their *Handbook for Folklore*, and the Royal Geographical Society's *Hints For Travellers* was in its sixth edition by 1889. In 1887, the anthropologist James (later Sir) Frazer, author of the *Magic Bough*, issued his own series. These were amended and republished in 1889, 1907, 1910 and 1916.[25] Such questionnaires were subsequently completed by a disparate group of lay people in the field and transformed into 'scientific' data by the anthropologist in Britain.

In the case of Torday's data, collected in the Congo, the social groups of Ba-Mbala, Ba-Huana, Ba-Yaka, Ba-Teke are dealt with under the headings of: Physical Appearance, Psychology (which in fact meant an 'intelligence' assessment), Ornament and Dress, Food, Agriculture, Habitations, Crafts, Navigation and Swimming, Trade and Property, Government, Social Organisation, Amusements, Morality and Justice (both of which actually dwelt to a significant extent on sexuality), War, Sickness, Death and Burial, Religion, Time and the Elements, Reproduction and finally a rudimentary vocabulary. While this list would seem to emphasise comprehensiveness as the prime criteria, it nevertheless prioritised certain kinds of information which reflected some of the preoccupations of the museums establishment as discussed in the previous chapter. In the first place, one of the justifications for studying these Congo societies was that in most instances the complex sexual and reproduction taboos amongst different members of the group, and in relation to other social groups, inhibited marriage outside of a very limited circle. While this concern with kinship and genealogy was symptomatic of developments in academic anthropology after the return of the Torres Straits expedition in

1899, and W.H.R. Rivers' 'invention' of what he called the 'genealogical method', the emphasis on sexuality, which infiltrated many more categories of the questionnaire than is immediately apparent, is resonant of another familiar concern of the museums establishment.[26] Consequently, one of the most important features of these societies (and one which corresponded to the museum ethnographer's brief) was that they were thought to be racially pure, and therefore their material culture was assumed to be less adulterated through culture contact.[27]

The other aspect of the questionnaire which corresponded directly to what we now know of the concerns of the ethnographic curator was the attention devoted to physical aspects of those social groups under scrutiny. The extent to which the body was surveyed through the detailed documentation of physical data is found in the diagrams incorporated into various editions of the *Notes and Queries on Anthropology*. In the earliest editions, these included inventories of possible decorative motifs, together with eye colour charts and skull measurements as well as other limb calculations (figs 54 to 58).[28]

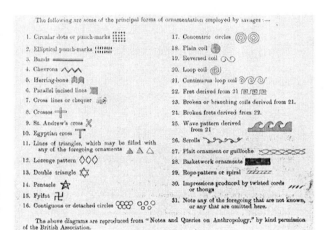

54. A page showing 'the principal forms of ornamentations employed by savages', *Anthropological Queries for Central Africa* (London 1905–6).

55. Plate showing the 'traveller's anthropometer' used in this instance to take measurements of the head and facial features. *Notes and Queries on Anthropology*, third edition (London 1899).

56. Plate from *Notes and Queries on Anthropology* (1899). These illustrations were to asssist the traveller in answering the 'query': 'Is the nose straight, fig. 1; aquiline, fig. 2; concave, fig. 3; high-bridged (busqué), fig. 4; clubbed or sinuous, fig. 5? Or has it the Chinese type (straight but flat), fig. 6; or the negroid (short, broad, nearly straight), fig. 7; or the Australoid or Papuan (broad, with the lower part forming a flattened and depressed hook), fig. 8?'

57. Plate from *Notes and Queries on Anthropology* (1899), showing varieties of hair and eye colours.

58. Plate from *Notes and Queries on Anthropology* (1899), showing varieties of skin colours.

II

For the visitor to the ethnographic section of the Liverpool Mayer collection, the most striking material in terms of sheer presence of numbers would have been the West African section. Even prior to the sort of co-operation extended by Jones, Ridyard and other Liverpool merchants, the overcrowding was sufficiently severe to warrant the removal of Australian and New Guinean material from the east side of the gallery to make way for African exhibits.[29] Furthermore, it was anticipated as early as 1898 that, since the objective was to 'make the collection thoroughly representative of that great country [Africa] . . . the present gallery will be too small to hold the exhibits illustrative of the arts and crafts of the native races of Africa alone.'[30] The statement is interesting on two counts. It indicates the extraordinarily large percentage of African material in the Museum's holdings at a very early date, and suggests a deliberate and successful attempt to cultivate the West African aspect of the ethnographic collection. It also signals an emphasis in the collecting policy on illustrating the arts and crafts of those societies represented.[31]

Although few illustrations of earlier displays are extant, the accessions lists and the acknowledgements in the annual reports give some idea of the preferred objects and categories employed in the arrangement of the ethnographic material. Finer details, such as the descriptive entry in the accessions files beside each item, tell us something of the intended function of certain objects within the display devised by the Museum. One of the most striking features of the Liverpool Museum's ethnographic material visible to the public, was its dependence on photographic 'evidence' to enhance the significance of the objects on display. As early as 1895, it is evident that this was part of an educational initiative since the Museum stated that 'the addition of these photographs and drawings will be continued as rapidly as they can be obtained or made, till . . . there is no object which shall require other information for its elucidation than is found close to it.'[32] In 1896, the practice was endorsed in the Museum's annual reports for that year as an essential means of adding 'greatly to the interest and value of the collection.'[33]

That same year, the *Journal of the Anthropological Institute* carried a lengthy article on the virtues of photography for the anthropologist and for amateurs in the field.[34] Photography had already been put to considerable and systematic use, both by anthropologists and colonial administrators, by the 1860s and had a well-established amateur following, particularly in India, although it is also true to say that the Royal Geographical Society was much more willing to invest in photographic activity in the field than the Anthropological Institute, no doubt partly because it had more funds available.[35] By the end of the nineteenth century technical developments such as the hand-held Kodak camera meant that the injunction in the *Notes and Queries on Anthropology* 'to devote as much time as possible to the photographic camera . . .' had become more of a reality.[36] In fact, photography had by this date taken over as the ultimate method of ensuring a verifiable 'objectivity', since

> by these means the traveller is dealing with facts about which there can be no question, and the record thus obtained may be elucidated by subsequent inquirers on the same spot, while the timid answers of natives to questions propounded through the medium of a native interpreter can be but rarely relied upon, and are more apt to produce confusion than to be of benefit to comparative anthropology.[37]

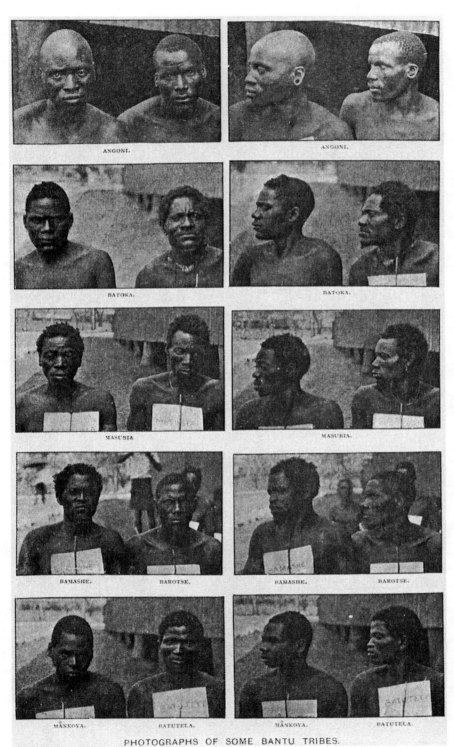

ANGONI. ANGONI.

BATOKA. BATOKA.

MASUBIA MASUBIA.

BAMASHE. BAROTSE. BAMASHE. BAROTSE.

MÂNKOYA. BATUTELA. MÂNKOYA. BATUTELA.

PHOTOGRAPHS OF SOME BANTU TRIBES.

59. A series of profile and full-face shots of individuals supposedly demonstrating physiognomic characteristics amongst different 'tribal' affiliations, *Man*, no. 35, vol. 7–8 (1907).

Maurice Vidal Portman, a professional photographer employed by the British Museum to make a comprehensive photographic study of the Andaman Islanders, was explicit in his directives for the amateur photographers' photographic interpretation of the questionnaire in each section of the Notes and Queries: 'In Part 1 of that work, external characters could be illustrated, and large photographs of the face, in full face and profile, should be taken.' If there is any doubt concerning the invasive violation that accompanied such scrutiny, Portman's candid language eradicates it in one fell swoop. Photographs to illustrate 'Physiognomy', Portman specified,

> should be taken stark naked, a full face and a profile view should be taken of each, and the subject [referred to throughout as 'the savage'] should touch a background painted in black and white chequers, each exactly 2 inches square. All abnormalities, or deformation, whether natural or intentional, should be photographed.[38]

Considerable work has now been done on the development of anthropological genres of photography, in relation to the development of the medium in the service of criminology and medicine. This involved 'documenting' what were perceived in nineteenth-century Europe to be the characteristics of degeneracy and deviancy writ large on the physiognomy of the subject. Such research makes explicit the relations of power involved in this kind of photographic surveillance.[39] The incorporation of photographic material in museum exhibits should also be understood as a strategy of authenticating the objects in the collection, by providing visible 'proof' through the tangible eyewitness 'evidence' provided by the photograph. As a form of verification, the photograph was accredited in the eyes of the general public, and of the scientific establishment, with a degree of 'truth' and 'objectivity' which museum staff were quick to exploit (see figs 59 to 63).

It appears from the records that a substantial proportion of the photographs in the Mayer Museum in Liverpool were used to illustrate racial 'types' following the

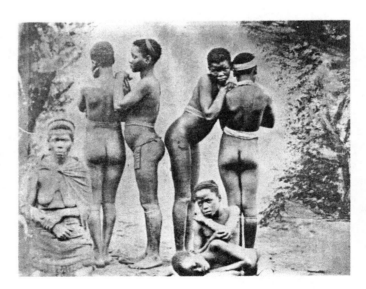

60. 'A group of Zulu women', C. Collis photographic studios (London pre 1907). The photograph conforms to the demands for anthropological data supplied by the photographic convention of incorporating profile, back and full-face views, together with, in this example, a variety of age groups. Collis' photograph achieves this, however, while deploying the more 'picturesque' format reserved for ethnographic postcards. Royal Anthropological Institute.

 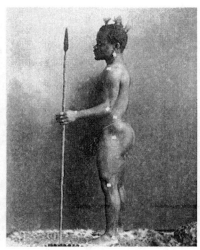 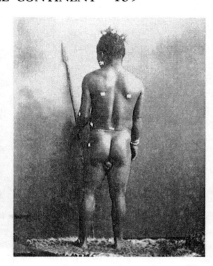

61, 62, 63. Bokane, one of a group of Batwa pygmies from the Ituri forest of the then Congo, who were brought over to London by Colonel James Harrison in 1905. This series from the London photographic studio of W. & D. Downey shows anthropometric markers to facilitate anthropometric measurements. Royal Anthropological Institute.

'mug-shot' formula cited above. In 1896, for example, photos depicting Kru-boys (*sic.*) from Liberia, apparently 'taken from life', were enlarged for display purposes.[40] By 1897, the initiative had been followed by a series of photographs illustrating 'The Races of Mankind'. These enlargements apparently proved so popular, and news of their appeal travelled so fast, that copies were requested by both the British Museum and the Cambridge Museum of General and Local Archaeology and Ethnology.[41] By 1899, the series numbered some one hundred and twenty-eight photographs with an additional twenty-five casts from life, coloured for good measure, and five maps. This suggests that there might well have been scope for professional photographers working in the field to produce orders for a museums market, although it is unlikely that this ever developed to the same degree as in Germany, where ethnography's more secure status increased the potential for this type of market.[42] This preoccupation with the body should be understood in the context of those scientific discourses which elaborated this form of racial determinism. It also complimented W.H. Holmes' suggestions for displaying models of family groups according to racial type. Indeed, the 1903 annual report contains a description of a case in the Mayer Museum showing a group of South African 'natives' hoeing. A woman, man and child are included to stress the 'typical' racial characteristics present in one family.[43] In 1896, the ethnographic collection in the Mayer Museum was divided into two sections, one 'historical' and the other 'racial'. The group deemed Melanesian included Africa, New Guinea, the Solomon Islands, the New Hebrides, Polynesia, New Zealand, Micronesia and Matty Island. The Mongolian race comprised South America, China, Japan, Burma and the Malay Archipelago, while the Caucasian race placed Europe together with India and Egypt (which was significantly not classified as African).[44] The ethnographic material in the collection was by no means equally distributed between these different categories, however. A far larger area was necessary

for the West African section due to the ever-increasing proportion of material from this region.[45] By 1899, it occupied the whole of the east side of the gallery, as well as the central cases, and more space was continually being made available for it. Significantly, the curatorial staff had no scruples about shifting or eliminating other material in order to expand the African section.

Furthermore, as early as 1895, the director was prepared to acknowledge that unlike the Natural History half of the Museum, the ethnographic collections were clearly gaining popularity with the public, and an educational programme was devised in order to capitalise on its success.[46] Consequently, by 1896, there was an established lecture series introducing those attending (a total of 3,372 for all lectures given that year), to the principal racial divisions adopted for the classification of the ethnographic sections.[47] As one might expect with such a large proportion of African material, the lectures in the series (which went under the title 'The Pedigree and the Races of Mankind'), as well as reflecting the racial taxonomy adopted in the overall schema for the Museum, were frequently devoted to some aspect of African culture. Most of these concentrated on specific regions and social groups within Africa, and often on particular aspects of their cultural production, as opposed to a geographical or sociological analysis.[48] The programme was also devised to take advantage of current events in West Africa and the public's familiarity with different aspects of political and cultural life in the colonies, as well as capitalising on local connections to bring the material 'alive'. Consequently, the influx of Benin material, most of which Liverpool acquired through such locally-based business contacts as James Pinnock, provided the occasion for a lecture series with the rather candid title of 'Loot from Benin'.[49] Similarly, the opening up of the Cape to Cairo railway line provided the opportunity for another series by Rev. W.A. Elliott.[50] Between 1890 and 1913, Africa and things African took pride of place in the lecture series just as it did in the Museum's acquisition policy.

While there is no way of knowing the degree to which these lectures would have reinforced or challenged the persistent and derogatory racial stereotypes associated with Africa, it is safe to assume that they would certainly have functioned in another significant respect. They were a means of drawing attention to the African material in the collections, not least because of the frequency with which items from these were used to illustrate talks, either as lantern slides or through presentations of the objects themselves. Through the public circulation of knowledge generated around Africa and its material culture, the authenticity of the Liverpool collection was assured and its cultural and market value enhanced. The 'disappearing world' discourse, familiar in the context of academic anthropology's attempts to validate its own existence, was also a recurrent theme in the annual reports of the Liverpool Ethnographic Department.[51] It too served to legitimise the Museum's collections.

The interest in physiognomy, and the use of physical traces as a means of cataloguing racial difference, was further amplified in this system through reliance on colour as an index of race. Thus, in 1901, the proposed reorganisation was explained as a division between 'the three great ethnic divisions of the globe, namely, the Caucasian (white), the Mongolian (yellow), and the Melanian (black) races.'[52] These were to be arranged with the Mongolian occupying the topmost floor of the Mayer Museum, and the Caucasian on the ground floor in the main hall together with the surrounding balcony. The Melanian was to be located in the basement area and in the existing Ethnographical Gallery. It is

no accident that the Caucasian section is the first that the visitor would have encountered on entry into the main hall. Objects here received the accolade of being 'those of the civilised races', functioning as the standard against which to judge the relative stages of 'civilization' of the other sections.[53]

The three racial divisions employed by the Mayer Museum correspond to those laid out by A.C. Haddon in his book, *The Study of Man*, which had been developed from the four racial groups into which Alfred H. Keane divided mankind, in his 1899 book, *Man, Past and Present*.[54] By this date, Keane was emeritus professor of Hindustani at University College London, author of the much cited *Ethnology* published in 1896, and a vice-president of the Anthropological Institute. Keane's theories on race, publicised in his numerous articles and textbooks on the subject, are important to any study of museum ethnography over this period because of his influence on many of the leading ethnographic curators of the day, including Haddon.[55] Keane's detailed account of his choice of categories sheds some light on their appropriation by the Museum. Keane, arguing from a monogenist evolutionary position, stated that mankind originated from one racial stock. Through adaptation to different environmental conditions, four primary racial stocks emerged which became the independent ancestors of the four primary races of mankind. The belief was that, even in a racially mixed population, the dominant racial characteristics were inherited and remained stable. Consequently, the scientist (and in particular the anthropologist and the biologist) believed that they were able to classify and therefore compare peoples whose racial characteristics were believed to be fixed through reproduction and heredity. Significantly, not only physical elements were hereditary. Keane also attributed inherant mental and moral characteristics to his selected racial categories. Thus Keane assigned the Ethiopic negro to the lowest division of mankind: 'a sensuous, indolent, improvident folk, fitful, passionate, and cruel, with no sense of dignity, therefore born slaves.'[56] Next in order in this sequence came the Mongol family: 'a thrifty, industrious folk, with low moral standard, who are very well represented by the modern Chinaman.' Following from this came the 'American man' and at the summit of achievement the 'Caucasic man, the heir of all ages.'[57] The assumed interdependence of biological and moral characteristics, presented here as a clear hierarchy, consistently underpinned the ethnographic narratives in the Liverpool Museum and other collections nationwide.

III

Besides the emphasis on the body and physiognomy, and their attendant ideological premises, a feature of the ethnographic displays in the Mayer collection was the curator's early decision to capitalise on the collection's potential as a component in an arts and crafts category. As early as 1898, reference is made to the speed at which this special aspect of the Ethnographic Gallery was growing, especially in relation to the African exhibits.[58] Similarly, when discussing recent donations or acquisitions in the annual reports, the category dealt with most extensively is 'handicraft'. Other aspects, such as religion or domestic life, do not feature as donations worthy of remark in either of the Museum's publications – the *Bulletin* or the annual reports. By 1901, a distinction emerges between 'material culture' and 'art', with the contents of the Mayer Museum described as 'a very valuable collection of Antiquities, Ethnography and Pottery, besides a large assemblage of

objects which may be classed under the heading of Art.'[59] While this suggests that the ethnographic material falls firmly outside that category designated as art, by 1903 a shift in the terms used to describe the 'Melanian' material implied that it had now acquired a new status within the collection as a whole. Originally described dismissively as 'the Ethnographical collections of barbaric races', by 1903 they became 'collections illustrating the ethnography of the Mongolian and Melanian races.'[60] Consequently, while as 'handicraft' these objects fall within a different category from the objects assigned to the designation 'art', they none the less derived a degree of distinction from their former taxonomy by virtue of this qualitative addition, and by 1906 it was possible to claim that the Ashanti collection could be used 'to prepare a most interesting exhibit of the art metalwork of the Ashanti natives.'[61]

Descriptions in the accessions files and in the *Bulletin of the Liverpool Museums* are also notable for the frequent emphasis on the formal aspects of the objects. In 1897, three West African masks, for example, were singled out for special mention in the first edition of the *Bulletin*.[62] The information considered relevant here is of a different category from that usually supplied by the donors themselves, and tells us something of the possible transformations in meanings once the items had been handed over to the Museum staff. In this case, the social context which was often a feature of the information included by many of Ridyard's helpers is obliterated. The three Setté Cama masks from Gabon that are the subject of the review are meticulously described according to their formal properties alone, with minute details regarding proportions and markings. The information was evidently deemed to be of some note, since this was the first issue of what was considered by the director to be the prestige publication of the Museum. The extent to which a bald formalism was supposed to capture the readers' attention, and signify cultural value, corroborates the evidence presented in the first few chapters that aesthetic criteria were an acceptable means of describing African material culture, from quite an early date in some museums.

Already by 1904, there is certainly evidence of regular interest, specifically in the ethnographic collection, by art students from Liverpool Art School and pupils from Mount Street School of Art who attended weekly.[63] Neither were the curators of the African section unaware of the collection's potential for local manufacturers. Here, too, it was the craft and more specifically what was appreciated as the 'design' aspect of the textiles that were thought to profit the trader since, 'The usefulness of many of the objects of the African section for trade purposes is evinced by the reproduction of designs on native cloths, by a local firm and the copying of designs by Manchester calico printers.'[64]

IV

In the Pitt Rivers Museum, one aspect of the classification and organisation of the collection which remained a priority throughout the debates regarding the ideal public for the Museum, was the emphasis on what was termed 'the growth of ornamentation, the survival of rude forms of art among civilised peoples, the recurrence of similar forms in different localities, and the dependence of art upon physical conditions' (see fig. 64).[65] In this respect, the Pitt Rivers was one of the first, in 1883, to devote a special 'series' to 'The Evolution of Ornamental Art'.[66] By 1906, this was still a growth area in relation to the rest

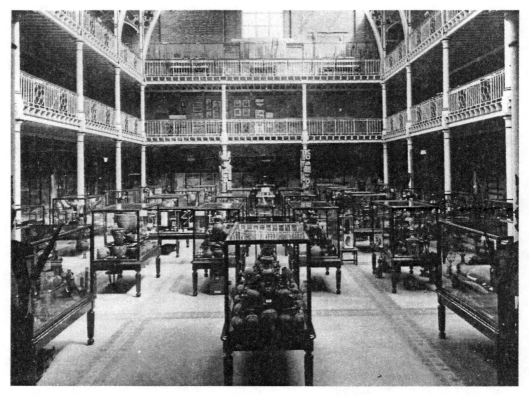

64. General view of the collections *c*.1895. Courtesy of the Pitt Rivers Museum, University of Oxford.

of the collection, with the provision of a four-sided glass case specially built around a column in order to facilitate visibility.[67] This emphasis, evident in the domain of display and in the sphere of education, is consistent with the general development of the collection and its use as part of the University teaching infrastructure.[68] During the years 1894 and 1895, two large exhibitions were put on to cement this interest: 'Animal form in Art' and 'Representations of Human form in Savage Art', both in the main court of the Museum (fig. 65).[69] Not surprisingly, given Balfour's personal research and publications on the origins of art, the 1897 lectures continued this trend with a series entitled: 'Realistic and Decorative Art of Primitive Peoples' and by 1907 these were still on the curriculum under the title of 'Early Stages of Art and Knowledge'.[70]

The other lecture series developed alongside that on decorative art concentrated on physical deformation of the body.[71] Such a preoccupation comes as no surprise after an analysis of the Liverpool Mayer Museum's exploitation of the body as an element in its ethnographic displays. Scrutinising the body of colonised races was by now a familiar procedure through popular scientific journals and general books on the history and distribution of mankind, where photographic 'views' or racial 'types' were a standard presentation of racial difference by 1890.[72] The use of 'deformation', as opposed to the contemporary terminology 'body decoration', accentuated the display's function as 'evi-

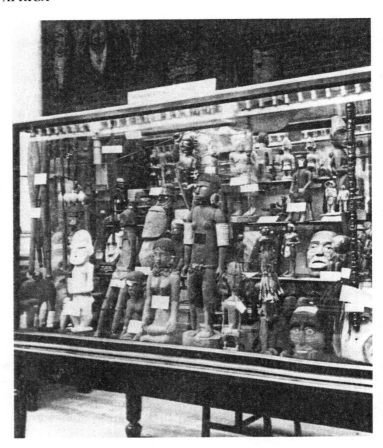

65. 'Human form in Savage Art' display-case at the Pitt Rivers Museum, Oxford, c.1900. Courtesy of the Pitt Rivers Museum, University of Oxford.

dence' of barbarism, and in this respect it may be significant that although the title of the lecture series was 'Deformation World-Wide', African examples predominated. (One of the most striking things about this series is the extent to which every aspect of the colonised body was pulled apart – it would not be going too far to use the term dismembered – and subjected to minute scrutiny. Each lecture focused on a specific area of the body: trunk, legs, arms, feet, hands, nails, head and teeth.)[73] Such practices were often the first aspects of traditional life and custom to be eliminated in colonised areas. Although the colonial administrator's justification for this was usually on the grounds of health, it was often politically expedient to put a stop to a practice associated with a *rite de passage* that served to strengthen traditional ties and ruling structures, and which interfered with the judicial procedures which the British were attempting to set up. In this sense its eradication was, the British argued, a necessary step to protect the colonised subject from him or herself. As we have seen, this interest in the physical state of colonised peoples extended outside of the explicitly ethnographic context. The Central African pygmies that caused such a stir on their arrival in England with Colonel Harrison in 1905 are a case in point (see figs 61 to 63).[74] Their diminutive stature aroused immediate excitement, fed by reports in the national press and their public exhibition. The insistence

on the body in ethnographic collections, as the source of all knowledge regarding the colonised subject, encouraged the museum public to see these Africans as simply one more ethnographic 'specimen'.

Prior to 1890, there is little mention of African material in the Pitt Rivers Museum annual reports. Throughout the following years, however, the collection received a large number of African donations and, more significantly, actually made a similarly important set of purchases from this continent, something which appears to have been a consistent policy throughout Balfour's curatorship.[75] Furthermore, several individual displays were devoted entirely to African material culture. Consequently, to the public who visited the Museum, Africa was presented as a particular entity. It did not suffer the fate of some of the other items on display by becoming subsumed in the crowded cases, illustrating various typological series along with objects with similar functions from many regions of the world.

The donations of African material in the Pitt Rivers collection came, like Liverpool's, from areas which represented British spheres of interest on that continent. In conjunction with Balfour's own interest in South African material, and in particular with the rock paintings of the 'Bushmen' (fig. 66), the Museum had a very early collection of such

Unsolicited proof of the realism of Bushman paintings — Krugersdorp, Sept. 5, 1910.

66. 'Unsolicited proof of the realism of Bushman paintings – Krugersdorp, 5 September 1910'. An illustration from Henry Balfour's 1910 South African notebook. Pitt Rivers Museum, University of Oxford.

exhibits which pre-dated the more public interest aroused in such paintings by the exhibition in the Royal Academy of facsimile 'Bushmen' paintings executed by Helen Tongue.[76] These were augmented by Balfour himself on his lecture trips to South Africa in 1905, 1907 and again in 1910. This culminated in 1912 with a series

> illustrating the Graphic Art of primitive peoples which was brought together for exhibition in the lower gallery, and a number of copies of late Stone Age paintings in the Cave at Altamira in Spain which were framed and displayed, together with copies of Bushmen Rock paintings from South Africa, in order that the art of these two regions and periods may be compared.[77]

Balfour's most extensive knowledge of African material was primarily in relation to musical instruments, a series in the collection greatly enlarged under his curatorship. These were treated to the same systematic evolutionism as the other series in the collection. The idea behind these was to demonstrate the family resemblance between what, on the face of it, appeared to be diverse objects with distinct functions. In the case of the musical instruments, Balfour wrote several papers proposing a probable connection between the archer's bow and a variety of stringed instruments, using predominantly African examples.[78] To make his case, he employed a hypothesis entirely in keeping with Pitt Rivers' own evolutionism.

Balfour set out to demonstrate slow and continuous transformation from bow to harp, despite the ultimately very different functions of each object. The series thus posited also demonstrated the change from simple (bow) to complex form (harp), from forms suggested by 'natural' or 'organic' forms, to more elaborate designs which moved toward increasing specialisation.[79] The Africa that is represented here is one which is inhabited by living 'survivals'. Since progress and technology were supposedly less advanced in these societies, their material culture was presumed by both Balfour and Pitt Rivers to be 'innately conservative', since they manifested a much stronger dependence on what was defined by both men as tradition and traditional forms of design.[80] Balfour's special interest was further augmented by a display entitled 'Geographical Distribution and Development of the Musical Bow', supported by maps, sketches and photos (fig. 67).[81]

In September 1900, Charles Kingsley transferred Mary Kingsley's collection of objects from Benin and other parts of West Africa to the Pitt Rivers Museum. A feature of the donation was the large amount of highly decorated and elaborately worked pieces, the details of which are meticulously described in the 'Donations and Accessions' book.[82] In some instances, and particularly in relation to the Benin material, there are qualitative judgements made regarding the objects, such as the bronze casket with cover and suspending chain, listed as 'a very fine specimen – covered with relief figures and chased work.'[83] Clearly, the Benin material was highly prized by the Museum, the donation being praised as an example of 'the now extinct artistic bronze work of Benin, which has created so much stir of recent years, since the punitive expedition first brought these forgotten treasures to light.'[84] Both in terms of the 'lost worlds' discourse, and in terms of the acknowledged notoriety of the material in the eyes of the scientific as well as a more general public, the collection was a significant coup for the Museum. Indeed, Mary Kingsley's own status as an outspoken writer and traveller, and as an avid collector of natural history as well as ethnographica, considerably enhanced the value of the collection by virtue of its association with her. The accompanying description in the annual reports

67. 'The Evolution of the Bow' display-case at the Pitt Rivers Museum, Oxford, c.1900. Courtesy of the Pitt Rivers Museum, University of Oxford.

for another large donation, in 1904, of Masai material culture presented by a colonial administrator A.C. Hollis, from Nairobi, gives a good indication of the Museum's recognition of how the value of a collection could be enhanced by such association, in this case with travelogues and ethnographies written by the donor, since they were 'rendered more valuable by his recently published book on the Masai.'[85]

In 1903, this material was the subject of a special display in the lower gallery to demonstrate ironwork processes with particular reference to the *cire-perdue* method associated with Benin, and illustrated in this instance with examples from both Benin and Ashanti.[86] The display seems to have been a fairly permanent feature in the Museum since it is mentioned again in 1910 with additional material from the collection of an ex-diploma student, R.S. Rattray, who was to become an administrator for the colonial government on the Gold Coast, and the author of a book on Ashanti art and religion.[87] Here, very clearly set out, were the technology and techniques involved in the casting process. It consisted of 'three specimens illustrating the three stages in casting a head in brass by the *cire-perdue* process, made by a Yoruba living in Togoland.'[88] The entry in the annual reports for that same year testifies to the consistent interest in Benin material from the point of view of the technological processes involved.

In 1902, the African material again provided a special focus with the exhibition of the infamous Mavungu (a Bakongo nail fetish from the Congo Free State), described in the annual reports of the Museum as 'probably the finest of its kind in any museum'. This was exhibited in the court of the Museum together with West African fetish figures (*sic*.) and associated objects, presented primarily by Rev. W. Allen.[89] While their significance, according to the annual report, was primarily 'scientific', they were also inevitably

'of historical interest in connection with the opening up of Southern Nigeria and the suppression of the gruesome practices connected with the superstitious beliefs of the natives of the region.'[90] It would seem, therefore, that while other comparative series existed for objects associated with world-wide religious worship, religious practices from various African societies were treated somehow with less tolerance. Such a focus could only have fuelled the stereotype of the African, as a savage whose lust for blood was satisfied through self-indulgent acts of gratuitous violence, particularly since their religious practices were presented as superstitious nonsense, motivated by fear alone. It is significant that while the Reverend Allen's donation consisted of a larger proportion of items that were not concerned with any religious practices, those concerned with the religious aspect are the ones that were selected for a special exhibit.

Emil Torday, provider of the bulk of the contemporary collections from the Congo in the British Museum, was also a frequent contributor to the Pitt Rivers Museum. His generosity resulted in a series of donations in 1904, 1907 and 1910. The first, collected during four years' travel in the Congo Free State, is notable for the number of figure carvings. The 1907 donation, collected in 1905 and 1906 in the Kwilu river region and the Kasai district, is notable for the amount of 'grass cloth' included (now known as cut-pile raffia cloth). However, the donation in 1910, collected during his expedition in the region of the Kasai, Kwilu and Lomami rivers in South Western Belgian Congo from 1907 to 1909, is the largest, consisting of over two hundred items. These cover every aspect of the material culture of the region, from musical instruments to toys, clothing, personal ornaments and objects associated with religious ceremonies.[91] The fact that such extensive collections were donated would seem to corroborate my earlier suggestion that such activity was perceived as mutually beneficial to donor and museum.

In addition to these donations, the Pitt Rivers Museum bought a number of African collections. These fall consistently into the three main categories of being material from the Congo region, South Africa, or Benin, with some exceptions coming from other West African countries.[92] While the British Museum bought mainly from the London Missionary Society collection of Oceanic material, the Pitt Rivers spent their money on the Society's African material, consisting of mostly weapons and axes.[93] The total cost for the one hundred and seventy-eight objects aquired was ten pounds and fourteen shillings. On the other hand, the Pitt Rivers Museum was prepared to pay considerably more for other items, and in particular those from Benin. Three years prior to the purchase of the London Missionary Society material in 1910, the Museum bought a cast plaque from Benin. Described as 'a very fine plaque of bronze cast by the cera perduta process from Benin City . . . hidden away from our soldiers after the capture of Benin on the Punitive Expedition of 1897 and . . . brought to Lagos by a native trading woman', it was bought for five pounds, that is half the *total* amount paid for the London Missionary Society's one hundred and seventy-eight miscellaneous African objects.[94] Evidently, the emphasis in terms of the collecting, displaying and special exhibitions policy regarding Africa, while mediated to a large extent by the need to supply those objects that might fill in the gaps in any 'series', also corresponded to the aquisitions policy at the Mayer Museum at Liverpool. The emphasis in both museums on items from Benin and the then Congo also reflects the state of the ethnographic market at this time and the rise in value of material culture from these two regions of West and Central Africa.

Furthermore, the Pitt Rivers collection serves to reinforce the suggestion that, despite academic anthropology's developments away from a Darwinian or Spencerian evolutionism, the mode of presentation adopted and preserved here, only perpetuated these conceptions in the public domain. Evidently, the Museum was a paradigm emulated by other insititutions, if not wholly, at least partially. On the basis of the constant stream of eminent scientists and museologists to the Museum over the period of 1890 to 1913, it is clear that it had acquired and maintained considerable notoriety on an international level. A further instance of the persistence and tolerance of this type of evolutionism is demonstrated by the re-publication, in 1906, of Pitt Rivers' book, *The Evolution of Culture and Other Essays*, with a preface by Balfour. This is not to say that there were no critiques of this thesis available or audible by this date, or that the book itself was received uncritically, but rather that, despite these often quite vociferous attacks, the paradigm remained extraordinarily intact. In a tone reminiscent of earlier criticisms of Balfour's paper to the Society of Arts, one reviewer made the claim that, 'Today there is hardly anyone south of the Channel and the North Sea, except perhaps a few very old (and it must be admitted very learned) men, who subscribe to such a formula.' The reviewer went on to say that:

> To tell us that there first comes this, and then by extremely slow changes of detail that other more complex things follow is to tell us nothing, for it is equally true that by another process of change going on all around us the more complex is passing into the less complex.[95]

The writer challenges the use of such concepts as 'advanced' and 'degradation', and also questions the terms 'inferior' and 'superior' when applied to race:

> The more you look into the assumption lying behind evolutionary theory the more you find it taken for granted that the particular experience of the writer is the summit up to which change has toiled, and from which if it departs it will only depart in order to fall.[96]

These objections would not be out of place in a contemporary critique of evolutionism. That such an analysis existed alongside an acknowledgement that Pitt Rivers' work on his collection

> was one of those material sides of human change to which the clothes of evolution will fit as well as the clothes of any other philosophy and in the arrangement of his matter to an evolutionary form the accomplished results are of the highest possible value to the positive side of archaeological science,

only serves to highlight the dogged resistance offered by this continually reproductive thesis.[97] Notwithstanding this evidence, it is sufficiently significant that it was thought appropriate to reprint Pitt Rivers' collection of essays by 1906, with a preface in which Balfour endorsed the validity of its contents, rather than critically reassessing them in the light of contemporary developments in folklore, anthropology and ethnography. It is a good illustration of some of the means by which such contradictory discourses could be sustained. In the final account, British empiricism wins out as a valuable contribution to science in its own right. According to even the most critical response, which recognised that it was premised on inherently racist suppositions of racial superiority and the

relentless march of a linear progress, after all was said and done, evolutionism suited ethnography well enough, providing it was systematically and rigorously applied.

<div align="center">V</div>

The Horniman collection was also heavily dependent on a number of established dealers and auctioneers specialising in ethnographic material. Frederick Horniman himself, in the days before the London County Council took over Surrey House, actively pursued officials and administrators in the field and was especially reliant on missionaries (fig. 68).[98] In 1897, he was quick to buy up a considerable amount of Benin material from established commercial sources and from private collections.[99] As we have already seen, the naval officer W.J. Hider's Benin material received coverage in the local and national press, and served to bring the Museum to the attention of a broader public. Hider was adamant that his objects were the only ones to survive the sack of the city, and because of the additional public interest that he thought would be generated by this information, he felt confident enough to ask for one hundred pounds from the Museum for the objects![100] In line with both the Pitt Rivers and the Mayer Museums, the Horniman also systematically collected material gathered by Torday and others in the Congo (in particular the two Baptist missionaries William Holman Bentley and John H. Weeks). The same highly decorated features found in material from this region in both the Liverpool and Pitt Rivers Museums were present and noted in the Horniman selection.[101] It comes as no surprise that these items found a permanent home in the 'Evolution in Art' display series.

The purchase of Benin material in 1897 coincided with a proposed change in the system of display of the collections, which were now to be constructed around two

68. Frederick Horniman with friends and family in the Ethnographical Saloon of Surrey House Museum c.1892. Horniman Museum.

69. Interior of the South
Hall of the Horniman
Museum c.1904.
Horniman Museum.

70. Interior of the South Hall of
the Horniman Museum c.1904.
Horniman Museum.

main divisions: Art and Natural History.[102] This twofold division of the material provides
one of the more lasting characteristics of Horniman's Museum. Symptomatic of the
transformation was the commencement of accessions files where previously there had
been no regular record kept (although it was only in 1903 that these were systematically
maintained). By 1901, after the opening of the new building when it was handed over to
the London County Council, the descriptions and categories used to define the material
come under the typological labels already familiar from the Pitt Rivers collection, with a
selection, rather than a 'series' of objects, sharing similar functions.[103] However, the
arrangement was slow in appearing throughout the Museum. By 1901, only two sections
were explicitly evolutionary in their arrangement, although, given the evidence in the

71. Interior of the South Hall of the Horniman Museum showing Benin display on the left and the 'Evolution of Decorative Art' in the centre *c*.1904. Horniman Museum.

previous chapter, more may certainly have been perceived through an evolutionary perspective by many visitors. By 1904, though, the two sections receiving the most attention and subject to a rigorous development policy, reflecting the preoccupations already encountered in the Liverpool and Oxford museums, were those concentrating on decorative art and personal ornament (figs 69 and 70).[104]

In what was, at this time, the only display-case devoted to the subject, most of the material singled out for particular attention in the reshuffle came from the Solomon Islands, Torres Straits and the Papuan Gulf. Material from other countries, including Africa, went into those parts of the case that showed the influence of gourd forms on the shape of the manufactured vessel, and demonstrated Colley March's thesis on the influence of bindings and other textiles on carved wooden patterns on utensils. The 1904 guidebook to the collections, however, makes more mention of African objects, and in particular those from Benin, in this section.[105] By this date, also, there is evidence that the new sections provoked a particular interest from art students who visited the Museum on a fairly regular basis.[106] Even by 1905, there is no explicit taxonomy consistently structuring the material on display at this stage, except in relation to cases 30 to 32, referred to in the guide as 'The Evolution of Designs'.[107] Placed adjacent and opposite to this case are two containing carvings. It is in these two sections, together with the section on metal-work, that the major part of the African material falls by 1905. In both displays, the material that is selected comes again from Benin, and despite the dominance of Benin articles already in these two sections, there is also an entire case devoted solely to Benin carvings in ivory and wood (fig. 71).[108]

The other items of African material culture which received the most attention in local press coverage of the collections were the tobacco pipes.[109] Sometimes, in a desperate effort to cover all possible bases, the reporting reproduced an amalgam of received ideas on the relation between culture and identity. The *South London Press* claimed that the pipes

had been the subject of decoration more or less tasteful, and of design more or less beautiful, quaint and original and to a great extent can go arm in arm with the history of man. In pipes only the characteristics of a race, the tastes and customs of peoples, the skill and ingenuity of individuals, may be distinctly traced.[110]

These exhibits seem to have sustained a degree of public interest for some years, and by 1904 the *Studio*, a major art journal covering contemporary developments, had published a lengthy piece by the Horniman's curator, Richard Quick, entitled 'Primitive Art as Exemplified in Tobacco Pipes.'[111] Although many of those illustrated come from the British Museum collection, all of the African pipes were in the possession of the Horniman (fig. 72). These are the items that are described in the most glowing terms, as 'made of nearly every possible material, and full of design.'[112]

1907 marked the appearance of a new section entitled 'African Art'.[113] As late as 1912, the 'Decorative Art' section still retained the taxonomy of the 1890s, divided now between 'realistic' and 'decorative' art. The former focused on examples of work from the 'Cave Period' and, in line with evolutionary theory, followed this with a modern 'survival', in the form of the Eskimo and the 'Bushman' of South Africa.[114] The centre case was dedicated to 'Evolution in Decorative Art'. It was here, in particular, that the objects were inscribed within the degenerationist theories of the 1890s. Thus, the 1912 guidebook could reiterate a familiar thesis:

72. A selection of pipes from East Africa in the Horniman Museum, illustrated in Richard Quick's article. *Studio*, vol. XXXIII (November 1904).

Amongst backward races, such decoration is sometimes realistic, but more usually the designs are conventional, though they may often be traced to the modification of realistic representations of natural objects, or to the copying of patterns produced by technique.[115]

The display categories illustrate this principle, in a literal sense, with headings such as 'Origin of ornament and patterns by suggestion'; 'Origin of patterns from textiles'; 'Influence of textiles on Design'; 'Origin of form of vessels', and 'Degeneration of human and animal figures'. What this corroborates is the fact that, notwithstanding developments in the field that Haddon was well aware of, and had even substantially contributed to, somehow the evolutionary, typological paradigm developed in the early 1890s persisted in the public sphere of the Museum up to the First World War. And, as if to herald the revival of a theory which had never quite died, the lecture series for the winter term of 1912 was dedicated to the concept of 'Evolution'.

VI

By 1902, A. C. Haddon had been appointed as advisory curator at the Horniman, a post which he held until 1915. His appointment marks the inauguration of a series of lectures open to the general public on a regular basis.[116] It is this initiative which gives the Horniman its distinctive character in the history of the rise of ethnographic collections as public institutions in this country. The Horniman is an example of one of the most consistent and developed uses of the museum context for educational purposes. Furthermore, the Museum went to great lengths to make explicit, to the public, the rationale employed in selecting, displaying and even buying the material in their collections. New additions were labelled, catalogued, and put in a special case marked 'Recent Acquisitions', so that 'by this arrangement visitors are able to see at once in what direction the collection is being developed'.[117]

Evidently, the Museum's connection with the London County Council is responsible in some measure for the greater degree of public accountability of the Horniman. The institution's declared objective was, as already seen, to attract a broad public and to maintain a high profile on a local and national level, as well as on a 'popular' and 'general scientific' level. Even in the context of publics designated as 'scientific', they were more in the nature of informed individuals who were members of scientific but not necessarily professional societies.[118] As a means of ensuring a good turn out, the Horniman curators became proficient publicists, and the Museum early embarked on a policy of placing regular notices in the local press.[119] The curator, Richard Quick, was a tireless writer on the collections in numerous journals of general, scientific, and archaeological interest.

The first lecture series, in line with interests predominant at the Pitt Rivers Museum, consisted of 'The Natural History of Man' and 'The Natural History of Decorative Art'. The initiative was such a success that the state-funded Technical Education Board agreed to subsidise a similar series the following session. It is significant here that such recognition was forthcoming, in view of what has already been said with regard to prioritising certain sections of the working classes as the target audience. Although this was partly an acknowledgement of the Horniman's work with regard to the natural sciences, it was also an appeal for the use of ethnographic material as an aid in technical education to pro-

vide skills for the unemployed.[120] The lecture courses were meticulously organised, with syllabi sold to students for one penny and containing bibliographies for more detailed study.

While Haddon's special interest lay in the 'art' of British New Guinea, we know from the accessions record that from Africa it was the Congo material that was used substantially to demonstrate the evolution of design. The lecture series was split into five sections: 'How Designs Arise'; 'Art and Handicraft'; 'Art as a means of Instruction'; 'Art and Religion', and 'The Decorative Art of the British New Guinea as an example of Method'. The highest attendance was for the first in the series, totalling sixty-three, and the lowest for the last, at forty-six, the average attendance at the lectures numbering fifty-six.

Because of the emphasis on education and accessibility, the text of these lectures gives us a further purchase on how those peoples whose cultural artifacts were displayed in the Horniman were inscribed in various racialising narratives through the dramaturgy of both museum and lecture. With the removal of the Egyptian mummies to the south corridor, and the dispersal of other Egyptian antiquities into the 'Magic and Religions' sequences in 1907, the path was paved for a section to house 'Physical Anthropology'. It is this section that characterises the racial classification also outlined in the lecture syllabus on 'Native Races of the Empire', published in 1907, and which is signalled by the early presence of casts in the Ethnographic Room (or the 'Figure Room' as it was sometimes called). It was proposed that the new section would 'illustrate the zoological affinities of man by means of specimens and preparations of allied animals (apes and monkeys), and . . . give the outlines of the more important external and skeletal differences that exist between the various races of man.'[121]

So far, such an objective sounds innocuous enough, and to suggest a link with the science of physiognomy might seem untenable here. However, a glance at the syllabus notes for the same year suggests otherwise. On pages thirty to thirty-six are outlines of various groups of African societies. It is not discernible how these groups have been arrived at, that is, what the system of classification is that has grouped them together. One thing that all the sections have in common, though, is the fixing of certain mental and moral traits through physical characteristics as indexes of racial identity. Thus, following a detailed analysis of their physique, the 'Negrillos' are described as 'markedly intelligent, innately musical, cunning, revengeful, suspicious, never steal. Sometimes steatopygic . . . go naked.'[122] That this has a familiar ring about it is not surprising, since Haddon freely recommended A.H. Keane's work to those students interested in the study of race. The culmination of this scrutiny of the colonised subject and the habitual concentration on the body, came, like both the Oxford and Liverpool museums, with a display case on body decoration. By this date any physiognomic emphases would have been reinforced through the inclusion of photographic plates from those popular volumes on race and anthropology, such as *The Living Races*, with which Haddon had long been associated.[123]

Up until 1905, the plan of the south hall and the organisation of the material here followed a loosely comparative system. On entering the Museum, the visitor now moved between an impressive and heavily carved archway from Jaipur, India, on the left, to the right of which was a facsimile of the British coronation chair from Westminster Abbey. The total effect upon entering the Museum, therefore, was of an imposing imperial

presence representing the seat of government and the 'jewel' in the imperial crown. From here, the visitor moved through the archaeological section which ranged around the walls comprising prehistoric exhibits, bronze age pieces, ancient and oriental pottery, to arrive amidst a series of cases which grouped material from all those geographical regions represented in the entire collection, arranged according to type. After the rearrangement of 1905, however, visitors were greeted with a different perspective on entering the Museum. They now encountered ethnographic material, arranged according to different sections, in five divisions: 'Weapons, armour, hunting, and fishing appliances . . . Examples of the decorative art of savage, barbaric and civilised peoples . . . pottery, basketry, weaving and other specimens illustrating the Domestic Arts . . . religious objects and musical instruments' and finally 'means of transport by land and water.'[124] The groupings were now more closely identifiable as the typological arrangement associated with the Pitt Rivers Museum. No longer met by the coronation chair and the carved Jaipur doorway, the visitor now confronted an arsenal of weapons. The premise for their display is explicitly 'in the probable order of evolution of the class to which they belong.'[125]

By 1912, the Museum had already published, in addition to the 1904 handbook of the collection and the various lecture syllabi, three separate handbooks on particular sections of the collection. The first, in 1908, dealt with 'Weapons of War and Chase', which were thought to be more particularly representative of 'primitive' man since, 'With the progress of civilisation, the art of war tends to become a professional pursuit, while hunting degenerates into a mere past-time.'[126] This seems to provide one of the reasons for their inclusion at the very entrance to the section dealing with 'ethnography'. More importantly, the evolutionary paradigm here further served to 'naturalise' the colonising process since, 'Many races and peoples have been left behind in the advance of invention, and the savage, armed with club and spear may sacrifice himself against the magazine rifle and the machine gun.'[127]

The second publication, of 1910, treated the 'Stages in the Evolution of the Domestic Arts'. These were divided between two handbooks, one devoted to 'Agriculture, the Preparation of Food and Fire-Making', and the other to 'Basketry, Pottery and Weaving'. This book is characterised by its careful consideration of the division of labour between the sexes, for while 'food vessels are indispensable in women's work, some form of cord or string is equally necessary for that of the man.'[128] African material features strongly in this section, and once again it is clear on what premise the display is constructed. Referring to manufactured household goods in 'the higher stages of culture', the guide continues: 'Objects of luxury such as these, as well as the great variety of bowls, dishes, plates, saucepans, and kettles of the modern kitchen, are the derivations of the meagre outfit of the savage housewife.'[129] Notwithstanding this predictable structure, the material culture from Africa frequently meets with praise, and details of the decorative schema applied to the surface of many of the utensils are described in depth.[130] Basketry comes in for special mention in this respect, since

basketry and matting together constitute a most important division of savage invention. They are the one art that is more beautiful among the uncivilised. Enlightened nations express their aesthetic conceptions in lace and cloths and embroideries, the savage woman gives vent to her sense of beauty in basketry.[131]

It is to the maker of coiled basketry, however, that a more complete control over the materials is accredited, and subsequently a greater variety of form and ornamentation. Significantly, the best examples of this were attributed to African manufacture among the Somali, Barotse and others, and also to some Native American groups. The section of the handbook dealing with hand-built pottery also focuses on African material. Processes of potting by women from the Hausa (Northern Nigeria), British Central Africa, Nubia, and the Lower Congo Region are described in a step by step account. Similar attention is devoted to an account of spinning in Dahomey (West Africa) and South West Africa.[132]

Apart from corroborating what has been already acknowledged as an interest in decorative art and technical processes of manufacture, the guidebook is consistent in its representation of African women as neither indolent, dirty nor lazy. A pertinent quote from David Livingstone is supplied to reinforce the image of an industrious housekeeper:

> The markets or sleeping-places are well supplied with provisions by great numbers of women, every one of whom is seen spinning cotton with a spindle and distaff . . . A woman is scarcely ever seen going to the fields, though with a pot on her head, a child on her back, and the hoe over her shoulder, but she is employed in this way.[133]

The specific interest in the distinction between women's experience in different societies from that of the men in the same group, is further evinced through the various lecture series, which list in 1909 a contribution to the programme entitled: 'Women's Sphere in Savage Africa', and a further contribution in 1912 entitled: 'Women's Work in Central Africa'.[134] The production of such detailed publications, in conjunction with the displays, is testimony enough to the seriousness with which the curatorial staff pursued the educational potential of the collections. This is especially so when compared to the other rather half-hearted attempts made by the Liverpool Museum and the Pitt Rivers Museum, and indeed of almost any other sizeable ethnographic collection in this country. This is possibly one of the reasons for the frequent demand for the handbooks from other collections and museum curators. They would have provided a model for their own publications when any were forthcoming. Interested parties who were not connected with museum administration also bought copies of these books, perceiving in them a thorough introduction to the topic.[135]

Contrary to many recent commentators on nineteenth and early twentieth-century museology, who insist on the flux and indeterminacy of the narratives provided through the museum experience over this period, much evidence suggests that both Haddon and Harrison (Quick's successor as curator) left very little to chance in the interpretation of the objects in their collection. Barbara Freire-Marreco, one of the first to complete the Diploma in Anthropology from Oxford University, left a detailed notebook of her visits to regional ethnographic museums which provides further information regarding the Horniman displays from 1908.[136] She describes the labelling of exhibits as 'elaborate'. 'In each case are large labels describing the series. Dr Harrison begins with very full type-written labels; these serve as material for writing a handbook; then printed labels . . . are substituted.'[137]

Also by this date there is a reaffirming of the educational importance of the collection.[138] The number of school visits in 1908 more than doubled those in any previous year, and further educational aids were produced in the form of questionnaires on aspects of the collection. Pupils were encouraged to answer these, making use of the information at

hand, whether labels, or guidebooks, or the more detailed handbooks.[139] This initiative is in direct accordance with the objective of increasing accessibility to the 'general public, students, and school children', declared in the 1906 annual reports.[140] Over the period, the lecturing work of the institution grew apace, culminating in 1912 with a purpose-built lecture hall capable of accommodating two hundred people. The increasing attendance figures testify to their growing popularity.

VII

From the guides, annual reports, accessions files and related correspondence of these three major ethnographic collections in Britain, it is possible to draw several conclusions about the role of material culture studies in the representation of Africa. From the lists of donors, and the obvious trouble taken to obtain material on behalf of museums, it is clear that a very diverse sector of the public was implicated in ethnographic collecting. Colonial administrators, missionaries, engineers, members of the local community with friends and family in the colonies, travellers, and even Africans themselves, provided these

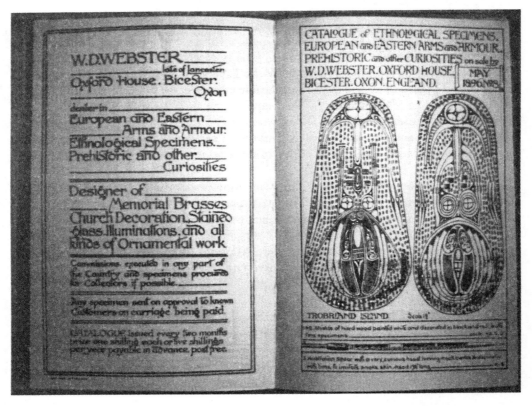

73, 74. Pages from W.D. Webster's 'mail order' *Catalogue of Ethnographical Specimens* (May 1896).

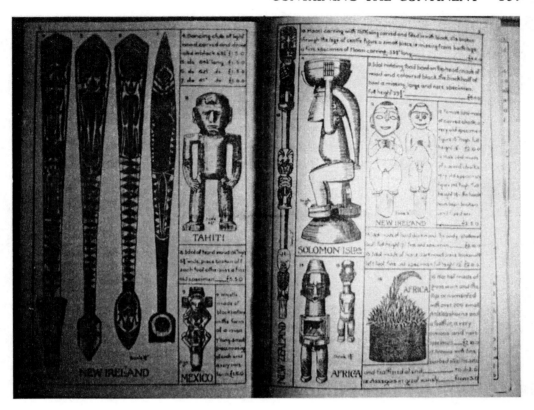

museums with a steady supply of material. While the personal motivation for donations may not always be obvious, it is clear that such contributions were not always given in the same spirit or with the same intention. Once in the hands of the curator, it was the overall schema and environment provided by the institution that constructed the object's relation to the whole display, and subsequently some of its meaning for the viewer.

The 1890s signalled a more systematic method of organisation and classification of ethnographic material, and witnessed the shift from eclectic 'curiosity shop' to 'scientific repository'. The same period saw the growth of a market for ethnographica through such channels as the dealers W.D. Webster and W.O. Oldham, and through the auction houses of Stevens and Fenton & Co. which specialised in ethnographic sales. Certainly by 1896 Webster and Oldham, whose stocks replenished the display cases of both the Pitt Rivers Museum and the Horniman, operated in addition to their shops a system of mail order catalogues which were fully illustrated and updated regularly (see figs 73 and 74). Such developments made a considerable impact on the kinds of ethnographic 'meaning' that could be produced through any museum collection. After the 'scramble' for territory in Africa in 1890, there was a corresponding influx of African material culture to museums. The representation of Africa through such displays is therefore paradigmatic of the new emphasis on classification and science and of the enhanced and multiple values attached to ethnographic material as a result of the salerooms' interest.

Whether the taxonomy was geographical, 'racial' or typological, many ethnographic collections shared certain characteristics in their representation of Africa. The focus on the body, whether on its decoration, scarification, skin colour, or measurements and proportions, is a consistent feature of the African exhibits in this context. Because of the concentration on the relation of physical 'evidence' to mental and inherited characteristics, the association of the body of the African with displays of material culture did much to encourage the popular conflation of living Africans with inert 'specimens'. Yet an important aspect of this research is that such classification systems were not closed circuits of sealed signification. The museum space, although rigorously constructed to conform to a particular sequence, could not hope to account for every spectator's ideological vantage point. Consequently, certain aspects of the more comparative typological displays provoked very different readings from members of the public. Crucially, however, in both the 'scientific' and the more eclectic stages of these collections, most material was viewed through an evolutionary prism. It is this principle, and its attendant ideology of European racial superiority, which overwhelmingly characterises all of the museums examined here up to at least 1913.

'FOR GOD AND FOR ENGLAND': MISSIONARY CONTRIBUTIONS TO AN IMAGE OF AFRICA

If the ethnographic collection in the local or national museum can now be seen as the site of production of a tacit consent for some of the tenets of the imperial project (while simultaneously offering the possibility of their disruption, through the constant negotiations of the main players in the museological drama either in relation to professional identities, colonial duties or personal proclivites), evangelical missionary societies were arguably the more active agents in both the promotion and criticism of colonial policy in West Africa. Most of the existing scholarship on missions and the colonial encounter concentrates on the effects on indigenous societies, as a result of contact with missionary communities in the field, in African and other colonies. However, almost no consideration has been given either to the home missions' role in the representation of the mission fields abroad, or to the make-up of the constituency of interested participants in England.[1] Where missionary contributions are dealt with, they are inevitably dismissed as the ranting propaganda of idol-bashing evangelicals. This predictable stereotype does not take into account the varying degrees of sophistication with which the missionary societies deliberately promoted an image of themselves as the more humanitarian and philanthropic face of colonialism, through the rhetoric of 'brotherly love'. What I want to suggest in this chapter is that it was through the careful cultivation of a distinct, though by no means disinterested, position in relation to the colonial enterprise, that the home mission was particularly effective in disseminating an image of Africa and the African that ultimately served imperial interests.[2]

The evangelical missions' relationship to the colonial state is particularly ambivalent in the case of those African colonies coming under British rule after the piecemeal division of the continent between the European powers in 1890. This was partly because, unlike India and certain other colonies, missionary societies had preceded the establishment of colonial governments in Africa, and were initially in more of a position to negotiate the terms on which they interacted with the indigenous communities of the various African states. After the instatement of colonial rule in the continent, the missionary societies were forced to reinvent both their role in relation to the colonial administration, and their self-image. Consequently, those contradictions which were endemic to the missionary enterprise generally, between the rhetoric of universal brotherhood and the implicit paternalism of the imperial mandate enabling missionaries to assume a progressive outcome for the 'civilising mission' (by definition European, if not explicitly British), are more transparent in relation to the African mission fields, and the home missions' representation of the significance of their work there to the congregations back home. In addition, while missionaries in the various societies had no doubt about the legitimacy of

their war against the pagan, they were also operating under another article of faith; one that declared that salvation was freely available and potentially efficacious for all sinners, including the 'heathen'. Paradoxically, this doctrine forced the missionaries into conceding a certain space for a re-evaluation of the position of the colonised subject. This applied in particular to the African who, it was popularly believed, was on the lowest rung of the evolutionary ladder. Adherence to this article of faith meant that it was not in the missionaries' interest to assume that the African was intrinsically and irredeemably of that order.[3]

The missionary exhibition was one of the activities most energetically pursued, by the societies at home, as a primary means of informing the congregations in Britain of progress in the field, and of drumming up financial and moral support.[4] An analysis of the development of this practice shows that the popular notion of the 'bible-bashing' missionary has taken no account of the scope and appeal of these public spectacles, and their relationship either to the contemporary trend of popularising anthropological theory or to colonial policy. While such events were often staged on a similar scale to colonial and other exhibitions involving representation from, and of, the colonies, the contradictions which are intrinsic to the missionary experience, and which were evident in the missionary exhibitions, were distinct, both in kind and in degree, to their colonial counterpart.

I

One of the factors supporting the contention that evangelical missionary societies were effective agents in disseminating a considerable body of heterogeneous knowledge about Africa to a diverse British public is that, far from being inconsequential over the period of 1890 to 1914, this particular aspect of religious activity was able to draw on a much broader cross-section of the population than many other social and cultural institutions implicated in the imperial project.[5] Missionary societies were able to capitalise on the romantic, exotic (and latterly economic and technical) appeal of the mission fields in order to recruit support, if not a vocation, from many who would otherwise have dismissed involvement with organised religion. The humanitarian appeal, especially when mobilised in connection with the slave-trade, could count on a tradition of support from various denominations, and in particular from Congregationalists within dissenting nonconformist groups. These were the societies, including the London Missionary Society, with the biggest public profile in England. The other society with a similar visibility was the Church Missionary Society. This nonconformist tradition gave the missionaries a strong base in the Liberal party, and many of their own number were influential Liberal M.P.s.[6]

Such an involvement in Liberal politics could not avoid engaging in the ideology of social imperialism, and it is this which helps to explain how the missionary societies negotiated the contradiction between the humanitarian rhetoric of equality and imperial objectives. Indeed, there is much evidence to suggest that because missionary societies had the ear of so many influential individuals, they had considerable political clout over the period up to the First World War, enough at any rate for one contemporary to caution his readers:

Neither in England nor in the United States does the Government dare to speak of the regulation of the missionary enterprise, even by way of advice. The statesman suspected even on the lightest evidence of wishing it anything but more adventurous and more persistent than it is might as well have committed an unpardonable offence.[7]

A brief consideration of the home missionary societies' recruiting policy, over the first decade of the twentieth century, provides some insight into their effectiveness at reaching a broad public. It also helps to distinguish the terms of reference on which both colonial and missionary exhibitions made their appeal to such a diverse public. Records indicate that the recruiting drive over this period focused on the lower-middle and artisan classes, and special emphasis was placed on the necessity of active participation in home mission affairs by working-class women and children.[8] The phenomenal growth of Juvenile Associations, affiliated to the missionary societies, is a case in point. By 1901, these Associations formed approximately twenty percent of the total annual financial contributions to the societies, and this expansion is commensurate with the growth of women's auxiliaries in the mission at home.[9] The majority of the children in the Juvenile Associations came from working-class homes, and the missionaries were adamant about the singular importance of their contribution. It was mission policy to encourage working-class children in particular to raise funds from especially underprivileged neighbourhoods. The sustaining notion that ensured the success of this policy was the doctrine that everyone – young, old, rich, and poor – could become contributors for the same cause, since no matter how impoverished the Englishman, the heathen was even more spiritually and materially bereft.

The full insidiousness of this notion, and the capital it acquired through the missionary exhibition, is best illustrated by a quotation from the final paragraph of the opening speech at the London Missionary Society 'Orient in London' exhibition of 1908, delivered by Winston Churchill and reported in *The Times* of that year. This exhorted the public to consider the exhibition as a manifestation of a common national goal, which would inspire them to turn their minds to a higher purpose, and to elevate them from the drudgery of their own hardships. 'Even the poorest', he said, 'are called upon to feel for the injustices of others and to forget their own.'[10] While national unity through class unity was also a common theme of colonial exhibitions, the working classes and women were assimilated very differently into the missionary exhibition. In many national and international exhibitions of the type discussed in chapters four and five, these sectors of the public were represented through separate exhibits in which they effectively became part of the spectacle of the event.[11] The missionaries, however, had pursued a policy of integrating these sectors into the day-to-day running of the society. Consequently, it is possible to see the missionary exhibition as an event that consolidated, through a philanthropic discourse, the misleading sense of class unity propagated by their recruitment and fund-raising activities, coupled now with the powerful panacea of national unity, both of which adequately served imperial interests. This was particularly true when concern about ill health amongst the working classes had resulted in the setting up of the Physical Deterioration Committee, causing other social commentators to be critical of what they saw as the squandering of capital on developing trade interests in the colonies while conditions at home degenerated.

Strategies for incorporating the largest possible public at missionary exhibitions

included selling tickets at reduced and special rates, especially to those on low incomes, children and teachers, and leaders of other educational and social organisations. Guide-books to the exhibition were sold to leading residents in the district through local book-sellers, and copies were distributed to the local press for review.[12] Omnibuses, cinemas, sandwichmen and even 'advertisement carriages' were pressed into service in the cause of the exhibitions. The Automobile Association and the Royal Automobile Club were employed to supply route signs for the exhibition, and concessions were made with the railways so that reduced fares, special rates and a late service could be offered to visitors. For the 'Orient in London' exhibition of 1908, *The Times* reported that:

> A large number of special trains have been engaged to bring parties of visitors from the West and South of England, from Wales, from the Midlands and East Anglia, from Lancashire and Yorkshire and even from Scotland. Parties travelling by ordinary train can obtain tickets for the return journey for single fares. In London, the County Council will grant special trams to parties travelling over its tramway system on application to the Chief Officer. The City of South London Railway Co. has agreed to convey 'Orient' visitors to its station at the Angel, close to the Royal Agricultural Hall, at reduced fares. Special rates for parties travelling by the Piccadilly and Hampstead 'tubes' may be obtained on application.[13]

Not surprisingly, a favourite publicity venue was the railway waiting room where missionary magazines and other publicity material were often placed with the approval of the station-master.[14] In addition, the preparations for some exhibitions were published as a continuing saga in newspapers or weekly magazines that were not specifically associated with missionary activities.[15] It is clear from the study of other publicity and reviews that it was important for the missionary societies to attain credibility in the eyes of a public who were not primarily concerned with missionary activity, and, in many cases, this aspect was deliberately subdued in order to encourage non-churchgoers.[16]

The *Rochdale Observer*, for instance, reviewing a missionary exhibition in the town, was thus by no means unusual in claiming that 'the ordinary citizen to whom missions are of little or no interest will find a vast deal which will be not only irresistibly fascinating but really instructive as well.'[17] The educational potential of the event was another aspect of the publicity which was designed to reinforce the non-sectarian aims of the exhibition. A report in *The Times* went as far as to claim that the 'Orient in London', 'although . . . a missionary exhibition . . . had no sectarian aims and that many scenes and objects from India, China, Africa and other countries to be shown here would be a geography lesson of the highest value.'[18] In fact, the London Missionary Society approached London County Council to get permission for schoolchildren to visit the exhibition during school hours, and for this to be counted as part of their curriculum if they were accompanied by their teachers. Schoolchildren were thus able to obtain free admission to the exhibitions. Similar permission had already been granted at the Church of England Mission Exhibition in Manchester, where,

> the large numbers of children who came with their teachers not only enjoyed but benefited from the visit. The society envisaged no problem in obtaining Council permission in view of the precedents already set in Manchester and in other counties where missionary exhibitions have been held.[19]

Such exhibitions were not merely tolerated by local government, but actively supported. It was a support which was to continue at least up to 1922.[20] The London and other local education authorities were contacted, and schools furnished with notices of forthcoming missionary exhibitions.[21] Furthermore, the societies regularly publicised their exhibitions in specialist educational journals such as *The Times Educational Supplement*, the *London Teacher* and *Education*. Obviously, the missionary exhibition, far from being seen solely as a testimony 'to the civilising and humanising influence of Christianity', successfully promoted an image of itself as an educational excursion for a broader sector of the public than those directly served by particular denominations. The fact that the organisers were reliant on individuals and learned bodies who had little concern with the missionary aspect of the event, ensured that the societies were inclusive rather than exclusive in the content and display at the exhibitions.

Most of the London sites selected for missionary exhibitions avoided the central districts, and tended to gravitate towards the areas of the city where a large percentage of the population were lower middle-class; areas such as Islington and Battersea were chosen. Four of the largest missionary exhibitions were held at the Royal Agricultural Hall, and the adjoining Gilby Hall, in Islington in 1890, 1908, 1909 and 1922.[22] In other cities, however, more central sites appear to have been chosen. In Liverpool, the Picton Hall was the site of a very large Church Missionary Society exhibition in 1909, and this location, apart from ensuring its visibility, contributed to the exhibition's description in the press as an ethnographic and colonial enterprise *and* as an educational event, because of other similar functions already associated with the Hall.[23] This also applies to the Agricultural Hall, since it was here that many of the colonial exhibitions and military tattoos were held.[24]

In all these instances the exhibition locations were capable of housing large crowds, and the choice of venue gives a clear indication of the numbers of visitors which were anticipated by the various societies. Records suggest that this was far from an idle miscalculation. In 1909, *The Times* reported that 'the demand for tickets for "Africa and the East", the great Church Missionary Society exhibition, continues to be very brisk. Over 500 ticket secretaries have been appointed.'[25] The 1912 Society for the Propagation of the Gospel exhibition at Church House reported 26,000 visitors, and the Church Missionary Society 'Africa and the East' exhibition of 1922 boasted 250,000.[26] At the London Missionary Society 'Orient in London', of 1908, opening day alone drew crowds of over 3,000.[27]

These, then, were obviously events on a grand scale, where the diversity of activities on the programme necessitated large open spaces which could easily be divided up without contravening fire regulations, as well as being able to accommodate crowds. Most provincial exhibitions appear to have lasted for about ten days, whereas the larger London events ran for a whole month.[28] Had the exhibitions been in any way a hazardous venture, not assured of success, it is unlikely that the missionary societies would have booked premises on such a scale and over such a long period of time. Neither would they have committed themselves to such expenditure on publicity if they had not been fairly confident of the result of so much time and money. Indeed, missionary exhibitions were so much an established part of Victorian and Edwardian leisure that certain businesses, capitalising on their assured custom, developed products especially for use in these spectacles.[29]

II

Since the 1870s, the missionary societies, and in particular the Church Missionary Society, had embarked on a policy to establish some sort of academic credibility.[30] Crises of confidence from within the societies resulted (at the initiative of the Church Missionary Society) in the setting up of theological colleges at both Oxford and Cambridge Universities.[31] This promoted a closer correspondence between these establishments and the Church Missionary Society's own training institute in Islington.[32] By the 1890s, certain missionaries had become familiar figures within the academic circuit, outside of the purely theological domain. Canon C.H. Robinson, author of ethnographies on the Hausa of Northern Nigeria, some of which are still in use, was lecturer in Hausa language at Cambridge by 1896.[33] By 1901, it is clear that it is the missionary, and not the colonial administrator (who formed the backbone of the committee for the colonial exhibition), that took advantage of the nascent science of anthropology in courses offered at these Universities.[34] On one occasion, the Right Reverend Warden of Saint Augustine's College, Canterbury, wrote to tell Haddon 'how very useful I found some elementary lectures which you gave in the October term of 1902 to intending missionaries.' A Reverend Knight goes on to say that, while in Rangoon, the lessons he'd learnt from Haddon protected him 'from any danger that might have existed, of lightly estimating native customs, etc. – of failing to give them attention and respect.'[35]

Missionaries also took advantage of the educational programmes on offer at ethnographic museums, an interest which often resulted in missionaries teaching ethnography themselves, and certainly of featuring heavily as contributors on the lecture programmes of many museums.[36] As late as 1907 the Anthropological Institute, the main organ for the promotion of anthropology, was still prepared to recognise the missionary as the harbinger of colonisation:

> As the missionary and trader are usually the pioneers of colonisation the question of anthropological training is in their case one of great importance, since the conduct of the first settlers usually determines the subsequent hostility or friendliness of the native towards the white man.[37]

Until Radcliffe-Brown and Malinowski instituted the primacy of fieldwork as the final test of any theoretical proposition, most academic anthropologists relied soley, as we have already seen, on those already in the field.[38] By far the most fruitful long-term correspondence was that set up between missionary and anthropologist. A case in point is that established, by 1901, between the Reverend John Roscoe, author of work on the Baganda still referred to today, and Sir James Frazer.[39] Frazer had been keen to establish a working relationship with Roscoe at least as early as December 1896. By this date, he had written to E.B. Tylor at Oxford, describing Roscoe of the Church Missionary Society as a 'missionary from Africa, resident in Cambridge . . . who knows a great deal about Uganda.'[40] Frazer had approached him with the objective 'to work him up to the point of contributing a paper or papers to the [Anthropological] Institute.'[41] According to Frazer, Roscoe had apparently already taken steps in the right direction by stimulating the 'native Prime Minister' to write down a history of Uganda and its customs and traditions. The letter ends with an attack on 'the deplorable ravages of Christianity and civilisation among

the people', but also with an acknowledgement that, thanks to missionaries such as Roscoe, 'there is hope of putting on record a good deal of their old life.'[42]

Such correspondence establishes not only an early reciprocal exchange of knowledge between the 'armchair' anthropologist and the missionary, it also indicates a fairly sophisticated method on Roscoe's part of obtaining information in the field.[43] Thus, the missionary and the anthropologist developed a particularly symbiotic relationship during this period.[44] This factor is especially significant when considering the use made of material culture from the colonies in either the colonial or the missionary exhibitions.

A further instance of proselytising zeal tempered by ethnographic curiosity is provided by Reverend William Allen, who was a prolific contributor to many ethnographic collections. The British Museum, the museum at Bergen in Norway, and other institutions, were the recipients of his gifts on different occasions.[45] A Church Missionary Society missionary in West and North Africa, he is probably best known, however, for his gift of figures associated with West African religion donated to the Pitt Rivers Museum in 1902, which were almost immediately given a prominent position in the Museum's display.[46] The correspondence between Allen and Balfour is revealing in several respects. It appears that Allen himself had a small museum in Bungay, Norfolk, but, due to his wife's blindness, felt obliged to relinquish his 'living' and consequently his museum collection. This points to the significant fact that there was probably quite a number of small private 'museums' with quantities of ethnographic material, run by missionaries in various provincial towns, just as there were others run by those with different personal interests in Africa and the colonies.[47] The correspondence also makes it clear that Allen appreciated the material culture he had acquired as possessing 'great interest from an Ethnological as well as Missionary point of view.'[48]

Furthermore, other details of his letters to Balfour indicate that it was not always the missionaries that took it upon themselves to destroy figures associated with indigenous religious practices in Africa.[49] As in this instance, they were often the ones to salvage the 'idols'. We might expect that this was done solely to demonstrate the progress of the 'civilising' mission. What is interesting here, therefore, is the amount of painstaking detail and information which accompany the donation, regarding the objects' functions in their original context. Allen went to considerable trouble to specify the exact uses of each item he donated. At times, this involved correspondence with other missionaries in the field whom he thought might have more information.[50] Clearly, Balfour relied heavily on Allen's information in order to contextualise the objects. In one instance, Balfour returned Allen's sketches of some of the items sent to him with queries, which the latter duly answered (fig. 75). Moreover, the correspondence makes it clear that Allen was particularly interested in having missionary documents, concerning African material, circulated amongst the scientific community (in this case by Archdeacon Crowther). In March 1902, Allen wrote to Balfour, claiming, 'I quite agree with you that there can no longer be any objection to printing such portions of Archdeacon Crowther's manuscript as you may think well, especially in a scientific periodical.'[51]

Such examples demonstrate the close correspondence and positive co-operation between some evangelical missionaries and ethnographic curators in established public collections. They also indicate that, in some cases, the missionaries concerned preferred to donate their collections to secular museum collections rather than those of their own mission house. In this case, Allen gave Balfour first refusal on the items before offering

75. Sketches of items donated to the Pitt Rivers Museum by Reverend William Allen, annotated with his replies to Henry Balfour's questions. Pitt Rivers Museum, University of Oxford.

them to the Church Missionary Society. In neither instance was money exchanged, so this should be dismissed as a consideration for Allen's choice of recipient, and it seems likely that such generosity was the result of a desire to make a contribution to what was acquiring popular, if not academic, recognition as a significant science.

III

What the missionary in the field did not give, or sell, to the national or local ethnographic collection back home, they donated to their own society's ethnographic collection. Two of the earliest museums in Britain, which were founded independently of any concern for forming stock for use in exhibitions, belonged to the London Missionary Society (fig. 76) and the Wesleyan Missionary Society. (The latter was the first to incorporate a museum into the mission headquarters as early as 1838.)[52]

Although the Wesleyan collection contained more than the usual missionary memorabilia, its ethnographic material was fairly sparse. The majority of the African pieces were West African in origin, and came from mission stations in the Gambia and from Badagry and Yorubaland in Nigeria. The objects fell primarily into four categories: domestic utensils, and weapons, together with some textiles and costumes. From the entries in the catalogue, begun at the time of the Society's move to Bishopsgate in 1838, it is not possible to gain any insight into the home administration's objectives concerning the display of these items. The catalogue entries are devoid of any comment except the most empirical details, even, surprisingly, in instances where the Society could have made capital out of its acquisition as a result of a successful conversion. Items are merely listed in the catalogue as, for example, 'an idol', followed by the donor's name, or in one instance, as 'The God of Thunder, an idol much represented by the natives of West Africa.'[53]

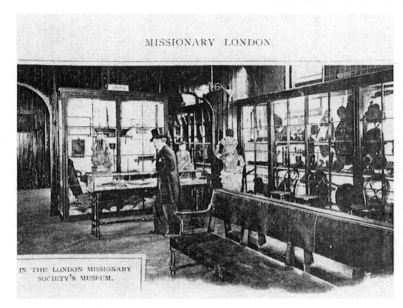

MISSIONARY LONDON.

IN THE LONDON MISSIONARY SOCIETY'S MUSEUM.

76. The London Missionary Society Museum, illustrated in ed. George R. Sims, *Living London* (London 1903).

Although the Yoruba 'shango' cult, to which this entry refers, was described in greater detail in the training manual issued to stewards for the exhibitions, no effort is made in the Museum catalogue itself to provide any information on the uses of this cult object in Yoruba society.

More importantly, such catalogue entries register no acknowledgement of repeated denials of idol worship from the donor, the missionary in the field, who, in compliance with the home mission's demand for articles to add to their 'curio' collection, sent back figures, images and domestic utensils for the edification of the English congregations. The Reverend Dennis Kemp provides a good example of such a disparity between the intentions of the donors and the actual use which the home mission made of their donation.[54] Kemp, who was eventually made Wesleyan General Superintendent of the Gold Coast mission, lived there from 1887 to 1896 and was the author of a number of serious books on the cultural life of the region.[55] He was responsible for contributing many items to the Methodist Museum collection, and had clearly stipulated that 'it is most unusual to see a pagan adoring a block of wood or stone. No heathen temples adorn the land.'[56] On another occasion, Kemp mentions that 'In return for a rather insignificant quantity of salt we were presented at Bekwai with another handsome Ashanti pipe . . . [and a] beautifully carved native stool which may be seen in the museum of our London mission house.'[57] The tone of his description and his evident embarrassment at having received the gift for such a paltry offering, implies his considerable admiration for Ashanti workmanship. This is not the commentary of someone who sees these items as primarily a means of demonstrating the savagery of their makers.

Another example of a well-known missionary in the field protesting against the naive teachings of the home mission that all Africans worshipped wooden figures, was William M. Bentley, of the Baptist Missionary Society in the Congo. In his book, *Pioneering in the Congo*, he goes as far as to claim that:

The image is but an accident. If a child models in clay, a little man is the first definite object he thinks of making; so a little man is the first thing which suggests itself to a native carver as an artistic vehicle of a fetish. When some mystery powder has been put onto it, it becomes a charm, *not an idol or god of any kind*.'[58]

It is an interesting statement, not only because of its refusal of the standard presentation of Africans as idolaters, but also because it none the less ironically reinforces the familiar conjuncture of a liberal cultural relativism coupled with the complacent paternalism that could relegate the African to perpetual childhood.

One of the reasons for focusing on the missionary museum at this point is to demonstrate that although the museums did not have the popular appeal or accessibility of the exhibitions, they too were recognised outside of the mission context, and their collections were acknowledged not only by major public ethnographic museums but also on a more general level of public interest. In 1899, the *English Illustrated Magazine* included the London Missionary Society Museum in a series of articles entitled 'Lesser Known Museums.'[59] The sections of the collection which receive most attention are those devoted to Central Africa, the Sudan, Madagascar, different manifestations of Hinduism, and the South Seas. However, by the time the article was published, most of the South Seas material had been acquired by the British Museum, which might also account for a more general public interest in the London Missionary Society collection.[60]

While the *English Illustrated Magazine* article was written in the context of advocating missionary enterprises for 'the suppression of unspeakable cruelties among savage races, and in opening up countries to the traveller and trader', the author went on to say that the items exhibited were by no means uniquely religious, but were often for household and domestic use.[61] Headrests from Central Africa are mentioned in this connection, together with a collection of musical instruments. Another aspect of African societies which was signalled in the article was the practice of supplicating what are talked of as 'the spirits of dead ancestors and chiefs represented by greasy wooden fetishes', illustrated in the text by three figures from the Bakuba peoples of the Congo Free State (fig. 77).[62] The contents of a 'medicine-man's basket' is also described and illustrated, together with a charm supposedly carried by childless women. Africa was also well represented in the Museum collection in the section dealing with the slave-trade. The article concentrates solely on the Sudan where Arabs, supposedly in the pay of wealthy Sudanese merchants from Khartoum, had depopulated the Shilluk country in the southern region to provide slaves for the north-western provinces of Darfur and Kordofan. This is of interest primarily because the yokes and cuffs associated with the slave-trade were displayed in the same case as the headrests from Central Africa.[63] Evidently there was no consistent classification system applied at the Museum. It seems rather to have served as a more coherent version of the Surrey House Museum, prior to its inauguration in 1901 as the Horniman Free Museum. As a missionary museum all the items in its collection would have been associated with conversion, suppression of the slave-trade, philanthropy and education; the four main activities which British congregations associated with the missionary endeavour.

The Church Missionary Society, another active participant and organiser of exhibitions, also had a substantial museum collection, although by a much later date than the London or the Wesleyan missionary societies. Before 1906, the Church Missionary

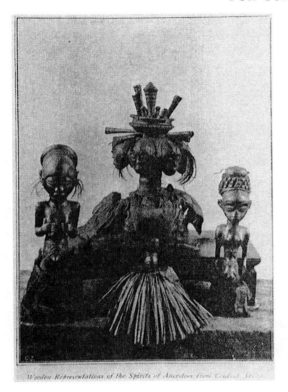

77. 'Wooden representations of the spirits of ancestors from Central Africa', *English Illustrated Magazine*, vol. 21 (April 1899).

Society's Museum functioned mainly as a temporary repository for 'curios' until they were needed for exhibitions and other forms of missionary demonstrations, or for loan to colonial exhibitions and ethnographic collections. This lack of interest in a permanent museum structure is understandable, since the Society was most active in using material culture from the mission field for evangelising purposes and therefore preferred the more popular exhibition format. By 1906, the 'Museum' had been transformed into a 'rest and waiting room' for missionaries on furlough, or visitors to the mission house.[64] In this instance, the room chosen for rest and quiet was the same room chosen to house a selection of exhibits from the Church Missionary Society's 'curio' collection. Consequently, it seems unlikely that the exhibits were designed to shock or discomfort the visitor. If the missionaries had recognised the figures or 'idols' on display as functioning solely as trophies of successful conversions, it is probable that the figures would merely have commanded disgust. Whilst the display would have emphasised the triumph of missionary endeavour, it would certainly not have been a fitting environment for a recumbent reverend. That the emphasis was intended to lie not with the horrors of idol worship, but on a more comparative view of African religious practices, is clear from the following examination of the guide to the collection, published in I.H. Barnes' history of the mission house.[65]

Barnes begins by describing how the exhibits are arranged in and on glass cases, remarking on the sizeable collection of weapons, spears and shields. She asks, 'Why

should such an unromantic collection be promoted to the dignity of a place on the museum shelves?', not of these objects, but, surprisingly, of a silver tea set and tongs once belonging to a missionary in service.[66] The fact that missionary 'relics' have been relegated to a secondary position of importance to the ethnographic material in the collection represents not only a rehearsal of the familiar romance of the exotic, but some kind of an acknowledgement of another cultural value for the 'curios' in their care by 1906.

The choice of articles selected for exhibition from Africa is also significant. Out of the entire collection, only some items would have been displayed, and those singled out for attention in this instance were the figures which the author suggests 'make a striking collection.' That the association of the objects with conversion merely 'adds to their intrinsic interest' supports the view that by 1906 the Church Missionary Society had already recognised the value of their African collection outside of a purely missionary context.[67] Certainly by 1907, their collection was not beyond mention in specialist journals such as the *Reliquary*.[68]

Also significant is the fact that Barnes devotes over half the chapter on the collection to a lengthy account of the rituals connected with the various 'gods' of the Ibo and Yoruba tribes of West Africa that are represented on the Museum shelves. Much of the detail of these ceremonies is a duplication of the information produced in the stewards' handbooks, which were the published training manuals for the prospective stewards at exhibitions.[69] It is notable, in the case of the Church Missionary Society, that some care is taken to provide an indigenous context for any figures associated with religious worship in the catalogue of items donated to the Society.[70] Here, the emphasis of many entries, which were often descriptions provided by the donor, was on the fact that the figure in question 'was worshipped not necessarily as an idol itself but as a common mediator.'[71] Unlike the London and the Weslyan societies, then, this indicates a greater consistency between the public (exhibition) and private (museum) spheres in the Church Missionary Society representation of Africa and other mission fields.

Consequently, while the objects in the museum would be significant to the mission community as trophies testifying to the success of the mission's campaign in the field, it is also clear that even here they were open to more complex interpretation. In some cases the items displayed were not explained through such discourses alone, but were also accompanied by more detailed information regarding the indigenous use of many domestic utensils; information which contributed considerably to anthropological knowledge, and was certainly valued by that community of interest to the same degree that many missionaries obviously cherished participation in the new 'science'.

On another, more general level, the Allen, Kemp and Bentley correspondence, all of which came from different denominations, is a reminder of the disjuncture which often existed between the missionary society's intentions for donated material and the donor's aspirations for the same. Significantly, in the case of the missionary, this often pointed to a more liberal and comparative cast of mind in relation to African culture. But it was also because the missionary, like the anthropologist, had several different public faces to juggle simultaneously. These various roles demanded various responses to, and presentations of, missionary activity in the field. Consequently, in the same way that it was often more expedient to promote one rather than another facet of colonial activity and the colonised subject, in the exhibitions analysed in the previous chapter, so certain aspects and not others came to the fore at different times in the missionary presentation of Africa. This

should not be interpreted as an apology for missionary activities in Africa, or a suggestion that their ethnographic documents and museum connections were a sign that their overriding concern lay with the interest of the indigenous cultures among which they worked. Such an argument would be difficult to sustain unequivocally, if only on the evidence that the evolutionary principles that the missionaries endorsed wittingly or unwittingly, through their co-operation in building up such collections, were responsible for reinforcing an essentially racist notion of Africa.

None the less, what this data does reveal is that those missionaries working in the field were in touch with current ideas in anthropology, and were interested enough in, or at least recognised, the scientific kudos beginning to be attached to the study of the indigenous culture of the communities that they worked among to collate evidence for later and contemporary anthropologists to use as valuable field data. Finally, although the proportion of missionaries who did correspond with museums and did lecture and publish material was relatively small when compared with the number out in African mission stations, it is important to acknowledge their role in much of the material which the missions back home in Britain mobilised in their construction of an image of Africa at missionary exhibitions.

IV

Although the first missionary exhibition had been held by 1867, it was not until 1882 that this became a more established vehicle for the missionary societies.[72] That this was a particularly English phenomenon is evidenced by the fact that it was not until the Boston exhibition of 1910 that missionary exhibitions became popular in the United States. By 1882 their objective was to show 'articles of foreign manufacture, samples of food and clothing, models of native life, habits and religions in the field of labour' occupied by the various missions.[73] The success of the venture encouraged further exhibitions. What is interesting, even at this early stage, is the support from lay persons not directly associated with the mission, and it is largely due to their active encouragement that the exhibition became such a popular feature of the societies' work. By 1899, Eugene Stock, the Church Missionary Society's official historian, was able to report that:

> Missionary exhibitions seem more attractive than ever. Very large ones have been held at Birmingham, Bristol, Rochester, Paddington, Newcastle and Liverpool . . . The articles displayed and still more the lectures and explanatory talks have enlightened thousands of hearers.[74]

The Society for the Propagation of the Gospel had organised a large exhibition at Kensington by 1898, and the Scotch Presbyterians held a still larger one at Glasgow.[75] According to Stock, even national press opinion had shifted from outright antagonism to being very favourably disposed towards the idea of missionary exhibitions.[76] At this early stage, the individual societies do not appear to have had a store of items which could be readily drawn upon for exhibition purposes. Most of the exhibitions after 1882 were co-operative ventures.[77] As an added incentive to commit items to the care of the organising society who took overall responsibility for the exhibition, a grant was offered to those societies willing to lend the items. Hence the ventures became known as 'missionary loan

exhibitions'.[78] Of those who most consistently took an active part in the exhibitions, and whose material comprised a large proportion from Africa, the Church Missionary Society was the first to recognise the potential of the exhibition as a means of propagating knowledge of developments in the mission field abroad, and generating interest and support among the congregations at home. Consequently, it was this society who initiated not only the 'missionary loan exhibition', but also the establishment of a department, within their London headquarters at Salisbury Square, specifically dedicated to obtaining loans for this purpose.[79] These were obtained, not simply from missionaries in the field, nor from other missionary societies, although these were approached, but from the very earliest date local residents were involved in providing the exhibits.[80] These articles would be collected and sent off to the exhibitions in boxes which constituted what amounted to a DIY exhibition kit. The studies produced for the training of stewards for exhibitions encouraged the use of 'curio boxes' and postcards, supplied by the Society, for local provincial use.[81]

This practice is very close to the idea of the travelling specimen cabinets initiated as part of the Liverpool Derby Museum's educational policy in 1883.[82] The earliest specimen cabinets, however, contained natural history specimens and not ethnographic material, which was the prerogative of the Mayer Museum. It is possible that the missionary societies were the first, therefore, to initiate this policy in what effectively became the equivalent, applied to ethnographic specimens. It was the exhibition 'curio box' which, once instituted, ensured that the missionary exhibitions had maximum mobility, thereby reaching a much broader spectrum of the public than the ethnographic museums or even the colonial exhibitions of the period.

An anecdote referring to the fact that many of the 'curio boxes' returned to Salisbury Square not as full as when they left is also very revealing.[83] That the items were consistently stolen indicates that the exhibits on display at the exhibition were generally recognised as authentic by a public who, by the late 1890s, would possibly have associated such items with museums or salerooms. This is further corroborated by a report on the 1909 exhibition, which noted that one visitor, when questioned, was found to have no personal interest in the mission's work, and had spent five hours simply inspecting the exhibits.[84] This is an important consideration in establishing the appeal of the missionary exhibition to a varied public, many of whom clearly had little personal investment in missionary affairs. Another factor contributing to the credibility of the exhibits is that many of the items on display were indeed on loan from well-known ethnographic dealers including Oldham and Webster.[85] In the light of this, it is evident that the missionary exhibitions acted very much as a mobile museum, taking articles, generally reserved for ethnographic collections, into a much more lively and equally controversial context.

VI

Before dealing with the physical presentation and arrangement of the exhibition itself, it is important to examine the sort of information packs with which those responsible for explaining the exhibits were equipped, and the methods of training that were employed prior to the event. For the purposes of this chapter, I am going to look at the material produced by the two most active organisers of exhibitions, the Church Missionary Society

and the London Missionary Society. Although other societies were important contributors to these events, the largest exhibitions were co-ordinated by these two. Most of the available printed material, published in conjunction with exhibitions run by these Societies, deals with two major events, both held in London: the Church Missionary Society 'Africa and the East' of 1909, and the London Missionary Society 'Orient in London' of the previous year (figs 78 and 79).

Each Society operated a system which employed the local congregation as 'stewards' or guides in each of the 'courts', areas designated to each country or mission field represented. In the larger exhibitions this could involve up to as many as 10,000 male and female stewards.[86] More often than not, particularly in the provinces, the stewards were not equipped to inform the public on any aspect of the court to which they were assigned.

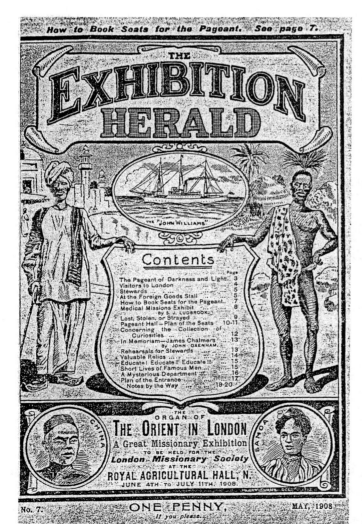

78. Front cover of the London Missionary Society magazine, the *Exhibition Herald*, which gave advance notice of its exhibitions.

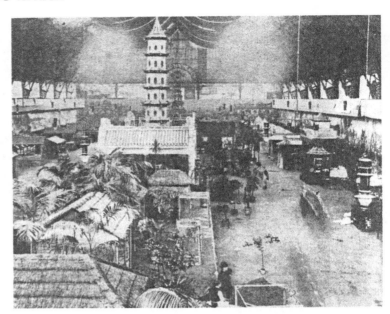

79. View of the London Missionary Society exhibition, 'The Orient in London' (1908).

This meant that their only source of information and preparation was the material given to them by the co-ordinating missionary society. Once chosen by their parish, the stewards formed themselves into study groups, in which they were provided with a standard text book relating to the individual courts, prepared essays on specific questions to which they were directed in the text, and reported back to each other with problems and for general discussion. Favourite topics for the West African court for Church Missionary Society stewards were 'Religion and Fetishism in West Africa', 'The Liquor Traffic in West Africa' and 'Slavery in West Africa'.[87] All of these were themes in which missionary history figured strongly. The last two areas were especially popular, since here the missionaries could be represented as the catalysts necessary to bring the colonial government to its senses for the good of the indigenous population.

In all of these topics, the benefactor was the white coloniser, in the form of the missionary. Considerable emphasis was placed on their ability to destroy evils portrayed as entrenched in African society, and to change moral weaknesses they believed to be inherent in the people and destructive of the common good of the indigenous race. The political implications of these topics would have been obvious to a congregation at the time, who would have been aware of the well-publicised controversy over the liquor trade, and the moral dilemmas involved, as they would also have been with the debates over the abolition of slavery. The timely recounting of the story of the life of Samuel Crowther, the first African Bishop appointed in the field by the Church Missionary Society, and himself rescued from slavery, would reaffirm the success of the missionaries' role in West Africa.[88] By suggesting these topics as papers for the stewards, the missionaries proclaimed their political alliances and grievances while at the same time declaring their advocacy of the principles of colonial expansion, and affirming their participation

and necessity for the colonial government. Thus, they defined their position under cover of a purely ecclesiastical interest while effectively operating in a secular sphere.

The other recommended areas for study were essentially ethnographic in character, with some time set aside for the work and development of the church in West Africa. The most thoroughly condemned religious practices were reserved not for 'pagan' Africans, but for Islam.[89] 'Mohammedanism' and also Hinduism both represented far more of a threat to the progress of Christianity than did the indigenous African religions.[90] The African was essentially represented as a wayward child who, under the right guidance, was completely compliant with the coloniser's wishes and therefore harmless.[91] This optimistic picture, from the point of view of the missionary, of the misguided but malleable African was given credibility in the manuals for the stewards by citing the success of colonial commercial enterprise in West Africa, particularly using local labour.[92] The other means of ensuring that this image was perpetuated was to concentrate on the devious and mercenary practices of the 'witch doctor', who was described in the manuals as one who capitalised on the fundamental simplicity of the African by conning him into paying for treatment which was bound to fail, and for creating a blackmail situation where fear of retribution from the 'ju-ju' provided the only motivation necessary to keep him worshipping his reprehensible 'idols'.

The blame was thus transferred from the African in general, who was now merely being manipulated, to the real malefactor, the devious medicine man. The missionaries, by offering a solution based on the principles of Christianity and not on the basis of fear from which the medicine man operated, promoted themselves as providers of a gentler alternative for the African, who was thought bound to recognise the benefits of such a proposition eventually. The stewards employed as guides to the various courts were not in a position to question the simplicity of this logic, being often only members of the local congregation, namely enthusiastic volunteers who saw their efforts as furthering the missionary cause, and possibly encouraging recruitments for the field.[93]

From the earliest days of Church Missionary Society endeavour in West Africa, the exhibition stewards' manual for this region was primarily concerned with equipping the guides with information about the various 'idols' which were the most numerous objects in the court.[94] This corresponds with the emphasis in the Society's Museum catalogue, where the majority of entries were figures or 'idols' of some kind. Despite the fact that the focus in the early manuals of 1899 concentrated on the handing over of these deities on conversion, mainly by the Yoruba, the ritual processes involved are consistently described in detail.[95] It is probable that in the exhibitions before the turn of the century, the descriptions only served to add to the overall repugnance already engendered by the mere sight of the sizeable collection of Yoruba 'idols' on display. Certainly, in these exhibitions, the Church Missionary Society was guilty of the sort of distortion of the facts and sensationalism which has already been discussed.[96] Nevertheless, the persistent provision of a context for these items does constitute a development away from the attitude which Waddell, Kemp and Bentley were protesting against.

Inadvertantly, the missionary encouraged the public to interpret the carvings within a social context, albeit a naive one, and not as they were presented in most of the ethnographic collections of the day, where they functioned primarily as an illustration of stages in evolutionary development. There was always some steward on duty at each of the courts, and often missionaries from the field who would give illustrated talks, so that

although in the earlier exhibitions the items were arranged geographically on stalls, rather in the manner of a grand bazaar and with only the most perfunctory explanatory labels, the steward would have been on hand giving regular talks on the 'curios', and explaining the significance of each of the figure carvings in terms of the rituals concerned with them.

Notably, by the time of the 1909 Church Missionary Society 'Africa and the East' exhibition, the only 'idol' described in an overtly derogatory way is the 'Oro' figure, seen as a 'repulsive-looking image of human form with face and lips smeared with blood.'[97] On the other hand, by distorting the information in some instances, the missionary societies were able to use the material far more successfully for their own ends. Yoruba Gelede masks (recurring images on Church Missionary Society publications and at their exhibitions), are a good example.[98] The information in the handbook suggests that the Gelede masquerade was part of the same ceremony as the Egun-Gun masquerade, which is ostensibly a male dominated ritual that operates by attacking the spiritual qualities recognised as destructive powers in some women.[99] As with the ceremonies associated with Oro, another Yoruba male dominated cult, the emphasis in the handbooks is on the implication which both cults have for Yoruba women. 'The object of this worship', says the manual, 'like the use of Oro, is to intimidate women.'[100] The fact that the Gelede masquerade, which is actually a *celebration* of the positive aspects of Yoruba womanhood, is presented as being antagonistic to women is symptomatic of the way in which some aspects of African culture were subverted in order to reinforce others which more readily fitted in with the image that the missionary wished to convey. The missionary exhibitions generally exploited this image of oppressed womanhood in traditional African societies, since it guaranteed them the support of the women in the audience.[101] To this extent, they have much in common with many of the colonial exhibitions discussed above. This particular aspect of African life was something that the Indian Zenana courts shared with the African ones. Once again it was the woman, here both African and Indian, who was the victim and at all costs must be saved from the fate secured for her at the hands of her own society.[102]

VII

One of the features which distinguishes the missionary exhibition from their colonial counterpart was their greater degree of mobility. The Royal Agricultural Hall in Islington, while it was by no means small, having the same surface area as the British Museum, was more self-contained than the purpose-built White City for example.[103] No pavilions or other architectural monuments could be permanently erected here, and structures such as the African Village, a recurrent feature in both types of exhibition, had to be contained within the Victorian edifice of the Agricultural Hall and be easily dismantled. It is, in part, due to this factor that the missionaries were able to make their appeal to a far larger public than the huge, but static colonial exhibitions.[104] Both the London and the Church Societies took their exhibitions to Manchester, Liverpool, and Birmingham, and in a modified form to smaller towns in the provinces.[105] The plans of the 'Africa and the East' and 'Orient in London', held at the Royal Agricultural Hall in 1909 and 1908 respectively, give some idea of the scale and scope of the larger missionary

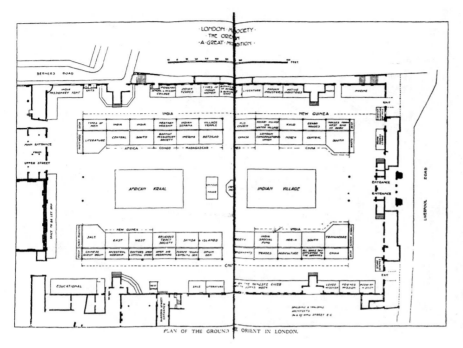

PLAN OF THE GROUND THE ORIENT IN LONDON.

80, 81. Ground floor and first floor plans of the London Missionary Society exhibition, 'The Orient in London' (1908).

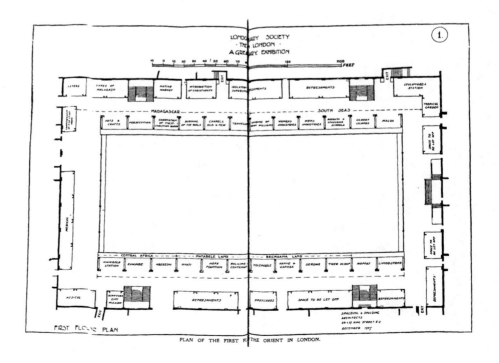

FIRST FLOOR PLAN

PLAN OF THE FIRST F THE ORIENT IN LONDON.

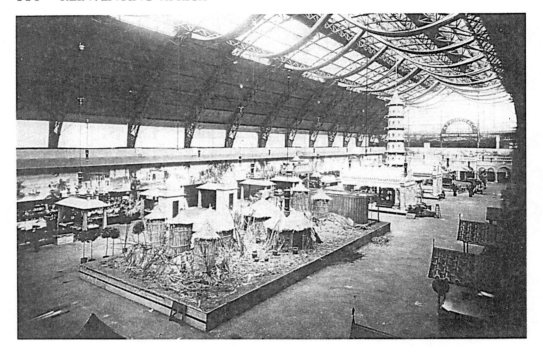

82. The 'African Village' at 'The Orient in London' (1908). World Council of Missions archive, School of Oriental and African Studies, University of London.

exhibitions (figs 80 and 81). They also indicate the relative significance of the African sections, since they provide a means of calculating the proportion of space delegated to each of the mission fields. In all of these plans, the African sections take over the largest area.

The plans and programmes provided in the handbooks for all the major exhibitions also indicate that, apart from the material collected and exhibited on the stalls representing the various mission fields, there were other features similar to those found in their secular counterparts which contributed to the representation of the various countries subjected to missionary labours. Some of these took the form of pageants, which consisted of parades to demonstrate the variety of costumes from the mission stations. Other attractions consisted of tableaux and plays written by missionaries which occasionally incorporated a score specially composed for the event.[106] Such pageants were very popular until about the 1920s, when the press reviews baulked at 'the number of stallholders whose oriental garb cannot disguise the fact that they are stolid, spectacled British matrons, on whom the gorgeous robes of the East do not sit well.'[107]

The other main aspect through which Africa was represented at these exhibitions was the 'African Village' (fig. 82). While this exhibit seems very similar in appearance, albeit on a smaller scale, to those in the colonial exhibitions, the 'African Village' of the missionaries was designed to encourage a somewhat different set of interpretations. It was this feature of the exhibition on which contemporary press reports most consistently focused.[108] From these, it is clear that the Nigerians, who usually peopled the 'village',

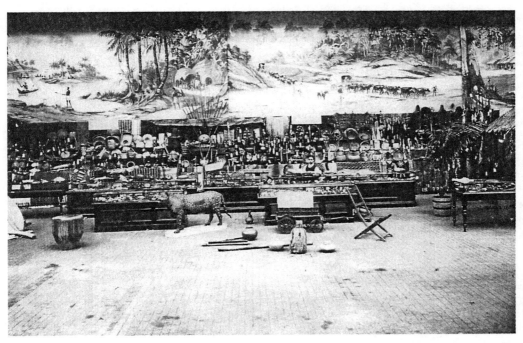

83. The 'Central African Court' at 'The Orient in London' (1908). World Council of Missions archive, School of Oriental and African Studies, University of London.

constituted a major attraction for the public. While the African is still a 'spectacle', the spectacle is of a very different nature.

Classified as 'artisans', the men and women who were brought over by the missionaries were employed to demonstrate their traditional crafts of weaving, dyeing, carving, forging iron and leatherwork.[109] The very use of the term 'artisan' is in itself a significant departure from the way in which similar displays were represented in the colonial exhibitions. There, these activities were primarily presented to the public as curious hobbies to help fill in the dark and empty days. The missionaries, on the other hand, had good reason to exploit a term that indicated a specialist craft. The contemporary press reportage was quick to pick up on the distinction implied by this classification. The effect was to encourage a re-evaluation of the African as a skilled craftsperson. As early as 1905, coverage of a Church Missionary Society exhibition in Rochdale provides a cogent comparison for the disparaging dismissal of African cultural production found in the reports of most colonial exhibitions. The reporter begins: 'One is particularly struck by the rare capacity of carving either in wood or other materials, which marks these men we call savages. There are specimens of remarkable beauty and taste by these black natives.'[110] The article concludes with the suggestion that, 'From an industrial point of view they would well repay the trouble of expert training.'[111] This latter comment was, in fact, the desired response. The strategy of employing Africans to demonstrate their skill as manufacturers was an attempt by the missionaries to encourage government support for the growing number of technical schools that the societies were setting up in Africa.

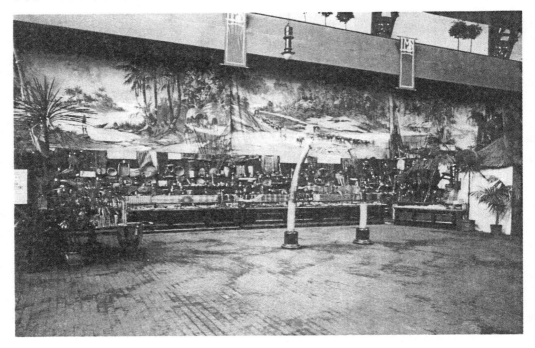

84. The 'Central African Court' at 'The Orient in London' (1908). World Council of Missions archive, School of Oriental and African Studies, University of London.

Further displays of material culture, in what was known as the African court (see figs 83 and 84), consolidated this emphasis on the potential skill of the African as a manufacturer of ingeniously crafted objects. At the Church Missionary Society 1909 exhibition, for example, they incorporated objects of both traditional and mission manufacture, the latter in the form of furniture made by Nigerians at the Onitsha Industrial Mission. One of the most consistent exhibits of traditional manufacture was a massively carved Yoruban throne, given as a gift to a missionary in the early nineteenth century by King Ogunbige. It is described in the 1899 edition of the steward's handbook as 'the beautifully carved throne of a Yoruban king.'[112]

While the official literature produced for both the missionary and colonial exhibitions describe these objects as 'curios', the term takes on a distinct meaning in both cases. In conjunction with the militarism already disclosed in the dramatic re-enactments featuring Africans of most colonial exhibitions, these 'curios', similarly selected from notorious but vanquished fighters, should be recognised as functioning primarily as trophies of war.[113] It could be argued that the missionary use of 'curios' was also, in a sense, as trophies from the war against the heathen, yet their deployment as publicity for their own technical training institutions was significant in furthering a popular recognition of a certain ability and skill accredited to the African, without the qualification 'degenerate' attached to the producers. Consequently, if the African is still a 'spectacle' – a tamed savage in an evidently crudely constructed village, contained literally and metaphorically within the architectural edifice of the Royal Agricultural Hall, and a living witness to the efficacy of

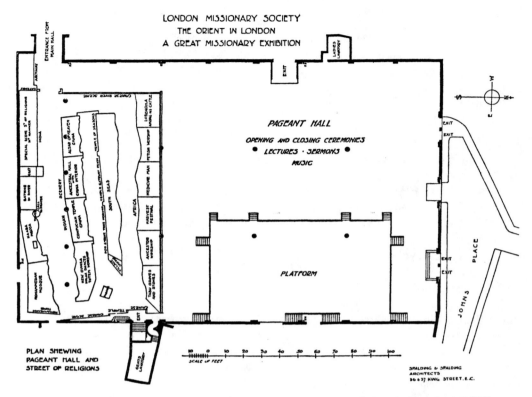

85. Plan of the pageant hall and the 'Street of Religions' at 'The Orient in London' (1908).

the 'civilising mission' – this African can still be differentiated from that of the colonial exhibition.

One of the best examples of overt usage of anthropology at a missionary exhibition is provided at the London Missionary Society 'Orient in London', where A.C. Haddon was called in to supervise a particular display on comparative religion.[114] Haddon was an anthropologist of considerable academic standing by this date as Reader in Ethnography at Cambridge and an associate of the Museum of Anthropology there, as well as advisory curator at the Horniman Museum.[115] Through a display called 'The Hall of Religions', anthropology was used to provide a somewhat different representation of the African to that usually encountered at the colonial exhibition (fig. 85). The missionaries' declared objective in this display, and one acknowledged by the press, was reported in *The Times* as 'appealing to the student of comparative religion.'[116] While the exhibit was ultimately designed to show that 'It was only by the comparative study of religions that the unique gift which Christianity has to give to the world can be brought out', this already constitutes a departure from the colonial exhibition, in its emphasis on a comparative approach.[117] An article on the exhibition, written by a London Missionary Society representative, Reverend Lewis, for the supplement to the *Christian World*, affirms the educational and scientific appeal, calling the exhibit 'the marriage of religion and science', and specifying the scientific nature of the study of comparative religion.[118] The writer goes

on to suggest that the 'Hall' embodies all that is modern in the missionary movement, and continues:

> Outwardly the 'Hall of Religions' will be a collection of much that is primitive, crude, gross and superstitious, but whereas formerly such things have provided simply the foil of darkness against which the light of Christianity has shone with an enhanced splendour, the method to be adopted now is that of comparison rather than contrast . . . This modern method seeks to disclose in the most primitive faiths a germinal religious consciousness. [119]

Haddon's essay, *Introduction to Primitive Religions*, published in the *Handbook of the Hall of Religions*, was an erudite text with copious references to the work of fellow anthropologists James Frazer, Alice C. Fletcher, J. Holmes, Andrew Lang, R.R. Marett and E.B. Tylor, among others. It was his task to explain words such as 'totem' and 'fetish', and terms such as 'ancestor cult', 'supernaturalism' and 'animism'.[120] The inclusion of such a text in the handbook, which sold for only 2d, is suggestive of the Society's enlistment of anthropology as a further means of validating the 'seriousness' of their work in the field. The sections on Africa – the Congo State, Bechuanaland and Bulawayo – also refer to texts published in the journals of societies such as the African Society.[121]

The 'Hall of Religions' itself was situated at the Upper Street entrance to the Royal Agricultural Hall, in a prominent position. African indigenous religion was arranged according to the headings 'fetish worship', 'ancestor worship', 'harvest festivities', 'taboo' and 'medicine man'. The British public had already been thoroughly inducted into the rites of 'fetish' and 'taboo', largely through missionary texts that had been responsible for introducing these terms.[122] By 1908, however, the Society had vested interests in proposing a reappraisal of the derogatory context in which these terms were commonly used. To this end, and in order to promote themselves as a progressive and modern force, the missionaries applied Tylor's more comparative methodology, and appropriated his concept of Christianity as a natural development from 'primitive' predecessors.[123] It is an evolutionary concept that the author of an article in the *Christian World* takes to extremes, observing that:

> It is not easy to make a man understand that behind cannibalism there may be in germ a spiritual idea, perhaps it is less easy to make him understand that between this 'faint beginning' and that astonishing word 'except ye eat the flesh of the son of man and drink the blood, ye have no life in you', there is an unbroken line of development in the religious consciousness of humanity.[124]

Another important factor responsible for tempering the antagonism of the missionaries towards objects associated with non-Christian religious practices, is the new status they had acquired as ethnography. This is a factor that I would argue is not acknowledged to the same degree in the colonial exhibition. It is known that, as early as 1879, the London Missionary Society had lent the British Museum a substantial number of figures of Polynesian household gods, given them as a gift by King Pomane after his conversion in 1816. By 1908, the exhibition handbook was able to boast proudly that these objects were 'of priceless value since the complete abolition of idolatry, so much so that the authorities of the British Museum are reluctant to let them pass out of their custody.'[125] By this date, the missionary societies were well aware that this status also applied to their African

collections. In the case of the London Missionary Society, these constituted mainly carved figures and cut-pile raffia embroidery from the Baluba or the Bushongo of the then Congo Free State.[126] These were the groups distinguished by their preoccupation with rectilinear surface decoration on all they produced, and whose material culture had by now found its way into many of the larger ethnographic collections thanks to Emil Torday. In 1899, a small collection of these figures, along with the caption 'wooden representations of the spirits from Central Africa', is reproduced as the only plate in the article on the London Missionary Society Museum published in the *English Illustrated Magazine*.[127] The sole comment relating to these objects in the text is that of 'greasy wooden fetishes.'[128] By 1908, the date of the London Missionary Society exhibition, the British Museum had already arranged a special exhibition of Bushongo objects collected by Torday on his 1907 expedition to the Congo Free State. The exhibition was reviewed in *Man*, at that time the less academic of the two Royal Anthropological Institute journals, as

> comprising chiefly specimens of wood carving and fibre-cloth of a quality surpassing anything yet collected in Africa; in particular two portrait statues of chiefs who ruled at the end of the eighteenth century are the most remarkable specimens of indigenous art yet discovered in that contintent.[129]

Consequently, it is clear that the Society was not unsusceptible to the benefits to be reaped by exploiting the new status of the objects in their possession. By 1910, they had negotiated with the British Museum on the loan of their Bakuba material, and were keen to emphasise their links with other ethnographic collections – a link which they hoped would seal the stamp of academic approval and at the same time reinforce the authenticity of the objects on display.[130] It was obviously no longer in the interests of the missionaries to pass these figures off as 'greasy wooden fetishes'. More capital could be made out of exploiting their desirability as valuable ethnographic documents and as examples of local woodcarving skills. A discourse then, produced as a more enlightened liberalism informed by a body of anthropological scientific 'knowledge' is, in part, a consequence of more material considerations bound up with the desire for credibility in the eyes of both the educational establishment and the government. Paradoxically, the same missionaries who were responsible for precipitating the obsolescence of these objects of worship, were also the people who benefited from their subsequent enhanced economic and ethnographic value.

In conclusion, it is clear that while the missionary societies were by no means impartial bystanders in the face of colonialism, they exploited an ambivalent position as both intrinsic to, and on the fringes of, that enterprise. As a consequence, they were able to present an image of Africa and the African through their exhibitions that can be distinguished from the representation of the African in the colonial exhibition. As we have already seen, anthropology itself maintained, at this time, a peculiarly ambivalent status both as a science and in relation to the colonial government. It is largely due to its precarious position that the missionary contribution was so prominent. To a great extent, the missionaries shared this ambivalent relationship to the government. Although harbingers of colonialism, they were also responsible for the creation of an 'educated elite' in certain African colonies, that provided a potential threat to the hegemony of the British government.[131] While this 'elite' were mostly assimilated into the colonial administration

as white-collar workers, their presence none the less constituted the possibility of a rupture in the colonial discourse on the inherent animality of the African.

The 'image' of Africa that emerges is the product of a complex network of interests, one of the results of which is that the missionary can be seen as a collaborator in a reappraisal of the object of indigenous manufacture, as skilful artifact. Underlying this reappraisal, however, is the missionaries' need for the approval of a colonial government, on whose protection they were now dependent in order to continue as a presence in Africa and the other colonies. This presence derived its sanction from the supposedly God-given right of the missionaries to impose their religious beliefs on the colonised races; a mission executed in the name of salvation and civilisation, arbitrarily designated as the prerogative of European culture. Any missionary exhibition of material culture from the colonies must therefore be understood primarily in the context of this mandate. As V.V. Mudimbe has so aptly observed:

> With equal enthusiasm, [the missionary] served as an agent of a political empire, a representative of a civilisation and an envoy of God. There is no essential contradiction between these roles. All of them implied the same purpose: the conversion of African minds and space.[132]

NATIONAL UNITY AND RACIAL AND ETHNIC IDENTITIES: THE FRANCO-BRITISH EXHIBITION OF 1908

Over the period 1902 to 1910, the constitution of a 'national' culture was a feature of the bid for political ascendancy by both Tory and Liberal administrations in Britain. It is a factor which makes this a particularly valuable historical moment for untangling the ambiguous and highly equivocal nature of national identity, specifically in terms of its inextricable relationship to the colonial process. With consolidation rather than expansion at the heart of the imperial project from 1905 to 1912, the colonial exhibition, whether missionary or otherwise, acquired a new resonance as a site where the myth of national unity was consummated in the public domain. Paradoxically, of course, the success of this ideal, both here and in other arenas of public culture, relied on the painstaking elaboration of a series of 'differences' constituted along both ethnic and racial lines. Although the biological and cultural hierarchy established between the coloniser and the colonised was crucial in this respect, especially in relation to those peoples classified as 'black', it was only one co-ordinate on the map of the imaginary colonial community. Another important co-ordinate which consistently featured as an integral component of the colonial exhibition was the appropriation of certain contested communities as part of a thriving and ancient 'British' heritage. Such appropriation necessarily invoked 'primitivist' discourses on these communities, and we should recognise them as being produced in relation to those other repositories of primeval dread and desire for the colonial imagination – the colonies. It is, in fact, only through a better understanding of the relation between these two faces of British imperialism that we can begin to come to terms with the potency of the myth of a homogeneous national identity, and the means by which it implicated various and conflicting constituencies within Britain over this period.

This is not to say that the international or colonial exhibition promoted the idea of a unified national culture in a form easily dismissed as naked propaganda. Earlier chapters should already have alerted the reader to the complex and contradictory nature of national identity in Britain at this time. Even in terms of the conditions under which such spectacles came into being, some insight can be gained into the kinds of competing interests at stake. Contrary to the usual practice in either America or France, successive British governments refused to finance these exhibitions directly. The king might well give his tacit approval by opening the proceedings, and his government ministers might be on the executive committees, but the funding for such events had to come from those sources indicated in Hobson's critique; namely small groups of businessmen and politicians.[1] Consequently, while the exhibitions' executive committee and the honorary president were often members of the British Empire League, the chairpeople of the

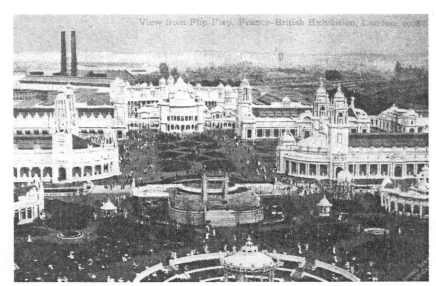

86. General view of the
Franco-British Exhibition,
White City (London 1908).
Postcard.

various sections were not always as wholeheartedly dedicated to the same concept of empire, even while one vision might prevail.[2] While conflicts of interest sometimes produced idiosyncratic exhibits, the contradictory knowledges that resulted often set up an interesting dynamic within the same exhibition. Similarly, some of the altruistic ideals regarding educational benefits emerging from the official publications were not always shared by those who held the franchise for many of the 'attractions', despite their reiteration of similar objectives. Moreover, while one such attraction was at pains to reinforce its image as 'a very serious exhibition where visitors come to study and be wise',[3] it was not guaranteed that even in those displays dedicated to learning, the visitor would appreciate their finer points. Indeed, a more sceptical reviewer remarked that 'despite a great deal of attention spent on the organising of the education section, comparatively few visitors to an exhibition go to spend time on such a heavy subject.'[4]

One of the most successful and widely acclaimed exhibitions, which later served as a model for so many others on the same site, was the Franco-British Exhibition of 1908 (fig. 86), held at the White City site in London under the aegis of Imry Kiraly's firm, London Exhibitions Limited.[5] While the declared occasion for any exhibition was generally a 'stock-taking of the resources of civilisation . . . a periodical summing up of the achievements of a progressive age',[6] in the case of the Franco-British Exhibition it was also designed to cement the *entente cordiale* between France and England.[7] A further clue to the show's objective was the degree to which the official and unofficial publications deployed the language of racial determinism to assert a naturalised order. It was acknowledged here that a

natural fitness underlies the *Entente Cordiale* . . . the highest international results are obtained when leading racial characteristics and prominent industries are not opposed . . . when Anglo-Saxon energy blends with French *savoir vivre*, when British

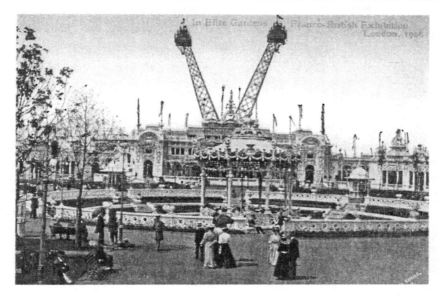

87. The 'Flip Flap' at the Franco–British Exhibition, White City (London 1908). Postcard.

empiricism is ordered by French method, when British solidity is adorned by French grace, a combination is reached which embraces the highest achievements of the human race.[8]

The rhetoric of racial fitness, and the superiority of the specifically Caucasian races, surfaced in different sections of the exhibition. This obsession with 'nationhood', in 1908, can partly be explained as a response to the perceived threat to Britain's imperial supremacy from Germany, America and Japan.[9] Its persistence, however, also needs to be understood as the residual by-product of a ruling bloc anxiety over imperial decline in relation to the physical deterioration of the population. As we have seen, this was especially true since the Boer War recruitment drive for the armed forces had made it painfully clear that working-class recruits were no longer physically 'fit' for active service in defence of the empire. The findings of the social investigators Charles Booth and Seebohm Rowntree did nothing to allay these anxieties.[10] For Edwardian England then, social decline and the industrial economy at home were inextricably linked to the concerns of Empire. While different factions proffered different solutions to such problems, one of those advocated in varying measure by many was the doctrine of social imperialism. It is within the context of this doctrine, either in its more conservative guise of 'national efficiency' or in its more liberal cast as 'social reform', that the Franco–British Exhibition should be seen.[11] Furthermore, it was under this brief that both Liberals and Tories could be accommodated comfortably at the Franco–British Exhibition. Perhaps more importantly, it could also be argued that the concept of Empire in Britain was less unequivocally supported by 1908.[12] As a result, certain nuances and shifts are perceptible in the way 'Empire' was now packaged and marketed, in the public and popular culture of the exhibition, to different British publics, many of whom were now rather less convinced of the necessity of the imperial enterprise.

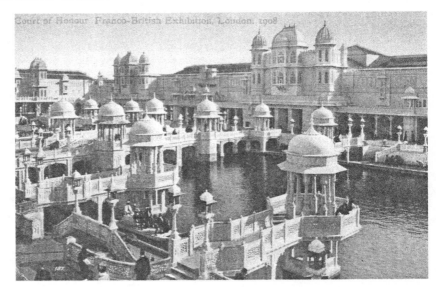

88. The 'Court of Honour' at the Franco-British Exhibition showing the reliance on 'orientalist' domes and lattice-work. Postcard.

The appeal for national unity and working-class co-operation, both corollaries of social imperialism, operated on several levels here. Excursion fares and tickets were arranged by employers with the co-operation of the exhibition committee, so that special provision was made for visiting parties of workers. By August, a number of such excursions had visited the White City, including 3,500 employees from Lever Brothers at Port Sunlight and 1,100 from Messrs. Bass, Ratcliffe and Grettons at Burton Brewery. Arrangements were even made to accommodate the former group after the rest of the public had left the exhibition at 11 p.m., since the six special trains for Port Sunlight left at midnight.[13] On another occasion, the Palace of Music was temporarily converted into a refreshment room to cater for employees.[14] In July, employers of Chubb & Sons Lock and Safe Company entertained their London workforce at the Franco-British Exhibition.[15]

The meeting of London's 'East' and 'West', always a sensitive issue, was accomplished when the Queen paid the expenses of Lady Dudley to treat a party of about fifty children from the EastEnd of London to a tour of the grounds. For those 'Eastenders' not fortunate enough to be the beneficiaries of such philanthropic concern, a scale model of the White City, complete with 'Flip-Flap', was set up in Whitechapel.[16] There were also special incentives provided to enable those living in rural areas to visit the exhibition. These were known as 'County Days'.[17]

The deliberate care with which such provision was made and publicised, in the face of often quite baffling logistics, would seem to confirm that the persistent inclusion of working-class contingents was no afterthought. The degree of attention that these particular outings attracted in the local and national press, and in the illustrated weeklies, supports the suggestion that their visibility at the exhibition was especially important. Contemporary reports give the impression of a docile workforce enjoying the benefits of their generous employers' thoughtful provision, and thus visibly profiting from the accumulated wealth of the nation and the fruits of imperial endeavour. This was precisely

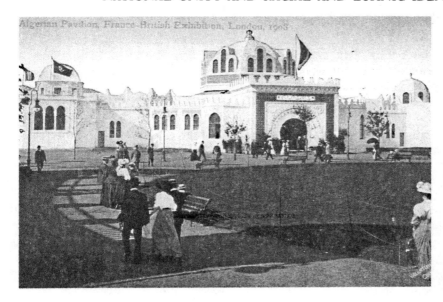

89. The 'Algerian Pavilion' at the Franco-British Exhibition, White City (London 1908). Postcard.

the message of the social imperialists.[18] Such an inclusion also indicates a growing aware-ness of the emergence of a working class of quite different dimensions and constitution: audible through an increase in organised union activism, profiting from state educational initiatives, but also instituting additional educational provision from within their own ranks.[19] The concomitant rise of the Independent Labour Party during this period was another factor that helps to account for the deliberate inclusion of working-class participants at the Franco-British Exhibition, and the high profile given to this policy in the official publications. What precisely was on offer, then, to the motley and massive crowds flooding in to the 140 acre exhibition ground? What vision of Empire and of its inhabitants were they presented with?[20] Furthermore, how did this vision enhance the ideal of a unified Britain?

The ways in which British discourses on national unity and racial superiority were produced at the Franco-British Exhibition are best explored initially through two, by now familiar, aspects of any exhibition: displays of material culture from the colonies and dependent territories, and displays consisting of the peoples from these colonies and from selected communities designated as part of the British Isles, in what are referred to in the guidebooks and official catalogues as 'villages'. The British section, under the guidance of the Hon. Sir John Cockburn K.C.M.G. (an active member of the British Empire League), featured displays from India, Gambia, the Gold Coast, Southern Nigeria, Fiji, Canada, Australia and New Zealand, in various purpose-built pavilions.[21] It also included two 'villages', one Ceylonese and one Irish, and a feature known as the Indian Arena. French colonialism was represented by pavilions for Algeria, Tunisia, French West Africa and Indo-China, together with a Senegalese 'village'. It is important to emphasise, from the start, the differential status assigned to the pavilions and the 'villages'. The pavilions, because they were self-contained and fairly solid architectural structures which gave the appearance of a greater degree of permanence, acquired an immediately elevated status by

comparison to the 'villages', billed as 'daily life' and categorised in the guides as one of the 'attractions' of the exhibition. The meaning of this category becomes apparent when it is understood that both 'Flip-Flap' and 'Wiggle-Woggle' were also billed as 'attractions'! (See fig. 87.) However, while the pavilions were evidently designed as the 'showcases', those aspects of the colonial sections that received the most attention in the local and national press in Britain were the Indian pavilion, the Senegalese 'village' and the Irish 'village'.

One of the striking aspects of these representations of the colonies and colonised races is the degree to which cultural production was used as a means of naturalising an arbitrary racial hierarchy. This hierarchy effectively operated as the equivalent to an evolutionary scale, with, in the case of the British exhibits, the African colonies at the bottom, India somewhere considerably higher up the ladder, and the Dominions of Canada, Australia and New Zealand at the top. Otherwise, the paradigm which dominates the exhibition, not least through the architectural style adopted for the construction of most of the plaster buildings, was 'orientalist' (fig. 88).[22] While the white stucco which clad the pavilions makes little concession to the integrity of distinct North African or Middle Eastern architectural idioms, the French guidebooks were keen to differentiate their 'Orient' from the hybrid confection of the fairground (fig. 89). Moreover, official catalogues emphasised the modernising aspects of the French presence in North Africa, packaging Algeria and Tunisia as attractive and 'modern' tourist resorts of long-standing, able to provide the traveller with

> agreeable places to stay during the cold season . . . Algiers, Blidah, Biskra, Tunis, now provided with comfortable hotels, are well equipped for the reception of globe-trotters, lovers of beautiful scenery and sunshine. It is chiefly in this respect that the Algerian and Tunisian exhibits will provide results.[23]

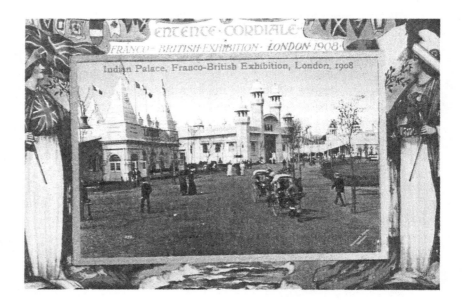

90. The 'Indian Palace' at the Franco-British Exhibition, White City (London 1908). Postcard.

Significantly, French colonisation was a modernising force which was also at pains to present itself as a discerning conservationist, selectively nurturing and promoting indigenous culture. On an earlier occasion, at the 1900 Paris Worlds Fair, the French administration had projected a similar self-image as not only the guardian, but more importantly the 'discoverer' of Tunisian heritage and history, with the archaeological excavations at Carthage and other Roman sites. In other words, the benevolence of the French colonial enterprise extended to 'producing' a historical memory for Tunisia, which only the French were then capable of preserving in the face of the evident dereliction of duty and lack of interest of the Tunisian people. In 1908, this custodianship had been expanded to incorporate contemporary indigenous crafts, the better to promote the development of tourism in the region.

This is not to say that reinventing historical memory and promoting local culture was only effective as a marketing ploy for the colonial government. Other research has shown that such initiatives also provided incentives from within the colonised community, which took advantage of the mythic histories produced by the colonial power, for short-term gain. After the 1904 publication of Robert Hitchins' book *The Garden of Allah*, set in Biskra, some Algerian guides were able to turn the enhanced popularity of the town with European travellers to their own advantage. The itineraries of their guided 'tours' began to include visits to 'sites' supposedly associated with the fictional characters of Hitchins' romantic novel.[24] The fact remains, though, that the immediate economic advantage belonged to France.

Tourism was also part of the paternalistic rhetoric employed in the British colonial government's descriptions of the 'Indian Pavilion' (fig. 90). Here, however, it emphasised not the visceral comforts of a modern resort, but the cerebral pleasures of an old established culture; 'the art of the land's dreamers, the joy of work of the land's craftsmen . . . flung prodigal for your delight.'[25] It is the way in which this discourse around tradition and heritage is articulated differently in relation to the various colonies, which becomes, in fact, one of the key features of descriptions of the British exhibits, and a component in the language of unification deployed in the official literature at the exhibition. The recognition and promotion of an Indian heritage, for example, was an expediency capitalised on by the British in a way that an acknowledgement of an equivalent African past never was. This was partly accomplished through a calculated use of Indian material culture and artifacts.

For both colonial powers, the material culture which was an integral part of the Indian exhibit on the one hand, and the Algerian and Tunisian on the other, becomes a useful signifier, not only of an 'authentic' and therefore marketable indigenous culture, but of the distinct benefits provided by the respective colonial governments. In the French Tunisian products catalogue, while a short section deals with the raw materials available from the country and certain manufacturing processes, twice as much space is devoted to 'Native Trades'. This section, which forms an entire chapter, is ostensibly a catalogue of local crafts including pottery, carpet weaving, coppersmithing, leather tooling and silkweaving (fig. 91).[26] Apart from the tempting reassurances to the visitor that the items are all very reasonably priced, the other emphasis in the catalogue is on the 'picturesque', artistic, and decorative qualities of such work which the colonial government was presented as fostering. Significantly, in the Algerian, Tunisian and East African handbooks, produced by the French section of the organising committee, the combined effect

91. 'Carpet weaving' illustrated in the official French programme for the display of French colonies (Paris 1908). Bibliothèque Nationale, Paris.

92. Photograph from the official French programme for the display of French colonies, showing 'A woman from the Ouled-Nail'. Text on the export and consumption of coal in the colonies accompanies the picture (Paris 1908). Bibliothèque Nationale, Paris.

93. 'A street in Biskra' illustrated in the official French programme for the display of French colonies (Paris 1908). Bibliothèque Nationale, Paris.

94. A page from the official French programme for the display of French colonies ostensibly illustrating the productivity of a date palm plantation! (Paris 1908.) Bibliothèque Nationale, Paris.

of text and image was to emphasise the romantic aspect of these colonies (figs 92 and 93). Various industries of course are detailed, and statistics and revenue are listed, but the accompanying illustrations in the text of both the individual guides and the official book outlining French colonial representation in the exhibition reproduce none of these industries. Instead, the images present a parallel text which produces the peoples of each region in a timeless, exoticised, and often explicitly sexualised, format (fig. 94).

The British were also keen to promote the cultural production of some of their colonies, none more so than India. India's contribution was hailed as

> a remarkable one. The official Indian Palace with its wonderful arch of carved wood, its beautiful tableaux of ruby mines and teapicking, its treasures of silver and bronze, its silks and painted work, is in itself one of the most interesting buildings in the western end of the exhibition.[27]

Various illustrated papers ran supplements which highlighted this particular aspect of the exhibition, one of the more notable being the *Sketch*'s 'Is the Franco-British More Indian than India or is India more Indian than the Franco-British?', which consisted of a selection of comparative photographic views of well-known architectural monuments in India with shots of the exhibition pavilions.[28] The Ceylon 'village' was also 'filled with clever artistic craftsmen', comparing favourably with the superstitious 'curios' of African manufacture.[29] The catalogue for Mysore State gave over a full fifteen pages to a description of a wooden showcase designed and constructed by an executive engineer in the Palace Division at Mysore[30] (fig. 95). After this detailed eulogy to the craftsmanship

95. Wooden showcase designed and constructed by an executive engineer in the Palace Division at Mysore. F.G. Dumas, *The Franco-British Exhibition Illustrated Review* (London 1908).

involved in such a piece, further chapters were devoted to sandalwood and ivory carvings. Moreover, unlike the items in the French colonial pavilions mentioned above, the artifacts from the Mysore State were anything but cheap. For such evidently skilled workmanship, the purchaser was expected to pay the price.[31]

It was no accident that most of the items on display from India came predominantly from the art colleges set up by the British in Lahore, Bombay, Punjab and Madras.[32] While these were promoted as skilfully crafted objects of cultural and economic value, their other function at the exhibition was spelled out in no uncertain terms as demonstrating 'the watchful care of the Government that had fostered that genius' and 'the wisdom of the rulers of a strange land in encouraging all talent in the men they ruled.'[33] Through this means, the visitor was reminded of the 'splendid miracles' wrought by such benevolent colonialism.[34] In view of the rather disastrous record of British rule in India in the years directly preceding the exhibition – especially the famine and uprisings of 1907 – this was a very timely piece of propaganda. The British handling of the situation in India

had not escaped the attention of certain West African commentators, who were able to make use of the crisis to draw attention to their own criticisms of British rule in West Africa. The *Sierra Leone Weekly News* reported King Edward VII's speech to the Indian people, ending with the terse rejoinder:

> The following paragraph of the Royal message is noteworthy, and we hope that the King's Representatives, throughout the British Empire may note it down and act accordingly. 'Steps are being continually taken towards obliterating distinctions of race, as the test of access to posts of public authority and power. In this path I confidently expect and intend the progress henceforward to be steadfast and sure, as education spreads, experience ripens, and the lessons of responsibility are well learned by the keen intelligence and apt capabilities of India.' Would that all in authority, might ponder these weighty words in the King's message and act out the same in the administration of their respective Governments.[35]

From the context of this remark, it is likely that the racial hierarchy upon which the Franco-British Exhibition was predicated would not have escaped West African critics, especially since the crown colonies of Gambia, the Gold Coast, and Southern Nigeria came in for rather different treatment in most of the British exhibition reviews. Here also, material culture played a crucial role in the representation of these colonies and protectorates. One only has to look at the report in the special exhibition edition of the *Daily Mail* of the 'Land of Marvels, Thrills and Wonders from India and "Crown Colonies"' on the one hand, and 'Sinister Relics of the Savage King', on the other. Here, the coral cloak of the royal insignia from the court of Benin City, and the notorious slaver 'Tippoo-Tib' 's war horn, despite being acknowledged as a 'fine piece of ivory carving', are nevertheless seen primarily as 'some of the strangest things in the exhibition.'[36] Descriptions quickly gave way to sensationalist accounts of the war drum captured by the Jebu expedition of 1892, whose 'associations are very gruesome, as it was used only at the execution of criminals or on the field of battle.'[37] These 'associations' were promptly cemented by the statement that 'Devil worship is associated with many of the curios. Sinister indeed is a triple-faced mask covered with human skin flayed from sacrificial victims.'[38] Despite a mention of the 'artistic skill' visible in the Benin bronzes, the final impression rests, predictably, with the 'cannibalism and other unpleasant habits' that were said to exist side by side with them.[39] Significantly, the *Lagos Weekly Record* shared the *Daily Mail*'s conviction that popular interest was generated by what were called 'native curiosities'. The difference here was that the columns of the *Record* focused almost entirely on G.W. Neville's now prestigious and extremely valuable collection of bronzes from Benin City.[40]

Africa's 'heritage', then, was represented as a past that was not worth preserving or nurturing, and which had been necessarily 'killed off' by the benevolent colonial forces. The 'trophy' method of display, which was the chosen format at such events, would have further compounded the images of horror and violence which were the dominant sentiments. The trophy format has already been encountered in chapter four in relation to the 1890 Stanley and African Exhibition, but it is worth expanding here on the possible implications of such a technique. The trophy method could be said to signify on a number of levels. As the name suggests, it served as a signifier of 'capture' and 'conquest'.[41] On another level, the effectiveness of this type of display relied on specific

THE MARLBOROUGH COTTON GINNERY AT IBADAN
LA FABRIQUE DE COTON MARLBOROUGH À IBADAN

96. 'The Marlborough Cotton Ginnery at Ibadan' from the *Catalogue of Exhibits from Southern Nigeria* (London 1908).

connotations of 'private' space. The effect of such a display in a public museum or exhibition was to replicate the sense of personal achievement and acquisition that such displays inculcated in the private domain. As a public display, this was effective precisely because it mirrored the sort of arrangement that was so popular in private and thus was able to exploit the same appeal to the individual, that feeling of intimacy and personal satisfaction. Because of the consistent use of only certain objects in this context, usually weapons, shields, and other material associated with the 'chase' or warfare, it was also a form of display that reinforced a specifically male presence in the colonies, since these were signifiers of predominantly masculine pursuits. The sense of achievement was therefore theirs alone. The appeal to the white middle-class male, through the trophy format, played on his own perception of his role as 'the great white hunter' in search of his 'prey'.[42] Furthermore, while the trophy arrangement also helped to constitute the African as 'other', it nevertheless relied on a certain degree of identification with the warlike characteristics attributed to the African male in order to provide a sense of achievement. There is nothing heroic about an easy catch.

As if to further reinforce the eradication of any trace of a historical memory worth preserving, the official guidebooks for both Southern Nigeria and the Gambia, in direct antithesis to the romanticism of the French guides on their African colonies, provide a visual record of only modern and profitable colonial industries (figs 96 and 97).[43] There are no soft focus details of 'local colour' in the British guide, just a record of modernisation in the wake of colonialism. It is significant, therefore, that so little of the reporting in the local or national press does justice to the quantity, variety or quality of the material results of these modern industries, despite the fact that certain exhibits of contemporary cultural production within the 'Southern Nigeria and Gambia' display won medals.[44] Where this did exist, it was evidently rather partial. The exhibit of articles of furniture made from West African timber for the Liverpool firm of W.B. Mc'Iver & Co., for

example, won a gold medal and a diploma. Most British reporting of the award stressed the total control over the product of the firm's own management – a prejudice which the *Lagos Weekly Record* was keen to disrupt with the sardonic comment that, 'It savours too much of that monopolistic policy which makes John Rockefeller the one and sole medium from the digging of the crude kerosine oil from the ground until it reaches the consumer's lap.'[45] Moreover, to John Payne Jackson's patriotic eye, the share of the honours to which he rightly laid a West African claim proved that 'in the not too distant future local coast workmen will be able to cater for the requirements of their own people in a thoroughly satisfactory manner.'[46] He was also politically astute enough to turn the Liverpool company's involvement on the coast to his own advantage, since, as he pointed out:

> The development of local material and talent is certainly more useful and helpful to the native than having him to rely upon others for what he possesses and can make for himself. In this respect Messrs Mc'Iver & Co's saw mill is filling a highly useful role.[47]

For the most part, the reporting in the British national press simply offers similar sensationalising comments to the *Daily Mail* report referred to earlier. Even in the official guides there is not much, if any, commentary on items of indigenous manufacture, unless relegated to an apparently firmly fading past as in the case of the Benin material lent by George Neville. Here the familiar details regarding antiquity, originality and influence discussed in chapter one, are rehearsed again in the context of the Franco-British Exhibition.[48] The nature of the spectacle ensured that it was precisely those sections of the Crown Colonies Pavilion that 'illustrate native manners and handicrafts' which were also generally observed as being more interesting to the 'casual' or 'ordinary' visitors.[49] Their preference was apparently for 'native curiosities' over those exhibits demonstrating the

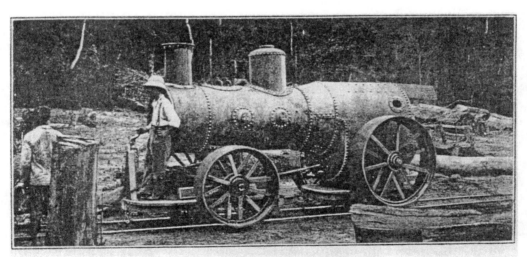

TRANSPORTING BOILER TO BITUMEN WORKS
UNE CHAUDIÈRE EN ROUTE POUR L'USINE À BITUME

97. 'Transporting Boiler to Bitumen Works' from the *Catalogue of Exhibits from Southern Nigeria* (London 1908).

raw materials and other products, supposedly so necessary to the well-being of the Briton at home and to the country's economy, and suggestive of the kinds of self-reliance foregrounded by Jackson in the pages of the *Record*.[50] Unlike their French counterparts' versions of Tunisia and Algeria at the exhibition, the British organisers could not promote Southern Nigeria as a booming tourist industry with the colonial power as the preservers of an ancient and thriving heritage. Any heritage resonant in the material culture of the Protectorate was rather transformed into the sign of a successfully suppressed violence and barbarism – a past which had no future in the modern Protectorate.

British West African representation at the exhibition did not go unnoticed by West African commentators in London at the time, who made their voices heard through the national and local British press. Edward Blyden was one particularly influential visitor who came to the exhibition as part of a delegation from the Liverpool Chamber of Commerce. His address on this occasion was published in the *Liverpool Post* and reprinted in the *Sierra Leone Weekly News*, where it was interpreted as a patriotic call for Europe's recognition of African self-determination. Blyden waxed lyrical about the prospects for furthering world peace presented by the Franco-British Exhibition:

> The Franco-British Exhibition has the sanction of the Great Arbiter of human destinies. His messengers of peace have been hovering over the nations and dictating the sentiments which in this period of intense competition, of strain, of stress, of almost universal suspicion, should pervade the hearts of the Rulers of the Imperial races.[51]

He also, however, reiterated the message of self-reliance voiced by Jackson in the pages of the *Lagos Weekly Record*:

> Let it be the new policy to mention in despatches and present medals and clasps to your officers in Africa who have made two blades of grass to grow where only one grew before. Decorate the promoters of agriculture, the agents of the British cotton-growing Association, the man who can turn the largest area of that continent now occupied by jungle into a cotton-producing district, who can convert by sweet reasonableness the largest number of swords into ploughshares, and the largest number of spears into pruning-hooks.[52]

The fact that the speech was published in both a respected organ of the British trading establishment *and* a leading West African newspaper signals the importance of Blyden's words. It is perhaps telling that their significance in the Sierra Leone newspaper was clearly identified as 'patriotic', as it introduces a new complexity into the issue of West African participation in the modernising process in the newly established commercial enterprises of the Protectorate. Perhaps it was the emerging ambivalence of such developments in the face of comments on their value for a self-determination for the African, which the colonial government was far from willing to concede, that was partly responsible for the rather hushed discussion of this aspect of the Franco-British representation of Southern Nigeria in the British press.

The 'crisis', or transformation, in the social relations produced under British imperialism surfaces at the Franco-British Exhibition in another activity long popular with such spectacles. Here a shift was signalled in the previous practice of populating the 'villages' in the 'attractions' section of exhibitions with Africans billed either as 'Zulus', 'Matebele' or 'Sudanese', and usually topically associated with a recent act of subjugation by the

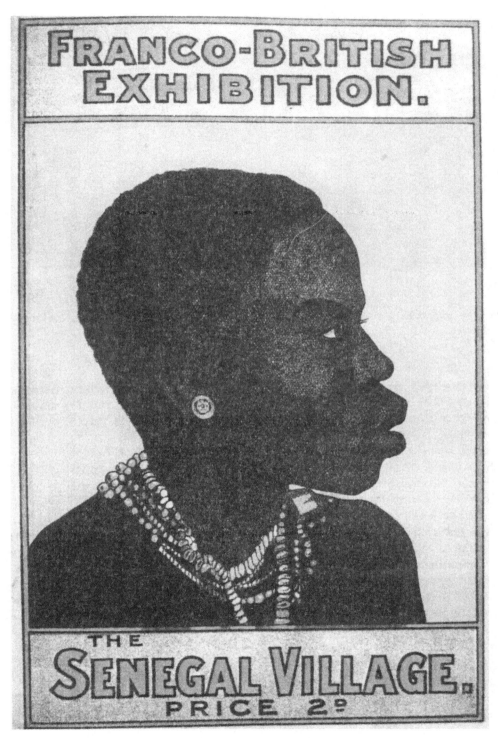

98. The cover of the official programme for the 'Senegal Village' (London 1908).

The Senegalese Village. THE FRANCO-BRITISH EXHIBITION.

99. 'The Sengalese Village' at the Franco-British Exhibition, White City (London 1908). Postcard.

British. Significantly, at the Franco-British Exhibition, the British produced no African 'village'. This was left to the French concessionaires MM Bouvier and Tournier, both members of the Comité National des Expositions Coloniales which was responsible for the 'Senegalese Village'.[53] By this date, most of the 'Africans' appearing in this capacity, certainly at the larger exhibitions, were billed as coming from French colonies: Senegal, Somali and Dahomey being the most popular, although both Ashanti troupes and a 'Dinka' village made fleeting appearances at Crystal Palace, Earl's Court and Liverpool.[54] The Nigerians who most frequently came over for the missionary exhibitions were, of course, also employed to populate 'villages' of a kind similar to the colonial and international exhibitions.

The difference here lay in the fact that as converts to Christianity they were strategically presented as associated with that 'class' of 'educated elite' which the missionaries were largely responsible for creating in West Africa. It was this 'elite' that comprised a considerable section of the white-collar workers of the British colonial administration in Nigeria in particular.[55] Such Africans were not organised professional entertainers in the sense that some of the French, and earlier British troupes evidently were, but rather individuals or families who were personally known on the mission. It has already been seen that it was not generally recognised as in the best interests of the various missions to perpetuate an image of the African as a wayward savage, impervious to change and to the 'benefits' of a Christian education. It was this same mission-educated elite, with their spokesmen of considerable visibility, which were capable of making good use of the press by this date. It is quite possible, therefore, that because of the British colonial administration's relation with, and reliance on, this particular sector of African society, the exhibi-

tion organisers were reluctant to reproduce a 'village' susceptible to the category of 'side-show' to the same degree as the Senegalese village. Furthermore, as James Coleman has discussed, from the outset 1908 was already proving to be a troublesome year for the British administration in Lagos.[56] Protests by Lagosians against the colonial government's expropriation of land for government residences, and the levy of a discriminatory water tax on the local population amongst other grievances, resulted in the founding of the People's Union, in 1908, by two leading African doctors. The aim of the Union was to fight for indigenous rights and against changes in land tenure. By 1909, the government was anxious enough about local pressure and dissent to pass the Seditious Offences Ordinance, in order to forcibly stem the tide of anti-government criticism in the press. John Payne Jackson was one of the first to be prosecuted under the new Ordinance. Under these circumstances, and given the Nigerians' effective and organised antagonisms to certain government initiatives, it must have seemed politically inadvisable to the organis-ing committee to include Nigerians amongst the 'amusements' at the Franco-British Exhibition. There had, in any case, already been considerable discussion in the House of Commons regarding the treatment of the Tamils and Ceylonese in their 'village', and anxieties were expressed over the inclusion of such features at exhibitions generally. Even in the official literature, misgivings were aired, and the same objections are raised in other places in connection with descriptions of the 'Irish Village' as a 'side-show'.[57]

I would argue, instead, that in the case of the representation of the British West African colonies at the Franco-British Exhibition, any sense of 'spectacle' had, therefore, to be constituted solely through material culture where it assumed a central role in the display. The exhibits functioned on one level as signifiers of British sovereignty, and this was specially the case because of the organisers' highly selective concentration on those prestigious kingships that had eventually been forced, after bloody confrontations, to succumb to British conquest; in this case Benin and Ashanti. On another level, the attribution of such significance to ethnographic material at this time can only be fully appreciated in the light of those other initiatives, from within the professional and semi-professional bodies, that were responsible for the public presentation of such material outside of the exhibition context and in ethnographic collections up and down the country, which have already been treated in earlier chapters. It is worth recapping here the state of such initiatives by 1908.

Even by this time, anthropology in Britain was still negotiating its status as an academic discipline. Such a tenuous position made it expedient to continue to promote as wide a relevance as possible for its work. One of the more pernicious results of anthropology's campaign of popularisation was that, by 1908, a highly selective version of anthropological theory was thus available to be appropriated by parties with diverse interests in colonisa-tion. As a version, this owed more to the evolutionary theory of the nineteenth century than to the comparative methodology developed by Tylor and Haddon, or the later functionalism of Malinowski and Radcliffe-Brown. By 1908, any difference between the supposedly distinct domains of 'scientific' and 'popular' knowledge regarding the colonised subject had been effectively obscured for a large proportion of the public who visited these exhibitions. It was an elision accomplished partly through the agency of texts describing and defining the colonised subject. Although some were described as 'fiction' and others as 'objective scientific truth', both categories of text often shared the same author. For example, John Buchan, better known as author of *Prester John*, published in

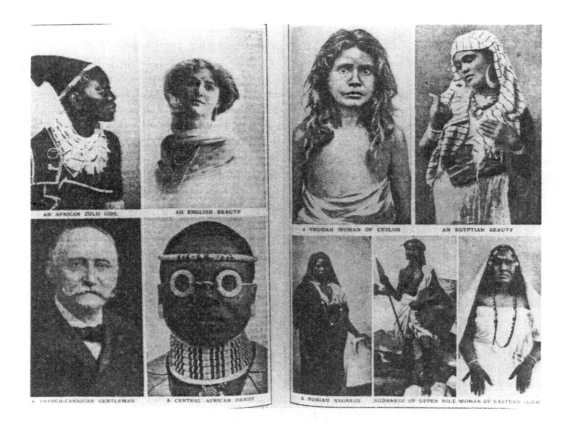

100. Pages from *The Harmsworth History of the World* (London 1909), captioned 'Racial Contrasts under the British Flag', and 'Dusky Beauty and Ugliness Under the British Flag.'

1910, also wrote, a year earlier, a handbook for the student colonial administrator in South Africa: *The African Colony*.[58] On another level, this elision was also being reinforced through those initiatives taken by the museums establishment as a means of popularising their collections.[59]

The public faces of anthropology were represented at the Franco-British Exhibition by four different aspects, three of which were present in the British Science Pavilion. The anthropology section here was supervised by the same A.C. Haddon who was advisory curator at the Horniman and who had been responsible for the 'Hall of Religions' at the London Missionary Society 'Orient in London' exhibition. The section consisted of a set of charts, instruments and statistics prominently displayed 'to demonstrate how measurement of physical and mental characteristics', through anthropometry, was 'a reliable test of physical deterioration and progress.'[60] If there were any doubts in the viewer's mind by this date about the mutual dependence of anthropometry, anthropology, eugenics, evolution and the colonised subject, another display at the exhibition was calculated to dispel them: 'The Life of Primitive Man with Particular Reference to the

Stone-Age Peoples Pre-Historic and Contemporary'.[61] Here, the explicit evolutionism of the doctrine of 'the past in the present', with its resonant racism, complemented the implicit racial hierarchy already operating on other levels at the Franco-British Exhibition. The display of finger-printing apparatus, and other items relating to the sphere of criminal anthropology, also had resonances in relation to colonised races.[62] It is symptomatic of anthropology's entry into a broader 'popular' consciousness by this time, that the explicit demonstration of anthropology at the exhibition in the 'Science Pavilion' attracted little attention from the reviewers, even while anthropological theory permeated so many aspects of the exhibition as a whole. It remains the implicit rather than explicit organising principle.

As a hierarchical distinction existed in relation to the material culture displays, so it was also the case with the 'attractions'. In the case of the 'Senegalese Village', for example, one British reviewer wrote, 'The home industries carried on in the stockade, though numerous, cannot approach those of Ceylon and India in variety, extent, and merit.'[63] If this sounds like a simple case of colonial rivalry, it should also be noted that the same British reviewers who produced such derogatory copy regarding French Senegal ('black' Africa) had nothing but compliments for the French Arab sections of Algeria and Tunisia.[64] The distinction was further made that 'if the negroes fall far behind the Tamils and Ceylonese in artistic culture and skill, and in agility of mind, they are undoubtedly superior to them in physical strength and muscular development.'[65] The ubiquitous wrestling match was designed to seal this comparison. This was the visual image most frequently used to encapsulate the spirit of the 'village'. Presented as 'fine exhibitions of untiring and determined natural force', these qualities became here, as in other similar displays, a naturalised racial characteristic attributed to the African male.[66]

The same process of objectification takes place in the texts produced in conjunction with this exhibition that has already been witnessed in earlier versions. The reiteration of adjectives like 'ebony', 'jet black', and 'polished', produced an analogy destined to be preserved for posterity in such works as the *Harmsworth History of the World*, a series in the mould of the 'popular educators'.[67] Here, the influential statesman and colonial administrator, Sir Harry Johnston, author of numerous 'authoritative' volumes on West Africa, could categorically state that 'in no part of the British Dominions are there more handsome men, from the sculptor's point of view, than among certain types of Nilotic negro or Negroid, Bantu or Fulbe.'[68] Most significant, perhaps, is the fact that these generalisations became revived again as the order of the day over this period, popularised through not only the *Harmsworth History of the World* but other numerous series produced in the years 1908 to 1909 for a 'popular', that is educated, middle-class and general readership, purporting to be encyclopaedic and 'scientific' in their presentation of the British Empire and the colonial subject, and written by anthropologists and colonial administrators (fig. 100).[69] The number of such compilations published over these years suggests that the publishers felt they had identified a burgeoning market.

Previously, the terms used to describe these inhabitants of the 'villages' had been more sexually explicit, but the anxieties over interracial union, that had erupted over the 1899 'Briton, Boer and Black' exhibition and had never quite abated, made the adoption of the sculptural analogy particularly pertinent as a safe way of maintaining the requisite distancing between viewed and viewer. Consequently, while the men are described as 'throwing themselves into the exercise with warlike and unbridled energy, displaying in

En 1906, il a été procédé à 130.600 inoculations antivarioliques : un arrêté du 7 janvier 1906 a rendu la vaccine obligatoire et a imposé à chaque colonie la création de centres vaccinogènes ; ces laboratoires existent déjà à Saint-Louis, Bamako, Kindia, Bingerville, Bouaké et Savé.

Les institutions qui viennent d'être indiquées ont été prises spécialement en faveur des indigènes. Dans la réorganisation des différentes branches de l'administration, dans les réglementations nouvelles intervenues sur les objets les plus divers, il a été toujours fait une part aussi large que possible à nos sujets. Leurs droits ont toujours été scrupuleusement sauvegardés (décrets sur le domaine public du 14 octobre 1904 ; sur le régime forestier, décrets de 1900, sur le régime minier, 6 juillet 1899 ; sur l'émigration (décrets des 17 juin 1895 et 12 janvier 1897 pour le Sénégal, 25 octobre 1901 pour la Côte d'Ivoire, 14 octobre 1902 pour le Dahomey). La justice indigène a été organisée (décret du 10 novembre 1903). Enfin, en ce qui concerne le régime foncier du décret du 24 juillet 1904, qui transporte en Afrique occidentale et adapte au pays le système du Torrens Act, ils jouissent des mêmes garanties que les Européens.

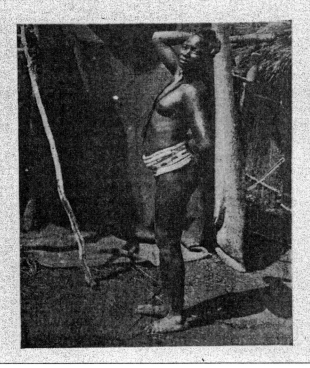

101. Page from the official programme for the display of French colonies at the Franco-British Exhibition showing 'Young Negress', apparently illustrating a text discussing the benefits of French medical provision and the importance of safeguarding the legal rights of French colonial subjects in French West African colonies (Paris 1908). Bibliothèque Nationale, Paris.

their steps their exuberant and primitive natures', the 1908 commentator was also at pains to reassure the visitor that, 'in all their dances the natives of the village observe the greatest decency and good conduct, naturally and without prompting.'[70] Wrestling took place at the exhibition supposedly on the slightest pretext, and at times when 'typical scenes from daily life' were said to be being enacted. Physical prowess had already become a naturalised precondition of blackness by this date, and the concept of 'natural' racial characteristics, biologically determined, is consistent with that emphatic preoccupation with the body and with details of black and white physiognomy to which I have already alluded.

The female equivalent to the wrestling black man is also present at the Franco-British Exhibition. While the perennial 'dancers' are still present, these are now described as girls rather than women in order to play down any hint of unregulated sexuality. In the official guide to the 'village', as opposed to the official guide to the French colonial section, the women's most prominent role was as mother. This aspect of Senegalese womanhood is represented primarily through repeated illustrations of mother and child – both re-assuringly black. There was no risk of encouraging the possibility of miscegenation here, as there had been at previous exhibitions. While the images of North and West African women represented in the pages of the general guide to the French colonial section are produced in highly eroticised and suggestive poses, they are also clearly located in the distant geographical locations of their own lands (fig. 101).[71] Such explicit sexuality was to be avoided in the destabilising proximity of the exhibition grounds.

One of the functions previously allotted to African, or Indian for that matter, women in other exhibitions, as reminders to the middle-class white woman of her highly privileged position in society, is now also served by another sector of the exhibition inhabitants. Any lessons for recalcitrant feminists were cemented through the display of Irish 'colleens' (sic.) in the Irish 'village' of Ballymaclinton. The amount of attention paid to this 'attraction', not only in the British press but also in terms of the sheer physical space it occupied in relation to the rest of the Franco-British Exhibition, indicates that this exhibit was clearly intended to be a particularly memorable showcase. (See figs 102 and 103 where the contrast between the entrances to the 'Irish Village' and to the 'Senegalese Village' is striking.) It also provides one of the clearest examples of how inextricably interrelated were the discourses on national identity, gender and imperialism, and the role played by a truncated version of what passed in the popular consciousness as 'anthropology'. While the 'village' boasted several noteworthy features, such as the Donegal carpet weaving factory, a linen-loom, soap-making, lace-making and embroidery, the real stars of the show were the one hundred and fifty colleens employed to populate the site. The national and local press are full of illustrations of these women: laughing, smiling and working. Few representations of the 'village' exist without these women prominently displayed, so much so that we could be forgiven for thinking that it was uniquely populated by these women, although this was certainly not the case (see figs 104 to 107). The commentator who had pronounced the African man a perfect model for the sculptor had dismissed the African women as irredeemably ugly, but with regard to the Irish woman, however, Sir Harry Johnston waxed lyrical about their beauty: 'The same flag covers what we believe to be the handsomest people in the world today – English and Irish – who seem to have acquired by some mysterious process of transmission or of independent development, the physical beauty of the old Greeks.'[72] Further clues to the

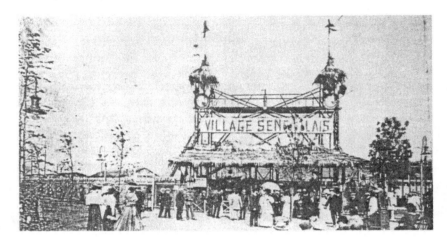

102. The entrance to the 'Sengalese Village' at the Franco-British Exhibition, White City (London 1908).

103. The entrance to the 'Irish Village' Bally-maclinton, at the Franco-British Exhibition, White City (London 1908).

significance of the colleens at the exhibition are provided by one of the popular compilations mentioned earlier. *Women of All Nations*, published by Cassell in 1908, produced Ireland in entirely sexualised and gendered terms as feminised and impotent, where 'the virility of the country has been sapped by excessive emigration', and where those remaining were 'stagnating below the line of reason and even sanity', but where at least the women knew their place, since, 'no country in Christendom reveals a higher standard of chastity'.[73] According to the writer of this section, Ireland had the lowest standard of living anywhere in the British Empire, and any invitation to marriage for the lower classes (who were the group classified as 'solidly Roman Catholic and Nationalist') would simply mean starting 'another homestead of indescribable dirt and untidiness, a fresh breeding-place for consumption, the curse of Ireland.'[74]

The colleens at the 'Irish Village', then, served to solidify a whole set of ideologies. They were the compliant beneficiaries of the aristocracy in the form of the Countess of Aberdeen's Irish Tuberculosis Fund, to which went all proceeds from the franchise.

104. The 'Colleens' dancing in the 'Irish Village' at the Franco-British Exhibition, White City (London 1908).

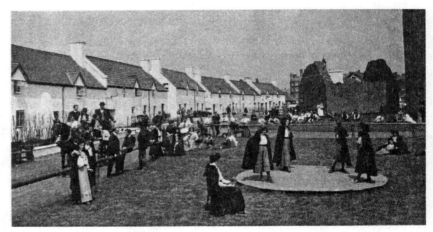

105. The 'Colleens' dancing in the 'Irish Village' at the Franco-British Exhibition, White City (London 1908).

Consequently, there was also a comparative display of an hygenic and unhygenic living space, and an exhibition on TB. To complete this image of a rigorous regime of health and hygiene, the women rose at the crack of dawn for spartan cold baths to keep the disease at bay! They were thus living proof of a supposedly successfully implemented government health programme.[75]

Lord and Lady Aberdeen occupied an interestingly ambivalent relation to the British government in some senses, since they were both predisposed to Home Rule from the very beginning of Lord Aberdeen's first period of office in 1886 and later from 1906 to 1915. Lady Aberdeen herself had been closely associated with the Gaelic Revival, setting up the Irish Industries Association in 1886 to promote and market cottage industries in Ireland, which interest continued into their second term of office. While not being totally identified with Westminster, then, (it is true, for example, that the Aberdeens certainly alienated sectors of the Ascendency elite with their championing of the poor and their partiality for what they identified as Irish culture) they were none the less members of

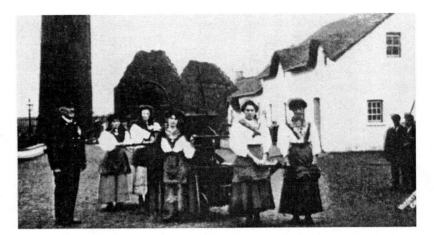

106. 'Women firemen: the Colleens' Brigade at the Franco-British Exhibition, White City (London 1908). Postcard.

the Anglo-Irish Protestant Ascendency and treated with considerable suspicion by most members of the nationalist Gaelic League after its foundation in 1893. It was not insignificant that the Irish Industries Association, which had been the brainchild of Ishbel Aberdeen, had promoted itself as a 'neutral' body able to incorporate all factions of Irish society.[76] This, then, was the acceptable face of the Gaelic Revival, a body able, or at least aspiring, to unite, 'Roman Catholics, Episcopalians, Presbyterians, Methodists, Quakers . . . as well as nationalists and Unionists of all sections.'[77] The ambivalence of Lady Aberdeen's status as both champion of the Gaelic Revival, but also representative of English Protestant aristocratic society within Ireland, made her particularly appropriate as a 'safe' Liberal spokesperson for Ireland. Thus she was a useful figurehead at a time of increasing confusion over the Liberal government's Irish policy, a factor which had seen both the rise of Sinn Féin as an effective alternative to the Irish party, and a dissatisfaction with the Liberal alliance in the face of what was rapidly becoming perceived as an enslaving paternalism.[78]

Indeed, it would perhaps not be going too far to argue that the 'Village of Ballymaclinton' served partly as a way of incorporating and diffusing the, by now, far more militant aspects of the Gaelic Revival and its associations with an aggressive nationalism, replacing this with a 'folksy' rendition of what was presented as a common Celtic heritage. The women's good-natured compliance with the day-to-day activities of the 'village', demonstrating cottage industries and producing items for sale to the exhibition-goer in the 'village shop', making soap or dancing and singing in their identical costumes, presented a harmonious picture of archaic and simple living. Margaret Ward's early study of the different factions within the women's movement in Ireland makes it clear that the image of the cloaked and smiling colleen was already being contested by 1908.[79] The first issue of *Bean na hÉireann*, the organ of Inghinidhe na hÉireann, in November 1908 carried an article on the disempowering effects of the stereotyping of Irish womanhood as colleen.[80] More than this, of course, her study demonstrates that women's involvement in the nationalist struggle was developed enough to have several shades of political opinion on the 'woman question' by the early 1900s, and that this

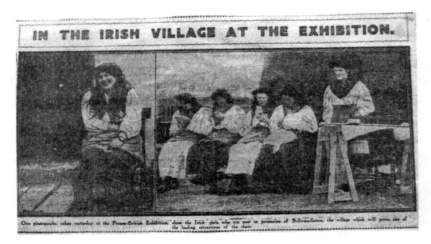

IN THE IRISH VILLAGE AT THE EXHIBITION.

107. Unidentified newspaper clipping of the 'Irish Village'. The Irish women had become synonymous with the exhibit.

debate which went on within an organised and vocal activism intensified over the period 1907 to 1909.[81] It can surely be no mere coincidence that the pervasive image at the exhibition was precisely that one which was challenged by certain more aggressive nationalist groups within Ireland.

The colleens' presence also had implications for English middle-class women, reinforcing the ideology that philanthropy was the proper avenue of public service open to British women. In the light of an increasingly militant suffragette activism, it is significant that so much store was set by an appeal to British womanhood, or rather middle-class white women, based on philanthropy rather than on a discourse of women's rights or 'equality'.[82] Other aspects of the exhibition confirm this interpretation. In the official catalogue for the exhibition, the 'Palace of Women's Work' is described as including 'everything which concerns the eternal feminine.'[83] The items which are singled out for attention here are telling, despite the fact that:

> There is hardly any form of activity that has not been attempted by women, with various degrees of success . . . The 'Nursery' . . . illustrates woman's true vocation in the home . . . It is in this power of organising . . . that women of the present day appear to have made a great stride forward. An illustration of this is the Bureau run under the superintendance of Miss Spencer, where information on everything connected with Philanthropy and women's work, can be obtained, and where every would-be philanthropist can be directed in his or her efforts. There is no nation in the world perhaps, where the women are so determined in their efforts to solve social problems by the institution of every kind of home, hospital, club, crèche and industrial enterprise.[84]

Described in wistfully nostalgic terms, Ballymaclinton served another crucial function in the exhibition. Through the living out of a Celtic tradition, eulogised in the guidebooks as it was in the press, the 'village' served as irrefutable proof of the possibility of a unified Ireland with Protestant and Catholic peacefully cohabiting – a harmonious resolution under Liberal guidance. One notable review in the local press went to some lengths to

assist this mythology. Reporting the Sunday service at the 'village', it described 'a unique gathering representative of every part of Ireland . . . The quiet peacefulness of the Irish Village and Protestant and Roman Catholic, stern Orangemen and laughing colleen united in appreciation of fruit and nut butter.'[85] Furthermore, even while maintaining its image as a feature essentially distinct from the Englishness of their host country, the 'Irish Village' none the less was indispensable to that larger objective of national unity, so much a feature of the Franco-British Exhibition.

A necessary corollary to the ideology of national unity was the construction of a 'National Culture'. In this respect the 'Irish Village' played an important role. As early as 1904, Balfour, in his capacity as president of the Anthropological Institute, laid plans for what he called a museum of national culture. Balfour specified that this museum would denote 'British' in nature rather than possession, which had so far been the designated function of material culture from the colonies and material in the larger survey museums. 'We want a National Museum', he said, 'national in the sense that it deals with the people of the British Isles, their arts, their industries, customs and beliefs, local differences in physical and cultural characteristics, the development of appliances, the survival of primitive forms in certain districts and so forth.'[86] Although this objective was not realised in the museum context until much later, it is important to note here that this proposal for a national, or, more accurately, 'folk' museum is a persistent element in museum discourse from about 1902 through to 1912.[87] The rhetoric of extinction and preservation, applied by academic anthropologists to specifically colonised races, had since been applied systematically to certain communities within the British Isles. This concept of a national British culture as a resilient 'folk' culture, surviving in rural communities (and Ireland was included here), was a popular fantasy shared by those at both ends of the political spectrum.

Since 1905, supposed 'folk' culture had been officially mobilised in juvenile education to instil the correct patriotic spirit.[88] By October 1907, Cecil Sharp, that untiring middle-class campaigner for the revival of 'folk song', had published his collection of what he defined as 'authentic' folk music. His definition is a telling one. The true folk song was 'not the composition of an individual and as such, limited in outlook and appeal, but a communal and racial produce, the expression, in musical idiom, of aims and ideals that are primarily national in character.'[89] The equivalent qualities are to be found in the exhibition, expressed in the 'villages'. At the Franco-British Exhibition, the Senegalese and Ceylonese 'villages' on the one hand, and the 'Irish Village' on the other, are all represented in the official guidebooks as quaint 'survivals' in the anthropological sense. Yet, while both European and African villages were produced as 'primitive', it was a 'primitiveness' that had already been clearly qualified in both cases in terms that would have been familiar to a large proportion of the exhibition public.[90] Consequently, the proximity of these 'villages' on site had the effect of accentuating the distance between the European 'primitive' and its colonial counterpart. The suggestion in the guidebooks was that, even in these supposedly simple European communities, there was evidence of an inherent superiority in relation to the colonised races represented. Descriptions like 'spick and span' and 'wide and white and clean', as well as 'healthy', 'beautiful' and 'industrious', predominate in descriptions of the 'Irish Village'; and they can be compared to the constantly reiterated assurances that the Africans are in fact much cleaner than they look! In this respect, the emphasis on food preparation by the women of the 'Senegalese

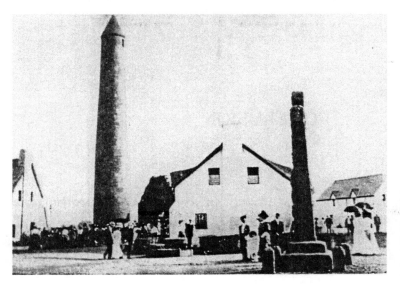

108. The interior of Bally-maclinton, showing two of the monuments in the 'Irish Village', White City (London 1908). Postcard.

Village' serves as a case in point. Here the spectator was reassured: 'It is quite curious to watch her black hands, and if you saw the same in the kitchen of a London restaurant you might be disturbed. I assure you the colour of those hands, like her smile, is one that "won't come off".'[91] In view of the anxieties over health and racial deterioration, such qualifications served only to reinforce popular conflations of 'blackness' with dirt.[92] Similarly, while the guidebooks are full of references to the ancient traditions of the Irish, the Africans are credited with no such history or tradition, and that of the Ceylonese and Indians is acknowledged but hardly elaborated (fig. 108).[93] The official guide to the exhibition catalogued no less than five 'realistic reproductions' of ancient monuments reconstructed in the 'Irish Village'.

Consequently, what appears to constitute an irreconcilable contradiction, the construction of certain 'British' communities as themselves essentially 'primitive', should be recognised as a means of establishing the notion of an originary and resilient 'national' culture. In this way, the representation of Ireland at the Franco-British Exhibition emphasised the essential difference between the European and the colonised subject. Within this context, for the English, the representation of Ireland as an 'authentic' originary culture and an integral component in a *British* heritage, served to solidify the illusion of a homogeneous national identity.

CONCLUSION

The categorisation and racialisation of the African continent occupied an important place in both the scientific and the popular imaginations of late Victorian and Edwardian England. Through the taxonomies and descriptions devised to orchestrate African material culture in museums and exhibitions nationwide, and through the incorporation of Africans as part of spectacles of Empire, expansion or conversion, a heterogeneous public was introduced to a symbolic universe with the British Empire at its heart.

Those responsible for the establishment and organisation of ethnographic collections and museums, and for the various exhibitions involving the representation of Africa, came from diverse sectors of British society. Such public cultural institutions drew support and maintenance from different areas of civil society with varying degrees of dependency on the imperial state. The mainstay of both museum ethnography and of exhibitions in Britain were industrial capitalists, entrepreneurs and civil servants in the colonial service, together with the semi-professional elites of the amateur scientific bodies and the emergent professionals of learned societies like the national and regional geographical societies and the Anthropological Institute. This broad-based constituency was augmented by those with a more equivocal relation to aspects of official imperialism, such as the various evangelical missionaries in the field and the anti-slavery lobby at home. These groups frequently held antagonistic and oppositional viewpoints to one another on single issues, although they might temporarily form coalitions in the interests of a broader imperial vision. As a result, the exhibitions in particular, and to a lesser extent the museums, were able to draw a mass audience within their orbit. The rhetoric of combined leisure and edification produced by these institutions was a further incentive to different sectors who might otherwise have viewed such events with suspicion. Furthermore, the ideals of social imperialism promoted by both liberals and conservatives in different guises ensured that the concept of Empire was represented as correlative with the desires and needs of a working class who were disaffected by the often appalling living conditions at home. Thus class and national unity were invoked in the official discourse of both museum and exhibition, and the myth of peaceful coexistence was advanced through educational initiatives on the one hand and the promised pleasure of the exhibition ground and its 'amusements' on the other.

The professionalisation of anthropology over this period, and the fight for academic recognition and state support which accompanied its emergence as a university discipline, contributed an important dimension to the representations of Africa which were available to this multifarious public in both the exhibition and museum context. Because the anthropologist was forced to inhabit an indeterminate terrain somewhere between the

category of professional scientific academic and enthusiastic amateur, this encouraged the wide dissemination of popularised versions of supposedly anthropological 'theories' on race and culture. Since anthropologists' primary public presence was relegated to museum ethnography and the colonial and ethnographic displays at exhibitions, those aspects of anthropology which were popularised were largely confined to the more sensational elements of the science. In particular, because of these cultural arenas' dependence on spectacle, the focus tended to be on aspects which were highly visible and susceptible to spectacularisation. Often this meant a concentration on the physical and the body through, for example, displays of anthropometry which frequently bore some relation to aspects of eugenic theory. Other times it resulted in the scientific racism of the predominantly evolutionary narratives constructed for material culture from certain colonies, notably those on the African continent and in the South Pacific.

Consequently, the spurious hierarchies of race and culture, and the designation of supposedly inherent racial characteristics constantly emphasised through the official discourse and tangible displays of the exhibitions, gained credibility through their association with the 'science' of anthropology. This was not least because of eminent anthropologists' direct involvement in these displays. Such an association facilitated the denial of the heterogeneous nature of the African experience and presence in Britain. It also aided the public's capacity to absorb evidence which flatly refuted the demeaning stereotypes relentlessly reproduced at many of the exhibitions analysed in this book, without that evidence disrupting the complacent assumptions of English superiority. Such contradictions remain the stuff of race ideologies today. What this study has hopefully achieved is to unpack some of the conflicting professional and political interests in the colonial community that ensured that such contradictory representations could be sustained.

However, the Edwardian era, so often dismissed as a sleepy watershed, was nevertheless a historical moment which posed various challenges to the established social and moral universe of the Victorian period. These challenges came from various quarters, both within Britain and from different British territories in Africa and other colonies and dependencies. The formation of the Independent Labour Party, the visible and often violent demands of the Suffragettes, and the constant pressure that ensured that the 'Irish question' was on every political agenda, were challenges which may not always have achieved the goals they intended but which certainly rattled the prevailing order.

Transformations in the social and political structure of various African colonies, due partly to the colonising process itself through, for instance, the establishment of an educated elite, resulted in a different kind of challenge to the British state. While political developments in Britain may have facilitated humanitarian lobbies, such as the Aborigine Protection Society and to a lesser extent The Anti-Slavery Society, these in turn often aided the passage of those Africans who were prominent churchpeople, traders and statesmen who came to England, sometimes with vocal criticisms of their colonial rulers. Small radical presses over this period gave voice to their demands and exchanged copy with a number of West African newspapers, for example, which were known for their outspoken editorials on the colonial government. Meanwhile protests against the colonial administration were also taking place in the colonies themselves. This book has suggested that such criticisms and protests made an impact in Britain, whether directly or indirectly. Certainly there are perceptible shifts in the range of representations of certain more

critical African colonies at the later British exhibitions, whether missionary or colonial. The final chapter of this book has provided evidence that suggests that, by this date, it was no longer politically expedient to dismiss the populations of these African colonies and protectorates as 'wilful savages'.

To understand the extent of the challenge which such developments represented to the imperial state, we have only to look back at the constantly reiterated discourses on racial purity that have surfaced at the different historical moments explored in this book, and the army of professional practitioners and social scientists who staked their careers on the validity of such a concept. The activities of the Physical Deterioration Committee, the Eugenics Education Society and, to a certain extent, the kinds of enquiry embodied in the social science and anthropological questionnaire, while by no means uniformly repressive or motivated by a singular political and social agenda, were often underpinned by a concern with racial purity. The contradictory histories and interpretations surrounding the Benin bronzes in the first three chapters of this book confirm that not only the social sciences, but aesthetic discourses produced from within the emergent art and anthropological establishments, propounded theories which were rooted in such a belief. Anxiety over miscegenation was a corollary of such a discourse, and, as we have seen, the African was often the prime butt of any resultant apprehension. The spectre of 'degeneration' then, was never easily confined to Africa and the other colonies. It haunted the very centre of the imperial heartlands and threatened to undermine irrevocably the myth of racial purity which continues to cling so tenaciously to notions of 'Englishness' today.

EPILOGUE:
INVENTING THE 'POST-COLONIAL'

Clearly, it would be overdetermined to presume a tidy continuum between ideologies marking the formation of anthropology as a discipline in the early twentieth century, and the present 'post-colonial' context. I want to suggest, however, that some vestiges of these earlier preoccupations remain at the root of contemporary debates on the value of cultural objects, which might at one time have been the concern of ethnography, but which today inhabit an ambiguous terrain somewhere between fine art and ethnography. Paradoxically, it is precisely in the recognition and celebration of a concept, mobilised specifically to counter so many of the assumptions of cultural superiority which marked the earlier production of ethnographic 'meaning', namely, hybridity, that discourses on racial purity, originary unity and progress have re-emerged in another form.

Over the years, a series of exhibitions in western metropolitan centres, have attempted in various ways to radically disrupt the boundaries of that diad, the 'West' and its 'Other', a relationship so often characterised as the distance between centre and periphery.[1] A number of contemporary strategies have emerged from within the more self-conscious curatorial establishments in the West, as an antidote to the familiar discourse of timeless anonymity, and originary unity, which was so often the corollary of the concern with racial purity. Many curators have sought to provide an exhibitionary context which is somehow representative of a new 'post-colonial' consciousness.[2]

In curatorial terms, a shared feature of many such initiatives has been the prioritising of transculturated objects as a visible referent of the self-determination of those nations once subjugated under colonial domination. More specifically, the cultural object has been reinstated as the primary signifier of cultural, national and ethnic identity, in a tactic reminiscent of earlier histories. In this contemporary reincarnation, however, these identities are designed to function as a *celebration* of integrity and 'difference' from the centres of western capitalism. Crucially, the deliberate focus on transculturated or 'hybrid' material culture has also been promoted as the sign of a mutually productive culture contact – an exchange on equal terms between the western centres and those groups on the so-called 'periphery'.

In many ways any contemporary curatorial strategies which prioritise hybridity should be welcomed. Historically, for example, hybridity has often been an important cultural strategy for the political project of decolonisation.[3] Additionally, the many manifestations of creative transculturation by those assigned to the margins do potentially provide productive interruptions to the West's complacent assurance of the universality of its own cultural values. And certainly, the celebration of hybridity also implies an acknowledgement of the ways in which western culture has been, and continues to be, enriched by the

heterogeneous experience of living in a multi-ethnic society. Nevertheless, there is still a considerable distance between the utopian desire to envision a truly 'cosmopolitan' society, representative of a 'post-colonial' context, and the conditions upon which such a social transformation might depend. In particular, perhaps, we need to interrogate the complex meanings attributed to the transculturated or 'hybrid' object in the narratives of western metropolitan art and ethnographic museums, and to ask what relations of power and transgression it might articulate there.[4]

One of the difficulties of appropriating 'hybridity' as a sign of post-colonial self-determination is that, as a cultural concept and as a descriptive term for the cultural object itself, it already has a particular pedigree in the discourse of both art history and anthropology as Surrealist, Pop, Folk, and Tourist art, that is, art or popular versions of historical cultural practices, redefined for a commercial market. The meanings and values of each category are dependent on the conditions of any given historical moment. Any cultural object is, of course, recuperable to some degree. But as the previous chapters have shown, such ambiguity has always been intrinsic to western consumption of material culture from erstwhile colonies.

More importantly, any exhibition foregrounding hybridity may well heighten awareness of the multiple meanings of the objects on display, but it often disavows the complexity of the ways in which such meanings are acquired and articulated across a series of relations at the level of the social. Consequently, as a curatorial strategy, it actively undermines the potential of such exhibitions to explore and explode the means by which differentiation reproduces the experience of multiple, but specific, forms of social and political disempowerment – and conversely, empowerment.[5]

In a sense, of course, hybridity is particularly inappropriate as a sign of post-coloniality when mobilised in the sphere of visual culture. This is precisely because of the way in which the site of its public consumption – the art or ethnographic museum – is predicated on 'visibility'. The 'visibility' of the museum of today owes less to a legacy of Victorian empiricism, than to the continuing hegemony of the presumption of modernist universalism in most national collections. For the most part, then, the museum's 'visibility' reaffirms and naturalises the apparently imminent meaning of the cultural object. Because the celebration of the transculturated object is often tied to the liberal project of cultural diversity, the 'visibility' of the museum increases the mystification which this project can produce, that is, the assumption that all players are equal in the global arena. An invitation to participate in a supposedly shared culture, the address to the citizen, has underwritten all public museums since the institution's historical transformation from private courtly collection.[6] In such spaces, the relationship between public and subjective identities, and the values and exclusions implicit in both, is confounded. The confusion invoked by this address, and the contradictions between this and the actual conditions of access to cultural capital, might account for why, for example, the huge North African diaspora in Paris is a regular user of the videotech and library at the Beaubourg, but rarely, if ever, uses the exhibition space downstairs.[7] This is despite the fact that the Beaubourg is predicated on an almost monstrous visibility, which declares through the 'transparent' functionalist architectural idiom a condition of permanent and open accessibility.[8]

Crucially, many critiques of these kinds of curatorial strategies have come from those whose experience is often silenced through such representation. The example which immediately comes to mind is the protest made against the Museum of Mankind's

'Hidden Peoples of the Amazon' exhibition in 1985. Notwithstanding the use of the intractable interior of Burlington Gardens as an unlikely substitute for the Amazon Jungle, the exhibition itself provided a spectacle which represented the various indigenous populations of the Amazon basin as productive, active, and evidently in possession of an encyclopaedic knowledge of the complex ecology of their environment. However, the meta-narrative of the exhibition (if not already evident simply through the actual and metaphorical 'containment' of diverse strata of Amerindian societies in three rooms of the museum) is made explicit in the accompanying guide. After cataloguing the threats to the very environment represented in the display, the writer continues:

> In the light of this, reservations such as the large Xingu Indian park set up in Brazil in 1959, must be seen as the most acceptable of alternatives for the protection of Indian interests in the welter of modern economic development.[9]

The tone of resignation and inevitability here is continuing proof of the way in which those discourses used to justify ethnographic practice, during its historical formation as an 'officially' accredited 'profession', are continually invoked today.

However, on 8 August 1985, the Museum was picketed by representatives from Survival International and two Indian representatives from different Indian rights organisations. What is interesting here are the particular terms of their critique of the exhibition, and the way it highlights some of the difficulties of addressing the issue of culture contact through the display of culturally 'hybrid' objects. The demonstration concerned not the absence of culture contact, assimilation and adaptation in the display, but rather the absence of any acknowledgement of the dialectical and dynamic relationship of diverse Amerindian populations to such contact. Not simply at the level of the hybridisation of material culture, but at a much more fundamental social level, it concerned, in fact, the absence of any evidence of the ongoing struggle between the Indians and the Brazilian government. This absence of any signs of selective and strategic resistance was, in short, the absence of any self-determination by those Indians represented in the exhibition. The Museum's concession to the contemporary situation was to put up a story-board, advertising western aid campaigns against the decimation of the Amazonian rain forests and two photographs supposed to demonstrate a flourishing hybrid culture: a ceremonial house made out of recycled cans and a Panare Indian in 'traditional' clothing riding a yellow Yamaha bike on a cleared highway. The statement made by Evaristo Nugkuag, one of the leaders of an Indian rights organisation, neatly sums up the problem: 'It was as though we could have the white's machine without losing our land and our way of life.'[10]

Four years later, the Calgary exhibition, 'The Spirit Sings: Artistic Traditions of Canada's First Peoples', put on to coincide with the Winter Olympics in January 1988, became the centre of another controversy. The Lubicon Lake Cree organised a demonstration and boycott of the Olympic games, in order to draw attention to their forty year-old land claim. The exhibition itself gradually became the focus of the boycott, since its very existence was only assured as the result of a substantial grant from Shell Oil Canada Ltd., who also happened to be drilling in precisely the area of the land claim. In the words of Bernard Ominayak, Chief of the Lubicon: 'The irony of using a display of North American Indian artifacts to attract people to the Winter Olympics being organised by interests who are still actively seeking to destroy Indian people, seems

obvious.'[11] The curator's response was to play the old 'objectivity' card: 'Museums, like Universities, are expected by their constitutions, to remain non-partisan.'[12] In answer to the Lubicon's retort that Glenbow Museum had already made a political stand by accepting Shell sponsorship, the astounding response was that there was no 'evidence that the public confuses corporate support for corporate policy'.[13]

Clearly, those who apparently 'cannot represent themselves' are more than able to do just that. In both the Tukano and the Lubicon Cree cases, their intervention exposed not only hidden agendas of corporate sponsorship and 'objective' museum scholarship, but also the inextricability of discourses of cultural continuity and/or cultural transformation as a result of contact with western capitalism, with other more problematic discourses around the concept of 'tradition'.[14] Most importantly, both Amazon and Lubicon Indian rights groups have made it clear that there are complex interests at stake in the representation of culture contact in western museums. The implied formal or spiritual affinities that accompany displays of hybrid objects in these exhibitions, and the apparently mutually productive exchanges that are made to reside in the sign of the transculturated object, can function as a highly problematic disavowal. The examples of the Amazon and Lubicon Lake Cree have demonstrated that if such an object has a symbolic value as a kind of transaction or negotiation between the centre and periphery, it also serves another function in the narratives of the western metropolitan museum. It can displace the discomforting traces of the social and political transactions and negotiations for which the transculturated object has always been a repository. As earlier chapters have suggested, these exchanges, though rarely acknowledged, have always been present in colonial society from the beginning. The context which needs to be made explicit in such displays is no longer solely the old functionalist call for 'mythic' and 'ritual' significance, or a reassessment of the validity of such practices for the canons of the western art establishment, but the ways in which such cultural activities are often framed within a specific engagement with global politics, and certainly with local demands. The meanings attributed and attributable to such practices are, in fact, politically contingent, unstable and often strategic.[15]

If, as Paul Gilroy has suggested, 'diaspora' enables a way out of a binary constituted across 'essentialism' versus 'difference', we need to recognise the significance of the fact that hybridity and difference, in most of these exhibitions, is articulated as a symptom of what is identified as 'post-colonial' (itself a rather dubious category) as opposed to 'diasporic' formations.[16] It is a coincidence which effectively marginalises diaspora, the 'other' within, a concept which is far more politically disquieting to western bourgeois hegemonic culture. Diaspora, after all, so often signals a hybridity of a very explicit nature, for it incorporates the possibilities of new communities. More effectively than any cultural object, these 'hybrid' minglings of different cultures challenge the myth of racial purity which has so persistently accompanied definitions of 'Englishness'. Perhaps this also accounts for the disruptive and transgressive power, for all their failings, of exhibitions like Rasheed Araeen's 'The Other Story' at the Hayward Gallery, and the earlier exhibition 'From Other Worlds' in London's Whitechapel Gallery.[17] Attentiveness to audience and constituency is all. Who is doing the looking, or more specifically, who is being addressed, is of course a central issue. In both these exhibitions, the primary constituency was precisely these 'new communities' (the result of migration, dispersal and settlement) that have transformed for good the face of British society. Paradoxically,

it may be the ethnographic museum (traditionally the site of 'visibility' of colonial appropriation and territorial expansion) where this dialectical relation between the hybrid cultural object and social change is most likely, precisely because its 'visibility' was never the neutral indifference of modernist universality, that claim to subjective individualism that is historically the project of the modern art museum. And perhaps, for this very reason, those exhibitions in the western metropolis which have turned an ironic and self-critical eye on the viewing subject and on the museological process of 'othering', have been most successful in pointing a way forward. In this respect the Museum of Ethnography at Neuchâtel, under the direction of Jacques Hainard, has been one of the most innovative precursors.[18]

The chasm is too great between the actual experience of economic, social and political disempowerment, and the philosphical relativism of the way in which hybridity has been used as an unproblematic sign for the flux and mobility of global capital. An account of hybridity is required which acknowledges the inequality of access to economic and political power, a recognition which would carry with it an analysis of class and gender relations within subaltern *and* dominant groups, and which would articulate the ways such differences are constituted (not only in relation to the western metropolitan centres). Maybe this would allow us to explore hybridity as a condition occurring within and across different groups interacting in the same society. Canclini has usefully discussed the short-comings of the cultural relativist model as a means of explaining the 'hybridity' of Latin American culture, as one of conflictual groups with common or convergeant histories which may no longer exist separately.[19] Hybridity so often remains a term which primarily describes the culture of the 'margins'. In these exhibitionary narratives, it rarely disturbs the equilibrium of the culture of the 'centre'. We need, in other words, to recognise the hybridity of all cultures and to explore the specific conditions of this hybridity – the *how* and the *who* of it – which might then dispel the monolithic repetition (despite post-modernist pretensions) of hybridity as an encounter between the West and its 'Other' and the ultimate reassertion of a Manichean model.[20]

If I were to end on such a cautionary note, however, I would run the risk of erasing the memory of those long struggles which have indeed resulted in transformations, both within and without the cultural establishment, at the level of policy and curriculum. Perhaps this book should return at its ending to the place where it began – with some of the most resonant cultural icons from the African continent, the Benin bronzes. Even as I write, a small segment of the complex history of the bronzes has been recovered and incorporated as part of the history core on the new national curriculum at secondary level in Britain.[21] Evidently, the Benin bronzes are still at the nexus of competing discourses which often reproduce the contradictions that made them such significant icons in the late nineteenth and early twentieth centuries. It is in the space opened up by such contradictions that a more productive dialogue might emerge.

In 1983, for example, 'Treasures of Ancient Nigeria' was put on at the Royal Academy of Arts in London, having already toured North America.[22] The British context for the exhibition added a certain poignancy to each of the narratives played out in the text of the catalogue. On the one hand, there were tales of colonial benevolence, revealed through detailed accounts of the British-led archaeological excavations. On the other hand, his-tories unearthed were invested with Nigerian hopes of self-determination, and charged with the task of reinscribing Africa in the West's consciousness as a continent with a

109. The glass doors at the entrance to the Museum of Mankind in London, showing a Benin bronze figure engraved into the glass. Author's photograph.

long and complex historical memory. The tension between paternalistic discovery and disenfranchisement, manifested itself on this occasion in the challenge extended by Ekpo Eyo, director of the Nigerian Federal Department of Antiquities, and active campaigner on UNESCO's International Council of Museums. Eyo ended his introduction with a plea to western museums to reassess, as he put it, 'the circumstances in which these objects were removed from Benin', and to give the Benin museum the opportunity to display more than just photos and casts of a once thriving local industry.[23] In the case of Benin, the restitution issue gives a particular edge to the nature of the visibility of these cultural objects in western museums. Persistent demands for the restitution of Benin material have been made since independence. Perhaps one of the best known occasions was during the 1977 Festival of International Black Art in Lagos (Festas), where the organisers requested the loan from the British Museum, of a fifteenth-century Benin ivory hip mask which had been chosen as the festival's logo. The loan was refused.[24]

By 1989, the restitution debacle compelled the Museum's director, Sir David Wilson, to publish a public rebuttal of criticisms of the British Museum as elitist and neo-imperialist.[25] Evidently a heartfelt response by a member of an increasingly harassed breed of public servant, Wilson's case none the less turns unhelpfully, but tellingly, on the twin obfuscations of political neutrality and internationalism:

> The establishment of the Museum as a trust with a board of trustees, was surely intended to inhibit political, emotional, nationalistic or sentimental influence . . . our argument is . . . the sense of curatorial responsibility, of holding material in trust for mankind throughout the foreseeable future. In a period when all our aspirations are based on the hopes of international agreement, we cannot let narrow nationalism destroy a trust for the whole world.[26]

The fact that the majority of the trustees are selected by the Prime Minister, and that one of the Museum's major benefactors is the National Heritage Memorial Fund, suggests some ambiguity over Wilson's definitions of 'neutrality' and 'internationalism'. Even more perplexing in this defence is the fact that, despite the directorate's evident recognition of the delicacy of the restitution issue (particularly, one imagines in terms of maintaining good 'international' relations), the Benin bronzes have for some time been more prominently displayed than almost any other items in the Museum's collection. Etched indelibly into the very fabric of the architecture, they usher the visitor into the British Museum's ethnographic section – the Museum of Mankind (fig. 109). Obsessively repeated in the British Museum main building, they are unavoidable encounters on the central staircase leading to the collections (figs 110 and 111).[27] Finally, the still ambivalent status of the Benin and Ife bronzes as neither art nor ethnography, but simultaneously both, makes them the perfect items to mediate the impending reabsorption of the ethnographic Museum of Mankind into the main body of the British Museum. Accordingly, they became again ethnography's ambassadors to the Bloomsbury site in a recent exhibition entitled 'Man and Metal in Ancient Nigeria'.[28]

Of course, what is significant about their current trajectory is that it coincides with a moment in Britain when enterprise and heritage jockey for position with multiculturalism and globalism in the discourse of the New Right. Consequently, the contradictions which characterised the debates about the origins of the Benin bronzes at the turn of the century now take on a new potency. If unyielding possession and flagrant display of the bronzes

110. The main staircase at the front entrance to the British Museum, London, showing the Benin bronzes. Author's photograph.

111. Detail of the display of the Benin bronzes at the top of the main staircase of the British Museum, London. Author's photograph.

can be understood, in part, as the manifestation of an unconscious desire – the fantasy of a continued British sovereignty – it could also be interpreted as one outcome of the management of what other commentators have rightly identified as the tensions between the ideology of national sovereignty and a strong state on the one hand, and the increasingly multinational character of finance capital on the other. In other words, the tension between an appeal to an older imperial identity, and the realities of an increasingly politicised multicultural society.[29]

Perhaps it is as well to remember, however, that it is precisely in the gap between the

populism that is the New Right's answer to these contradictions, and the recognition by some of the electorate of the exclusivity which it masks, that the possibility exists for an alternative vision of social transformation (fig. 112). Ultimately, it is only from a more complex understanding and admission of the historical role that the cultural object has played in an imperial past that we can envisage the part it might now play in the realisation of a truly Post-Colonial future.

112. Poster for Black History week. Produced by the London Borough of Southwark (1991). Photograph by Nancy Jachec.

NOTES

Introduction

1. Walter Benjamin, 'Theses on the Philosophy of History', in *Illuminations, Essays and Reflections* (1968), p. 256.
2. Peter Murtagh, 'A Present From Buffalo Bill: Aids in Africa', *Guardian* (3 February 1987), p. 25.
3. For further analysis on press hysteria in the reporting on AIDS in Africa, see Watney (1987); 'Missionary Positions: AIDS, "Africa", and Race', in eds. Ferguson, Gever, Minh-ha, West (1990), pp. 89–103. See also Treichler, 'AIDS and HIV infection in the Third World: A First World Chronicle', in eds. Kruger and Mariani (1989), pp. 31–86; R. and R. Chirimuuta (1989). Judith Williamson and I wrote our dismay at this report in a letter to the *Guardian*. It is a measure of the controversial nature of this report that many others did the same.
4. *Guardian* (3 February 1987), p. 25.
5. Recent years have seen a spate of texts dealing with museums in general, most of which foreground fine art collections. One of the best and earliest of these remains C. Duncan and A. Wallach, 'The Universal Survey Museum', *Art History*, vol. 3, no. 4 (December 1980), pp. 448–69. See also Horne (1984). Bourdieu (1984); Some of the more useful collections of essays which treat museum culture, including ethnographic museums, are: ed. Lumley (1988); eds. Karp and Levine (1991); eds. Karp, Mullen Kreamer and Levine (1992); Stocking Jr. (1985); Dias (1991). For a particularly insightful analysis of the museum in relation to questions of gender and narratives of history, see D. Haraway, 'Teddy Bear Patriarchy: Taxidermy in the Garden of Eden, New York City, 1908–1936', *Social Text* (Winter, 1984 to 5), no. 11. See also ed. Appadurai (1986), for an important collection of essays dealing with commodification and cultural exchange which has obvious implications for any study of material culture in museums.
6. See, for example, Pelling (1979); Field (1982); Kiernan (1982); Fieldhouse (1973). For a more expansive conception of imperial ideology, although prior to the period under consideration in this book, see Curtin (1965); Cairns (1965). MacKenzie (1986), while more lucid on the public appeal of various images of Africa, nevertheless tends to reproduce a fairly monolithic account of these representations as propaganda.
7. It is important not to confuse criticism of the methods of imperialism and colonial administration over this period, with a critique of the principle of imperialism. For many critics, including J.A. Hobson, it was not the principle but its administration which was at fault.
8. T.E. Perkins, 'Rethinking Stereotypes', in eds. Barrett, et al. (1979), pp. 135–59. See also Homi. K. Bhabha, 'The Other Question: The Stereotype and Colonial Discourse', *Screen*, 24, no. 6 (November–December 1983), for a discussion on the colonised subject as both the object of desire and derision.
9. Said (1978). Said was one of the earliest cultural historians to theorise the colonial encounter in this way.
10. For various and conflicting views on the degree of working-class participation in imperialist jingoism, see Price (1972) who argues for their minimal involvment. For an opposing view, see Blanch, 'Nation, Empire and the Birmingham Working Class', (unpublished Ph.D. dissertation, University of Birmingham), 1975.
11. Tony Bennett, 'Popular culture: defining our terms', in *Popular Culture: Themes and Issues*, 1 (1981), p. 86.
12. To a certain extent, this aspect of the book engages with the debate on the significance of the leisure industry's development over this

period, and to what extent popular culture can be interpreted as an arena of social control or class struggle. For a discussion on this debate, see Gareth Stedman Jones, 'Class expression versus social control? A critique of recent trends in the history of leisure', *History Workshop Journal*, 4 (1977). See also Cunningham (1980); Bailey (1978).

13. *The Times* (21 March 1890), p. 14. The standard histories of the larger national and international exhibitions and world fairs offer little insight into this particular form of cultural event, in terms of ideologies of race or nationalism. See, in particular, Allwood (1977); Altick (1951). However, two books have produced particularly insightful analyses of the role of such exhibitions in the constitution of racial and national identities in North America and in France respectively; Rydell (1984); Schneider (1982). For an earlier example of an excellent analysis of the 1889 Paris Exposition, and one of the first to raise the issue of national unity in connection with such events, see D.L. Silverman, 'The 1889 Exhibition: The Crisis of Bourgeois Individualism', *Oppositions*, 8 (1978), pp. 71–91. Few of these texts, however, have acknowledged the extent to which a variety of types of public exhibition incorporated some aspect of African and other colonies' culture into the spectacle. In addition, none of them acknowledge the existence of the missionary exhibition, or indeed any aspect of the missionary representation of the colonies to diverse British publics. Missionary activity in Africa was fundamental to the success of the British colonial enterprise (often preceding both trader and colonial administrator), while it also presented certain obstacles in its path. Missionary societies were consequently also very active on the home front. This book is a small contribution to a hitherto absent passage in the history of the representation of the colonies to British publics.

14. For the former tendency, see G.W. Stocking Jr., 'What's in a Name? The Origins of the Royal Anthropological Institute (1837–71)', *Man*, vol. 6, no. 3 (September 1971), pp. 369–90. Stocking emphasises the philanthropic origins of anthropology while he concludes that, 'It took for granted the British Empire and the White Man's Burden, but it was not actively concerned with either colonial policy or savage uplift.' (See p. 386.) If this was the situation in the 1860s, by the first decade of the twentieth century things had certainly changed. As a useful example of the latter tendency, see S. Feuchtwang, 'The Colonial

Formation of British Social Anthropology', in ed. Asad (1973), pp. 71–100.

15. G.W. Stocking Jr., 'The Ethnographer's Magic: Fieldwork in British Anthropology from Tylor to Malinowski', in ed. Stocking Jr. (1983), pp. 70–120; Penniman (1935); Harris (1969); Kuper (1975).

16. See, in particular, ed. Rubin (1984); Goldwater (1938). James Clifford's review of the MOMA 'Primitivism' exhibition of 1984 remains one of the most perceptive analyses of the problems inherant in this kind of history. See J. Clifford, 'Histories of the Tribal and the Modern', *Art in America* (April 1985), pp. 164–77. For other critiques of the modernist use of the term 'primitivism', see ed. Hiller (1991); Torgovnick (1990) and Hal Foster, 'The primitive unconscious of modern art or white skin, black masks', in *Recodings* (1985).

17. Goldwater, *ibid.*; Lloyd (1991).

18. See, for example, R. Deutsche, 'Alienation in Berlin: Kirchner's Street Scenes', *Art in America*, LXX (December 1982), pp. 76–89; M. Leja, '"Le Vieux Marcheur" et "les Deux Risques": Picasso, Prostitution, Venereal Disease and Maternity 1899–1907', *Art History*, vol. 8, no. 1 (1985); A. Solomon-Godeau, 'Going Native', *Art in America*, LXXVII (July 1989), pp. 118–29 and Lloyd, *ibid.*

19. For an important contribution to this kind of analysis, see T. Ranger, 'The Invention of Tradition in Colonial Africa', in eds. Hobsbawm and Ranger (1983), pp. 211–62. See also eds. de Moraes Farias and Barber (1990). See also the recent work on gender, western women and imperialism, and the contradictions of white, middle-class women's experience of the colonial encounter, in particular eds. Chaudhuri and Strobel (1992); Callaway (1987); Ware (1992) and Birkett (1989).

20. See, in particular, Gayatri Chakravorty Spivak, 'The Rani of Sirmur', in eds. Barker et al., vol. 1 (1985), pp. 128–51; Spivak (1987); Said (1978); J.H. Gates Jr., 'Writing "Race" and the Difference it Makes', *Critical Inquiry*, vol. 12, no. 1 (Autumn 1985), pp. 1–20; Homi K. Bhabha, 'The Other Question: The Stereotype and Colonial Discourse', *Screen*, 24, no. 6 (November to December 1983); Parry (1972); Brantlinger (1988); Lloyd (1987); Lowe (1991); JanMohamed (1983); Pratt (1992); Miller (1985); Hulme (1987); West, vol. 2 (1993). See also the important contribution of the Subaltern Studies Group: Guha and Spivak (1988).

21. Foucault (1970); (1972); (1977).

22. See Dreyfus and Rabinow (1982) for an analy-

sis of Foucault's work on power and truth, and its implications for action and resistance. For a useful, short, polemical intervention which is critical of certain aspects of Foucault's work, in terms of the possibilities or impossibilities for oppositional activism which it suggests, see J. Weeks, 'Foucault for Historians', *History Workshop Journal* (Autumn 1982).

23. Gramsci (1971). See also S. Hall, 'Gramsci's Relevance for the Study of Race and Ethnicity', *Journal of Communication Inquiry*, 10 (1986), pp. 5–27; Adamson (1980); ed. Sassoon (1982).

Chapter I

1. Technically speaking, the term 'bronze' is a misnomer. Analysis has shown that these objects are not always bronze but may be zinc, brass or leaded bronze, and are generally an alloy of copper, zinc and lead in varying proportions. The use of 'bronze' here is as a shorthand.

2. O.M. Dalton, 'Booty from Benin', *English Illustrated Magazine*, vol. XVIII (1898), p. 419.

3. *Illustrated London News* (23 January 1897), p. 123.

4. Igbafe (1979); Ryder (1977), p. 260. Most of the non-attributed factual information in this chapter regarding details of the situation in Benin, and the Oba's relations with the British government, derives from these works. For details of British relations with West Africa generally, see Crowder (1968).

5. Ryder (1977), p. 265. C.M. Macdonald was appointed Commissioner to the Oil Rivers in 1888, and was Commissioner and Consul-General from 1891 to 1895. There is some controversy over the issue of Macdonald's aggression. Crowder (1968), p. 121, for example, suggests that his administration in the region was characterised by non-aggression.

6. Ryder suggests that this was because Macdonald saw the priesthood of the Oba's government as hampering trade and hindering the development of Benin's resources. As he points out, the treaty itself actually makes no mention of human sacrifice.

7. See Street (1975), p. 117; Bolt (1971), p. 118.

8. Ryder (1977), p. 273.

9. *Ibid.*, p. 283.

10. *Ibid.*, p. 288.

11. Henceforth referred to in the Notes as the *ILN*.

12. *ILN* (23 January 1897), p. 123.

13. See Said (1978), p. 40; Linda Nochlin, 'The Imaginary Orient', *Art in America* (May 1983), pp. 119–31, and pp. 187–91.

14. Richard Quick, 'On Bells', *Reliquary*, vol. VI (1900), pp. 226–41.

15. *ILN* (27 February 1897), p. 283; *ILN* (20 February 1897), p. 241. Both of these pages show illustrations of chiefs and their wives who had accepted British sovereignty, and are shown fully clothed. For a development of the concept of the nude in 'High Art' practice, see T.J. Clark, 'Preliminaries to a Possible Treatment of "Olympia" in 1865', in Frascina and Harrison (1982), pp. 259–73.

16. Bolt (1971), pp. 112–13.

17. Letter from Mary Kingsley to Frederick Lugard, 31 December 1897, cited in Birkett (1992), p. 94.

18. Linda Nochlin (see note 13), makes this point regarding the eroticism of Orientalist paintings of the slave market, specifically in relation to the representation of women.

19. T.B. Auchterlonie, 'The City of Benin', *Transactions of the Liverpool Geographical Society*, vol. V1 (1898), pp. 5–16.

20. *Ibid.*, p. 7.

21. *Ibid.*, p. 11.

22. For accounts of the ideological implications of colour in earlier periods, see Winthrop D. Jordan, 'First Impressions: Initial English Confrontations with Africans', and James Walvin, 'Black Caricature: the Roots of Racialism', in Husband (1982), pp. 59–72; Bolt, op.cit., p. 132. For contemporary examples of the ideological function of colour in the racial context, see Errol Lawrence, 'Just Plain Common Sense: the "Roots" of Racism', in eds., Centre for Contemporary Cultural Studies, *The Empire Strikes Back. Race and Racism in Seventies Britain*, London, 1982, pp. 47–94, p. 60.

23. *ILN* (23 January 1897) p. 123.

24. Boisragon (1897). Boisragon's book received wide coverage in the national press. The reviews were uniformly positive. See for example: *Liverpool Courier* (27 October 1897); *Bristol Western Press* (24 September 1897); *Nottingham Guardian* (24 September 1897); *Daily Chronicle* (27 September 1897); *St. James Gazette* (19 November 1897); *Army and Navy Gazette* (6 November 1897); *Leeds Mercury* (14 October 1897).

25. Boisragon (1897), p. 16.

26. *Ibid.*, p. 19.

27. See, for example, J.B. Donne, 'The Celia Barclay Collection of African Art', *Connoisseur* (June 1972), pp. 88–95.

28. The Ashanti in particular had a long history of

successful resistance to British colonisation, beginning in 1824 with the killing, in battle, of Governor Sir Charles MacCarthy. A succession of wars, which included the sacking of Kumasi by the British in 1874, finally resulted in capitulation in 1896.

29. Boisragon (1897), p. 189.

30. *ILN* (27 March 1897), p. 10, supplement.

31. Many of the photographs of the 1892 mission to Benin City, by J.H. Swainson, were exhibited by Pinnock at the Exchange Rooms in Liverpool, in January 1897 prior to the punitive raid.

32. See Bacon (1897), p. 7. Many of these correspond to the photographs taken by J.H. Swainson. See Merseyside County Museum, Liverpool, Swainson Papers, photographs.

33. See Karpinski, 'The Palm Oil Ruffians', unpublished MS, 27 February 1980, p. 8, Liverpool County Museum. The author mentions that Pinnock's exhibition of Swainson's photographs of Benin City, at the Exchange News Room in Liverpool, was reported in the *Liverpool Journal of Commerce* (14 January 1897). See also Merseyside County Museum, Liverpool, Swainson Papers, photographs.

34. Pinnock (1897).

35. Bacon's book was reviewed in *The Times* (19 April 1898), p. 13. For other reviews, see the *Daily Telegraph* (17 November 1897); and *Echo* (13 November 1897).

36. Bacon (1897), p. 7. He makes these claims despite the fact that names of officials on the expedition are consistently misspelled, and dates often confused. For example, H. Gallwey's visit to Benin City is dated 1894 (p. 15); Felix Ling Roth is called Dr. Routh (p. 67). The preface to Boisragon (1897) p. 1, makes a similar statement regarding the 'objective', unsensationalist, tone of his account.

37. Bacon (1897), p. 30.

38. *Ibid.*, p. 57; Boisragon (1897), p. 173; Ryder (1977), p. 279.

39. Boisragon (1897), pp. 186–87.

40. Auchterlonie (1898), p. 8.

41. *Ibid.*, p. 10.

42. Bacon (1897), pp. 91–92.

43. *Ibid.*, p. 92.

44. *Ibid.*, p. 97.

45. H.O. Forbes, 'On a Collection of Cast-Metal Work of High Artistic Value from Benin, Lately Acquired for the Mayer Museum', *Bulletin of the Liverpool Museums*, vol. I (1898), pp. 49–70.

46. *Ibid.*, p. 52.

47. *Ibid.*, p. 68.

48. *Ibid.* The paper illustrates and discusses the same objects that appeared in the coverage of Liverpool acquisitions from Benin in *Nature* (7 July 1898). In addition, it refers to a cast-metal pipe, two plaques from the British Museum, a figure of a woman in coral bead regalia, a brass head-stand, a cast leopard with enamel spots, and a cast statuette of the Oba.

49. Forbes citing Bacon (1898), p. 57.

50. *Nature* (7 July 1898), p. 224.

51. *Ibid.*, p. 225. The writer makes a point of arguing against the use of the term 'bronze', since it is more accurately a copper-lead-zinc compound.

52. *Ibid.*, p. 224.

53. *Ibid.*, p. 225.

54. *Ibid.*, p. 224.

55. Richard Quick, 'Notes on Benin Carvings', *Reliquary*, vol. V (1899), p. 251. This mentions exhibiting the Benin material before the British Archaeological Association on 19 May 1897.

56. *ILN* (10 April 1897), p. 493; *Sydenham Gazette* (17 April 1897); *Examiner*, no date; *Gentleman's Journal* (1 March 1898), pp. 2938–9.

57. *ILN* (10 April 1897), p. 493. The next series of objects from Benin to be illustrated in the *ILN*, in the 7 August 1897 issue, p. 194, were from the collection of a Matthew Hale. Here the photographed display consists of two bronze leopards and a memorial bronze head. In this instance, the commentary consisted of only a caption, and, as with the earlier review, it reiterates both the narrative of Egyptian influence, and the fact that this was evidence of antiquity, since it suggested an origin which pre-dated the Portuguese colonisation of Benin. However, the primary significance of the objects in question is found in the repetition of the phrase 'symbolic objects connected with the hideous sacrificial rites of Benin'.

58. The same carvings and castings from the Horniman Museum which were illustrated in the *ILN* are annotated by Richard Quick in the annual report of that year. (*Annual Report of the Horniman Free Museum for 1897 and for January 1898*, pp. 18–19.) Having reiterated Hilder's claims of virtual uniqueness, the chief feature of Quick's description is his attribution of Egyptian influence, specified as manifest through the position of the carved box (described as a 'mirror frame' by the *ILN* correspondent). Quick sees this as resembling the manner in which Hittites commence their inscriptions, and cites inscriptions on stone tablets in the possession of the British Museum as corroboration. The ornamentation is the clue that apparently links the pieces to some Portuguese contact. The fact that the figures

are carved 'in the round' is a feature that seems again to demand particular acknowledgement. The carving on the other box with sliding cover is similarly likened to Egyptian representation, because of the face's profile view with the eye represented from the front. Apart from the two ivory bracelets described as 'very fine ancient pieces of ivory carving', and the hide fans, 'beautifully made, painted and worked', the other items, in common with the *ILN* report, concentrate on associations with the ritual of human sacrifice.

59. Quick (1899), p. 248.
60. *Ibid.*, p. 249.
61. *Ibid.*
62. *Ibid.*, p. 255.
63. *Nature* (7 July 1898), p. 226.
64. *Ibid.*

Chapter 2

1. Pinnock (1897).
2. *Ibid.*, p. 42.
3. *Ibid.*
4. *Ibid.*, p. 46.
5. *Ibid.*, p. 47.
6. *Ibid.*, p. 48.
7. For a history of the West African press over this period, see Ernest Ikoli, 'The Nigerian Press', *West African Review* (June 1950), p. 626; July (1968); Echeruo (1977). See also Coleman (1965), p. 184, where he cites Ernest Ikoli, 'a newspaper's popularity was often measured by the intensity of its assault on the only target [that is the government] that was available.'
8. *Sierra Leone Weekly News* (26 September 1897), p. 5.
9. *Ibid.* The leading editorial felt compelled to point out that 'as the trade of Lagos with an unappropriated hinterland has increased almost beyond belief, within a comparatively brief period, so would the commercial progress of Sierra Leone have been more marked, had it not lost the Northern rivers, and it would be to its interest if the Government does not drive the aborigines within the Protectorate to French territories, by means of the Protectorate Ordinance, as our hinterland is the only avenue remaining to Sierra Leone to make its way.'
10. Cited in Igbafe (1979), p. 51.
11. *Ibid.* See also Dilke (1956), for a history of trading relations between West Africa and Britain.
12. *The New Age* (6 February 1896), no. 71, vol. III, p. 290.

13. See Martin (1967), p. 23, for some brief information on the early history of the review.
14. *The New Age* (6 February 1896), no. 71, vol. III, p. 290.
15. Coleman (1965), p. 185, cites A.B. Loation, editor of the *Catholic Press*, Lagos, Nigeria, in a typed copy of 'Notes on the History of the Nigerian Press', where he says, 'The *[Lagos Weekly] Record* was so powerful that at one time, on account of its uncompromising attitude in the national interest, all foreign advertisements were withdrawn, but it stood its ground unflinchingly'. Coleman (p. 184) says of John Payne Jackson that 'his pungent criticism, expressed in lengthy editorials, always hung on the edge of sedition.'
16. *Lagos Weekly Record* (20 March 1897), no page numbers.
17. *Lagos Weekly Record* (7 April 1897).
18. G.W. Neville, 'Benin City – The Mysterious', *Staff Magazine of the Bank of British West Africa Ltd.* (1913), pp. 9–12.
19. H.L. Gallwey, 'West Africa Fifty Years Ago', *Journal of the Royal African Society*, no. CLXIII (April 1942), pp. 90–100, cited in Igbafe (1979), p. 62.
20. *Aborigine's Friend* (February 1899), p. 372.
21. Porter (1968), p. 52.
22. July (1968), p. 179.
23. *Anti-Slavery Reporter* (July–August 1899), vol. IX, no. 4, p. 179; (September–October 1889), p. 215; (May–June 1890), p. 94; (March–April 1893), p. 83.
24. Fox Bourne (1900).
25. *The New Age* (11 November 1897), p. 94.
26. *Aborigine's Friend* (May 1897), pp. 169–71.
27. *The New Age* (11 November 1897), p. 94.
28. *Newcastle Leader* (7 October 1897); *Black and White* (6 February 1897); *Liverpool Courier* (15 September 1897). Commander F.G. Dundas and James Pinnock are two prominent figures from the armed forces and trading establishment who maintained that the Oba was the unwilling puppet of powerful chiefs in the region.
29. *The New Age* (9 September 1897), p. 381.
30. *Ibid.*
31. *Ibid.*
32. *Lagos Weekly Record* (31 July 1897). See also Halévy (1939), pp. 68–9, where he discusses the events in Armenia and Crete.
33. *The New Age* (9 September 1897), p. 381.
34. *Ibid.* See also, Alan J. Lee, 'The Radical Press', in Morris (1974), pp. 47–61, where he discusses the importance of the weekly press for Edwardian radicalism, among them *The New Age*, which he argues 'carried exceptional

weight amongst even orthodox Liberals' (p. 54).

35. *Anti-Slavery Reporter* (July and August 1898), p. 182. See also *Aborigine's Friend* (March 1898), p. 349, for a mention of Fletcher's attendance at a meeting of the Association, in January 1898, where he addressed the assembly. See also *Fryer* (1984), p. 280 for more detail on the African Association.

36. The *Aborigine's Friend* (November 1897), p. 297, mentions that it was a 'commendable' rule of the Association that only those of African descent could be a member or have any share in its management. One of its most significant interventions was, of course, the Pan-African Congress, organised in London in July 1900, 'in view of the circumstances and a widespread ignorance which is prevalent in England about the treatment of Native Races under British Rule [and] in order to take steps to influence public opinion on existing proceedings and conditions affecting the welfare of the Natives in various parts of the Empire, viz. South Africa, West Africa and the British West Indies'. See *Anti-Slavery Reporter* (March and May 1899), p. 112.

37. *The New Age* (9 September 1897).

38. *The New Age* (14 October 1897), p. 19.

39. *Lagos Weekly Record* (9 October 1897).

40. *Ibid.* See also the *Sierra Leone Weekly News* (16 October 1897).

41. *Aborigine's Friend* (July 1896), p. 52. See also the *Edinburgh Evening News* (2 July 1897), where Da Rocha describes himself as 'a patriotic though loyal African.' In this context, 'loyal' refers to the British government in Nigeria.

42. *The New Age* (9 September 1897), editorial.

43. *The New Age* (16 September 1897), p. 393.

44. *Ibid.*

45. *Lagos Weekly Record* (6 November 1897); *Sierra Leone Weekly News* (16 October 1897), p. 6.

46. *Lagos Weekly Record* (6 November 1897).

47. *Ibid.*

48. *Ibid.*

49. *Lagos Weekly Record* (17 April 1897).

50. Reindorf, cited in July (1968), p. 257.

51. *Lagos Weekly Record* (6 March 1897).

52. *Ibid.*

53. *Lagos Weekly Record* (20 March 1897).

54. July (1968), p. 350. July also points out here that preference for British administration was seen by Jackson too as one of the only ways to ensure the peace necessary for developing economic and commercial prospects in the country.

55. Richard Beale Blaize was described by the Governor of Lagos, Sir William Macgregor, as one of the wealthiest African merchants in the colony.

56. *Liverpool Courier* (23 September 1897).

57. See Coleman (1965), pp. 82–83. Coleman discusses the importance of West African traders, in the nineteenth century, for the development of trade in the Niger Delta region and the hinterland beyond, and its demise after World War I. Even by the late nineteenth century, however, a variety of measures had been taken by European firms and the British government which were designed to limit the powers of the West African traders. Sometimes, as we have seen with the examples of King Jaja and Nana, these measures took the form of a punitive expedition and resulted in the exile of those West African leaders who refused to toe the line.

58. *Liverpool Courier* (23 September 1897).

59. *Lagos Weekly Record* (23 October 1897).

60. *Ibid.*

61. Blyden (1892), p. 31, cited in July (1968), p. 221.

62. Blyden (1874?), pp. 5–6, cited in July (1968), p. 222.

63. These sentiments are reiterated in Blyden (1888). See also Mudimbe (1988), chapter four. In this chapter, Mudimbe discusses Blyden's thought and writings and some of the contradictions in Blyden's work. The chapter is organised as an analysis of what Mudimbe perceives to be the three main tenets of Blyden's political philosophy, 'the basic organised community under Muslim leadership, the concept of the African nation and, finally, the idea of the unity of the continent.' Both Mudimbe (pp. 105–14) and July (1968), pp. 221–2, discuss at length what they both recognise as the discourse of racial purity in Blyden's work and thinking.

64. See 'The Influence of an Extraneous Culture', *Lagos Weekly Record* (13 March 1897). The author signs as 'a young patriot'; W.E.B. Du Bois, 'The Conservation of Races', *Lagos Weekly Record* (31 July 1897).

65. *The New Age* (9 September 1897).

66. *Ibid.*

67. *Ibid.*

68. Porter (1968).

69. Kingsley (1900), chapter ten, quoted in Porter (1968), p. 50.

70. See July (1968), p. 215, where he discusses Edward Blyden's advocation of polygamy. It is a debate which resurfaces in the period 1890 to 1910 as a central tenet in the defence of the

Africans' right to determine their own social structures in both liberal British discourse and African nationalist discourse.

Chapter 3

1. It should not be assumed that designating material culture from various colonies as 'art', decorative or otherwise, was in any sense an index of progressive thinking. What concerns me here is not whether objects categorised as 'ethnographic' were simultaneously conceived of as 'art', but rather how either of these categories contributed to a conception of African culture and society through their effect on the display, and hence consumption, of material culture from that continent. I am primarily concerned with those discussions produced from within the ethnographic community by people directly responsible for exhibiting material culture to the public via the museum, rather than those treatises on aesthetics produced within the fine arts establishment. There are, however, occasions where the two interlock. See, for example, Henry Balfour, 'Evolution in Decorative Art', *Journal of the Society of Arts*, vol. XLII (27 April 1894), pp. 455–71; Carl Lumholtz, 'Conventionalism in Primitive Design', *Journal of the Society of Arts*, vol. LI (21 August 1903), pp. 785–97; Sir George Birdwood, 'Conventionalism in Primitive Art', *Journal of the Society of Arts*, vol. LI (9 October 1903), pp. 881–9. The first two articles were treated by the Society members as contributions from anthropologists, while the latter was treated as art history. The *Studio*, vol. 8 (July 1896), carried a review of A.C. Haddon's book, *Evolution in Art*, 1895.

2. H.O. Forbes, 'On a Collection of Cast-Metal Work of High Artistic Value from Benin, Lately Acquired for the Mayer Museum', *Bulletin of the Liverpool Museum*, vol. 1 (1898), pp. 49–70; H. Ling Roth, 'Notes on Benin Art', *Reliquary*, vol. V (1898), pp. 161–73. See also H. Ling Roth's articles in the *Halifax Naturalist* (June 1898); 'Primitive Art from Benin', the *Studio* (December 1898), pp. 174–83. H. Ling Roth was the curator of the Bankfield Museum in Halifax at the time of writing these articles.

3. Forbes, *ibid.*, p. 3.

4. H. Ling Roth, 'Notes on Benin Art', *Reliquary*, vol. V (1898), p. 167.

5. *Ibid.*, p. 162.

6. *Ibid.*, p. 170.

7. *Ibid.*, p. 171.

8. Pitt Rivers Museum, Oxford, E.B. Tylor Papers, Box 6 (1) and (2), Pitt Rivers to E.B. Tylor, 7 August 1898.

9. Pitt Rivers (1900), p. IV; H. Ling Roth, 'Notes on Benin Art', *Reliquary*, vol. V (1898), p. 172. Ling Roth suggests here that the technique possibly came from ancient Egypt via trade routes. See also Ling Roth (1903).

10. Pitt Rivers, *ibid.*

11. C.H. Read and O.M. Dalton, 'Works of Art from Benin City', *Journal of the Anthropological Institute*, vol. XXVII (1898), pp. 362–82; Read (1899).

12. Read and Dalton, *ibid.*, p. 366.

13. Ben Amos (1980), p. 25, describes this as the head of the queen mother. See also William Fagg, 'The Allman Collection of Benin Antiquities', *Man*, vol. 53–54 (1953), pp. 164–9. This is a comparison of two such heads, one in the British Museum and one in the Allman collection.

14. Read (1899), p. 9.

15. C.H. Read and O.M. Dalton, 'Works of Art from Benin City', *Journal of the Anthropological Institute*, vol. XXVII (1898), p. 371.

16. *Ibid.*, p. 372.

17. Haddon (1895); Balfour (1893).

18. Haddon (1894), pp. 252–3. Dr Hjalmar Stolpe shared similar views to Balfour and Haddon on the importance of ornament as the basis of all art. The other protagonists of the degeneration thesis in Britain, Dr Colley March and Charles Hercules Read of the British Museum, contributed to the thesis through their conception of art as originating in symbolic representations of religious or magical practices. Stolpe is particularly important to the debate on the origins of art due to his early recognition that a unilinear evolution could not provide the origin of all decoration, but that there was in all probability a plurality of origins. See Gerbrands (1957), p. 42. See also H. Colley March, 'The Meaning of Ornament; or its Archaeology and Psychology', *Transactions of the Lancashire and Cheshire Antiquarian Society*, vol. 7, pp. 160–92; C.H. Read, 'On the Origin and Sacred Character of Certain Ornaments of the South East Pacific', *Journal of the Anthropological Institute*, vol. XXI, pp. 139–59; K.H. Stolpe, 'On Evolution in the Ornamental Art of Savage Peoples', *Transactions of the Rochdale Literary and Scientific Society*, vol. 3 (1892). Although originally published in Swedish, Stolpe's work was translated by Mrs Colley March and published in 1892, later reprinted in *Collected Essays on Ornamental Art* (1927).

19. Semper (1878–9); W.H. Holmes, 'Use of

Textiles in Pottery Making and Embellishment', *American Anthropologist*, vol. 3 (1901), pp. 397–403; 'Aboriginal Pottery of the Eastern United States', *Annual Report Bureau of American Ethnography*, vol. 20 (1903), pp. 1–237. Holmes' work on ornament has since been interpreted as providing the empirical data to support Semper's argument. Holmes used casts taken of impressions of lines on some examples of Native American pottery. He attributed these lines to the imprint of textiles and nets made on the damp clay in the early stages of manufacture. Holmes thus 'proved' that the decoration left by the impression of the nets was caused through their use as part of the construction process in the first instance and was later adopted consciously as a decorative motif. His work was well-known to both Haddon and Balfour. See Balfour (1893), which includes a lengthy list of Holmes' publications in the Appendix on useful books for further research into the subject of decorative art. See also Gerbrands (1957), p. 31, where he discusses Semper and Holmes; Steadman (1979), especially chapter seven where he discusses the genesis of the degeneration thesis and its relation to Semper's work.

20. Gerbrands, *ibid.*, p. 29.
21. See the anonymous review of Haddon's *Evolution in Art* (1895), in *Reliquary*, vol. II (1896), p. 127. The reviewer criticises Haddon's analysis on the grounds that it does not acknowledge the geometric origin of ornament. It is a criticism which provides some idea of the longevity and continued currency of Semper's thesis.
22. For a later formulation of a similar thesis see Worringer (1907). This later formulation is, of course, far better known because of Worringer's acknowledged influence on the avant-garde in Britain and France in the first decade of the twentieth century.
23. As we have already seen, the principle of criteria of form was applied with two objects in mind: to prove culture contacts by the aid of resemblances in style and to demonstrate diffusion of cultural elements.
24. Steadman (1979), p. 94.
25. *Ibid.*
26. Balfour (1894), p. 456.
27. Balfour (1893), p. 77.
28. *Ibid.*
29. Balfour (1894), p. 457.
30. Balfour (1893), plates I and II.
31. Balfour (1894), p. 462, fig. 8.
32. See Steadman (1979), p. 106.
33. Although in his book Balfour makes no specific mention of African material culture, it is clear from the West African examples which he supplies to illustrate his lecture to the Royal Society that the implications of his thesis are applicable here also.
34. See note 29.
35. Both Gerbrands (1957), p. 53, and Goldwater (1986), p. 29, suggest that few ethnographers or anthropologists were interested in three dimensional work or reproduced it in contemporary ethnographies over this period. The high proportion of material from the Congo in most British collections would seem to be an anomaly, which might partly be explained by this interest in 'decorative art' among anthropologists who were also curators. See also Mack (1990), for more information on the British Museum's acquisition of material from Zaire.
36. Hudson and Luckhurst (1954), p. 151.
37. Sir George Birdwood, 'Conventionalism in Primitive Art', *Journal of the Society of Arts*, vol. LI (9 October 1903), p. 881. An acknowledged 'authority' on Indian art by this date, see Birdwood (1878); 2 vols. (1880); (1898); (1909).
38. Birdwood (1903), p. 881.
39. It is significant, in respect of the criticisms levelled against anthropological theses on the 'origins of art', that A.C. Haddon was initially a zoologist and associated with this branch of science.
40. Hudson and Luckhurst (1954), p. 348.
41. Birdwood (1903), p. 882.
42. *Ibid.*, p. 883.
43. Birdwood (1903), p. 468, responding to Balfour's paper 'Evolution in Decorative Art'.
44. A.C. Haddon (1894), p. 1.
45. *Ibid.*, p. 251. See also C.H. Read, 'Presidential Address to the Anthropological Institute', *Journal of the Anthropological Institute*, vol. XXX (1900), p. 17. He too speaks of the relationship of anthropology to studies on art and stresses the virtues of anthropological as opposed to art historical studies of culture. Read suggests that anthropological researches over the last twenty years have proven that in all centres the urge to make art develops as a need for beauty, and that this is as applicable to the Bronze Age as it is to the Renaissance. He further suggests that there must be a continuous chain linking all art. To the extent that all art was therefore supposedly reducable to the same criteria in order to establish its origin, this might well be seen, in retrospect, as a progressive premise, except for the dominance of the evolutionary basis.
46. Haddon (1894), p. 5.
47. *Ibid.*

48. Birdwood (1903), p. 884.
49. *Ibid.*, p. 883. In this respect Birdwood is in agreement with Balfour, who also singles out Inuit work. See Balfour (1893), p. 5.
50. See the Presidential Address, *Journal of the Anthropological Institute* (January 1900).
51. See, for example, 'The Two Paths; Deteriorative Power of Conventional Art Over Nations', in eds., Cook and Wedderburn, vol. XVI, pp. 245–425. My thanks to Will Vaughan for drawing my attention to earlier debates on degeneracy in art. See W. Vaughan, 'The Englishness of British Art', *The Oxford Art Journal*, vol. 13, 2 (1990), pp. 11–23, where Vaughan discusses Ruskin's thesis in relation to the concept of a true English art.
52. See Sheehy (1980); Dean (1988) on the ressurgence of Irish cultural nationalism over this period.
53. Tylor (1958), 1st ed. 1871, p. 16., cited in Harris (1969), p. 164. See also Burrow (1966), pp. 240–1. Sir James Frazer, Herbert Spencer and J.F. McLennan were other contemporary exponents of this concept.
54. Balfour (1893), p. 14.
55. *Ibid.*, p. 15.
56. A.C. Haddon (1894), p. 252.
57. Read and Dalton (1898).
58. Booth (1892–1903); Rowntree (1901), were two of the better known sociological surveys carried out over this period.
59. See Searle (1976); ed. Webster (1981); Mort (1987); Weeks (1981); A. Davin, 'Imperialism and Motherhood', *History Workshop Journal*, 5 (1978).
60. Read and Dalton (1898).
61. Despite Pitt Rivers' complaint to the contrary, this represents an early attempt at some sort of methodical collation of information from an indigenous source, regarding the origin of the material in the British Museum's possession. See Pitt Rivers (1900), p. IV, where he attacks the British government for not taking sufficient steps to make sure that important data was collated systematically at the time of the punitive expedition.
62. For a general history of the British Museum which sets out some of the history of the development of the ethnographic department, see Caygill (1981); Miller (1974); Braunholtz (1970); Annie E. Coombes, 'Blinded by Science: Ethnography at the British Museum', in ed. Pointon (1994).
63. Miller, *ibid.*, p. 306.
64. See Bernal (1987), especially pp. 225–69, where he discusses the rise in popular interest in Egypt and Egyptology in Europe in the nine-

teenth and early twentieth centuries. See also Schwab (1950).
65. See Curl (1982).
66. Read (1899).
67. C.H. Read, 'Presidential Address to the Anthropologial Institute', 1901.
68. Flinders Petrie, 'Primitive Art in Egypt,' *Journal of the Society of Arts* (26 May 1893).
69. Flinders Petrie (1895).
70. *Ibid.*, p. 5.
71. *Ibid.*, p. 6.
72. Bernal (1987).
73. Flinders Petrie (1895), p. 121.
74. *Ibid.*
75. See, for example, *Birmingham Daily Gazette* (27 September 1897); *The Times* (25 September 1897); *Manchester Courier* (25 September 1897); *Leeds Mercury* (25 September 1897).
76. British Museum, Book of Presents, D 13/98 (20 January 1898) states that there were only 304 plaques in all after the inventory was taken.
77. Read and Dalton (1898), p. 327.
78. O.M. Dalton, *Report on Ethnographic Museums in Germany*, Department of British and Medieval Antiquities (14 June 1898).
79. *Ibid.*, p. 8.
80. *Ibid.*, p. 5.
81. *Ibid.*, p. 7
82. See also British Museum, Book of Presents, D 13/98 (8 December 1897). C.H. Read fights to maintain what he calls a 'representative' selection of plaques which amounts to two thirds of the existing number; D 13/98 (12 January 1898), Lord Salisbury, Secretary of State for Foreign Affairs, allows two hundred to remain in the possession of the British Museum. See also *Birmingham Daily Post* (13 September 1897), which writes that 'Their ultimate destination is at present unknown, but it is said to be not unprobable that they will be sold by public auction, which would hardly be a popular disposal of this interesting loot'.
83. After 1906, a series of popular anthropological texts were published which all contained prefaces railing against the British government's indifference by comparison to the German government's expansive support and recognition for German anthropologists. A case in point is Werner (1906). The preface by Northcote W. Thomas reiterates these grievances. Northcote Thomas became one of the first anthropologists formally appointed to a government post in the colonies in 1908, in what was then Southern Nigeria.
84. Ling Roth (1903), pp. XVII–XIX, and Appendix IV. See also Pitt Rivers (1900), p. IV. This recalls Pitt Rivers' earlier remarks on the

British governments's lack of appreciation of the necessity of studying colonised peoples in order to preserve records of their way of life before they are destroyed.

85. In 1866, the British, Medieval and Ethnographic collections had been transferred from the Department of Oriental Antiquities to form the Department of British and Medieval Antiquities, which included the ethnographic collections. The Department of Ceramics and Ethnography was formed in 1921 out of the ethnographic and ceramic material which existed in the British and Medieval Antiquities Department. See also *A Guide to the Exhibition Galleries at the British Museum* (1899), pp. 98–101.

86. *Nottingham Guardian* (21 September 1897).

87. *Parliamentary Papers*, vol. LXXI (1899), Accounts and Papers, p. 289.

88. *Ibid.*, p. 611.

Chapter 4

1. Hobson (1968), p. 215, (1st ed. 1902). It should be pointed out, however, that while the economist Hobson may have had far-sighted criticisms of the ways in which the British implemented imperial rule, he was frequently unequivocal in his praise for what he saw as the benefits which could accrue for the colonised subject, under colonial expansion given a benevolent administration.

2. *Journal of the Society of Arts*, vol. LV (21 June 1907), p. 803.

3. Said (1978), was one of the first to develop such a thesis. For histories of exhibitions, see Allwood (1977); Altick (1978); Luckhurst (1951); Plum (1977); Greenhalgh (1988); Burton, Benedict et al. (1983); Rydell (1984); Schneider (1982), chapter six; Leprun (1986). Most of these, however, treat only the International Expositions. Notable exceptions which do treat other types of exposition are; MacKenzie (1984), chapter four; Ben Shephard, 'Showbiz Imperialism: The Case of the Peter Lobengula', in ed. MacKenzie (1986), pp. 94–112. The main exhibition sites in London throughout the period 1840 to 1913 are Crystal Palace, Earl's Court, Olympia and the White City.

4. *Universal Exhibition Guide and Industrial Review*, vol. I, no. 1 (20 June 1890), cover.

5. *Ibid.*, pp. 4–5.

6. *Ibid.*, p. 5.

7. *Ibid.*, p. 5, the logic being that 'By making nations interdependent for the supplying of their wants, it makes them less willing to allow a breach of the peace to occur'. Lowe (1892), p. 24, cites Mr John Robinson Whitely (organiser of four early national exhibitions: the American Exhibition of 1887, the Italian Exhibition of 1888, the French Exhibition of 1890 and the German Exhibition of 1891), 'the oftener we bring artists, manufacturers and merchants of one country into close and intimate contact with buyers via other countries, the sooner shall we reduce aimless fighting and friction to a minimum . . . Bringing men from one country to work with men of another does more for peace than writing dozens of books about the horrors of war.'

8. *Ibid.*, p. 5.

9. See Rydell (1984) and Schneider (1982), for details regarding funding of larger national expositions and World's Fairs in America and France respectively. There were frequent complaints from exhibition organisers in Britain throughout the period under discussion, about the scarcity of available funds and the lack of government support. See for example; *Journal of Society of Arts*, vol. LV (21 June 1907), p. 803; *The Times* (10 January 1899), p. 4; Hartley (n.d.), p. 83. Lowe (MDCCCXCII), p. 22.

10. *Journal of Society of Arts*, vol. LV (21 June 1907), pp. 102–3. Those exhibitions properly designated as 'International' between these dates were held in: Glasgow (1901), Cork (1902), Wolverhampton (1902), Bradford (1904). See also *Journal of Society of Arts*, vol. LV (8 November 1907), pp. 1140–6, for a list of International Exhibitions 1851–1907.

11. Whitely, cited in Lowe (1892), p. 25; Hartley, p. 106.

12. For one of the most insightful earlier analyses of international and colonial exhibitions in this respect, see Deborah L. Silverman, 'The 1889 Exposition: The Crisis of Bourgeois Individualism', *Oppositions*, no. 8 (Spring 1977), pp. 71–91. For a more general later analysis, see Tony Bennett, 'The Exhibitionary Complex', *New Formations*, no. 4 (Spring 1988), pp. 73–102.

13. For an analysis of one such minstrel show in London see J.P. Green, 'In Dahomey in London in 1903', *Black Perspectives in Music*, XI/1 (Spring 1983), pp. 23–40; Fryer (1984), pp. 443–4. See also P. Summerfield, 'Patriotism and Empire: Music-Hall Entertainment, 1870 to 1914', in ed. MacKenzie (1986), pp. 17–48.

14. *The Times* (23 January 1890), p. 6; (20 February 1890), p. 5; (22 February 1890), p. 15; (27

February 1890), p. 5; (12 March 1890), p. 10; (21 March 1890), p. 14; (24 March 1890), p. 4; (10 May 1890), p. 13.

15. *The Times* (21 March 1890), p. 14.

16. *The Times*, (22 February 1890), p. 15, carried a complete list of the executive committee of the exhibition.

17. *ILN* (29 March 1890), p. 391.

18. By this date Horniman had already opened his own home and his private collection to the public.

19. It is important to recognise that the anti-slavery lobby was not unequivocal in its support of Stanley. The Aborigine Protection Society was much quicker to condemn Stanley, partly because it maintained a critical position in relation to trading and commercial ventures carried out in the name of British imperialism. The Anti-Slavery Society, on the other hand, was always a staunch supporter of commercial enterprise in the colonies in the 1890s.

20. *Anti-Slavery Reporter* (January to February 1889), p. 2.

21. *Anti-Slavery Reporter* (March to April 1890), p. 42.

22. *Anti-Slavery Reporter* (March to April 1889), p. 83.

23. *Anti-Slavery Reporter* (September to October 1889), p. 269.

24. *The Times* (21 March 1890), p. 14.

25. *The Stanley and African Catalogue of Exhibits* (1890), p. 9.

26. *The Times* (21 March 1890), p. 14.

27. See Pratt (1992), especially chapters three and four.

28. *The Times* (21 March 1890), p. 14.

29. *The Stanley and African Catalogue of Exhibits* (1890), p. 10.

30. *The Times* (22 February 1890), p. 15.

31. *The Stanley and African Catalogue of Exhibits* (1890), p. 9.

32. *The Times* (21 March 1890), p. 14.

33. The catalogue of exhibits itself is notable for the absence of such qualifying statements regarding the objects on display.

34. See *The Times* (27 February 1890), p. 5. This attributes the 'finest' and 'most representative' collection of spears to Sir Henry Peek. Mr Cuthbert E. Peek and Mr Joseph Thompson supervised the collecting and organising of these exhibits. *The Times* contains a list of lenders.

35. Royal Geographical Society, London, William Steains papers, W. Steains to Mr Bates (23 October 1890). Steains says that he will return to his post in the Drawing Office of the Royal Geographical Society after he has finished his 'task' at the Stanley and African Exhibition. See also *The Stanley and African Catalogue of Exhibits* (1890), insert. This refers to an offer of a limited edition of colour drawings of the exhibits.

36. British Museum, Museum of Mankind, London, Africa A-N [STE], vols. 1 & 11.

37. Royal Geographical Society, London, HMS 7/1, Ten Views of the Principal Exhibits.

38. *The Stanley and African Catalogue of Exhibits* (1890), p. 28, p. 35.

39. See chapter seven.

40. *The Times* (13 August, 1889), *Anti-Slavery Reporter* (July to August 1889), p. 179.

41. *Universal Exhibition and Industrial Review*, vol. 1, no. 1 (20 June 1890), p. 27.

42. *ILN* (29 March 1890), p. 391.

43. *The Times* (21 March 1890), p. 14.

44. *The Times* (24 March 1890), p. 4.

45. *Ibid.* See also *The Stanley and African Catalogue of Exhibits* (1890), p. 48. This makes a particular point of emphasising the fact that the artist responsible for the scene, a Leolyn Hart, produced the work on the basis of 'eyewitness' accounts by Lieutenant Stairs, Captain Nelson and Mr Joseph Thompson. Such accounts legitimised these scenes as authentic representations.

46. *Anti-Slavery Reporter* (September to October 1889), p. 218.

47. *Ibid.*

48. This thesis is developed in relation to French nineteenth century 'orientalist' paintings, in L. Nochlin, 'The Imaginary Orient' *Art in America* (May 1983), pp. 119–31 and 186–91.

49. Royal Geographical Society, London, HMS 7/1, Pamphlet, The History of the Two Boys, (1890).

50. *The Stanley and African Catalogue of Exhibits* (1890), p. 39.

51. *Ibid.*, p. 58. Entries 113 and 114 confirm this interpretation, where the evolutionary paradigm is made explicit:

 113. Photograph of skeletons of Akka woman, man and gorilla, presented by Dr Emin Pasha to the British Museum. Photographed by Gambier Bolton. F.Z.S.

 114. Emin Pasha's original manuscript (written at Wadelai) of the description and dimensions of a living Akka woman, published in Professor Flower's memoir on the osteology of the Akkas, *Journal of the Anthropological Institute*, vol. XVIII, exhibited by Professor Flower, C.B., F.R.S.

 The Akkas were a pygmy people 'discovered' by Stanley in the forests of Central Africa on the sources of the Welle or Ubangi and the

forests of Aruwimi.

52. *The Stanley and African Catalogue of Exhibits* (1890), p. 15.
53. *The Times* (27 February 1890), p. 5.
54. *The Stanley and African Catalogue of Exhibits* (1890), p. 10; pp. 48–51.
55. *Ibid.*, p. 1.
56. Tim Youngs, 'The Inscription of Self and Culture in British Narratives of Travel and Exploration in Africa 1850–1900', unpublished Ph.D. (1991), deals in detail with this controversy and the narrative accounts which were produced at the time.
57. *Aborigine's Friend* (December 1990), p. 90.
58. *Aborigine's Friend* (May 1990), p. 89. See also Felix Driver, 'Henry Morgan Stanley and His Critics: Geography, Exploration and Empire', *Past and Present*, no. 133 (November 1991), pp. 134–66.
59. *Anti-Slavery Reporter* (May to June 1890), p. 96.
60. *Anti-Slavery Reporter* (May to June 1890), p. 95.
61. *Anti-Slavery Reporter* (July to August 1891), p. 151.

Chapter 5

1. Most of the exhibitions covered in this chapter were the larger ones held in London over the period. Many of these travelled to other towns and cities in a condensed version. They have been selected because of their incorporation of an African component, but also partly on the basis of availability. Much of the material connected with these events is classified as 'ephemera' and has consequently often been misplaced or discarded. That the selection is representative, though, is supported by existing contemporary lists of exhibitions. See, for example, *Journal of the Society of Arts*, vol. LV (21 June 1907), pp. 802–5, for a list of some exhibitions held in Britain between 1890 and 1907. However, this is very incomplete.
2. MacKenzie (1984), p. 115.
3. Fryer (1984); Ziggy Alexander, 'Black Entertainers', in eds. Beckett and Cherry (1987), pp. 44–7; Jeffrey Green, 'In Dahomey in London in 1903', *Black Perspectives in Music*, XI/I (Spring 1983), pp. 23–40; Bernth Lindfors, 'Circus Africans', *Journal of American Culture*, vol. VI, no. 2 (1983) pp. 9–14.
4. *French Exhibition*, Earl's Court. Daily Programme (7 October 1890). 'The Wild East or Life in the Desert'.
5. *Ibid.*

6. *The Ashanti Village*, Crystal Palace. Official Guidebook (no date), p. 3.
7. *Briton, Boer and Black in Savage South Africa*, Olympia. Libretto and Programme Combined (1899–1900), p. 48.
8. *Ibid.*, p. 53.
9. *Ibid.*, p. 56.
10. *Ibid.*
11. *Military Exhibition*, Earl's Court. Official Guide, (1901), p. 83. The section comprised relics and souvenirs collected by reporters from Paardeberg, Ladysmith, Mafeking and Kimberley in South Africa, and consequently were extremely emotive exhibits.
12. *Barnum and Bailey's Great Show*, Olympia. District Railway Guide (1897–8), p. 31. The drama entitled 'The Mahdi or For the Victoria Cross: A Realistic Reproduction of Life in the Soudan', was written by the war correspondent of the Daily Telegraph.
13. See Street (1975).
14. *Universal Exhibition and Industrial Review*, no. 1 (20 June 1890), p. 20.
15. *Briton, Boer and Black in Savage South Africa* (1899–1900), p. 42.
16. This practice was not new. See Sander L. Gilman, 'Black Bodies, White Bodies: Toward an Iconography of Female Sexuality in Late Nineteenth Century Art, Medicine and Literature', *Critical Inquiry* (Autumn 1985), pp. 204–42. This documents the 1810 exhibition in London of Saartjie Baartman, known as the 'Hottentot Venus'. She was exhibited for five years in various European cities, primarily to show her steatopygia (protuding buttocks), a feature of interest to both the 'scientific' community and the general public. See also Bernth Lindfors, 'Circus Africans', *Journal of American Culture*, vol. VI, no. 2 (1983), pp. 9–14. *The Wonder Book of Freaks and Animals in the Barnum and Bailey Greatest Show on Earth* (1898), p. 1, says:

 'The collection of rare animals and the family of curious human beings both have a great value for the student who desires to know the origin and nature of things animate.'

 See also *Barnum and Bailey's Great Show* (1897–8), p. 13, which describes the show as having an 'unequalled museum of living human curiosities.'
17. *Barnum and Bailey's Great Show* (1897–8), p. 31.
18. *Ibid.*, p. 32.
19. *Ibid.*, p. 36.
20. *Naval and Military Exhibition*. Official Programme (1901).

21. *The Ashanti Village* (no date) pp. 12–15.
22. *Briton, Boer and Black in Savage South Africa* (1899–1900), p. 31.
23. *Journal of the Anthropological Institute*, vol. XXX (1900), p. 6.
24. *Briton, Boer and Black in Savage South Africa* (1899–1900), p. 44, emphasises the 'serious' side of the exhibition with the comment: 'As can easily be imagined the kraal affords many opportunities for interesting study and observation.'
25. Henry Morgan Stanley, cited in *ibid.*, p. 49.
26. *Briton, Boer and Black in Savage South Africa* (1899–1900), p. 42; *The Ashanti Village* (no date), p. 4.
27. *Woman's Exhibition*, Earl's Court. Daily Programme (2 June 1900), back cover.
28. Read (1910), p. vi.
29. *Briton, Boer and Black in Savage South Africa* (1899–1900), p. 48. The show moved to Olympia in 1899, where it continued until 27 January 1900.
30. *Ibid.*
31. *The Times* (28 April 1899), p. 6.
32. *The Times* (8 May 1899), p. 9.
33. *Aborigines' Friend* (June 1899), pp. 438–9, cited in Ben Shephard (1984), p. 110.
34. *Aborigine's Friend* (June 1899), p. 436.
35. *Ibid.*, p. 437.
36. *Ibid.*, p. 438–9.
37. Unfortunately most of the histories of international and colonial exhibitions, with a few notable exceptions, suffer from this tendency.
38. *Aborigine's Friend* (April 1900), p. 526.
39. See Ben Shephard (1984), for a review of the notices concerning the franchise in the *Graphic* (13 May 1899); *Daily Graphic* (9 May 1899); *The Times* (9 May 1899); *Reynold's News* (14 May 1899); *Rhodesia* (20 May 1899); *Illustrated Sporting and Dramatic Times* (13 May 1899); *Black and White* (13 May 1899); *Sketch* (3 May 1899).
40. *Ibid.*
41. *Ibid.*, p. 101.
42. *Greater Britain Exhibition*, Earl's Court. District Railway Illustrated Guide (1899), p. 15.
43. *The Times* (29 August 1899), p. 7.
44. *Ibid.*
45. *Greater Britain Exhibition* (1899), p. 29. See also *Barnum and Bailey's Great Show* (1897–8), p. 34.
46. See Street (1975), p. 100. He refers here to such devices in the plots of many colonial novels of the period.
47. *Ibid.*
48. *Ibid.*
49. *Briton, Boer and Black in Savage South Africa* (1899–1900), p. 48.
50. 'Matabele' Thompson, Rhode's former emissary to King Lobengula, quoted in Shephard (1984), p. 97.
51. *Daily Mail* reporter Lucius Pearce, quoted in Shephard (1984), p. 102.
52. *Ibid.*
53. See Anna Davin, 'Imperialism and Motherhood', *History Workshop Journal*, no. 5 (Spring 1978), pp. 9–65, for an analysis of the development of the ideology of motherhood and its relationship to the rise of eugenics between 1890 and 1910. For discussions on sexual morality and racial purity, see also Lucy Bland, 'Cleansing The Portals of Life': The Venereal Disease Campaign in the Early Twentieth Century', in eds. Langan and Schwarz (1985), pp. 192–208 and Frank Mort, 'Purity, Feminism and the State: Sexuality and Moral Politics 1880–1914', in *ibid.*, pp. 209–25.
54. Davin (1978).
55. *French Exhibition* (1890). See also Street (1975), pp. 101–5 where he discusses the concept of 'hybrid' races and racial purity in relation to the colonised subject and how this was used in the colonial novel. The examples he gives are from Rider Haggard, *Allan Quatermain* (1887), and Joseph Conrad, *Heart of Darkness* (1896).
56. *French Exhibition* (1890), Hartley (no date), p. 104. In his descriptions of the preparations for the Greater Britain Exhibition at Earl's Court in 1899, Hartley is at pains to emphasise the lack of contact experienced between the Zulus and Europeans prior to the exhibition. *Briton, Boer and Black in Savage South Africa* (1899–1900), p. 42 tells a different story.
57. *French Exhibition* (1890).
58. *Ibid.* See also *International Fire Exhibition*, Earl's Court. Official Guide (1903), p. 43. By 1903, the Arabs who populated the 'Assouan Village' in the International Fire Exhibition were billed as 'orientals', and came over to England under the aegis of the Egyptian government.
59. *Briton, Boer and Black in Savage South Africa* (1899–1900), p. 42.
60. *Ibid.*, p. 43.
61. *Ibid.*, p. 42.
62. *Ibid.*, p. 44.
63. *Ibid.*, p. 33.
64. *Ibid.*, p. 48. Reverend Johnson is quoted as saying: 'I truly believe that, if we could only take real advantage of it, there is a splendid opportunity for evangelising these natives while they are in England.'
65. *Ibid.*, p. 35.

66. See also *Greater Britain Exhibition* (1899), p. 21. The 'Kaffirs' (*sic*.) are noted for 'The splendid physique of the men, their bronzed polished skin.' *French Exhibition* (1890), describes the Arabs as 'bronzed, wiry and upright' and the four negro warriors as 'black as jet'.
67. *Ibid.*, p. 51.
68. *International Fire Exhibition* (1903), p. 43.
69. *Barnum and Bailey's Great Show* (1897–8), p. 33.
70. *City of Bradford International Exhibition.* Official Catalogue (1904), p. 49.
71. *The Ashanti Village* (no date), p. 5.
72. See chapters six and seven.
73. *Barnum and Bailey's Great Show* (1897–8), p. 33.
74. *Briton, Boer and Black in Savage South Africa* (1899–1900), p. 41.
75. *Ibid.*, p. 42.
76. *Ibid.*, p. 52.
77. *Ashanti Village* (no date), p. 1.
78. *City of Bradford International Exhibition* (1904), p. 49.
79. *Briton, Boer and Black in Savage South Africa* (1899–1900), p. 18; *Briton, Boer and Black in Savage South Africa*, (1899), p. 20.
80. *French Exhibition* (1890).
81. *The Ashanti Village* (no date), p. 12.
82. *Ibid.*, p. 5.
83. *Briton, Boer and Black in Savage South Africa* (1899–1900), p. 35.
84. *Ibid.*
85. *Ashanti Village* (no date), p. 14; *Briton, Boer and Black in Savage South Africa* (1899–1900), p. 41.
86. *Military Exhibition* (1901), p. 64.
87. For a history of the women's suffrage movement by this date, see Rowbotham (1973), chapters 15 and 16.
88. Hartley (no date), p. 107.
89. *Woman's Exhibition* (1900), pp. 5–6.
90. Those listed as participants were as follows: 'Canadian women, The Irish Colleens, English Types of Womanhood, The Bonnie Scotch Lassies, Pretty Piquant Yankees, Flemish Ladies, The Dutch Women, The Danish Ladies, Women of Sweden, Handsome Norwegians, The Muscovite Women, The Vivacious Austrians, Life in the Bavarian Alps, Romantic Switzerland, Life in France, The Daughters of Sunny Italy, The Castilian Women, Magyar Maidens, Egyptian Women, Women of India, Doll-like Japanese, Women of the Flowery Kingdom, South American Creoles, The Gallant Little Principality.'
91. *Woman's Exhibition* (1900), p. 4 and p. 11.
92. Hartley (no date), p. 109.
93. *Ibid.*
94. *Woman's Exhibition* (1900), p. 11.
95. Hartley (no date), p. 109.
96. *Ibid.*
97. *French Exhibition* (1890).
98. *Briton, Boer and Black in Savage South Africa* (1899–1900), p. 12.
99. *Greater Britain Exhibition* (1899), p. 43.
100. *Ibid.*, p. 15.
101. *Ibid.*
102. *Ibid.*, p. 21.
103. *The Yorkshire Post* (31 August 1904).
104. Hartley (no date), p. 104.
105. *Ibid.*, p. 105.
106. *Bradford Observer* (1 November 1904), p. 7.
107. One noteworthy exception was Kiralfy's 'China or The Relief of the Legations', in the Military Exhibition of 1901. Notwithstanding this feature, however, there were no less than five other spectacles devoted to the Boer War.
108. *International Horticultural Exhibition*, Earl's Court. Daily Programme (9 September 1892), p. 15.
109. *Briton, Boer and Black in Savage South Africa* (1899–1900), p. 29.
110. *Briton, Boer and Black in Savage South Africa* (1899–1900), p. 29.
111. Street (1975), p. 123.
112. See, for example, the coverage of the Matabele War in the *ILN* (6 January 1894), p. 4; (13 January 1894), p. 35; (24 February 1894), p. 224; (10 March 1894), p. 299; (13 March 1894), p. 332.
113. *Military Exhibition* (1901), p. 51.
114. See also the *ILN* (9 June 1894), p. 707, which reports on the Royal Military Tournament where events in the Sudan were the subject of another dramatic re-enactment. Here an attack on a Sudanese town was staged in the arena at Earl's Court. A full-scale model was used to demonstrate the superiority of the British military manoeuvres.
115. *City of Bradford International Exhibition* (1904), p. 49.
116. Merriman Labor (1909). Fryer (1984), gives further examples. See also Ware (1992).
117. See, for example, Mukasa (1975). This was first published as *Uganda's Katikiro in England* (1904). It concerns the visit of the Prime Minister of Uganda to Britain, in 1902, as an invited guest to the coronation of King Edward VII. Ham Mukesa was Sir Apolo Kagwa's secretary and kept the diary upon which the book is based. I am grateful to Dea Birkett for drawing this book to my attention.
118. Terence Ranger, 'The Invention of Tradition in Colonial Africa', in eds. Hobsbawm and

Ranger (1983), pp. 211–62, remains an important early contribution to the complex history of appropriation and transculturation in colonial Africa. I am also indebted to Karin Barber for drawing my attention to the work of Agneta Pallinder, 'Adegboyega Edun: Black Englishman and Yoruba Cultural Patriot', in eds. de Moraes Farias and Barber (1990), pp. 11–34. Here Pallinder recounts the case of Adegboyega Edun, the government secretary to the Alake of Abeokuta in what is now Nigeria. Under his mission name of Jacob Samuel, Adegboyega Edun studiously presented himself while in West Africa in the European garb associated with the educated elite. However, in 1904, on a state visit with the Alake to Britain, he re-fashioned himself in the image of an African nationalist dignitary wearing the full robes, hat and embroidered slippers associated with a highranking Egba.

119. Eds. de Moraes Farias and Barber (1990).

Chapter 6

1. Stephen Feuchtwang, 'The Colonial Formation of British Social Anthropology', in ed. Asad (1973), pp. 71–100; Street (1975).

2. Stephen Feuchtwang, *ibid.*; Kuper (1973); Penniman (1965); George W. Stocking Jr., 'What's in a Name? The Origins of the Royal Anthropological Institute (1837–71)', *Man*, vol. 6, no. 3 (September 1971), pp. 369–90, and *Race, Culture and Evolution* (1968). A notable exception to this rule is James Urry, '"Notes and Queries on Anthropology" and the Development of Field Methods in British Anthropology, 1870–1920', *Proceedings of the Royal Anthropological Institute* (1973), pp. 45–57.

3. Kuper (1973), p. 128. The first official government appointment of an anthropologist was that of R.S. Rattray in 1920 to the Gold Coast. An earlier appointment was made in 1908 with N.W. Thomas as anthropologist to West Africa. The lack of seriousness with which this post was regarded is indicated by the ridiculously vast area under his surveillance and the fact that his contract was not renewed.

4. *Journal of the Anthropological Institute*, vol. XXXIV (1904), p. 14.

5. The Anthropological Institute's title was augmented in 1907.

6. *Journal of the Royal Anthropological Institute*, vol. XXXVIII (1908), p. 489.

7. *Man*, vol. 7 (1907), p. 112.

8. *Journal of the Anthropological Institute*, vol. XXX (1900), p. 9

9. *Ibid.*, p. 10.

10. A case in point is the volume Werner (1906). The Preface by Northcote W. Thomas reiterates these grievances. See also Urry (1973), p. 49. See also A.C. Haddon, 'Ethnographic Museums', *Nature*, vol. 61 (December 1899), pp. 154–5. This deals with the rapid growth of German and American ethnographic collections as compared to British.

11. Dalton (1898).

12. See, for example: *Nature*, *Popular Science Monthly*, *Reliquary*, *Man*, *Journal of the Anthropological Institute*.

13. Dalton (1898). The visit of Dr A.B. Meyer (director of the Royal Museums at Dresden) to the Pitt Rivers Museum in Oxford is a case in point. On this occasion his report testified to his 'high appreciation of the methods adopted here and to the work so far accomplished, the verdict of so eminent an authority being a testimonial of considerable value.' See the *Annual Report for the Pitt Rivers Museum* (1902), p. 3. The annual report for 1907, p. 2, mentions the visit of Dr Foy, director of the New Ethnological Museum in Cologne. Similarly, the annual report for 1905, p. 2, mentions the visit from Dr Von den Steinen.

14. Pitt Rivers Museum, Oxford, Pitt Rivers Collection, Decrees and Letters, Private Correspondence, Mary B. Walters to the London Bishop (4 November 1898), in which the author rails against what she sees as 'the insult to Our Lord, by the placing of a crucifix and a statue of his Mother, in the glass case set apart for the study of the Religions of the World . . . The idea that such a show could teach or assist the study of any reasonable being is so childish.'

15. *Museums Journal*, vol. 1 (July 1901), pp. 4–6. The Museums Association was founded in York in 1888, at the invitation of the York Philosophical Society, as the professional body of museum curators and administrators, which function it still performs. The *Museums Journal*, founded much later in 1901, was to represent the interests of all types of museum within the British Isles, but also the Empire, and later, the Commonwealth and Dominions. The aim of the monthly publication was intercommunication between the museums in the Association. This is further evidence of the important role of the museum in the public sphere and of the increasing organisation and professionalisation of museum administrators. For a detailed analysis of the 1902 Education Act see Searle (1971), pp. 201–16; Halévy, vol. 2 (1939), pp. 114–29; Simon (1965), pp.

208–46.

16. The distinction was implicit rather than explicit, and is demonstrated through the absence of almost any discussion or mention of exhibitions in the pages of the *Museums Journal*, despite the active participation by members of the Museums Association and in particular by anthropologists. Such silence is stranger in view of the fact that many museums including the Horniman, Liverpool County Museum and the Pitt Rivers Museum acquired ethnographic material from such sources.

17. See, for example, Gilman (1923), pp. 435–42.

18. See, for example, the *Imperial International Exhibition*, Official Guide (1909), p. 43. Describing the 'amusement' entitled the 'Dahomey Village' the writer says: 'Entering the Gateway here, we are at once transported to Western Africa.' The entry for the 'Kalmuck Camp' in the same guide (p. 45) began, 'Entering their camp, we first detect them coming down the distant steep mountains with their camels and horses.'

19. This division was clearly not maintained as rigorously as the authorities would have wished. See Ben Shephard,'Showbiz Imperialism: The Case of Peter Lobengula', in ed. Mackenzie (1986), pp. 94–112. This examines an instance of marriage between an African 'performer' and a white woman, and the ensuing furore over miscegenation in the press.

20. *Museums Journal*, vol. 2 (March 1903), p. 269.

21. *Ibid*.

22. *Museums Journal*, vol. 4 (September 1904), p. 101. *Monthly Record* (July 1904), p. 6.

23. *Annual Report of the Horniman Free Museum* (1901–2), p. 4 (henceforth, *A.R. Horniman*). It should be noted that the Museum was only open three days a week by this date. At its formal opening to the public, along with the usual array of dignitaries there was also a deputation of members from a variety of trade, benefit and friendly societies, clubs and working men's organisations from South London (i.e. local groups) who presented an illuminated address conveying their thanks to Mr Horniman. See *A.R. Horniman* (1901–2), p. 9. On the other hand, the annual reports also recorded prestigious foreign visitors. See, for example, *A.R. Horniman* (1893), p. 6, which mentions a visit from the Maharajah of Bhunagai on 8 June. *A.R. Horniman* (1894), p. 9, mentions a reception for Viscount Apki, the Japanese Minister, and the president and members of the Japan Society.

24. *A.R. Horniman* (1891–1892), p. 2.

25. *A.R. Horniman* (1893), pp. 16–18. Horniman made a regular practice of personally inviting the 'poor' on Bank Holidays and Saturdays since the Surrey House Museum was only open by appointment. Free rail tickets were issued from Victoria to Lordship Lane as an incentive. See, for example, *Sussex Daily News* (18 January 1890).

26. *A.R. Horniman* (1893), p. 9. Horniman's status as a local philanthropist was widely acknowledged on a popular level. He was early included as one of the great public benefactors in one series entitled 'Portrait Gallery of Munificences', and another called 'Subject of the Month', in *Tinsley's Magazine* for April 1891.

27. *A.R. Horniman* (1893), p. 9.

28. *Museums Journal*, vol. 2 (March 1903), p. 269.

29. *A.R. Horniman* (1894), pp. 7–8; (1897), p. 16.

30. First *Guide to the Surrey House Museum* (pre 1901), p. 9.

31. *Ibid*. p. 19.

32. *Examiner*, no. X1X (1896).

33. *Examiner*, no. XV111 (1896).

34. Horniman Museum, London, Cuttings File 1888–1901, cutting (20 July 1894).

35. *Ibid*.

36. W.H. Holmes, 'Classification and Arrangement of the Exhibits of an Anthropological Museum', *Journal of the Anthropological Institute*, vol. XXXII (1902), pp. 353–72; Bolt (1971), p. 9. Holmes' suggestions were particularly influential on both Haddon and Balfour. See Haddon papers 3067, University of Cambridge Library, which includes Haddon's handwritten notes on Holmes' classification at the U.S. National Museum in Washington D.C.

37. Holmes (1902), p. 355.

38. The Royal Scottish Museum in Edinburgh, the British Museum in London, and the Mayer Museum in Liverpool all adopted a primary classification which was geographical.

39. For a thorough exposition of the classification adopted at the Pitt Rivers Museum, see Chapman unpublished Ph.D. dissertation, 2 vols (1981). See my chapter seven for an account of the Museum's development beyond 1900.

40. *University Gazette* (January 1883), p. 4.

41. Pitt Rivers Museum, Oxford, Pitt Rivers Collection, Henry Balfour papers (1863–1939), Notes on the Arrangement of the Pitt Rivers Museum, 1893, p. 1. See also *University Gazette* (6 February 1883), p. 294.

42. Balfour (1893), p. 3.

43. *Ibid*., p. 2.

44. *Ibid*.

45. *Ibid.*
46. William H. Flower, 'Inaugural Address to the British Association for the Advancement of Science', *Nature*, vol. 40 (September 1889), p. 465.
47. See Kuper (1988), in particular, chapter seven on Franz Boas and p. 153 where Kuper compares developments in British and North American anthropology, and discusses the extent to which British anthropologists were dependent for far longer on various versions of evolutionary theory than their North American counterparts.
48. *Standard* (3 March 1902).
49. See Pitt Rivers Museum, Oxford, Material Relating to the Development of the Museum, Pitt Rivers Collection, Decrees and Letters, Private Correspondence, Report of the Committee on the Care and Arrangement of the collections, appointed 21 February 1891. By 1891, Balfour had agreed to the division of the collections as (a) a working collection for teaching which would not be exhibited, (b) a permanently exhibited collection of specimens only to be removed for special reasons and (c) a collection for research.
50. Flower (no date) pp. 1 & 2.
51. Lieutenant General Pitt Rivers, 'Typological Museums as Exemplified by the Pitt Rivers Museum at Oxford, and His Provincial Museum at Farnham, Dorset', *Journal of the Society of Arts*, vol. XL (18 December 1891), pp. 115–22. This was also the theme of an address to the British Association For the Advancement of Science, at Bath in 1888.
52. *Ibid.*, p. 116. See also David van Keuren, 'Museums and Ideology: Augustus Pitt Rivers, Anthropological Museums, and Social Change in Late Victorian Britain', *Victorian Studies* (Autumn 1984), pp. 171–89.
53. *Ibid.*, p. 119.
54. *Ibid.*
55. Holmes (1902), p. 355.
56. *Ibid.*
57. See, for example, *Annual Report of the Committee of the Public Libraries, Museums and Art Galleries of the City of Liverpool* (1894), p. 15 (hereafter, *A.R. Liverpool Museums*); and *Museums Journal*, vol. 10 (November 1910), p. 155.
58. Holmes (1902), p. 355.
59. See *Man*, vol. 11 (1911), p. 157; Watt Smyth (1904), pp. 13–14.
60. *Journal of the Royal Anthropological Institute*, vol. XXXVIII (1908), pp. 489–92. *Man*, vol. 9 (1909), p. 128, describes the 'science' as demonstrating 'how measurement of physical and mental characteristics are a reliable test of physical deterioration and progress'.
61. Watt Smyth (1904).
62. Searle (1976); G.R. Searle, 'Eugenics and Class', in ed. Webster (1981), pp. 217–42; David Green, 'Veins of Resemblance: Francis Galton, Photography and Eugenics', *Oxford Art Journal*, vol. 7, no. 2 (1984), pp. 3–16, provides a useful documentation of the inter-relation between photographic techniques of recording social deviants and the classifications deployed by the eugenists. Anna Davin, 'Imperialism and Motherhood', *History Workshop Journal*, 5 (1978), pp. 9–65, gives an excellent analysis of the implications of eugenic theory for British women. See also Weeks (1981).
63. *Museums Journal*, vol. 7 (December 1907), p. 203–59.
64. William H. Flower, 'Presidential Address to the Museums Association, London 1893', in Flower (1898), p. 36. Sir William Flower, George Brown Goode (Asst. Secretary of the Smithsonian Institute, Washington D.C.), and W.H. Holmes are the three museum administrators most frequently quoted in the *Museums Journal* and the *Journal of the Anthropological Institute* as experts in the presentation, organisation and classification of material culture. See, for example, the *Museums Journal*, vol. 1 (December 1901), p. 181; vol. 5 (January 1906), p. 221; vol. 6 (November 1906), p. 189; vol. 8 (January 1909), p. 249.
65. *Museums Journal*, vol. 1 (July 1901), p. 10. The presidential address for this year emphasised the fact that the daily free opening of the Edinburgh Museums would 'put it in the power of even the poorest classes of the community to inspect and study its varied collections'.
66. For a detailed analysis of educational initiatives from within the working classes, see Simon (1965).
67. *Museums Journal*, vol. 2 (September 1902), p. 75.
68. Robb (1942), p. 148.
69. *The Times* (13 August 1909), p. 12.
70. *Ibid.*
71. *Museums Journal*, vol. 2 (July 1902), p. 11.
72. *Museums Journal*, vol. 3 (February 1904), p. 266.
73. *Museums Journal*, vol. 4 (January 1905), p. 235.
74. *A.R. Liverpool Museums* (1894), p. 19. The practice was possibly initiated even earlier, since the report suggests that this was a continuation rather than a new initiative by this

date. In any case, the specimens were primarily natural history rather than ethnography at this time. *A.R. Liverpool Museums* (1898), p. 29, mentions the importance of the new Education Code as a means of increasing school attendance at the museum, thus adding to the total annual attendance figures.

75. It is worth citing some examples from the Merseyside County Museum, Liverpool, Loans Book (23 August 1887), including material from the Mayer collection to give an idea of the range of requests for loans of ethnographic material: p. 60 (23 October 1890), W.I. Argent, for lecture on musical instruments; p. 77 (17 February 1891), W.I. Argent; p. 111 (8 June 1893), W.I. Argent, for lecture; p. 61 (2 November 1890), Mr Wardleworth of New Brighton to illustrate his address on Sunday. The list comprised: fetish, Gaboon (*sic.*); fetish, Congo River (*sic.*); double rattle, West Africa; dog or cattle bell, West Africa; gree gree charm or amulet (*sic.*) containing verses of the Koran (*sic.*); netted bag, New Guinea and a fork for branding slaves. Other entries for personal loans from the Museum included : p. 105 (15 July 1891), His Worship the Mayor J.B. Morgan, four items including one ivory horn from West Africa; p. 76 (6 January 1891), National Society of Professional Musicians (out of 67 items borrowed, 27 were from Central Africa).

76. *A.R. Liverpool Museums* (1904), p. 44.

77. Cambridge Museum of Archaeology and Anthropology, Cambridge, MM1/3/1 Box 14.

78. Chapman (1981) p. 25. Pitt Rivers' own view was that his museum at Farnham represented more nearly his ideal.

79. Kuper (1973), chapters 4 and 5; George W. Stocking Jr., 'The Ethnographer's Magic: Fieldwork in British Anthropology from Tylor to Malinowski' in ed. Stocking Jr. (1983), pp. 71–3; Oxford University Anthropological Society, *Anthropology at Oxford*, (1953).

80. Oxford University Anthropological Society *ibid.*, p. 13.

81. *A.R. Pitt Rivers* (1908), p. 60; (1909), p. 69; (1911), p. 51; (1912) p. 2.

82. Pitt Rivers Museum, Oxford, Material Relating to the Development of the Museum, Pitt Rivers Collection Decrees and Letters, Private Correspondence, Balfour to Professor Price (2 May 1890). This asks for more funds. Balfour to Professor Price (1 June 1890), raises the possibility of funding over and above the work on the catalogue of the collection. This is interesting in another respect. Whereas Balfour evidently entertained the idea of an expanding

department, the University, and in particular, the Anatomical Department (which the Museum was attached to) did not envisage it as such. Professor Price maintained that when the catalogue of the original collection was completed, the collection would be finished.

83. When Tylor retired in 1908, Dr Marett took over teaching the subject and in 1910 appointed a University Readership in Social, as opposed to Physical, Anthropology.

84. Pitt Rivers Museum, Oxford, E.B. Tylor papers, Boxes 6 (1) and (2), no. 10, Franz Boaz to Tylor (27 June 1895); no. 13, Franz Boaz to Tylor (5 June 1896).

85. Pitt Rivers Museum, Oxford, Pitt Rivers Collection, Decrees and Letters, Private Correspondence, Balfour to Mr Robinson (10 December 1891).

86. *Ibid.*, p. 2.

87. *A.R. Pitt Rivers* (1891), p. 2; (1897), p. 3; (1900), p. 3. The annual reports confirm that such additional data was already produced at Oxford by 1890, further augmented in 1897 and consistently employed throughout the development of the Museum.

88. Pitt Rivers Museum, Oxford, Pitt Rivers Collection, Decrees and Letters, Private Correspondence, Balfour to Mr Robinson (10 December 1891), p. 2.

89. For a fuller discussion of the policy of social imperialism, see Semmel (1960), and Searle (1976).

90. *Museums Journal*, vol. 2 (July 1902), p. 13.

91. *Museums Journal*, vol. 4 (September 1904), p. 100. The League published a journal entitled the *Monthly Record*.

92. *Museums Journal*, vol. 7 (July 1907) p. 8.

93. The conference was held at Caxton Hall under the presidency of Lord Tennyson. *Museums Journal*, vol. 7 (July 1907), p. 11.

94. *Museums Journal*, vol. 8 (July 1908), p. 12.

95. *Museums Journal*, vol. 9 (November 1909), p. 202.

96. Haldane (1912), p. 69 (this was given as a rectoral address in 1907). See also Haldane, (1902); Simon (1965) Chapter 5, 'Imperialism and Attitudes to Education'.

Chapter 7

1. See Merseyside County Museum, Liverpool, *Short History of the Museum Education Service* (no date). For brief chronologies of the development of the museums, see *Annual Report of the Committee of the Public Libraries, Museums and Art Gallery of the City of Liverpool* (1930–

1931), pp. 7–12, (henceforth A.R. Liverpool Museums).

2. *A.R. Liverpool Museums* (1898), p. 4.

3. *A.R. Liverpool Museums* (1896), p. 26, makes a comparison with the number of visitors to the British Museum (Natural History); *A.R. Liverpool Museums* (1894), p. 6, compares the average daily number of visitors to the British Museum (Bloomsbury); in 1894 the figures were Liverpool: 1,167 and British Museum: 1,743. *A.R. Liverpool Museums* (1898), p. 4, reports that the figures of visitors to the Liverpool Museum for that year exceeded those of the British Museum. *A.R. Liverpool Museums* (1893), p. 25, prior to the opening of the ethnographic galleries, predicted that they would, 'rank next in importance to the National collection.'

4. *A.R. Liverpool Museums* (1906), p. 48.

5. P.E.H. Mair, 'Liverpool and Black Africa in History', in *Liverpool and Africa* (1974), p. 11.

6. The following is a constantly repeated acknowledgement in the annual reports: 'Special thanks to Sir Alfred Jones and through his personal influence with the members of the West African section of the Chamber of Commerce, for the great interest they have shown in it, and the most generous offer they have made to assist in rendering it as complete a representation as possible of the Ethnology of West Africa, the region with which Liverpool is so intimately in relation', *A.R. Liverpool Museums* (1902), p. 58. See also Porter (1968), p. 255, where he discusses Morel's antagonism to Jones.

7. *A.R. Liverpool Museums* (1901), p. 28.

8. See my chapter six.

9. The most frequently recurring donors' names in this context were: A. Forman, H.L. Jones for the Cameroons and Rio del Rey; and A.A. Whitehouse, Eastern Divisional Commissioner for Southern Nigeria. Sir John Rodger, Governor of the Gold Coast, was another of Ridyard's frequent collaborators.

10. *A.R. Liverpool Museums* (1897) p. 49. This reads: 'To the continued generous assistance of Mr A. Ridyard, Chief Engineer (SS. Niger) this museum is again indebted for a very large number of specimens, illustrative of West African Ethnography; to the co-operation of Messrs. A. Forman, John Newberry, G.W. Stokes, S. Smith, H.L. Jones and other friends in West Africa, who have kindly interested themselves in obtaining for this museum specimens of the handiwork of the various tribes amongst which they are located, and to the kindness of Messrs. Elder Dempster and

Company for kindly allowing all goods to come freight free.'

11. *Merseyside County Museum, Donations and Purchases Book 1866*, Mr Showeress to Mr Ridyard (9 August 1898).

12. *Merseyside County Museum, Donations and Purchases Book 1866*, A.M. Warbourne to Mr Ridyard (20 August 1897).

13. *Merseyside County Museum, Donations and Purchases Book 1866*, I.A. Host to Mr Ridyard (4 May 1899).

14. *Merseyside County Museum, Donations and Purchases Book 1866*, O. Saunders to Mr Ridyard (14 January 1898).

15. *Merseyside County Museum, Donations and Purchases Book 1866*, Dr Mettle to Mr Ridyard (24 September 1900). This letter referred to a 'dansa' or 'life coat'. The discussion over the cost of this particular item is particularly pertinent here. 'The cost of this Life Coat in olden times is a compensation of 10 slaves or 10 Peredwans (80.00 pounds sterling).' Ridyard received it as a gift.

16. *Ibid.*

17. *Merseyside County Museum, Donations and Purchases Book 1866*, Mr Showeress to Mr Ridyard (9 June 1898).

18. *Merseyside County Museum, Donations and Purchases Book 1866*, Mr A.A. Whitehouse to Mr Ridyard (31 December 1904), and (4 April 1905).

19. See Mack (1990), p. 12.

20. See Coombes, 'The Representation of Africa and the African in Britain 1890–1913', unpublished Ph.D. dissertation (1987); especially chapter two which deals with Emil Torday and his collecting activities with T.A. Joyce for the British Museum. See also Kuper (1972), and Mack (1990).

21. Torday and Joyce, 'Notes on the Ethnography of the Ba-Huana', *Journal of the Anthropological Institute*, vol. xxxvi (1906), p. 275 and 'Notes on the Ethnography of the Ba-Yaka, with a Supplementary note to "Notes on the Ethnography of the Ba-Mbala, vol. xxv, p. 398"', *Journal of the Anthropological Institute*, vol. xxxvi (1906), p. 41.

22. *Notes and Queries on Anthropology* (1874), p. iv, quoted in Urry (1973), p. 47.

23. *Notes and Queries on Anthropology* came out in four editions, between 1870 and 1920. See Urry (1973), p. 45.

24. See Van Keuren, 'Human Science in Victorian Britain: Anthropology in Institutional and Disciplinary Formation 1863–1908', unpublished Ph.D. dissertation (1982). This dissertation has been useful in confirming my own analysis of

the institutional formation of British anthropology, particularly since Van Keuren, despite the fact that he focuses on an earlier period, has independently arrived at similar conclusions by using a different range of sources, primarily the *Annual Reports and Proceedings of the British Association for the Advancement of Science*. Van Keuren further provides a useful history of the early use of the anthropological questionnaire and the political implications in terms of debates on the issue of Home Rule in relation to those surveys carried out in the British Isles, especially in Ireland during the 1880s, (pp. 118–120). See also J. Urry, 'Englishmen, Celts, and Iberians, The Ethnographic Survey of the United Kingdom 1892–1899', in ed. Stocking, Jr., vol 2 (1984), pp. 83–105; Cullen (1975); Mort (1987).

25. Urry (1973), p. 48.
26. Kuper (1988), p. 157.
27. Torday and Joyce (1906), p. 40 and p. 275.
28. See Gould (1981), chapters two, three, and four. See also Torday and Joyce (1906), p. 275, where they examine three samples of hair from the Ba-Huana under a microscope. These were then drawn in section and included as diagrams for the edification of the reader, since they appeared to represent an anomaly in terms of the kind of wiry, black and closely curled hair associated with the 'negro'. See also Haddon (1894), p. 257. Hair was a particular index of 'race' in the period under discussion. The degree to which hair could be characterised as 'frizzy' or 'woolly' was significant in determining the racial designation of the person described. This scrutiny of physical characteristics, usually thought of as a particularly eighteenth- and nineteenth-century phenomenon associated with phrenology and craniometry, in fact gained popularity in the first decade of the twentieth century. See also Stepan (1982), p. 89, where she discusses A.C. Haddon's book, *The Study of Man* (1898), in which he emphasises the importance of racial measurement and classification.
29. *A.R. Liverpool Museums* (1898), p. 51.
30. *Ibid.*
31. *Ibid.* The same report mentions that the section illustrating the 'Arts and Crafts of "Primitive" Races' had increased so rapidly in the previous two years, that 'an extensive suite of rooms for its proper exhibition' was deemed necessary in the near future.
32. *A.R. Liverpool Museums* (1895), p. 35.
33. *A.R. Liverpool Museums* (1896), p. 45.
34. P.V. Portman, 'Photography for Anthropologists', *Journal of the Anthropological Institute*,

vol. xxv (1896), pp. 75–87.
35. See John Falconer, 'Photography in Nineteenth Century India', in ed. Bayly (1990), pp. 264–77; Royal Anthropological Institute, *Observers of Man* (1980) See also contemporary sources: Portman (1896), p. 87; J. Bridges Lee, 'Photography as an Aid to the Exploration of New Countries', *Journal of the African Society*, vol. I (1901–1902), pp. 302–11; Reverend H.N. Hutchinson, 'Suggestions for Forming a Collection of Photographs for the Anthropological Institute', *Journal of the Anthropological Institute*, vol. XXVIII (1909), p. 250.
36. Portman (1896), p. 76.
37. *Ibid.*
38. *Ibid.* See also Christraud M. Geary, ' "On the Savannah": Marie Pauline Thorbecke's Images from Cameroon, West Africa, 1911–1912', *Art Journal*, vol. 49, no. 2 (Summer 1990), pp. 150–8, where she deals with this in relation to German photographic practice in the Cameroons.
39. See, for example, Sekulla (1974), pp. 3–21; Tagg (1988).
40. *A.R. Liverpool Museums* (1896), p. 45.
41. *A.R. Liverpool Museums* (1899), p. 62.
42. See Geary (1988), p. 31.
43. *A.R. Liverpool Museums* (1903), p. 27, plate IV. See also Ira Jacknis, 'Franz Boas and Exhibits, on the Limitations of the Museum Method of Anthropology', in ed. Stocking, Jr. vol. 3 (1985), pp. 75–111 Jacknis describes the use of photographs in various ethnographic collections in North America in the nineteenth century.
44. By *c.*1899, Africa was in the Ethiopian section.
45. The African collection developed so quickly that by 1899 it was a commonplace in the annual reports to see, 'The West African section has again necessitated the alottment of additional space'. *A.R. Liverpool Museums* (1899), p. 34.
46. *A.R. Liverpool Museums* (1894), p. 7; *A.R. Liverpool Museums* (1895), p. 18.
47. *A.R. Liverpool Museums* (1896), p. 28. The subdivisions were *Melanesian*: Africa, New Guinea, Solomon Islands, New Hebrides, Polynesia, New Zealand, Micronesia and Matty Island; *Mongolian*: South America, China, Japan, Malay Archipelago, Burmah; *Caucasian*: India, Egypt and Europe.
48. *A.R. Liverpool Museums* (1896), p. 15; *A.R. Liverpool Museums* (1899), p. 37; *A.R. Liverpool Museums* (1900), p. 20; (1901), p. 31.
49. *Ibid.*, p. 39.
50. *A.R. Liverpool Museums* (1909), p. 23.
51. *A.R. Liverpool Museums* (1894), p. 15. By this

date the director was already claiming that the ethnographic collections were 'of great value, many of the specimens being now almost impossible to obtain.'

52. *A.R. Liverpool Museums* (1901), p. 27.
53. *Ibid.*, p. 28. The Museum regularly acquired Egyptian material through the Egypt Exploration Fund and had a substantial collection of 'Egyptian Antiquities' by this date.
54. Haddon (1898).
55. Keane (1896); (1899). See Stepan (1982), p. 89–90, where she discusses Keane's influence on Haddon.
56. *Reliquary*, vol. VI (1900), p. 273.
57. *Ibid.*, p. 274. In 1902 a further consolidation of the material's organisation resulted in the basement (now exclusively taken over with 'Melanian Ethnology'), devoting special attention to the African collections. By 1910 this had become a section in its own right, named as the continent and subdivided by country, unlike other areas represented in the ethnographic section which maintained the 'racial' sub-headings already mentioned. The importance of Africa as a culture area would have certainly impressed any visitor caring to descend into the bowels of the Museum.
58. *A.R. Liverpool Museums* (1898), p. 51.
59. *A.R. Liverpool Museums* (1901), p. 27.
60. *A.R. Liverpool Museums* (1903), p. 3.
61. *A.R. Liverpool Museums* (1906), p. 54; *A.R. Liverpool Museums* (1910), p. 37. The care with which this aspect of the African collection was systematically built up is indicated by the instruction issued by the Museum, to Arnold Ridyard, where he was asked to pay 'special attention to the procuring of examples illustrative of the primitive potter's art as now carried on in Africa, an art gradually disappearing owing to the introduction of European metal ware'.
62. *Bulletin of the Liverpool Museums*, vol. 1, no. 1 (August 1897).
63. *A.R. Liverpool Museums* (1904), p. 41.
64. *Ibid.*
65. *University Gazette* (6 February 1883), p. 294.
66. *A.R. Pitt Rivers* (1883), p. 30.
67. *A.R. Pitt Rivers* (1906), p. 1.
68. Already in 1893, the lecture series focused around the 'Arts of Mankind'. See *A.R. Pitt Rivers* (1893), p. 15 and *A.R. Pitt Rivers* (1894), p. 2. This documents a lecture series given in the Hilary and Easter terms entitled 'Progress in the Arts of Mankind Particularly as Illustrated by the Pitt Rivers Collection.'
69. *A.R. Pitt Rivers* (1894 & 1895 combined).
70. *A.R. Pitt Rivers* (1907), p. 2. While it is not possible to reconstruct completely the degree to which, and in what way, African material culture was dealt with in these different contexts, certain documents do exist which indicate the status of this material within the collections. One of the first students to graduate in the diploma in anthropology, Barbara Freire-Marreco, left a notebook of information taken in lectures from 1905–10. See Pitt Rivers Museum, Oxford, Barbara W. Aitken, née Freire-Marreco 1897–1967, papers, notebook 1905–1910.
71. The interest in physical deformation of the body of the colonised subject is an early pre-occupation in many ethnographic collections and in writings by anthropologists, as well as naturalists with an interest in anthropology. Sir William Flower (whose early treatises were later published in a single collection) was, as we have already seen, very influential in the museum sphere and devoted an essay to this topic. See Flower (1898), chapter twenty. The series on physical deformation was one of the first to be developed, along with that on the decorative art of 'savages', at the new museum at Oxford. See H. Balfour, 'Report as Sub-Curator of the Pitt Rivers Museum, Oxford', *University Gazette* (2 May 1890), no page number.
72. F. Galton, 'On the Application of Composite Portraiture to Anthropological Purposes', *British Association Report*, 51 (1881), pp. 690–1; Joseph Jacobs, 'On the Racial Characteristics of Modern Jews', *Journal of the Anthropological Institute*, vol. XV (1885), pp. 23–62.
73. Pitt Rivers Museum, Oxford, Barbara W. Aitken, née Freire-Marreco, papers, notebook 1905–1910. The most extensive range of examples noted by Freire-Marreco comes in the section devoted to teeth, which was also organised into the separate categories of: altered at initiation, pulling forward upper incisors, accidental incrustation, staining and deliberate staining.
74. These were brought over to England in 1905 by Colonel James Harrison, after a shooting trip in the Congo. See *Daily Express* (21 March 1905); *Daily Mail* (13 and 19 April 1905); *Daily Mirror* (2 June 1905); *Daily Graphic* (22 February 1906). See also Jeffrey Green's paper, 'The Ituri Forest Pygmies in Britain: 1905–1907', delivered at the Annual Conference of the African Studies Association of the United Kingdom, in London, December 1991. He discusses the ways in which personal contact with the pygmies, in Harrison's home town of Brandesburton in Yorkshire, mediated the

familiarly derogatory caricatures of the group that often abounded in the national press, and produced a very different account of this encounter.

75. Pitt Rivers Museum, Oxford, Henry Balfour papers, Balfour South Africa 1910; *A.R. Pitt Rivers* (1905), p. 2; (1907), p. 2.

76. Pitt Rivers Museum, Oxford, Donation II, 1894–1900 (15 March 1894), pp. 1–6.

77. *A.R. Pitt Rivers* (1912), p. 1.

78. H. Balfour, 'The Natural History of the Musical Bow, Oxford, 1899; Opening Address to the British Association for the Advancement of Science, Anthropology Section', *Nature* (1 September 1904).

79. Steadman (1979), pp. 88–9.

80. *Ibid.*, p. 88.

81. *A.R. Pitt Rivers* (1899), p. 3. It is primarily this collection that is referred to and expanded until 1913. *A.R. Pitt Rivers* (1904), p. 2, saw it as occupying 'an important and in some ways unique position among the systematic collections of musical instruments of the world.'

82. Pitt Rivers Museum, Oxford, Donations and Accessions 1900–1920.

83. *Ibid.*, p. 14.

84. *A.R. Pitt Rivers* (1900), p. 3.

85. Pitt Rivers Museum, Oxford, Donations and Accessions 1900–1920 (1910), pp. 2–5; *A.R. Pitt Rivers* (1904), p. 3.

86. *A.R. Pitt Rivers* (1903), p. 2.

87. Rattray (1927).

88. Pitt Rivers Museum, Oxford, Donations IV, 1906–11, 1910.152, no. 48, 1–3.

89. *A.R. Pitt Rivers* (1902), p. 1.

90. *Ibid.*, p. 3.

91. Pitt Rivers Museum, Oxford, Donations and Accessions 1900–1920 (1910), pp. 2–5.

92. Pitt Rivers Museum, Oxford, Purchases I, 1891–1900; Purchases II, 1901–1909, Purchases III, 1910–1921.

93. Pitt Rivers Museum, Oxford, Purchases III, 1910–1921 (1910), p. 3, no. 62.

94. Pitt Rivers Museum, Oxford, Purchases III, 1901–1909 (1907), p. 89, no. 66.

95. Pitt Rivers Museum, Oxford, Material Relating to the Development of the Museum, Decrees and Letters, Balfour papers, cutting, no date, no page number. See also a review in the *Journal of the African Society*, vol. VI (1906), pp. 317–8.

96. Pitt Rivers Museum, Oxford, *ibid.*

97. *Ibid.*

98. Horniman Museum, London, Accessions 1897–1920, 1897, 1898 and 1899. Registers for accessions to the Horniman were only kept from 1897. Prior to this period, the guides, letters and cuttings files are the only record of material in the collection. Missionaries were a particularly important source. Horniman is reported in a local paper, *Pearson's Weekly* (7 May 1892), to have said, 'I should never have been able to get this collection together had it not been for the missionaries.'

99. Horniman made good use of a wide selection of suppliers, buying from well-established dealers like W.O. Oldman and W.D. Webster, G. Vieweg, A. Inman, S. Fenton and Co., J. Burton, and the auctioneers Stevens and Sothebys.

100. Horniman Museum, London, Correspondence, W.J. Hider to R. Quick (23 March 1897).

101. Horniman Museum, London, Accessions, 1910, 174–181, 394.

102. *A.R. Horniman* (1898), p. 5.

103. By the time it was described in the *Reliquary* it was still fully integrated into this evolutionary system. *Reliquary*, vol. XII (1906), pp. 114–25.

104. *A.R. Horniman* (1901–1902), pp. 9–10; *A.R. Horniman* (1904), p. 6.

105. *Ibid.*; *A.R. Horniman* (1909), p. 18.

106. *A.R. Horniman* (1904), p. 5; (1905), p. 5; (1906), p. 18.

107. *Guide for the Use of Visitors to the Horniman Museum* (1905), p. 11.

108. *Ibid.*, p. 13.

109. This collection was apparently sizeable enough to warrant the comment from one reviewer that it was 'probably the most extensive outside the British Museum.' *Societies' Review* (May 1895), p. 9.

110. *South London Press* (30 December 1893); *Crystal Palace Times* (18 November 1892).

111. *Studio*, no. 140, vol. XXXIII (November 1904), pp. 133–8.

112. *Ibid.*, p. 135.

113. *A.R. Horniman* (1907), p. 6. Even by 1912, the Benin section was the largest percentage of material from Africa. A.H. Malet's collection of objects from the Congo Free State had also, by 1907, been incorporated into the then 'African Art' section.

114. *A Guide for the Use of Visitors to the Horniman Museum* (1912), pp. 30–2.

115. *Ibid.*, p. 32.

116. Van Keuren (1982), pp. 133–9, discusses anthropologists' unsuccessful efforts to set up a government-funded Imperial Bureau of Ethnography over the period 1892–1910. Their justification for the proposal focused primarily on its value in compiling and collating material on races within the British Isles. A.C. Haddon was one of the most enthusiastic advocates of this never realised project.

117. *A.R. Horniman* (1904), p. 7.
118. For example, the local Dulwich Literary and Scientific Society was a frequent visitor.
119. *A.R. Horniman* (1906), p. 6, signals an increase in publicity. Copies of large notices were sent to libraries, railway stations and schools.
120. *A.R. Horniman* (1903), p. 9.
121. *A.R. Horniman* (1908), p. 6.
122. Haddon (1907), p. 31.
123. Haddon (probably 1909). For more detail on Keane's work see Stepan (1982), p. 90.
124. *A Guide For the Use of Visitors to the Horniman Museum* (1905), p. 1. The rearrangement of the ethnographic material in the south hall was underway in 1904, so consequently some of the details regarding the order of the collections may not be accurate by this date. However, p. 1. of the *Guide* is a notice of the new arrangement. The *Guide* is useful for the information it provides regarding the displays from their installation in the new building in 1901 up until 1904.
125. *Ibid.*, p. 15.
126. 'Weapons of War and the Chase', *Horniman Museum Handbooks in Ethnology*, no. 8 (1908), p. 3.
127. *Ibid.*, p. 4.
128. 'Stages in the Evolution of Domestic Arts', *Horniman Museum Handbooks in Ethnology* (1910), p. 4.
129. *Ibid.*, p. 7.
130. *Ibid.*, p. 10.
131. *Ibid.*, p. 12.
132. *Ibid.*, p. 37.
133. *Ibid.*
134. *A.R. Horniman* (1909), p. 7.; (1912), p. 9.
135. *A.R. Horniman* (1905), p. 5. This particular report went so far as to claim that 'since a considerable number of irresponsible and frivolous visitors have been discouraged from using the Museum as a promenade . . . the decrease really represents an improvement rather than the reverse.'
136. Pitt Rivers Museum, Oxford, Barbara W. Aitken, née Freire-Marreco, notebook 1905–1910.
137. *Ibid.*
138. *A.R. Horniman* (1908), p. 5.
139. *A.R. Horniman* (1909), p. 6. In 1909 the figures for schoolchildren attending increased four-fold.
140. *A.R. Horniman* (1906), p. 5.

Chapter 8

1. See Bolt (1971), pp. 110–17. She mentions certain aspects of the propaganda of the home missions regarding Africa, but ultimately sees this as a uniform indictment of African societies. In addition, her analysis is only concerned with attitudes to Africa before 1890. Most of the literature which deals with missionary societies' representation to British publics of their work in the field is provided by the official histories of the societies concerned, and are consequently rather partisan sources.
2. See Susan E. Thorne, 'Protestant Ethics and the Spirit of Imperialism: British Congregationalists and the London Missionary Society, 1795–1925, unpublished Ph.D. dissertation, (1991), p. 18. Thorne's work is among the most perceptive analytical historical accounts of missionary activities both in the field and on the home front. While she cites Sir Harry Johnston's address to the British South Africa Company regarding the importance of each mission station as 'an essay in colonisation', she is also careful to acknowledge research which explores the ways in which some missionary activity was also potentially destabilising to the colonial project. See, for example, Karen E. Fields, 'Christian Missionaries as Anti-Colonial Militants', *Theory and Society*, 11 (1 January 1982), pp. 95–108; and Jean and John Comaroff, 'Christianity and Colonialism in South Africa', *American Ethnologist*, 13 (1 February 1986), pp. 1–22.
3. The success of the conversion process was of course a necessary factor in mission fundraising activities.
4. Neither the standard works concerned with entertainments and exhibitions during this period, nor histories of ethnographic collections and anthropology deal with these events. See, for example, Allwood (1977); Altick (1978); Kuper (1973); Frese (1960); Penniman (1965); MacKenzie (1984).
5. See Yeo (1976), McLeod (1984), for accounts of the public appeal of different Christian denominations in the period under discussion.
6. See Bebbington (1982); Tudor Jones (1962); Thorne (1991), pp. 39–45 where she discusses the relation between Victorian nonconformity and Liberalism.
7. Frederick Greenwood, 'The Missionaries and the Empire: An Appeal to the Missionary Societies', *The Nineteenth Century and After*, ccxciii (July 1901), pp. 21–30, cited in Thorne (1991), p. 90. See also Ayandele (1966).
8. A. Hodge, 'The Church Missionary Society Training College at Islington', *Journal of Religions in Africa*, vol. IV (1971), p. 83.
9. See F.K. Prochaska, 'Little Vessels: Children in the Nineteenth Century English Missionary

Movement', *Journal of Imperial and Commonwealth History*, vol. VI, no. 2 (1977), p. 107.

10. *The Times* (2 June 1908), p. 19. The irony of encouraging even the poorest to part with what little they had, did not go unregistered. Thorne (1991), pp. 328–9, gives examples of some critics of this policy including the working-class and socialist novelist, Robert Tressell, whose novel *The Ragged Trousered Philanthropist* (written 1906, published 1914), contains a vivid indictment of the hypocrisy of some ministers who reaped the benefits of the sacrifices of others, personified by the character of Reverend Belchers.

11. See for example, the *Franco-British Exhibition* official catalogue (1908), p. 40.

12. Church Missionary Society Library, H/H 30 A5, Exhibitions Department, General Secretary's Suggestions for Exhibitions: *Exhibitions Herald* (March 1908) thanks *The Times*, *Daily News*, *Daily Chronicle*, and *Morning Leader*, for placing notices of the exhibitions. The journal, published by the London Missionary Society, carried announcements of the latest developments on their own exhibitions.

13. *The Times* (6 June 1908), p. 4. Similar arrangements in connection with the 1909 Church Missionary Society 'Africa and the East' exhibition were reported in *The Times* (1 May 1909), p. 10.

14. See the *Homeworkers Gazette* (April 1910), published by the Society for the Propagation of the Gospel.

15. For example, *The Times* reported on every stage in the development of all of the large London exhibitions mentioned above, as well as some of the larger provincial ones.

16. *Exhibition Herald* (January 1908), p. 8. As an indication of the Society's recognition of the importance of encouraging even non-churchgoers, the journal acknowledges the success of the magazine as a promotor among mission societies, adding that 'something more is undoubtedly needed now for circulation among the people of other churches or of none.' See also *Record* (18 June 1909), p. 657, and the Church Missionary Society's *Africa and the East Handbook* (1922), p. 14.

17. *Rochdale Observer* (18 November 1905), p. 3.

18. *The Times* (1 June 1908), p. 8.

19. *Ibid.*

20. See Church Missionary Society Library, H/H 30, E1C A2/1, concerning publicity printed in *The Times Educational Supplement*, *London Teacher*, *Education*, and other recognised educational journals which reviewed the event.

21. Church Missionary Society Library, H/H 30, E1C A2/1. Educational authorities contacted by the Society included Camberwell School of Art and Craft. It is evident from the annual reports of the major ethnographic collections for this period that art colleges took a regular interest in the collections. Although it is not possible to ascertain exactly which sections of the missionary exhibitions would have appealed to art students at this time, it is evident that here too they were regular visitors.

22. Part of the reason for the popularity of the Islington site can be accounted for by the fact that the Church Missionary Society training college was situated there, and the work of the missionaries was well-known in the area. See Hodge (1971), pp. 90–1.

23. The Picton Halls were also the site of large colonial and ethnographic exhibitions in Liverpool, as well as being used for meetings and lectures organised by the adjoining Mayor and Derby Museums and the Liverpool County Public Library.

24. For a discussion of the previous uses of the Hall, see Bingham (1919), p. 20.

25. *The Times* (1 May 1909), p. 9.

26. Society for the Propagation of the Gospel Library, X111 Report of the Chairman of the General Committee (22 June 1912); *The Times* (16 June 1922), p. 7.

27. *The Times* (5 June 1908), p. 12.

28. See my text, above.

29. For example, G.M. Bridges and Son Ltd., Scenic Artists, Bazaar and Exhibition Contractors. The company's publicity actually specified their expertise in 'Missionary Exhibition Scenery' and 'Mission Contracts'. It is also worth bearing in mind that the exhibitions provided a wonderful opportunity for such reputable companies as Wellcome and Boroughs, and other drug and outfitting companies, to take advantage of the event to publicise their own products. This often resulted in a symbiotic arrangement whereby the firm would provide equipment for use in the various plays and tableaux, and receive free publicity in the programme's acknowledgements. The hospital scenes were those which benefited most regularly from this sort of arrangement.

30. A. Porter, 'Cambridge, Keswick and Late Nineteenth Century Attitudes to Africa', *Journal of Imperial and Commonwealth History*, vol. V, no. 1 (1976), p. 10.

31. Ridley Hall, Cambridge University, founded in 1881 and Mansfield College, Oxford University, founded in 1886.

32. Porter (1976), p. 12.

33. Robinson 2 vols, (1899, 1907, 1925); (1896, reprinted 1969). Another example was W.H. Bentley of the Baptist Missionary Society, best known as the author of *Pioneering on the Congo*, a 2 volume work published in 1900. See also Bentley, 2 vols. (1887–1895, reprinted 1967).

34. *Journal of the African Society*, vol. 1 (1901), p. 368. This carries a notice of a forthcoming lecture series at Cambridge University entitled 'Primitive Custom and Belief', which was designed especially for missionaries in the field, and was to be run by Haddon.

35. Cambridge University Library, Cambridge, A.C. Haddon Papers, 4067, Arthur M. Knight to A.C. Haddon, no date.

36. See for example, *Annual Report of the Horniman Free Museum* (1907), p. 17, which mentions the visit of the Deptford Missionary Study class. See also Cambridge University Library, A.C. Haddon Papers, 4067, Reverend Herbert Crouch to A.C. Haddon (20 December 1911). Crouch had been a student of Haddon's at Cambridge in 1906, and requested advice concerning a paper on 'Totemism' which he was giving to the local literary and debating society.

37. *Man*, vol. 7 (1907), p. 112. See also Weeks, of the Baptist Missionary Society (1911), and (1914). The latter was also published in German (translated by Ferdinand Hirt, 1914), a fact which testifies to the significance of the work which remains a source for anthropologists of the Bakongo today. For a list of the items which Weeks gave to the collection, see Horniman Museum Library, Correspondence Files, J.H. Weeks to A.C. Haddon (3 July 1910). For Weeks' lecture 'Congo Witch Doctors and Their Methods', given 31 January 1914 at the Horniman, see 'Free Public Lectures', *Annual Report of the Horniman Museum* (1914). See also *Annual Report of the Committee of the Public Libraries, Museums and Art Galleries of the City of Liverpool* (1907), for reference to Reverend C. Wright's slide lecture on 'Guiana' at the Picton Hall. Not only were missionaries encouraged and even employed to collect for public ethnographic collections, they were also engaged by the museums to lecture to members of the public who participated in the various educational schemes currently run by many of the large institutions. Rev. Weeks, for example, contributed to both the Horniman and the Baptist Missionary Society collections, and lectured on the Congo as part of a Horniman series in 1914 to which museum staff members also contributed.

38. James Urry, 'Notes and Queries on Anthropology and the Development of Field Methods in British Anthropology, 1870–1920', *Proceedings of The Royal Anthropological Institute* (1973), pp. 45–57.

39. R. Thornton, 'Narrative Ethnography in Africa, 1850–1920: The Creation and Capture of an Appropriate Domain for Anthropology', *Man*, vol. 18, no. 3 (1983), pp. 502–18; A. Rosensteil, 'Anthropology and the Missionary,' *Journal of the Royal Anthropological Institute*, vol. 89 (1959), pp. 107–16.

40. Pitt Rivers Museum, Oxford, E.B. Tylor Papers, Box 6 (1) and (2), James Frazer to E.B. Tylor (4 December 1896).

41. *Ibid*.

42. *Ibid*.

43. *Ibid*. See also Cambridge Museum of Archaeology and Anthropology, Cambridge, Ridgeway Papers, W 10/2 Box 110, Reverend John Roscoe to Ridgeway (16 June 1908). Roscoe mentions that he has enough 'curios' for four men to carry. He continues that he was 'able to tap four tribes and get just enough . . . to give . . . an idea of the importance of them.' The following paragraph is further indication of the seriousness with which Roscoe embarked on his 'fieldwork' for anthropologists such as Ridgeway and Frazer, and the anthropologists' dependence on such contacts: 'It will be splendid if you can get Anthropology fairly going and on a good basis as a science. Is it impossible to get a chair at Cambridge? Tell Duckworth I met an old student of his on Elgon named Newman who . . . attended his lectures. I hope that he and several others will make notes on the people they come upon. They promised me they would and asked for copies of Frazer's questions.' As late as 1913, James Frazer was trying to get the Colonial Office to appoint Roscoe as official Government Anthropologist to East Africa. See George W. Stocking Jr., 'The Ethnographer's Magic: Fieldwork in British Anthropology from Tylor to Malinowski', in ed. Stocking Jr. (1983), p. 80.

44. See R.W. Strayer, 'Missions and African Protest: a Case Study from Kenya 1875–1935', *Eastern African Studies*, vol. XII (1973).

45. Pitt Rivers Museum, Oxford, Correspondence and Related Documents, 1909, 1902–9, Donations III, Reverend W. Allen to Henry Balfour (19 January 1901).

46. See chapter seven; *Annual Report of the Pitt Rivers Museum*, Oxford (1902), p. 1.

47. The Pitt Rivers Museum, Farnham, Dorset, and the Powell-Cotton Museum in Birchington-on-Sea, Kent, are two examples of the latter.

48. Pitt Rivers Museum, Oxford, Correspondence and Related Documents, 1909, 1902–9, Donations III, Reverend W. Allen to Henry Balfour (6 January 1902), my emphasis.

49. *Ibid*. Allen mentions here that part of his donation to the Museum, particularly the national 'idol' of Asaba on the Niger, had been taken from the Africans by the Royal Niger Company. From here it had fallen into the hands of their Chief Medical Officer and had been passed from him to another man, who had finally given it to Allen!

50. Pitt Rivers Museum, Oxford, *ibid.*, A.J. Bowen to Reverend W. Allen (13 March 1902) and (17 March 1902). Bowen, author of *The Regions Beyond Missionary Union*, enclosed the address of a Reverend A. Billington of the American Baptist Missionary Union in the Congo in order to facilitate correspondence between Allen and Billington.

51. Pitt Rivers Museum, Oxford, *ibid.*, Reverend W. Allen to Henry Balfour (11 March 1902).

52. The Museum was situated inside Gunnersbury House, the home of the Wesleyan Missionary Society until 1838, when it moved to Bishopsgate, City of London.

53. This refers to entry number 188, in the Gunnersbury House Museum, which was presented by Reverend H. Badger.

54. For an early example of protestation against pressures of this sort being put on missionaries in the field who denied that the indigenous population were idolators, but who were nevertheless required to submit figures to be held up as examples of idol worship to local congregations at home, see Reverend Hope Waddell, 'Journal', vol. 1, pp. 116–17, quoted in Ajayi (1965), p. 262. Waddell was Superintendent for the Church of Scotland Mission at Calabar.

55. See for example, Kemp (1898).

56. *Ibid.*, p. 120.

57. *Ibid*.

58. Bentley, 2 vols. (1900), p. 259, my emphasis.

59. Helen C. Gordon, 'Lesser Known Museums: The London Missionary Society Museum', *English Illustrated Magazine*, vol. xx (1899), pp. 81–8.

60. *Ibid.*, p. 82. The London Missionary Society Museum was also featured and illustrated in Sims, vol. 3 (1903). By 1816, although many London Missionary Society members had been killed in the South Seas mission, the ones who managed to remain were rewarded by a gift from King Pomare I of his household gods.

61. Gordon (1899), p. 81.

62. *Ibid*.

63. *Ibid.*, p. 35.

64. Barnes (1906), p. 240, states that, 'It has been only a very recent move, through the liberality of two anonymous friends of the society to convert this repository of curios into a rest and writing room.'

65. *Ibid.*, chapter XIII

66. *Ibid.*, p. 205.

67. *Ibid.*, p. 209.

68. *Reliquary*, vol. XII (1907), p. 122. The writer is discussing ornamental features in Maori art, and uses an example from the Church Missionary Society Museum.

69. Church Missionary Society Library, H/H 30, E1A/A2, 'Africa and the East', *Notes for Stewards and Workers* (January 1909), and H/H 30, E/5/2A, *Stewards Handbook* (1899).

70. Church Missionary Society Library, H/H 30, E7/2.

71. This particular quote refers to a representation of a pigeon and a clerk used by the Ife and presented to the Church Missionary Society by Mr E. Fry, a missionary in Abeokuta.

72. The first missionary exhibition was the 'Church Mission to the Jews' exhibition, in 1867 and 1878. The first Church Missionary Society exhibition was suggested by Rev. John Barton (the Society's Secretary for India) at Cambridge, and was organised by Mr H.G. Malaher (Secretary to the Missionary Leaves Association, an auxilliary of the Society).

73. Stock (1899), vol 3, p. 306. Stock is quoting Barton who is also credited with the initiative for such events.

74. *Ibid.*, p. 306. Mr Arden, who taught Tamil and Teluga at Cambridge University at the time of the first exhibition, wrote to the *Gleaner* (a Church Missionary Society periodical), suggesting that there should be an exhibition 'held each year in one or other of the larger towns.'

75. *Free Church of Scotland Monthly Record* (February 1899), p. 37. This refers to an exhibition held in St Andrews Hall between 5th and 14th March, 1899, in which thirty-seven missionary societies attended and sent 'curios' and speakers. The author also mentions that 'the railways should be asked to give facilities for non-Glasgow visitors from all parts.' It is evident from this that the Society anticipated a good attendance.

76. See Stock (1899), p. 668, where the author remarks on the 'new found amenability of the press' and how much more receptive they are to the idea of a missionary exhibition than in the 1880s.

77. Church Missionary Society Library, London, H/H 30 A8, F.H. Reynolds, 'Notes on the

History of Missionary Exhibitions', unpublished MS (1939). There was considerable rivalry between evangelical and non-evangelical societies until 1890, when they were more co-operative. The first large-scale society exhibitions were those organised by the Society for the Propagation of the Gospel in 1898; the London Missionary Society in 1903; the Baptist Missionary Society in 1905; and the Methodist Missionary Society in 1907.

78. Not all societies were as quick as the Church Missionary Society to establish collections of their own specifically for the purpose of exhibitions. The Society for the Propagation of the Gospel was another frequent participant in these events, but despite holding regular independent and joint exhibitions after 1894, the Society seems not to have acknowledged the importance of establishing an exhibition department until after 1908, when a particularly successful exhibition at Southend necessitated a public request for 'curios'. The demand was met so successfuly that from 1910 the material became a sizeable collection, and, as there was no room for it at the Society's Tufton Street headquarters, it was moved to a specially rented site in Hammersmith at 37 The Grove. By this date the Society had also created the post of 'keeper to the 'curios' and by 1912 the keeper had classified and displayed them as a permanent collection at Hammersmith. See Society for the Propagation of the Gospel Library, London, X 111, Annual Reports and Statistics, Report of the Secretary and Superintendent of Exhibitions (1912). The report mentions that 'Mr F. Deans has done good service in the care, classification and proper display of the curios.' For Mr Deans' responsibility for the collection from 1910, see Society for the Propagation of the Gospel Library, X 1115.

79. Barnes (1906), p. 132. Mention is made here of a 'loan department' where Mr E.J. Staples was in charge, and which began when a Mr Edward Newton (of Newton and Co.) gave lectures with lantern slides on missionary work, despite the initial disapproval of the missionary societies (they later acquiesced after receiving the 100 pound profit from the evening viewing).

80. One of the earliest requests specifically for exhibitions was made to Bishop Samuel Crowther. See Church Missionary Society Library, H/H 30 A7, Bishop Crowther to Mission Secretary (15 February 1869). He states here that he will send articles from the Niger Mission for the exhibition. See also H/H 30 A7, notice of forthcoming missionary loan exhibition, Manchester 1869, requesting members of the public to supply the Society with 'articles used in heathen worship, idols, views of temples, specimens of native art, works of ingenuity in wood, metal and ivory, etc.' See also the Society for the Propagation of the Gospel's periodical *Homeworkers' Gazette*, vol. III, no. 1 (January 1909), p. 5, which asked for 'a large stock of curios. There must be a great number of these all over the country which the owners would gladly spare us if they knew how useful we could make them. There must be many of our friends at home who could induce our friends abroad to send us something.'

81. Church Missionary Society Library, H/H 30, E1A/A2.

82. *Annual Report of the Committee of the Public Libraries, Museums and Art Galleries of the City of Liverpool* (1883). See chapter seven.

83. Church Missionary Society Library, H/H 30 A8, p. 4.

84. *Record* (18 June 1909), p. 657.

85. *Exhibition Herald* (May 1908), p. 12, acknowledges loans from these sources. Church Missionary Society, *Exhibition Handbook for Bingley Hall, Birmingham*, acknowledges loans from the Horniman Free Museum, the Liverpool Mayer Museum and the Dorchester and County Museums.

86. For attendance figures at the London Missionary Society 'Orient in London', see *Daily Graphic* (4 June 1908), p. 5 and *The Times* (25 May 1908), 17.

87. Church Missionary Society Library, H/H 30, E1A/A2, 'Africa and the East', *Notes for Stewards*, no. 2 (January 1909). The 1909 *Official Handbook to the 'Africa and the East' Exhibition* is in fact remarkable for its detached presentation of information regarding religious practice in Yorubaland, Hausaland and Uganda. The same cannot be said of the Liverpool Handbook which does not attempt to give any explanation of the religious practice of any of the people whose household gods were represented. The handbook for the same exhibition in Ballsbridge, Dublin (14 May–1 June 1912) concentrates on lurid descriptions of those rites most likely to horrify the public. 'Fetishism' is described as 'the belief in charms and amulets composed of human eyeballs, human bones.' It is evident from these disparate emphases that the guidebooks for each of the exhibitions were written locally, and that the impression of African religious practices, as well as any interpretations associated with the 'idols' or 'figures' displayed in the 'courts', would have varied greatly from place to place.

88. Samuel Crowther's life story would have been well-known to the missionary congregations. As a Yoruba boy, he was rescued from slavery by the Church Missionary Society missionaries. He was then educated at the their Fourah Bay Institute and in 1842 went to their Training College at Islington. In 1843 he went back to Sierra Leone as a schoolmaster and catechist, and went on to be ordained and become a bishop.

89. Church Missionary Society Library, H/H 30, E1A/A2, *Modified Form of Study for Stewards' Meetings:* Suggestions for Papers, no. IVa and b.

90. For Church Missionary Society contact with Islam in East Africa before 1914, see James D. Holoway, *Journal of Religion in Africa*, vol. IV (1971–72), pp. 200–12.

91. For a manifestation of this attitude in the colonial novel, see Street (1975), p. 73.

92. See Church Missionary Society Library, H/H 30, E1A/A2, Ia.

93. By the 1920s this was no longer the case for the Church Missionary Society, who for the 1922 version of 'Africa and the East' recruited from various higher educational institutions in London. Church Missionary Society Library, H/H 30, E1C/ A2/2, H.F. Semor to Mr Howard, reports contacting various colleges for the provision of stewards. Goldsmiths' College and Bedford College are two of those that apparently agreed to provide them.

94. Church Missionary Society Library, H/H 30, E/5/2A, *A Manual for Stewards* (1899).

95. *Ibid.*, p. 5.

96. See above, note 20.

97. See Church Missionary Society Library, H/H 30, E5/2/A (1909), p. 4.

98. For details of their eventual sale, see Church Missionary Society Library, H/H 30, E52/A, and H/H 30, E5/2A.

99. H.J. Drewel, 'Gelede Masquerade, Imagery and Motif', *African Arts*, vol. VIII, no. 2 (1974), pp. 36–45.

100. Church Missionary Society Library, H/H 30, E5/2C, p. 3.

101. Church Missionary Society Library, H/H 30, E5/7, p. 79, and Society for the Propagation of the Gospel Library, *Handbook for the Stewards at Missionary Exhibitions* (1921).

102. See Thorne (1991), pp. 294–6, where she discusses the way in which missionary literature for the young often based its appeal on a comparison of the lot of women and girls in African and Indian societies with Britain.

103. Bingham (1919), p. 20. Although one of the factors influencing the missionaries' choice of site can be attributed to the proximity of the Church Missionary Society training college in Islington, the Royal Agricultural Hall was early established as a centre for colonial and trade exhibitions.

104. *Exhibition Herald* (March 1908), p. 18: 'Something more is undoubtedly needed now for circulation among the people of other churches or of none.' Acknowledgement is then given to *The Times, Daily News, Chronicle* and *Morning Leader* for advertising the forthcoming London Missionary Society 'Orient in London' exhibition. It is evident from the choice of site, and from the publicity, that the missionaries consciously sought a public in addition to church congregations.

105. The Picton Hall in Liverpool, site of the 1909 Church Missionary Society exhibition 'Africa and the East', was also used for large colonial and ethnographic exhibitions, and for meetings and lectures organised by the adjoining Mayor and Derby Museums and the Liverpool County Public Library.

106. *Daily Graphic* (4 June 1908), mentions the London Missionary Society 'Orient in London' Exhibition Pageant, with music by the popular song writers Hamish McClunn and Hugh Moss.

107. See *The Times* (25 May 1908), p. 17; *Daily Graphic* (4 June 1908), p. 5; *The Times* (13 June 1912), p. 10.

108. See *ILN* (12 June 1909), p. 851; *The Times* (9 April 1909), p. 9 and (6 June 1909), p. 10; *The Times* (25 May 1908), p. 17, and (2 June 1908), p. 19; *Daily Graphic* (4 June 1908), p. 5.

109. It was customary to pay passage, board and lodging for any Africans participating in the exhibitions. See Church Missionary Society Library, H/H 30, E1A/A3, p. 82 and H/H E1A/C2, Minute Book for Exhibitions, part 4 (1909). The latter mentions the issue of hospitality for the African 'artisans' arriving on 19 April 1909, for the 'Africa and the East' Exhibition.

110. *Rochdale Observer* (18 November 1905).

111. *Ibid.*

112. Church Missionary Society, *A Manual for Stewards at Missionary Loan Exhibitions* (1899), p. 19.

113. This applied not only to the Edo but also to the Ashanti of Ghana, who also sustained a notoriously durable resistance to British rule until the end of the nineteenth century. Like the Edo, they were subjected to particularly brutal 'punitive expeditions' (the Ashanti wars) well-publicised in the popular press.

114. For an indication of the longstanding relationship between Haddon and missionaries of the London Missionary Society and other denominations, see Cambridge University Library, A.C. Haddon Papers, 3078 and 4067.

115. London Missionary Society, 'Orient in London, *Handbook to the Hall of Religions* (1908), p. 5.

116. *The Times* (2 June 1908), p. 19.

117. R. Lewis, 'The Hall of Religions. The Whole World at Worship', *Christian World*, Supplement (4 June 1908), p. xii.

118. *Ibid.*

119. *Ibid.*

120. London Missionary Society (1908), p. 7–14.

121. *Ibid.*, p. 19.

122. Henson (1974), pp. 26–32.

123. Stocking Jr. (1968), p. 79. As Susan Thorne points out (1991), p. 191, in the late nineteenth century the missionaries were far more concerned about presenting an image of themselves as modern and in touch with the latest developments in 'progressive' thinking.

124. Lewis (1908), p. xii.

125. London Missionary Society, *Official Handbook to 'Orient in London'* (1908), p. 6.

126. The Church Missionary Society collection, on the other hand, comprised mainly West African material.

127. *English Illustrated Magazine*, vol. XX (1899), pp. 81–4.

128. *Ibid.*, p. 83.

129. *Man*, vol. 9 (1909), p. 128.

130. *Exhibition Herald* (May 1908), p. 12. In connection with the London Missionary Society 1908 'Orient in London' exhibition, the writer says, 'We are indebted to Mr Read of the British Museum and to several professional collectors, of whom we may mention Mr Oldham of Brixton, whose house is a museum, Mr Fenton of Oxford Street and his brother, and Mr Webster of Great Russell Street.'

131. See Ajayi (1965) and Ayandele (1966).

132. Mudimbe (1988), p. 47. See also p. 51, where he discusses the perspectives of the Cameroon philosopher, Eboussi-Boulaga, on missionary discourse in Africa.

Chapter 9

1. Hobson (1968), p. 215, first edition 1902. See chapter four.

2. For an outline of the declared aims and objectives of the British Empire League, see C. Freeman Murray, 'The British Empire League', *United Empire*, vol. VI (1916), pp. 431–9.

3. *Franco-British Exhibition*, Official Guide to the Senegalese Village (1908), p. 11.

4. Ed. Dumas (1909), p. 8.

5. After forming London Exhibitions Limited in 1895, Imry Kiralfy was to became one of five men constituting the central organising force behind most major colonial exhibitions. Until 1904, Kiralfy devoted his energies to developing the Earl's Court Exhibition Centre (the brain-child of J.R. Whiteley in 1887). After this date, Kiralfy oversaw the construction of the Great White City exhibition site, opened on 3 January 1907. The Franco-British Exhibition was the first one to be held on this site.

6. *Franco-British Exhibition*, Official Guide (1908), p. 1.

7. *Ibid.*, p. 2.

8. *Ibid.* See too Dumas (1909), p. 5, who also mobilises this concept of racial characteristics: 'We are supposed to have no sentiment, and to care for nothing but material things and particularly our own advantage. This is a great mistake. We are not excitable, but we are far more sentimental than many excitable peoples; and the simple truth is, we are really fond of France and the French. They who are the most popular nation in the world, are nowhere more popular than here.'

9. See Lucy Bland, '"Guardians of the Race", or "Vampires Upon the Nations's Health"?: Female Sexuality and its Regulation in Early Twentieth Century Britain', in eds. Whitelegg et al. (1982), pp. 373–88; B. Porter (1968), p. 130. For an example of this anxiety over foreign competitors in the literature for the Franco-British exhibition, see *The Franco British Pictorial* (1908), p. 34, where the writer comments on Japan's success: 'Our Far Eastern Ally has certainly done well at the last half dozen international exhibitions, carrying off in many cases, prizes that we have done. Hence it is gratifying to note that, if our manufacturers like, they can make a show worthy of the prestige of England.'

10. Booth, 10 vols (1892–1903); Rowntree (1901).

11. See Semmel (1960); Searle (1971).

12. See eds. Langan and Schwarz (1985); Shannon (1974); Beloff (1969).

13. *The Times* (31 August 1908), p. 9.

14. *Ibid.*

15. *The Times* (27 July 1908), p. 9.

16. *The Times* (2 January 1908), p. 22. The French also made arrangements for parties of workers to go to the exhibition. *The Times* (11 May 1908), p. 6, mentions that the French Cabinet

had passed a Bill to provide a grant for a 'working-class delegation'. *The Times* also reports that 'some thousands' of French workers came over to Britain for the exhibition.

17. *Daily Graphic* (22 October 1908), p. 8, mentions Kentish Day at the Franco-British Exhibition. See also *The Times* (24 August 1908), p. 9.
18. See Blanch, 'Nation, Empire and the Birmingham Working Class', unpublished Ph.D. dissertation (1975); Steadman Jones (1983), pp. 179–238; B. Porter, 'The Edwardians and their Empire', in ed. Read (1982); Price (1972); Hobson (1901); Schumpeter (1955), (first edition 1919); Pelling (1979).
19. See Simon (1965).
20. It is perhaps significant in this context that the Franco-British Exhibition was catalogued in the Index of *The Times* (13 May 1908) under the heading 'The Empire and Foreign Affairs'.
21. Other notable figures on the executive committee of the Franco-British Exhibition included the Earl of Derby, president of the British Empire League; the Viscount Selby, chairman of the British Empire League; and Lord Blyth, who was an active member of the League.
22. For an analysis of the possible significances of the architectural structures at the exhibition, see Paul Greenhalgh, 'Art, Politics and Society at the Franco-British Exhibition of 1908', *Art History*, vol. 8, no. 4 (December 1985), pp. 434–52.
23. Ed. Dumas (1909), p. 277. See also Wright (1991), for a fascinating analysis of the implications of town planning in the French colonial context in the late nineteenth and early twentieth centuries.
24. A discussion of this example can be found in Gareth Stanton, 'The Oriental City: A North African Itinerary', *Third Text*, vol. 3/4 (Spring/Summer 1988), pp. 3–38.
25. *Ibid.*, p. 267. *Franco-British Exhibition*, Official Guide (1908), p. 46 reinforces this view by stating: 'On entering the Indian Pavilion the visitor is at once in the midst of a profusion of the best examples of the renowned sumptuary artistic wares of our great Asiatic possessions.'
26. *Franco-British Exhibition*, The Tunisian Products Catalogue (1908), pp. 64–8.
27. *Daily Mail Special Exhibition Number* (July–October 1908), p. 5.
28. *Sketch*, Supplement (1 July 1908), p. 3.
29. *Daily Mail Special Exhibition Number* (July–October 1908), p. 5.
30. *Franco-British Exhibition*, Descriptive Catalogue of Art Exhibits from the Mysore State (1908), p. 3.

31. *Ibid.*, p. 15 lists the cost of the showcase, exclusive of its contents, as 300 pounds. Ed. Dumas (1909), p. 267 mentions a carved sandalwood box from Mysore State on sale for 90 pounds.
32. Ed. Dumas (1909), pp. 267–8, lists the Punjab School of Art, School of Art of Madras, Bombay School of Art, and Lahore School of Art.
33. *Ibid.*, p. 268.
34. *Ibid.*, p. 270.
35. *Sierra Leone Weekly News* (28 November 1908), p. 4.
36. *Daily Mail Special Exhibition Number* (July–October 1908), p. 5.
37. *Ibid.*
38. *Ibid.*
39. *Ibid. The Times* (4 July 1908), p. 18, bears out this analysis.
40. *Lagos Weekly Record* (1 August 1908).
41. See chapter four, the Stanley and African Exhibition, where this was the predominant form of display.
42. See MacKenzie (1986), pp. 1–19.
43. See, in particular, *Franco-British Exhibition*, Catalogue of Exhibits, Southern Nigeria (1908).
44. See *ibid.*, pp. 21–30. This contains a complete list of objects displayed which included many carvings, utensils and games, together with masquerade paraphernalia, from a very large number of different societies in Southern Nigeria. See also *Franco-British Exhibition*, Catalogue of Exhibits from the Gold Coast (1908), pp. 15–19, which contains a list of general categories of exhibits, most of which were on loan from Captain Armitage, D.S.O. For an account of his collection of objects acquired while a government official on the Gold Coast, see J.B. Donne, 'The Celia Barclay Collection of African Art', *Connoisseur* (June 1972), pp. 88–95. See also Pitt Rivers Museum, Oxford, Barbara W. Aitken, née Freire-Marreco, papers, notebook, 1905–10, which contains a series of drawings of musical instruments from Africa exhibited at the Franco-British exhibition. See also *Franco-British Exhibition*, The Gambia, Catalogue of Exhibits (1908), pp. 15–19, for a list of 'curios'.
45. *Lagos Weekly Record* (3 December 1908).
46. *Lagos Weekly Record* (5 December 1908).
47. *Lagos Weekly Record* (3 December 1908).
48. *Franco-British Exhibition*, Catalogue of Exhibits, Southern Nigeria (1908), pp. 25–6.
49. *The Times* (13 August 1908), p. 6.
50. *The Times* (4 July 1908), p. 18.
51. *Sierra Leone Weekly News* (15 August 1908), p. 4.

52. *Ibid.*, p. 5.
53. For examples of the use of these groups in a variety of exhibitions, see chapter five.
54. The Imperial International Exhibition at White City in 1909 had a 'Dahomey Village', and the Coronation Exhibition, also held at White City, in 1911, had a 'Somali Village'. An exception to this came in the Festival of Empire at Crystal Palace, 1911, which had an exhibit called the 'Kaffir Kraal'. However, the indigenous black South African population did not serve the same function within the British colonial administration, and therefore would not have posed the same problems as a display.
55. See Ajayi (1965); Ayandele (1966).
56. See Coleman (1965), pp. 178–82.
57. *The Times* (3 June 1908), p. 8. There was certainly a degree of sensitivity over the term 'side-show'. This was especially the case when the English were implicated over the suggestion of using children for the Physical Education display in the Franco-British Exhibition. *The Times* (4 June 1908), p. 19, reports that the General Purposes Sub-Committee 'were strongly of the opinion that the children should not form a side-show in any public exhibition.'
58. Andrew Lang and H. Rider Haggard are other authors whose work falls into this category.
59. See chapter five.
60. *Man*, vol. 9 (1909), p. 128. See also Van Keuren (1982), pp. 135, where he charts the arguments put forward in the 1880s and 1890s by A.C. Haddon, among others, for an Imperial Bureau of Ethnography. In 1908, the scheme was revived again when a combined Anthropometric and Ethnographic Bureau was suggested to the government by a group of anthropologists, scientists and businessmen. Such requests for funding for such an organisation continued throughout the period 1890 to 1913. Significantly, much of the case for the bureau revolved around the applicability and value of ethnography and anthropology as a means of collecting data on minorities and 'aliens' who had settled in Britain, and, consequently, of supplying valuable information to aid in social and health reform. See William Crooke, 'Address to Section H [Anthropology]', *Report of the British Association for the Advancement of Science*, 80 (1910), pp. 724–5, and quoted in Van Keuren (1982), p. 139.
61. *Franco-British Exhibition*, Official Catalogue (1908), p. 69.
62. David Green, 'Veins of Resemblance: Francis Galton, Photography and Eugenics, *Oxford Art Journal*, vol. 7, no. 2 (1984), pp. 3–16; Ellis (1890).

63. *The Times* (12 June 1908), p. 8.
64. *The Times* (29 May 1908), p. 17.
65. *The Times* (12 June 1908), p. 8.
66. *Ibid.*
67. Eds. Mee, Hammerton, and Innes (1909).
68. *Ibid.*, vol. 7 (1909), p. 5548.
69. See, for example, ed., Walter Hutchinson, FRGS, FRAI, with an Introduction by A.C. Haddon, *Customs of the World, A Popular Account of the Manners, Rites and Ceremonies of Men and Women in All Countries*, London; eds. Joyce and Thomas (1909).
70. *Franco-British Exhibition*, Official Guide to the Senegalese Village (1908), p. 9. As a further means of ensuring this distance, the descriptions of these and other occupants of the 'village' are couched in the pseudo-scientific jargon of 'types', which also served to authenticate the display.
71. Comité National des Expositions Coloniales, *Exposition Franco-Britannique*, Londres (1908).
72. Harry Johnston, cited in eds. Mee, Hammerton, and Innes (1909), vol. 7, p. 5548.
73. Eds. Joyce and Thomas (1908), p. 760.
74. *Ibid.*, p. 761.
75. *Standard* (10 August 1908).
76. Sheehy (1980), p. 147.
77. *Ibid.*
78. Hutchinson (1987), p. 185. See also Robin Wilson, 'Imperialism in Crisis: the "Irish Dimension"', in eds. Langan and Schwarz (1985), pp. 151–78.
79. Ward (1983), p. 71.
80. *Ibid.*, p. 74.
81. *Ibid.*, pp. 71–84. Ward elaborates the position of different Irish women's organisations in relation to women's franchise over the period 1907 to 1911, and the conflicting positions of Inghinidhe na hÉireann, the Munster Women's Franchise League, and the Irishwomen's Franchise League.
82. See Liddington and Norris (1978); Rover (1974); Morgan (1975); Rowbottom (1974). Lisa Tickner's important book on the part played by visual culture and spectacle (1987), provides copious evidence of the multiple ways in which the Suffragettes were able to give their campaign a highly visible momentum. 1907 and 1908 saw many of the largest Suffragette rallies and marches, including the famous 1907 'Mud March' and the 1908 Hyde Park Rally.
83. *Franco-British Exhibition*, Official Catalogue (1908), p. 40.
84. *Franco-British Exhibition*, Official Catalogue to the Palace of Women's Work, Women's Section (1908), pp. XII–XIV. See also *The*

Times (29 May 1908), p. 17, which defines the female spectator solely in terms of middle-class philanthropy.

85. *Daily Chronicle* (10 August 1908).
86. Henry Balfour, 'Presidential Address', *Journal of the Anthropological Institute*, vol. XXXIV (1904), p. 16.
87. See, for example, *Museums Journal*, vol. 3 (June 1904), p. 403, where Balfour repeats his sentiments regarding the necessity of a National Museum. *Museums Journal*, vol. 1 (December 1901), p. 176, Professor Ray Lankester stresses the importance of local interest exhibits in regional museums. For direct proposals for either a national or a folk museum, see *Museums Journal*, vol. 5 (January 1906), p. 222; vol. 5 (March 1906), pp. 295–301; vol. 9 (July 1909), pp. 5–18; vol. 10 (March 1911), p. 252. Later references between 1912 and 1913 in the *Museums Journal* are more specifically concerned with proposals for transforming the Crystal Palace into a Museum of National Culture.
88. D. Harker, 'May Cecil Sharp Be Praised?' *History Workshop Journal*, vol. 14 (Autumn 1982), p. 54.
89. Sharp (1907), p. x, quoted in Harker (1982), p. 55.
90. See Jean Jamin, 'Les Objets Ethnographiques Sont-Ils des Choses Perdue?', in eds. Hainard and Kaehr (1985), pp. 51–74, where Jamin discusses the distinctions between the use of the concept of the 'popular' and the 'primitive' in French ethnography in the nineteenth century, and the various debates on the relative value of including sections on French 'folklore' in the Trocadero Museum in Paris – discussions which were revived in the 1930s.
91. *Franco-British Exhibition*, Official Guide to the Senegalese Village (1908), p. 8.
92. Errol Lawrence, 'Just Plain Common Sense: The "Roots" of Racism', in eds. Centre for Contemporary Cultural Studies (1982), pp. 45–94; Jordan (1969), p. 8.
93. See, for example, the *Franco-British Exhibition*, Official Guide (1908), p. 53.

Epilogue

1. I have deliberately restricted my attention to large international institutions in western metropolitan centres, rather than smaller local institutions, since these museums still unfortunately maintain a hegemonic position in relation to the representation of other cultures. For an interesting set of observations about the comparative function of what he calls 'majority' and 'tribal' museums, see James Clifford, 'Four Northwest Coast Museums: Travel Reflections', in eds Karp and Levine (1991), pp. 212–54.
2. See, for example, the following exhibitions: Museum of Mankind, *Lost Magic Kingdoms and Six Paper Moons from Nahuatl* (1986); Museum voor Volkenkunde, *Kunst uit een Andere Wereld* (1988); Beaubourg, *Les Magiciens de la Terre* (1989); Center for African Art and New Museum for Contemporary Art, *Africa Explores* (1991). The term 'post-colonial' is itself problematic. It has been the subject of analysis in a recent issue of *Social Text*, where commentators have explored the worrying social and political ramifications of such a term in the context of its ascendency in the academy – in both educational and cultural institutions – and in relation to the process of denial and disavowal that it can be said to mask. See Anne McClintock, 'The Angel of Progress: Pitfalls of the Term "Post-Colonialism"', *Social Text*, 31/32, vol. 10 (1992), pp. 84–98; Ella Shohat, 'Notes on the "Post-Colonial"', *Social Text*, 31/32, vol. 10 (1992), pp. 99–113. This is not to say that the term has not been appropriated for more radical and productive ends. See, in particular, Gayatri Chakravorty Spivak, 'Poststructuralism, Marginality, Postcoloniality and Value', in eds. Collier and Geyer-Ryan (1990).
3. Although this chapter is partly framed as a critique of the kind of position on 'hybridity' articulated by Peter Wollen, 'Tourism, Language and Art', *New Formations*, no. 12 (Winter 1990), pp. 43–59, he usefully traces the adoption of hybridising strategies as models of resistance or nationalism in particular moments of Mexican, Irish and Jewish history. I would agree with the following, who all argue for a strategic essentialism, while also recognising hybridity as an important strategy of oppositional identity. They recognise the contingent and conditional nature of both essentialism and hybridity as cultural strategies which *can* be mobilised as part of the political strategy of de-colonisation. See, for example, Stuart Hall, 'Cultural Identity and Diaspora' in ed. Rutherford (1990), p. 223; Benita Parry, 'Resistance Theory/Theorising Resistance', in eds Barker et al. (1993) and Spivak (1987).
4. See Cornel West, 'Black Culture and Postmodernism', in eds. Kruger and Mariani (1989), p. 91, where he writes: 'The issue here is not simply some sophmoric, moralistic test that surveys the racial bases of the interlocutors

in a debate. Rather the point is to engage in a structural and institutional analysis to see where the debate is taking place, why at this historical moment, and how this debate enables or disenables oppressed peoples to exercise their opposition to the hierarchies of power.'

5. Cornel West, 'The New Cultural Politics of Difference' in eds. Ferguson et al. (1990), pp. 19–36, charts some of the pitfalls and difficulties of the use of the concept of 'difference' as an analytic tool and also its progressive potential. In certain respects, the 'hybrid' or transculturated object as it is used in museum culture as a sign of postcoloniality, is subject to similar failings and also potentials.

6. See Carol Duncan and Alan Wallach, 'The Universal Survey Museum', *Art History* (3 December 1980).

7. I am indebted to Michel Melot, who was director of the library at the Beaubourg, for this information.

8. For one of the most interesting critical assessments of the Beaubourg, see Cultural Affairs Committee of the Parti Socialist Unifié, 'Beaubourg: The Containing of Culture in France', *Studio International*, 1 (1978), pp. 27–36.

9. *The Hidden Peoples of the Amazon* (1985), p. 11.

10. *Observer* (11 August 1985).

11. Quoted in J.D. Harrison, 'The Spirit Sings and the Future of Anthropology', *Anthropology Today*, vol. 4 (December 1988), p. 6. See also Jean Fisher, 'The Health of the People is the Highest Law', *Third Text*, 2 (Winter 1987), pp. 63–75.

12. Harrison (1988), p. 8.

13. *Ibid.*

14. It is as a result of such acutely aimed and orchestrated protests from often disempowered indigenous peoples, that the liberal white establishment is now being forced to take on board criticism that has become politically embarrassing. One such instance is the recent series on Britain's Channel 4 T.V.; 'The Savage Strikes Back'. Instead of focusing solely on the 'inevitability' of extinction, this series, produced in direct consultation with local rights groups, highlighted the organised political struggles of a number of indigenous peoples to regain control over their lands and their lives. It is also interesting that the Chicago Field Museum have felt obliged to shut down their display of Hopi artifacts after protests by Hopi representatives. I am grateful to Luke Holland, Lisa Tickner and Sandy Nairne for information on these points.

15. See, for example, Brett (1986); Jules-Rosette (1984).

16. Paul Gilroy, '"Cheer the Weary Traveller", W.E.B. Dubois and the Politics of Displacement', in eds. Barker et al (1994).

17. Whitechapel Art Gallery, 'From Two Worlds' (1986), Hayward Gallery, 'The Other Story' (1990). See also 'The Decade Show' (1990).

18. See, for example, eds. Hainard and Kaehr (1985) and (1989).

19. See Nestór García Canclini, 'Culture and Power: the State of Research', *Media, Culture and Society*, 10 (1988), pp. 467–97. Thanks to John Kraniauskas for bringing Canclini's work to my attention. See also Lisa Lowe, 'Heterogeneity, Hybridity, Multiplicity: Marking Asian-American Differences', *Diaspora* (Spring 1991), pp. 24–44.

20. Homi K. Bhabha, 'The Commitment to Theory', *New Formations*, 5 (Summer 1988), pp. 5–23.

21. National Curriculum Council, History at Key Stage 2: 'An Introduction to the Non-European Study Units' (1993).

22. Eyo and Willet (1982).

23. *Ibid.*, p. 19.

24. This episode is treated in detail in Kenneth Coutts-Smith, 'Some General Observations on the Problem of Cultural Colonialism', in ed. Hiller (1991), pp. 14–31. See also Mauch Messenger (1989) and Greenfield (1989). It is worth mentioning, in connection with another group of cultural objects whose 'ownership' has been hotly contested, that at the time of writing Professor Anna Benaki, the new Greek Minister of Culture, was in London publicising a new museum at the foot of the Acropolis. As a protest, certain walls of the museum will remain pointedly blank until the return to Greece of the Parthenon Marbles.

25. Wilson (1984).

26. *Ibid.*, p. 115.

27. The extraordinary fact that the delicate Benin plaques on the wall of the central staircase are neither replicas nor protected in any way, makes a nonsense of any conservationist argument for keeping them in Britain.

28. 'Man and Metal in Ancient Nigeria' was held at the British Museum from 15 May until 1 September 1991.

29. Eds. Corner and Harvey (1991), p. 10.

BIBLIOGRAPHY

Primary Sources

ARCHIVES AND MANUSCRIPTS

BRITISH LIBRARY, LONDON:
Parliamentary Papers, British Museum Accounts and Papers, 1897–1921
British Museum, Bloomsbury, London:
British Museum Book of Presents, 1897–1907
British Museum, Museum of Mankind, London:
Accession Files, 1890–1952
Africa A–N [STE], William Steains Notebooks

CAMBRIDGE UNIVERSITY LIBRARY, CAMBRIDGE:
Alfred Cort Haddon Papers:
 3078 London Missionary Society Correspondence
 5099 Comparative Religion
 4067 Missionary Correspondence
Mary Kingsley Papers: C.58, 79–81, Additional Manuscripts

CAMBRIDGE UNIVERSITY MUSEUM OF ARCHAEOLOGY AND ANTHROPOLOGY, CAMBRIDGE:
Annual Reports, 1885–1912
FG1/1/15, Box 97, W.D. Webster Sale
MM1/3/1, Box 14, Minutes of the Anthropology Syndicate, Board of Anthropological Studies
MM1/3/1, Box 18, Lectures, 1904–1911
MM1/6/13, Box 119, Correspondence Relative to the Accessions
Baron Anatole Von Hugel Papers: AA4/5/2, Box 63
W. Ridgeway Papers: W10/2, Box 110

CHURCH MISSIONARY SOCIETY LIBRARY, LONDON:
AL 63 Correspondence Files
H/H 30, A2–A8, Exhibitions Department Publicity
H/H 30, E1–E7, Exhibitions Department Minute Books, General Secretary Exhibitions Department Suggestion Books, Catalogue of Items in Exhibitions Department, 'Africa and the East': Guidebooks, Stewards Handbooks, Printed Ephemera

Registers of Donators to the Museum, 1890–1916

HORNIMAN FREE MUSEUM AND LIBRARY, LONDON:
Accession Files, 1890–1914
Annual Reports for the Horniman Free Museum, 1891–1914
Correspondence Files, 1897–1914
Donations

ISLINGTON LOCAL HISTORY LIBRARY, LONDON:
YA 008 (H850)–(H968), Documents and Minute Books for Events at the Royal Agricultural Hall, London

MERSEYSIDE COUNTY MUSEUM, LIVERPOOL:
Accession Files, 1890–1916
Annual Report of the Free Public Library, Museum and Walker Art Gallery of the City of Liverpool, 1890–1913
Donations and Purchases, 1866 onwards
Loans Book, 1890–1916
A. Ridyard Papers: Correspondence
J.A. Swainson Collection: 1–99

METHODIST MISSIONARY SOCIETY LIBRARY, LONDON:
Correspondence Files, 1890–1915

MUSEUM OF LONDON, LONDON:
Imre Kiralfy Collection: Box 7, Exhibitions

PITT RIVERS MUSEUM, OXFORD:
Annual Reports of the Pitt Rivers Museum, 1888–1920
Decrees and Letters, Private Correspondence
Donations I–III, Correspondence and Related Documents, 1890–1919
Material Relating to the Development of the Museum Purchases, 1890–1919
Barbara W. Aitken née Freire-Marreco (1879–1967) Papers: Notebook 1905–1910
E.B. Tylor Papers: Box 6 (1), (2)
Henry Balfour Papers (1863–1939): Balfour, South Africa, 1910

Oxford University Anthropology Society Miscellaneous Papers: VI E
Reverend W. Allen Papers

PUBLIC MUSEUM AND ART GALLERY, BRIGHTON:
Accessions File and Related Documents, 1890–1914
Annual Reports for the Public Museum and Art Gallery, 1890–1914

ROYAL GEOGRAPHICAL SOCIETY, LONDON:
William Steains Correspondence
Henry M. Stanley Papers: HMS 7/1

ROYAL SCOTTISH MUSEUM, EDINBURGH:
Accessions File and Loans, 1890–1914
Annual Reports of the Royal Scottish Museum, 1890–1914

SCHOOL OF ORIENTAL AND AFRICAN STUDIES, UNIVERSITY OF LONDON, LONDON:
Council for World Mission Archives: Q9/23–37, London Missionary Society
'Orient in London', Printed Ephemera Boxes 2–31A, London Missionary Society, 'Orient in London', Photographic Albums and Documents
Wesleyan Missionary Society Archives:
 Ellis, Mrs, 'Notes on the Mission House,' unpublished MS, no date
 MMS 766, Gold Coast Correspondence, 1893–1902
 MMS Boxes 1/1194–2/1195, Photographs

SOCIETY FOR THE PROPAGATION OF THE GOSPEL LIBRARY, LONDON:
X 111–X 1115, Exhibitions Department Annual Reports and Statistics, Secretary's Reports to Exhibitions Committee, Exhibitions Programmes, List of 'Curio' Donations and Correspondence
X 510–X 512, Exhibitions Committee Minutes
X 748, Exhibitions Department Balance Sheets

NEWSPAPERS AND JOURNALS

(Unless otherwise indicated in the title, the place of publication is London)

Aborigine's Friend
All The World
Anti-Slavery Reporter
Art in America
Awake
Birmingham Daily Graphic
Birmingham Daily Post
Black and White
Bradford Daily Telegraph
Bradford Observer
Bradford Telegraph
Bristol Times
Cambridge University Reporter
Christian World
Church Missionary Gleaner
Church Missionary Intelligence
Cornish Post
Crystal Palace Times
Daily Argus
Daily Graphic
Daily Mail
Daily Post and Mercury
Daily Telegraph
Echo
English Illustrated News
Examiner
Exhibition Herald
Globe
Halifax Naturalist
Homeworkers Gazette
Hull Daily News
Illustrated London News
Illustrated Sporting and Dramatic News
International Review of Missions
Islington Gazette
Journal of the African Society
Journal of the Anthropological Society
Journal of the Royal Anthropological Institute
Journal of the Society of Arts
Lagos Weekly Record
Leeds Murcury
Liverpool Courier
Liverpool Journal of Commerce
Man
Manchester Guardian
Monthly Record
Museums Journal
Nature
New Formations
Nottingham Guardian
Oxford University Gazette
Popular Science Monthly
Reliquary
Sierra Leone Weekly News
South London Press
Studio
The New Age
The Times
Third Text
Royal Anthropological Institute News
Universal Exhibition Guide and Industrial Review
West London Observer
Westminster Gazette
Yorkshire Daily Observer
Yorkshire Post

PRINTED SOURCES

Acland, Henry W., 'Typological Museums', *Journal of the Society of Arts*, vol. XL (25 December 1891), p. 136.

Allan, Reverend W., 'My Visit to Africa', *Church Missionary Gleaner* (September–December 1888).

Anonymous, 'Cast Metal Work from Benin', *Nature*, vol. 58 (July 7 1898), pp. 224–6.

Anonymous, 'The Manneheim Conference on Museums as Places of Popular Culture', *Museums Journal*, vol. 3 (October 1903), pp. 105–9.

Anonymous, 'The Liverpool Tropical Products Exhibition', *Quarterly Journal*, vol. 3, no. 6 (January 1908), pp. 76–82.

Anonymous, 'Museum Guides and Education', *Museums Journal*, vol. 12 (October 1912), pp. 112–16.

Armitage, Cecil and A.F. Monteiro, *The Ashanti Campaign of 1900*, London (1901).

Ashanti Village, Official Guide, London and Liverpool (no date).

Auchterlonie, T.B. and James Pinnock, 'The City of Benin: The Country Customs and Inhabitants', *Transactions of the Liverpool Geographical Society*, vol. VI (1898), pp. 5–16.

Bacon, Commander R.H., *Benin the City of Blood*, London (1897).

Balfour, Henry, *The Evolution of Decorative Art*, London (1893).

Balfour, Henry, *Notes on the Arrangement of the Pitt Rivers Museum*, Oxford (1893).

Balfour, Henry, 'Presidential Address', *Museums Journal*, vol. 9 (July 1909), pp. 5–7.

Balfour, Henry, 'Evolution in Decorative Art', *Journal of the Society of Arts*, vol. XLII (27 April 1894), pp. 455–71.

Balfour, Henry, 'The Relationship of Museums to the Study of Anthropology,' *Museums Journal*, vol. 3 (June 1904), pp. 396–408.

Balfour, Henry, 'Presidential Address to Section H. (Anthropology) of the British Association for the Advancement of Science', *Nature*, vol. LXX (September 1904), pp. 438–44.

Balfour, Henry, 'The Relationship of Museums to the Study of Anthropology', *Journal of the Anthropological Institute*, vol. XXXIV (1904), pp. 10–19.

Balfour, Henry, 'Modern Brass-Casting in West Africa', *Journal of the Royal Anthropological Institute*, vol. XL (1910), pp. 525–8.

Balfour, Henry and F.A. Bather, et al., 'A National Folk-Museum', *Museums Journal*, vol. 11 (February 1912), pp. 221–5.

Barnum and Bailey Greatest Show on Earth, Official Programme, London (1898).

Barnum and Bailey's Great Show, with an Authentic Life of the Late Mr P.T. Barnum, The District Railway Guide, London (1897–1898).

Benn, A.W., *Modern England; a Record of Opinion and Actions, from the Time of the French Revolution to the Present Day*, London (1908).

Bentley, W.H., *Pioneering on the Congo*, London (1900).

Bethnal-Green Museum, *Catalogue of the Anthropological Collection Lent by Colonel Lane Fox for Exhibition in the Bethnal-Green Museum*, London (1874 and 1877).

Birdwood, George, *Handbook to the British Indian Section*, Exposition Universelle de 1878, Paris (1878).

Birdwood, George, *Industrial Arts of India*, 2 vols., London (1880).

Birdwood, George, *Indian Art at the Marlborough House* (1898).

Birdwood, George, 'Conventionalism in Primitive Art', *Journal of the Society of Arts*, vol. LI (9 October 1903), pp. 881–9.

Birdwood, George, *Relics of the Honourable East India Company*, London (1909).

Blackburn, *Annual Report of the Free Public Library and Museum* (1864).

Blyden, E.W., *Liberia, Past, Present and Future*, Washington (1869).

Blyden, E.W., *The Prospects of the African*, London (1874?).

Blyden, E.W., *Christianity, Islam and the Negro Race*, London (1888).

Blyden, E.W., *A Chapter in the History of Liberia*, Freetown (1892).

Blyden, E.W., 'West Africa Before Europe', *Journal of the African Society*, vol. 2, no. 8 (1903), pp. 359–74.

Bentley, Mrs William Holman, *William Holman Bentley: The Life and Labours of a Congo Pioneer*, London (1907).

Boisragon, Captain Alan, *The Benin Massacre*, London (1897).

Booth, Charles, *Life and Labour of the People in London*, London, 10 vols (1892–1903).

Brighton Public Museum and Art Gallery, *Popular Guide to the Brighton Public Museum*, Brighton (pre-1902), other editions 1908, 1909, 1910, 1911, 1913.

Briton, Boer and Black in Savage South Africa, Libretto and Programme Combined, London (1899–1900).

Briton, Boer and Black in Savage South Africa, Official Programme, London (1899–1900).

Buckman, S.S. 'Neglect of Opportunities', *Museums*

Journal, vol. 3 (April 1904), pp. 312–21.

Caddie, A.J., 'The Board of Education and Provincial Museums', *Museums Journal*, vol. 10, no. 5 (1910), pp. 126–32.

Cambridge, Museum of General and Local Archaeology and of Ethnology, *Catalogue of the Antiquarian Collections*, Cambridge (1892).

Carter, Huntly, 'How to Promote the Uses of Museums by an Institute of Museums', *Museums Journal*, vol. 7 (December 1907), pp. 193–204.

Cartwright Memorial Hall Inaugural Exhibition, 1904:

Manager's Report to the Executive Committee and Honorary Treasurer's Statement of Accounts, Bradford (1905).

Official Catalogue of Exhibits and Entertainments with Lists of President, Vice-Presidents, Committees, Officials, Exhibitors and Advertisers, Bradford (1904).

Official Souvenir, Bradford (1904).

Church Missionary Society, *Handbook of the Foreign Missionary Loan Exhibition and Sale of Works to be Held at Brigly Hall*, Birmingham, London (1896).

Church Missionary Society, *A Manual for Stewards at Missionary Loan Exhibitions*, London (1899).

Church Missonary Society, *Africa and the East Notes for Stewards and Workers*, no. 2 (January 1909).

Church Missionary Society, *Africa and the East*, guidebook for Liverpool, London (1909).

Church Missionary Society, *Guide to Africa and the East*, London (1909).

Church Missionary Society, *Notes on Special Exhibits at Missionary Exhibitions*, London (1909).

Church Missionary Society, *An Official Guide to Africa and the East*, Tonbridge, London (1909).

Church Missionary Society, *Pamphlet Notes on the Pictures in the Arcade Gallery*, London (1909).

Church Missionary Society, *Africa and the East Official Handbook*, London (1922).

Churchill, Winston, 'The Development of Africa', *Journal of the African Society*, vol. VI, no. 23 (1907), pp. 291–6.

Clarke, S.E.J., 'India and its Women', *Journal of the Society of Arts*, vol. XLIII (15 February 1895), pp. 262–77.

Cockburn, Sir John A., 'The Franco-British Exhibition', *Journal of the Society of Arts*, vol. LVI (29 November 1907), pp. 23–33.

Coles, John, ed., *Hints to Travellers, Scientific and General*, 2 vols., 8th ed., London (1901).

Coronation Exhibition, 1911:

Official Daily Programme, London (1911).

Official Guide and Catalogue, London, 1911.

Programme, London, 1911.

Coronation Exhibition of the British Empire, 1911, *Programme*, London (1911).

Crowther, Bishop S., *Journal of a Visit to the Niger Mission*, London (1868).

Crystal Palace, *The Ashanti Village in the North Tower Garden*, London (no date).

Curzon, Lord, 'Indian Art', *Journal of the Society of Arts*, vol. LI (2 January 1903), p. 128.

Dalton, O.M., 'Booty from Benin', *The English Illustrated Magazine*, vol. XVIII (1898), pp. 419–29.

Dalton, O.M., *Report on Ethnographic Museums in Germany*, London (1898).

Dalton, O.M., 'Note on an Unusually Fine Bronze Figure from Benin', *Man*, vol. 3 (1903), p. 185.

Dalton, O.M., 'Review of Evolution of Cultures', *Man*, vol. 7 (1907), pp. 108–9.

Day, Lewis Foreman, 'How to Make the Most of a Museum', *Journal of the Society of Arts*, vol. LVI (10 January 1908), pp. 146–160.

Dennett, R.E., *Nigerian Studies: or the Religious and Political Systems of the Yoruba*, London (1910).

Dennett, R.E., *At the Back of the Black Man's Mind or Notes on the Kingly Office in West Africa*, London (1906).

Dernburg, 'Germany and England in Africa', *Journal of the African Society*, vol. IX, no. 34 (1909–1910), pp. 113–19.

Dumas, F.G., *Franco-British Exhibition Illustrated Review*, London (1908).

Earl's Court Industrial Exhibition, *Daily Programme, Monday, August 13, 1894*, London (1894).

East, Alfred, 'The Sentiment of Decoration', *Journal of the Society of Arts*, vol. LII (13 May 1904), pp. 563–72.

Elgee, C.H., 'The Ife Stone Carvings', *Journal of the African Society*, vol. VII, no. 28 (1908), pp. 338–43.

Ellis, Havelock, *The Criminal*, London (1890).

Fison, C.J. and H.G. Malaher, *A Manual for Stewards at Missionary Loan Exhibitions*, London (1899).

Flinders Petrie, W.M., *Egyptian Decorative Art, A Course of Lectures Delivered at the Royal Institution*, London (1895).

Flinders Petrie, W.M., 'A National Repository for Science and Art', *Journal of the Society of Arts*, vol. XLVIII (18 May 1900), pp. 525–36.

Flower, William Henry, *Essays on Museums and Other Subjects Connected with Natural History*, London (1898).

Flower, William Henry, 'Inaugural Address to the British Association for the Advancement of Science', *Nature*, vol. 40 (September 1889), pp. 464–9.

Forbes, H.O., 'On a Collection of Cast Metal Work

of High Artistic Value, From Benin, Lately Acquired for the Mayer Museum', *Bulletin of the Liverpool Museums*, vol. 1 (1898), pp. 49–70.

Forbes, H.O., 'Cast Metal Work from Benin', *Bulletin of the Liverpool Museums*, vol. 2 (1900), pp. 13–14.

Fox Bourne, H., *The Claims of Uncivilised Races*, London (1900).

Franco-British Exhibition, 1908:
Official Programme, London (1908).
Official Souvenir, London (1908).
The Senegal Village, London (1908).

The French Exhibition, *Daily Programme, Tuesday, October 7, 1890*, London (1890).

Freshfield, D.W. and J.L. Wharton, *Hints to Travellers, Scientific and General*, London (1893).

Gallwey, Henry L., 'Journeys in the Benin Country, West Africa', *Geographical Journal*, vol. 1, no. 2 (1892), pp. 122–30.

Galton, F., 'On the Application of Composite Portraiture to Anthropological Purposes', *British Association Report*, 51 (1881), pp. 690–1.

Garson, J.G., and Charles Hercules Read, eds., *Notes and Queries on Anthropology*, 3rd ed., London (1899).

Geddes, Professor, 'The Museum and the City', *Museums Journal*, vol. 7 (May 1908), pp. 371–81.

Goldie, H., *Calabar and its Missions*, Edinburgh (1890).

Goode, George Brown, ed., *The Smithsonian Institution 1846–1896*, Washington D.C. (1897).

Goode, George Brown, 'The Museums of the Future', *Annual Report of the United States National Museum: Year Ending June 30, 1897*, Washington D.C. (1898).

Gordon, Helen C., 'Lesser Known Museums: the London Missionary Society Museum', *English Illustrated Magazine*, vol. XXI (April–September 1899), pp. 81–4.

Gray, John, 'An Anthropometric Survey: Its Utility to Science and to the State', *Journal of the Society of Arts*, vol. LII (2 September 1904), pp. 780–1.

Greater Britain Exhibition, Earl's Court, The District Railway Illustrated Guide, London (1899).

Greenwood, Thomas, 'The Place of Museums in Education', *Science*, 22 (1893), pp. 246–8.

Haddon, A.C., *The Decorative Art of British New-Guinea*, Dublin (1894).

Haddon, A.C., *Evolution in Art*, London (1895).

Haddon, A.C., *The Study of Man*, London (1898).

Haddon, A.C., 'What the United States of America is Doing for Anthropology', *Journal of the Anthropological Institute*, vol. XXXII (1902), pp. 8–24.

Haddon, A.C., 'What the United States of America

is Doing for Anthropology', *Nature*, vol. LXVI (August 1902), pp. 430–1.

Hamy, E.T., *Les Origines du Musée d'Ethnographie, Histoire et Documents*, Paris (1890).

Harrison, H.S., 'Ethnographical Collections and their Arrangement', *Museums Journal*, vol. 14 (January 1915), pp. 220–5.

Hartley, Harold, *Eighty-Eight Not Out. A Record of Happy Memories*, London (post 1906).

Her Majesty's Government, *The West African Pocketbook – a Guide to Newly Appointed Government Officers*, London (1916).

Holmes, William H., 'A Study of the Textile Art in its Relations to the Development of Form and Ornament', *Annual Report, Bureau of Ethnology*, vol. 6 (1884–1885), pp. 189–252.

Holmes, William H., 'On the Evolution of Ornament – an American Lesson', *American Anthropologist*, vol. 3 (o.s.) (1890), pp. 137–46.

Holmes, William H., 'Use of Textiles in Pottery Making and Embellishment', *American Anthropologist*, vol. 3 (1901), pp. 397–403.

Holmes, William H., 'Classification and Arrangement of the Exhibits of an Anthropological Museum', *Journal of the Anthropological Institute*, vol. XXXII (1902), pp. 353–72.

Horniman Free Library, *The Horniman Museum, A Handbook to the Library*, London, 1st ed. (1905).

Horniman Free Museum:
Guide to Surrey House Museum, London (c. 1890).
Guide for the Use of Visitors When Inspecting the Contents of Surrey House Museum, London, 3rd ed. (1890).
Guide for the Use of Visitors to the Horniman Museum, London, 10th ed. (no date).
Guide for the Use of Visitors, The Horniman Free Museum and Grounds, London, 13th ed. (1896).
London County Council Guide for the Uses of Visitors to the Horniman Museum and Library, London (1905).
Handbooks in Ethnology; *No. 8, Weapons of War and the Chase*, London (1908).
Handbooks in Ethnology; *Nos. 9 and 10, Handbook to the Cases Illustrating Stages in the Evolution of the Domestic Arts, Parts I and II*, London (1910).
Guide for the Use of Visitors to the Horniman Museum and Library, Forest Hill, London, S.E., London (1912).

Hoyle, William E., 'The Use of Museums in Teaching', *Museums Journal*, vol. 2 (February 1903), pp. 229–39.

Hoyle, William E., 'The Education of a Curator', *Museums Journal*, vol. 6 (July 1906), pp. 4–24.

Hutchinson, Johnathan, 'On Museum Education',

Museums Journal, vol. 8 (July 1908), pp. 5–23.

The Imperial International Exhibition, 1909:
Catalogue, London (1909).
The Dahomey Village, London (1909).
The Kalmuck Camp, London (1909).
Souvenir, London (1909).

The International Fire Exhibition, 1903:
Catalogue, London (1903).
Official Record, London (1903).

The International Horticultural Exhibition, *Daily Programme, 9 September, 1892*, London (1892).

The International Universal Exhibition, 1898, London (1898).

The Italian Exhibition, 1904, *Official Programme*, London (1904).

Johnson, Reverend Samuel, *History of the Yorubas from the Earliest Times to the Beginning of the British Protectorate*, London (1921, 1st. ed. 1897).

Jones, Robert, 'Physical and Mental Degeneration', *Journal of the Society of Arts*, vol. LII (4 March 1904), pp. 327–43.

Joyce, T.A., 'Note on the Relation of the Bronze Heads to the Carved Tusks, Benin City', *Man*, vol. 8 (1908), pp. 2–4.

Joyce, T.A., 'On a Wooden Portrait-Statue from the Bushonge People of the Kasai District, Congo State', *Man*, vol. 10 (1910), pp. 1–2.

Keane, A.H., *Ethnology*, Cambridge (1901, 1st ed., 1895).

Kemp, Reverend Dennis, *Nine Years at the Gold Coast*, London (1898).

Kingsley, Mary, *Travels in West Africa*, London (1897).

Kingsley, Mary, *West African Studies*, London (1899).

Knocker, F.W., 'The Practical Improvement of Ethnographical Collections in Provincial Museums', *Museums Journal*, vol. 8 (November 1909), pp. 191–208.

Lee, J. Bridges, 'Photography as an Aid to the Exploration of New Countries', *Journal of the African Society*, vol. I (1901–1902), pp. 302–11.

Ling Roth, H., 'Notes on Benin Art', *Reliquary*, vol. IV (1898), pp. 161–72.

Ling Roth, H., 'Primitive Art from Benin', *Studio*, vol. 15, no. 69 (1898), pp. 174–83.

Ling Roth, H., *Great Benin: Its Customs, Arts and Horrors*, Halifax (1903).

Ling Roth, H., 'On the Use and Display of Anthropological Collections in Museums', *Museums Journal*, vol. 10 (April 1911), pp. 286–90.

Liverpool Museum, *Bulletin of the Liverpool Museums*, Liverpool (1898).

London Missionary Society:

Illustrated Souvenir of the Orient in London, London (1908).
Official Handbook to the Orient in London, London (1908).
The Orient in London, *Handbook to the Hall of Religions*, London (1908).
The Orient in London, *Souvenir Programme*, London (1908).

Lovett, Edward, 'A Folk Museum', *Museums Journal*, vol. 5 (March 1906), pp. 295–301.

Lowe, Charles, *Four National Exhibitions in London and their Organiser*, London (1892).

Lumholtz, Carl, 'Conventionalism in Primitive Design', *Journal of the Society of Arts*, vol. LI (21 August 1903), pp. 785–97.

MacLauchlan, John, 'Museums Association Presidential Address', *Museums Journal*, vol. 6 (July 1907), pp. 4–17.

Macleod, Olive, *Chiefs and Cities of Central Africa*, Edinburgh and London (1912).

Maguire, Peter, 'West African Dyeing', *Journal of the African Society*, vol. 5, no. 18 (1906), pp. 151–3.

March, H.C., 'The Meaning of Ornament; or Its Archaeology and Psychology, *Transactions of the Lancashire and Cheshire Antiquarian Society*, vol. 7 (1889), pp. 160–92.

March, H.C., 'Polynesian Ornament, a Mythography; or, a Symbolism of Origin and Descent', *Journal of the Anthropological Institute*, vol. XXII (1893), pp. 307–33.

Merriman Labor, A.B.C., *Britons Through Negro Spectacles*, or *A Negro on Britons*, London (1909).

Military Exhibition, *Official Guide*, London (1901).

Moore, Sir R., *Blue Book Africa*, no. 6 (1897).

Myres, John L., 'A Terminology of Decorative Art', *Man*, vol. 7, (1907), pp. 143–4.

Myres, John L., 'The Influence of Anthropology on the Course of Political Science', *Nature*, vol. LXXXI (September 1909), pp. 379–84.

Naval, Shipping and Fisheries Exhibition, 1905, *Official Guide*, London, 1905.

Neville, George W., 'Benin City – the Mysterious', *Bank of British West Africa Ltd, Staff Magazine* (1913), pp. 9–18.

Ogden's Penny Guide to Glasgow and the International Exhibition of 1901, Glasgow and London (1901).

'The Orient' at Olympia, *Daily Programme*, London (1894).

Pinnock, James, *Benin: The Surrounding Country, Inhabitants, Customs and Trade*, Liverpool (1897).

Pitt Rivers [Colonel A. Lane Fox], *On the Principles of Classification Adopted in the Arrangement of the Anthropological Collection Now Exhibited in the Bethnal Green Museum*, London (1874).

Pitt Rivers [A. Lane-Fox], *Catalogue of the Anthropological Collection . . . in the Bethnal Green Branch of the South Kensington Museum*, London (1874).

Pitt Rivers, A.H., 'Principles of Classification', *Journal of the Anthropological Institute*, vol. 4 (1875), pp. 293–308.

Pitt Rivers [Lieutenant-General], 'Typological Museums, As Exemplified by the Pitt Rivers Museum at Oxford, and His Provisional Museum at Farnham, Dorset', *Journal of the Society of Arts*, vol. XL (18 December 1891), pp. 115–22.

Pitt Rivers [Lieutenant-General], *Antique Works of Art from Benin*, private (1900).

Pitt Rivers, A.H., *The Evolution of Cultures and Other Essays*, Oxford (1906).

Portman, M.V., 'Photography for Anthropologists', *Journal of the Anthropological Institute*, vol. XXV (1896), pp. 75–87.

Punch, C. 'Further Note on the Relation of the Bronze Heads to the Carved Tusks, Benin City', *Man*, vol. 8 (1908), p. 84.

Quick, Richard, 'Benin Carvings', *Seventh Annual Report of the Horniman Museum* (1897 and January 1898), pp. 18–19.

Quick, Richard, 'Tallies Used by Savages', *Reliquary*, vol. IV (1898), pp. 189–92.

Quick, Richard, 'Notes on Benin Carvings', *Reliquary*, vol. V (1899), pp. 248–55.

Quick Richard, 'On Bells', *Reliquary*, vol. VI (1900), pp. 226–41.

Quick, Richard, 'Primitive Art as Exemplified in Tobacco Pipes', *Studio*, vol. XXXIII, no. 140 (November 1904), pp. 133–8.

Read, C.H., 'On the Origin and Sacred Character of Certain Ornaments of the South Eastern Pacific', *Journal of the Anthropological Institute*, vol. XXI (1892), pp. 139–59.

Read, C.H., and O.M. Dalton, 'Works of Art from Benin City', *Journal of the Anthrological Institute*, vol. XXVII (1898), pp. 362–82.

Read, C.H., *Antiquites from the City of Benin and from Other Parts of West Africa in the British Museum*, London (1899).

Read, C.H., 'Presidential Address', *Journal of the Anthropological Institute*, vol. XXX (1900), pp. 6–21.

Read, C.H., 'Presidential Address', *Journal of the Anthropological Institute*, vol. XXXI (1901), pp. 9–19.

Read, C.H., *Queries for Central Africa*, London (1905).

Read, C.H., *British Museum Handbook of the Ethnographic Collection*, London (1910).

Read, C.H., 'Notes on Certain Ivory Carvings from Benin', *Man*, vol. 9–10 (1910), pp. 49–51.

Ridgeway, William, 'The Application of Zoological Laws to Man', *Nature*, vol. LXXVII (September 1908), pp. 525–33.

Ripley, W., *The Races of Europe*, London (1900).

Risley, Sir Herbert, 'The Method of Ethnography', *Journal of the Royal Anthropological Institute*, vol. XLI (1911), pp. 8–19.

Rivers, N.H.R., 'The Ethnological Analysis of Culture', *Nature*, vol. LXXXVII (September 1911), pp. 356–60.

Robinson, C.H., *Specimens of Hausa Literature*, Cambridge (1896, repr., 1969).

Robinson, C.H., *Dictionary of the Hausa Language*, 2 vols., Cambridge (1899, repr., 1907, 1925).

Roscoe, J., *The Baganda: an Account of their Native Customs and Beliefs*, London (1911).

Rowntree, B. Seebohm, *Poverty, A Study of Town Life*, London (1901).

Royal College of Surgeons, *Descriptive and Illustrated Catalogue of the Physiological Series of Comparative Anatomy*, 7 vols (1st ed. 1833–1852; 2nd ed. 1901–1903).

Seme, P. Ka Isaka, 'The Regeneration of Africa', *Journal of the African Society*, vol. V, no. 20 (1906), pp. 404–8.

Simon, Alfred M., 'Reduced Facsimile of the Souvenir Album of the Franco-British Exhibition, London, 1908', presented to the House of Moët and Chandon by the A.M.S., London, 1909.

Simon, Alfred M., *Reduced Facsimile of the Souvenir Album of the Franco-British Exhibition*, London (1909).

Sims, George R., *Living London*, 3 vols., London (1903).

Society for the Propagation of the Gospel:
 Guide and Handbook for Missionary Exhibition at Church House, Westminster, London (1912).
 Missionary Exhibition Department, *Handbook of West Africa*, London (1921).

Stanley and African Exhibition, *Catalogue of the Exhibits*, London (1890).

Stannus, Hugh, 'Native Paintings in Nyazaland', *Journal of the African Society*, vol. IX, no. 36 (1910), pp. 184–7.

Steven, Dorothy, *Africa and the East*, London (1909).

Stolpe, K.H., *Collected Essays in Ornamental Art*, Stockholm (1927).

Temple, Captain R.C., 'The Formation and Uses of An Anthropological Museum', *Journal of the Anthropological Society of Bombay*, vol. 1, no. 3 (1888).

Thompson, E. Maunde, *A Guide to the Exhibition Galleries of the British Museum* [Bloomsbury], London (1899).

Torday, Emil, 'On the Ethnography of the Ba-Mbala', *Journal of the Anthropological Society*, vol. XXXV (1905), pp. 398–422.

Torday, Emil, 'Notes on the Ethnography of the Ba-Huana', *Journal of the Anthropological Institute*, vol. XXXVI (1906), pp. 272–300.

Torday, Emil, 'Notes on the Ethnography of the Ba-Yaka, with a Supplementary Note to "Notes on the Ethnography of the Ba-Mbala", vol. XXXV, p. 398', *Journal of the Anthropological Institute*, vol. XXXVI (1906), pp. 39–59.

Torday, Emil, 'On the Ethnology of the South Western Congo Free State', *Journal of the Anthropological Institute*, vol. XXXVII (1907), pp. 133–56.

Torday, Emil, *Camp and Tramp in the African Wilds!*, London (1913).

Torday, Emil, *On the Trail of the Bushongo*, London (1925).

Torday, Emil, and T.A. Joyce, 'Note on the Southern Ba-Mbala', *Man*, vol. 7 (1907), pp. 81–4.

Tregaskis, J., *Antique Benin Bronzes and Other Works of Art*, London (1902).

Tremearne, Major A.J.N., *The Tailed Head-Hunters of Nigeria*, London (1913).

Tucker, Sarah, *Abeokuta; or Sunrise Within the Tropics: An Outline of the Origin and Progress of the Yoruba Mission*, London (1853).

Tylor, E.B., *Primitive Culture*, 2 vols., London (1871).

Waddell, H., *Journals*, vol. 1 (1846).

Watson, J. Cathcart, 'Lecture at the Imperial Institute on the Importance of West Africa', *Journal of the African Society*, vol. V, no. 20 (1906), pp. 421–31.

Watt Smyth, A., *Physical Deterioration: Its Causes and the Cure*, London (1904).

Weeks, Reverend John H., *Congo Life and Folklore*, London (1911).

Weeks, Reverend John H., *Among Congo Cannibals*, London (1913).

Weeks, Reverend John H., *Among the Primitive Bakongo*, London (1914).

Werner A., 'Anthropology and Administration', *Journal of the African Society*, vol. VI, no. 27 (1907), pp. 281–5.

Werner A., 'Bushman Paintings', *Journal of the African Society*, vol. VII, no. 28 (1908), pp. 387–93.

Wheatley, Henry B., *London Past and Present: Its History, Associations and Traditions (Based upon the Handbooks of London by Peter Cunningham)*, 3 vols., London (1891).

Whithouse, A.A., 'An African Fetish', *Journal of the African Society*, vol. IV, no. 16 (1905), pp. 412–16.

Whithouse, A.A., 'An Ibo Festival', *Journal of the African Society*, vol. IV, no. 13 (1904), pp. 134–5.

Woman's Exhibition, 1900, *Daily Programme, 2 June*, London (1900).

Women of All Nations Exhibition of Arts and Crafts and Industries, *Guide*, London (1909).

The Wonder Book of Freaks and Animals in the Barnum and Baily Greatest Show on Earth, London (1898).

Secondary Sources

Adam, Thomas Ritchie, *The Civic Value of Museums*, New York (1937).

Adam, Thomas Ritchie, *The Museum and Popular Culture*, New York (1939).

Adams, H.G., *Anthropological Essays Presented to E.B. Tylor in Honour of his Seventy-fifth Birthday, October 2 1907*, London (1907).

Adamson, W., *Hegemony and Revolution: A Study of Antonio Gramsci's Political and Cultural Theory*, Berkeley (1980).

Ade Ajayi, J.F., *Christian Missions in Nigeria, 1841–1891: The Making of a New Elite*, Harlow (1965).

Akenzua, Edun, 'Benin – 1897: A Bini's View', *Nigeria Magazine*, no. 65 (June 1960), pp. 177–90.

Altick, Richard D., *The Shows of London*, Cambridge, Mass. (1978).

Allwood, John, *The Great Exhibitions*, London (1977).

Althusser, Louis, 'Ideology and Ideological State Apparatuses (Notes towards an Investigation)', in *Essays on Ideology*, London (1984), pp. 1–60.

Anonymous 'The Horniman Museum', *Gentleman's Journal* (March 1898), pp. 2938–9.

Anonymous 'The New Liverpool Museums Extension Building', *Nature*, vol. 59 (December 1898), pp. 209–11.

Anonymous, 'Exhibitions in Great Britain and Ireland Since 1890', *Journal of the Society of Arts*, vol. LV (June 1907), pp. 802–5.

Appadurai, Arjun, ed., *The Social Life of Things, Commodities in Cultural Perspective*, Cambridge (1986).

Asad, Talal, *Anthropology and the Colonial Encounter*, London (1973).

Baeta, C.G., ed., *Christianity in Tropical Africa*, London (1968).

Bailey, P.C., *Leisure and Class in Victorian England: Rational Recreation and the Contest for Control, 1830–1885*, London (1978).

Bane, Martin J., *Catholic Pioneers in West Africa*, Dublin (1955).

Barber, K. and P. de Moraes Farias, *Self-Assertion and Brokerage: Early Cultural Nationalism in West Africa*, Birmingham (1990).

Barnes, Irene H., *In Salisbury Square*, London (1906).

Barrett Michele, Philip Corrigan, Annette Kuhn and Janet Wolff, *Ideology and Cultural Production*, London (1979).

Barrett, Michele, *Women's Oppression Today*, London (1980).

Baudet, H., *Paradise on Earth; Some Thoughts on European Images of Non-European Man*, New Haven, Conn. (1965).

Bayly, C.A., *The Raj, India and the British*, London (1990).

Bebbington, D.W., *Nonconformist Conscience, Chapel and Politics, 1870–1914*, London (1982).

Beckett, Jane and Deborah Cherry, eds., *The Edwardian Era*, Oxford (1987).

Ben Amos, Paula, *The Art of Benin*, London (1980).

Benedict, Burton, *The Anthropology of World's Fairs; San Francisco's Panama Pacific International Exposition of 1915*, Berkeley (1983).

Benjamin, Walter, *Illuminations*, New York (1968).

Bennett, Tony, 'Popular culture: defining our terms', Open University Course U 203, *Popular Culture: Themes and Issues*, Milton Keynes (1981).

Bennett, Tony, 'The Exhibitionary Complex', *New Formations*, no. 4 (Spring 1988), pp. 73–102.

Bernal, Martin, *Black Athena, The Afroasiatic Roots of Classical Civilisation*, vol. 1 (London 1987).

Bhabha, Homi K., 'The Commitment to Theory', *New Formations*, 5 (Summer 1988) pp. 5–23.

Bhabha, Homi K., 'The Other Question: The Stereotype and Colonial Discourse', *Screen*, 24, No. 6 (November–December 1983) pp. 18–36.

Bingham, Frederick, *Official Guide to the Metropolitan Borough of Islington*, London (1917).

Birkett, Dea, *Spinsters Abroad, Victorian Lady Explorers*, London (1991).

Birkett, Dea, *Mary Kingsley, Imperial Adventuress*, London (1992).

Blackwood, Beatrice, 'The Origin and Development of the Pitt Rivers Museum', in T. Penniman and B. Blackwood, eds., *Occasional Papers on Technology*, II (1970), pp. 7–16.

Blake, J.W., *Europeans in West Africa*, vol. 1, London (1941).

Blanch, M.D., 'Nation, Empire and the Birmingham Working Class', unpublished Ph.D. dissertation, University of Birmingham (1975).

Bland, Lucy, ' "Guardians of Race", or "Vampires Upon the Nation's Wealth"; Female Sexuality and its Regulation in Early Twentieth Century Britain', in Elisabeth Whitelegg, Madeleine Arnot Else Bartels, Veronica Beechey, Lynda Birke, Susan Himmelweit, Diana Leonard, Sonja Ruehl and Mary Ann Speakman, eds., *The Changing Experience of Women*, Oxford (1982), pp. 373–88.

Boas, F., *Race, Language and Culture*, New York (1940).

Bolt, Christine, *Victorian Attitudes to Race*, London (1971).

Bourdieu, Pierre, *Distinction: A Social Critique of the Judgement of Taste*, London (1984).

Brah, Avtar, 'Difference, Diversity, Differentiation',in eds. Donald, James and Ali Rattansi, *Race, Culture and Identity*, London (1992), pp. 126–45.

Brantlinger, Patrick, 'Victorians and Africans: The Genealogy of the Myth of the Dark Continent', *Critical Inquiry*, vol. 12, no. 1 (Autumn 1985), pp. 166–203.

Brantlinger, P., *Rule of Darkness: British Literature and Imperialism, 1830–1914*, Ithaca (1988).

Braunholtz, H.J., 'A History of Ethnography in the Museum After 1753', *British Museum Quarterly*, 18 (1953), part I, pp. 93–5; part 2, pp. 108–20.

Braunholtz, H.J., *Sir Hans Sloane and Ethnography*, London (1970).

Brett, Guy, *Through Our Own Eyes*, London (1986).

Brigand, Emile de, 'The History of Ethnographic Film', in P. Hockings, ed.,*The Principles of Visual Anthropology*. The Hague (1975), pp. 13–43.

Bristow, Edward J., *Vice and Vigilance*, London (1977).

Brooks, A.D., and F.A. Fletcher, *British Exhibitions and their Postcards*, Parts I and II, privately published (1978–1979).

Brown, Lucy, *Victorian News and Newspapers*, Oxford (1985).

Burrow, J.W., *Evolution and Society; A Study in Victorian Social Theory*, Cambridge (1966).

Cairns, A.C., *Prelude to Imperialism: British Reactions to Central African Society, 1840–1890*, London (1965).

Calloway, Helen, *Gender, Culture and Empire, European Women in Colonial Nigeria*, Oxford (1987).

Canclini, Néstor García, 'Culture and Power: the State of Research', *Media, Culture and Society*, 10 (1988), pp. 467–97.

Caygill, Marjorie, *The Story of the British Museum*, London (1981).

Centre for Contemporary Cultural Studies, ed, *The Empire Strikes Back: Race and Racism in 70's Britain*, London (1982).

Certeau, M. de, *The Practice of Everyday Life*, Los Angeles (1984).

Chapman, William Ryan, 'Ethnology in the Museum: A.H.L.F. Pitt Rivers (1827–1900) and the Institutional Foundations of British Anthropology', 2 vols, unpublished Ph.D. dissertation, University of Oxford (1981).

Chaudhuri, Nupur and Margaret Strobel, *Western Women and Imperialism, Complicity and Resistance*, Bloomington (1992).

Chirimuuta, R. and R., *Aids, Africa and Racism*, London (1989).

Church, Dorian, Yvonne Deane, James Johnson, Caroline Krzesinska and Paul Lawson, *Cartwright Hall, A Guide to the Building, its Architecture and the Fine Art Collections*, Bradford (1986).

Clark, T.J., 'Preliminaries to a Possible Treatment of Olympia in 1865', in Francis Frascina and Charles Harrison, eds., *Modern Art and Modernism*, London (1982), pp. 259–73.

Clifford, James, 'Objects and Selves–an Afterward', in George W. Stocking Jr. ed., *Objects and Others: Essays on Museums and Material Culture*, Wisconsin (1985), pp. 236–46.

Clifford, James, 'Histories of the Tribal and the Modern', *Art in America*, (April 1985), pp. 164–77.

Clifford, James, and George E. Marcus, *Writing Culture, The Poetics and Politics of Ethnography*, Berkeley (1986).

Clifford, James, 'Four Northwest Coast Museums: Travel Reflections', in eds., Karp and Levine (1991).

Clodd, Edward, *Pioneers of Evolution*, London (1897).

Cohen, Stanley, *Folk Devils and Moral Panics: the Creation of the Mods and Rockers*, Oxford (1972).

Coleman, James S., *Nigeria: Background to Nationalism*, Berkeley (1965).

Collier, P. and H. Geyer-Ryan, eds., *Literary Theory Today*, London (1990).

Comaroff, Jean and John, 'Christianity and Colonialism in South Africa', *American Ethnologist*, 13 (1 February 1986), pp. 1–22.

Coombes, Annie E., ' "For God and for England": Contributions to an Image of Africa in the First Decade of the Twentieth Century', *Art History*, vol. 8, no. 4 (December 1985), pp. 453–66.

Coombes, Annie E., and Jill Lloyd, ' "Lost and Found" at the Museum of Mankind', *Art History*, vol. 9, no. 4 (December 1986), pp. 540–5.

Coombes, Annie E., 'Museums and the Formation of National and Cultural Identities', *Oxford Art Journal* (December 1988), pp. 57–68.

Coombes, Annie E., 'Inventing the "Post-Colonial": Hybridity and Constituency in Contemporary Curating', *New Formations* (December 1992), pp. 39–52.

Coombes, Annie E., 'Blinded by Science: Ethnography at the British Museum', in ed., Pointon, Marcia, *Art Apart: Artifacts, Institutions and Ideology in England and North America From 1800 to the Present*, Manchester (1994).

Coombes, Annie E., 'The Recalcitrant Object: Hybridity and the Question of Culture-Contact', in eds., Barker, Francis et al, *Colonial Discourse, Post-Colonial Theory*, Manchester (1994).

Coombes, Annie E., 'The Distance between Two Points: Globalism and the Liberal Dilemma', in eds., Bird, Jon et al, *Travellers' Tales: Narratives of Home and Displacement*, London (1994).

Cooter, Roger, *The Cultural Meaning of Popular Science: Phrenology and the Organization of Consent in Nineteenth Century Britain*, Cambridge (1984).

Corner, John and Sylvia Harvey, eds., *Enterprise and Heritage, Crosscurrents of National Culture*, London (1991).

Cornish, Charles, *Sir William Henry Flower . . . a Personal Memoir*, London (1904).

Cranstone, B.A.L., and Steven Seidenberg, eds., *The General's Gift: A Celebration of the Pitt Rivers Museum Centenary 1884–1984*, Oxford (1984).

Crawford, O.G.S., 'The Dialectical Process in the History of Science', *Sociological Review*, 24 (1932), pp. 165–73.

Crossick, G., ed., *The Lower Middle Class in Britain 1870–1914*, London (1977).

Crowder, Michael, *West Africa Under Colonial Rule*, London (1968).

Cullen, M., *The Statistical Movement in Early Victorian Britain*, Hassocks (1975).

Cultural Affairs Committee of the Parti Socialist Unifié, 'Beaubourg: The Containing of Culture in France', *Studio International*, 1 (1978), pp. 27–36.

Curtin, P., *The Image of Africa: British Ideas and Action, 1780–1850*, London (1965).

Curl, J.S., *The Egyptian Revival, An Introductory Study of a Recurring Theme in the History of Taste*, London (1982).

Cunningham, Hugh, *Leisure in the Industrial Revolution*, London (1980).

Dalziel, Margaret, *Popular Fiction One Hundred Years Ago*, London (1957).

Dangerfield, George, *The Strange Death of Liberal England*, London (1935).

Dark, P.J.C., *An Introduction to Benin Art and Technology*, Oxford (1973).

Davies, P.N., *Trading in West Africa, 1840–1920*, London (1976).

Davin, Anna, 'Imperialism and Motherhood', *His-

tory Workshop Journal, no. 5 (Spring 1978), pp. 9–63.

Debord, Guy, *La Societé du Spectacle*, Paris (1967).

Dean, S., *Celtic Revivals*, London (1988).

Deutsche, R., 'Alienation in Berlin: Kirchner's Street Scenes', *Art in America*, LXX, (December 1982), pp. 76–89.

Dias, Nélia, *Le Musée d'Ethnographie du Trocadero 1878–1908*, Paris (1991).

Dilke, K. Onwuka, *Trade and Politics in the Niger Delta*, London (1962).

Dodds, Philip and Robert Colls eds., *Englishness, Politics and Culture 1880–1920*, London (1986).

Donald, James, and Ali Rattansi, *Race, Culture and Identity*, London (1992).

Donne, J.B., 'The Celia Barclay Collection of African Art', *Connoisseur* (June 1972), pp. 88–95.

Donne, J.B., 'African Art and Paris Studios', in Greenhalgh, Michael and Vincent Megaw, *Art in Society*, London (1978), pp. 105–20.

Dorson, Richard M., *The British Folklorists; A History*, London (1968).

Dreyfus, Hubert L. and Paul Rabinow, *Michel Foucault, Beyond Structuralism and Hermeneutics*, London (1982).

Duncan, Carol and Alan Wallach, 'The Museum of Modern Art as Late Capitalist Ritual: an Iconographical Analysis', *Marxist Perspectives*, no. 1 (Winter 1978), pp. 28–51.

Duncan, Carol and Alan Wallach, 'The Universal Survey Museum', *Art History*, vol. 3, no. 4 (December 1980), pp. 448–69.

Duncan, Marion G., 'A Historical Study of the Ethnographical Collections in the Horniman Museum, London', unpublished Diploma thesis, Museums Association (November 1972).

Ebin, V., and D.A. Swallow, *"The Proper Study of Mankind . . ." – Great Anthropological Collections in Cambridge*, Cambridge (1984).

Eboussi-Boulaga, F., *Christianisme sans Fétiche, Révélation et Domination*, Paris (1981).

Echuero, M.J.C., *Victorian Lagos*, London (1977).

Engels, Frederick, *The Origins of the Family*, London (1972).

Evans-Pritchard, E.E., *Theories of Primitive Religion*, Oxford (1965).

Evans-Pritchard, E.E., *A History of Anthropological Thought*, London (1981).

Eyo, Ekpo and Frank Willet, *Treasures of Ancient Nigeria*, London (1982).

Fabian, Johannes, *Time and the Other: How Anthropology Makes Its Object*, New York (1983).

Fagg, William, 'The Allman Collection of Benin Antiquites', *Man*, vol. 53 (1953), pp. 165–9.

Fagg, William, *The Tribal Image*, London (1970).

Fergusson, R., M. Gever, T. Minh-ha, C. West, eds., *Out There: Marginalization and Contemporary Cultures*, New York, Cambridge, Mass. and London (1990).

Feuchtwang, Stephen, 'The Colonial Formation of British Social Anthropology', in Talal Asad, ed., *Anthropology and the Colonial Encounter*, London (1973), pp. 71–100.

Field, John, H., *Towards a Programme of Imperial Life: The British Empire at the Turn of the Century*, Oxford (1982).

Fieldhouse, D.K., *Economics and Empire*, London (1973).

Fields, Barbara, 'Ideology and Racism in American History', in J.M. Kousser and J.M. McPherson, eds., *Region, Race and Reconstruction*, Oxford (1982), pp. 143–77.

Fields, Barbara, 'Christian Missionaries as Anti-Colonial Militants', *Theory and Society*, 11 (1 January 1982), pp.95–108.

Fisher, Jean, 'The Health of the People is the Highest Law', *Third Text*, 2 (Winter 1987), pp. 63–75.

Foster, Hal, *Recodings, Art, Spectacle, Cultural Politics*, Seattle (1985).

Foucault, Michel, *The Archaeology of Knowledge*, London (1972).

Foucault, Michel, *The Order of Things*, London (1970).

Foucault, M., *Discipline and Punish*, London (1977).

Frazer, Sir J., *The Scope of Social Anthropology, A Lecture Delivered Before the University of Liverpool*, May 14, 1908, London (1908).

Frese, H.H., *Anthropology and the Public: The Role of Museums*, Leiden (1960).

Fryer, Peter, *Staying Power. The History of Black People in Britain*, London (1984).

Gallwey, Henry L., 'Nigeria in the '90's', *Journal of the African Society*, vol. XXIX, no. CXV (April 1930), pp. 220–47.

Gallwey, Henry L., 'West Africa Fifty Years Ago', *Journal of the Royal African Society*, vol. 41–2 (1942–3), pp. 90–100.

Gates, J.H. Jr., 'Writing, "Race", and the Difference it Makes', *Critical Inquiry*, vol. 12, no. 1 (Autumn 1985), pp. 1–20.

Geary, Christraud, M., ' "On the Savannah": Mary Pauline Thorbeck's Images from Cameroon, West Africa (1911–1912)', *Art Journal* (Summer 1990), vol. 49, no. 2, pp. 150–8.

Geary, Christraud, M., *Images from Bamun, German Colonial Photography at the Court of King Njoya, Cameroon, West Africa, 1902–1915*, Washington D.C. (1988).

Gerbrands, A.A., *Art as an Element of Culture Especially in Negro Africa*, Leyden (1957).

Gilman, Benjamin Ives, *Museum Ideals of Purpose and Method*, Boston, Mass. (1923, 1st ed., 1918).

Gilman, Sander L., 'Black Bodies, White Bodies: Toward an Iconography of Female Sexuality in Late Nineteenth Century Art, Medicine and Literature', *Critical Inquiry*, vol. 12, no. 1 (Autumn 1985), pp. 204–42.

Goddard, David, 'Limits of British Anthropology', *New Left Review*, 58 (1969), pp. 79–89.

Goldwater, Robert, *Primitivism in Modern Art*, Cambridge Mass. (1986, 1st ed., 1938).

Gould, Stephen J., *The Mismeasure of Man*, Harmondsworth (1981).

Gourvish, T.R., 'The Standard of Living, 1890–1914', in A. O'Day, ed., *The Edwardian Age: Conflict and Stability 1900–1914*, London (1979), pp. 13–34.

Gramsci, Antonio, *Selections from the Prison Notebooks*, London (1971).

Gray, Robert, *The Aristocracy of Labour in Nineteenth Century Britain, c.1880–1914*, London (1981).

Green, David, 'On Foucault: Disciplinary Power and Photography', *Camerawork*, no. 32 (Summer 1985), pp. 6–9.

Green, David, 'Veins of Resemblance: Photography and Eugenics', *The Oxford Art Journal*, vol. 7, no. 2 (1985), pp. 3–16.

Green, J.P., 'In Dahomey in London in 1903', *Black Perspectives in Music*, XI/1 (Spring 1983), pp. 23–40.

Green, Nicholas and Frank Mort, 'Visual Representation and Cultural Politics', *Block*, no. 7 (1982), pp. 59–68.

Greenfield, J., *The Return of Cultural Treasures*, Cambridge (1989).

Greenhalgh, Michael and Vincent Megaw, eds., *Art in Society*, London (1978).

Greenhalgh, Paul, 'Art, Politics and Society at the Franco-British Exhibition of 1908', *Art History*, vol. 8, no. 4 (December 1985), pp. 434–52.

Greenhalgh, Paul, *Ephemeral Vistas, The Expositions Universelles, Great Exhibitions and World's fairs, 1851–1939*, Manchester (1988).

Griffith, W. Bradford, 'Native Stools on the Gold Coast', *Journal of the African Society*, vol. 4 (1904–5), pp. 290–4.

Groves, C.P., *The Planting of Christianity in Africa*, vol. III, London 1955.

Guha, R. and Gayatri Chakravorty Spivak, *Selected Subaltern Studies*, New York (1988).

Gwynn, Stephen, *Mary Kingsley*, London (1933).

Haddon, A.C., *The Native Races of the Empire; Syllabus of a Course of Twenty-five Lectures at the Horniman Museum, Forest Hill, S.E. London*, 1907.

Haddon, A.C., *The History of Anthropology*, London (1910).

Hainard, Jacques and Roland Kaehr, eds., *Temps Perdu Temps Retrouvé: Voir les Choses du Passé au Present*, Neuchâtel (1985).

Hainard, Jacques and Roland Kaehr, eds., *Les Ancêtres sont Parmis Nous*, Neuchâtel (1989).

Halévy, Elie, *A History of the English People: Epilogue, Vol. I, 1895–1905*, London (1926).

Halévy, Elie, *A History of the English People: Epilogue, Vol. II, 1905–1915*, London (1934).

Hall, S., 'Gramsci's Relevance for the Study of Race and Ethnicity', *Journal of Communication Inquiry*, 10 (1986), pp. 5–27.

Hall, S., 'Cultural Identity and Diaspora', in ed., J. Rutherford, *Identity: Community, Culture, Difference*, London (1990).

Haraway, Donna, 'Teddy Bear Patriarchy: Taxidermy in the Garden of Eden, New York City, 1908–1936', *Social Text*, no. 11 (Winter 1984/5).

Harker, D., 'May Cecil Sharp Be Praised?', *History Workshop Journal*, 14 (Autumn 1982), pp. 44–62.

Harris, John H., *Dawn in Darkest Africa*, London (1912).

Harris, Marvin, *The Rise of Anthropological Theory; A History of Theories of Culture*, London (1969).

Harrison, J. D., ' "The Spirit Sings" and the Future of Anthropology', *Anthropology Today*, vol. 4 (December 1988) pp. 6–9.

Haselberger, H., 'Method of Studying Ethnological Art', *Current Anthropology*, 2 (October 1961), pp. 341–83.

Hayward Gallery, *The Other Story*, London (1990).

Hebdige, Dick, *Subculture the Meaning of Style*, London (1979).

Henson, H., *British Social Anthropology and Language; A History of Separate Development*, Oxford (1974).

Herskovits, Melville J., *The Myth of the Negro Past*, New York (1941).

Herskovits, Melville J., 'A Geneology of Ethnological Theory', in M.E. Spiro, ed., *Context and Meaning in Cultural Anthropolgy*, London and New York (1965), pp. 403–15.

Hewat, Elizabeth G.K., *Vision and Achievement 1796–1956: A History of the Foreign Missions of the Churches United in the Church of Scotland*, London (1960).

Hibbert, Christopher, *The Illustrated London News; Social History of Victorian Britain*, London (1976).

Hiller, Susan, *The myth of Primitivism, Perspectives on Art*, London (1991).

Hinder, Rita, *Fabian Colonial Essays*, London (1945).

Hobsbawm, E.J., 'Mass-Producing Traditions: Europe, 1870–1914', in E.J. Hobsbawm and T.O. Ranger, eds, *The Invention of Tradition*, Cambridge (1983), pp. 236–307.

Hobsbawm and T.O. Ranger, eds., *The Invention of Tradition*, Cambridge (1983).

Hobson, J.A., *The Psychology of Jingoism*, London (1901).

Hobson, J.A., *Imperialism, A Study*, London (1902).

Hockings, Paul, ed., *Principles of Visual Anthropology*, The Hague (1975).

Hodge, Alison, 'The Training of Missionaries for Africa: The Church Missionary Society's Training College at Islington, 1900–1915', *Journal of Religion in Africa*, vol. 4 (1971–1972), pp. 81–96.

Holoway, James D., 'Church Missionary Society Contact With Islam in East Africa pre-1914', *Journal of Religion in Africa*, vol. 4 (1971–1972), pp. 200–12.

Howarth, O.J.R., *The British Association for the Advancement of Science: A Retrospective 1831–1931*, London (1931).

Hudson and Luckhurst, *The Royal Society of Arts 1754–1954*, London (1954).

Hulme, Peter, *Colonial Encounters*, Cambridge (1987).

Husband, Charles, ed., *'Race' in Britain: Continuity and Change*, London (1982).

Igbafe, P.A., Benin Under British Administration, *The Impact of Colonial Rule on an African kingdom 1897–1938*, London (1979).

Ikoli, E., 'The Nigerian Press', *West African Review* (June 1950).

Inglis, K.S., *Churches and the Working Classes in Victorian England* (1963).

Jamin, Jean, 'Les Objets Ethnographiques Sont-Ils des Choses Perdues?' in Jacques Hainard and Roland Kaehr, eds., *Temps Perdu Temps Retrouvé*, Neuchâtel (1985), pp. 51–74.

JanMohamed, Abdul, *Manichean Aesthetics: The Politics of Literature in Colonial Africa*, Amherst (1983).

Jeffries, C., *The Colonial Empire and Its Civil Service*, Cambridge (1938).

Johnston, Harry, *George Grenfell and the Congo: A History and Description of the Congo Independent State*, London (1908).

Jones, Gareth Stedman, 'Class expression versus social control? A critique of recent trends in the history of leisure', *History Workshop Journal*, 4 (1977) pp. 162–70.

Jones, Gareth Stedman, *Languages of Class: Studies in English Working Class History 1832–1982*, Cambridge (1983).

Jules-Rosette, B., *The Messages of Tourist Art*, New York (1984).

July, Robert W., *The Origins of Modern African Thought*, London (1968).

Kamm, Josephine, *Explorers into Africa*, London (1970).

Karp, I., and S. Levine, eds., *Exhibiting Cultures, The Poetics and Politics of Museum Display*, Washington (1991).

Karp, I., C. Mullen Kreamer and S. Levine, eds., *Museums and Communities, The Politics of Public Culture*, Washington (1992).

Karpinski, P., 'The Palm Oil Ruffians', unpublished MS., Liverpool County Museum (February 2 1980).

Kiernan, V.G., *European Empires from Conquest to Collapse, 1815–1960*, London (1982).

Knight, D., *The Exhibitions*, London (1978).

Knight, P., 'British Public Opinion and the Rise of Imperialist Sentiment in Relation to Africa, 1880–1900' unpublished Ph.D. dissertation, Warwick University (1968).

Kruger, B., and P. Mariani, eds., *Remaking History*, Seattle (1989).

Kuper, Adam, *Anthropologists and Anthropology; The British School 1922–1972*, London (1973).

Kuper, Adam, *The Invention of Primitive Society*, London (1988).

Langan, Mary, and Bill Schwarz, eds., *Crises in the British State 1880–1930*, London (1985).

Langham, G, *The Building of British Social Anthropology*, London (1981).

Lee, Alan J., *The Origins of the Popular Press 1885–1914*, London (1976).

Leja, M., ' "Le Vieux Marcheur" et "Les Deux Risques": Picasso, Prostitution, Venereal Disease and Maternity 1899–1907', *Art History*, vol. 8, no. 1 (1985).

Leprun, Sylviane, *Le Théâtre des Colonies*, Paris (1986).

Leubuscher, Charlotte, *The West African Shipping Trade 1909–1959*, Leyden (1963).

Liddington, Jill and Jill Norris, *One Hand Tied Behind Us: The Rise of the Women's Suffrage Movement*, London (1978).

Lips, Julius Ernst, *The Savage Hits Back*, London (1937).

Lindfors, Bernth, 'Circus African', *Journal of American Culture*, vol. VI, no. 2 (1983) pp. 9–14.

Lloyd, David, *Nationalism and Minor Literature: James Clarence Mangan and the Emergence of Irish Cultural Nationalism*, Berkeley (1987).

Lloyd, Jill, *German Expressionism, Primitivism and Modernity*, New Haven and London (1991).

Lorimer, D., *Colour, Class and the Victorians: English*

Attitudes to the Negro in the Mid-Nineteenth Century, Leicester (1978).

Lovejoy, A., *The Great Chain of Being*, Cambridge, Mass. (1936).

Lowe, Lisa, *Critical Terrains, French and British Orientalisms*, Ithaca and London (1991).

Lowe, Lisa, 'Heterogeneity, Hybridity, Multiplicity: Marking Asian American Differences', *Diaspora: A Journal of Transnational Studies*, no. 1 (Spring 1991), pp. 24–44.

Lowie, R.H., *History of Ethnological Theory*, New York (1937).

Luckhurst, Kenneth W., *The Story of Exhibitions*, London (1951).

Lugard, F.D., *The Dual Mandate in British Tropical Africa*, London (1922).

Lumley, Robert. ed., *The Museum Time-Machine*, London (1988).

Mack, John, 'W.H.R. Rivers. The Contexts of Social Anthropology', unpublished Ph.D. dissertation, Oxford University (1975).

Mack, John, *Emil Torday and the Art of the Congo 1900–1909*, London (1990).

MacKenzie, John M., *Propaganda and Empire: The Manipulation of British Public Opinion 1880–1960*, Manchester (1984).

MacKenzie, John M., ed., *Imperialism and Popular Culture*, Manchester (1986).

Mackenzie, Norman and Jeanne, *The First Fabians*, London (1979).

Maes, J., 'L'Ethnographie de l'Afrique Centrale et le Musée du Congo Belge', *Africa*, vol. VII (1934), pp. 9–183.

Mallgrave, Henry Francis, 'Gustave Klemm and Gottfried Semper: The Meeting of Ethnological and Architectural Theory', *Res*, 9 (Spring 1985), pp. 69–79.

Martin, Wallace, *The 'New Age' Under Orage, Chapters in English Cultural History*, Manchester (1967).

McLaren, Angus, *Birth Control in Nineteenth Century England*, London (1978).

McLeod, Hugh, *Religion and the Working Class in Nineteenth Century Britain*, London (1984).

McClintock, Anne, 'The Angel of Progress: Pitfalls of the Term "Post-Colonialism"', *Social Text*, 31/32, vol. 10 (1992), pp. 84–98.

Mee, A., J.A. Hammerton, and A.D. Innes, eds., *Harmsworth History of the World*, London (1909).

Messenger, Mauch, P., *The Ethics of Collecting Cultural Property*, Albuquerque (1989).

Miller, C., *Blank Darkness: Africanist Discourse in French*, Chicago (1985).

Miller, Edwin, *That Noble Cabinet*, London (1973).

Minh-ha, Trin T., *Woman, Native, Other: Writing Post-Coloniality and Feminism*, Bloomington (1989).

Montagu, M.F. Ashley, ed., *The Concept of the Primitive*, New York and London (1968).

Montgomery, H.H., *The History of the S.P.G. House*, London (1923).

Mordaunt-Crook, J., *The British Museum*, London (1972).

Morgan, David, *Suffragists and Liberals: The Politics of Women's Suffrage in England*, Oxford (1975).

Morris, A.J.A., ed., *Edwardian Radicalism 1900–1914: Some Aspects of British Radicalism*, London (1974).

Mort, Frank, *Dangerous Sexualities, Medico-Moral Politics in England Since 1830*, London (1987).

Mudimbe, V.Y., *The Invention of Africa, Gnosis, Philosophy and the Order of Knowledge*, Bloomington (1988).

Mukesa, Ham, *Sir Apolo Kagwa Discovers Britain*, London (1975).

Murray, C. Freeman, 'The British Empire League', *United Empire*, vol. VI (1916), pp. 431–39.

Murray, Dr D., *Museums, Their History and Their Use, with a Bibliography and List of Museums in the U.K.*, 3 vols., London (1904).

Neville, G.W., 'Nanna Oluma of Benin', *Journal of the African Society*, vol. XIV (January 1915), pp. 162–7.

Nochlin, Linda, 'The Imaginary Orient', *Art in America* (May 1983), pp. 119–31; 186–91.

Norton, Bernard, 'Psychologists and Class', in Charles Webster, *Biology, Medicine and Society, 1840–1940*, Cambridge (1981), pp. 289–314.

Odamtten, S.K., *The Missionary Factor in Ghana's Development (1820–1880)*, Accra (1978).

O'Day, Alan, ed., *The Edwardian Age: Conflict and Stability, 1900–1914*, London (1979), pp. 113–32.

Oliver, Roland, *The Missionary Factor in East Africa*, London (1952).

Oliver, Roland, and J.D. Fage, *A Short History of Africa*, Harmondsworth (1975).

Oxford University Anthropological Society, *The Proceedings of the Five Hundredth Meeting of the Oxford University Anthropological Society* (February 1953), Oxford.

Owen, Roger, and Bob Sutcliffe, eds., *Studies in the Theory of Imperialism*, London (1972).

Parry, Benita, *Delusions and Discoveries: Studies on India in the British Imagination, 1880–1930*, Berkeley (1972).

Pelling, Henry, *Modern Britain 1885–1955*, Edinburgh (1960).

Pelling, Henry, *Popular Politics and Society in Late Victorian England*, London (1968).

Penniman, T.K. 'The Pitt Rivers Museum',

Museums Journal, vol. 52, no. 10 (1953), pp. 243–6.

Penniman, T.K., *A Hundred Years of Anthropology*, London (1965).

Perkins, T.E., 'Rethinking Stereotypes' in Michele Barrett, et. al., eds., *Ideology and Cultural Production*, London (1979), pp. 135–59.

Plum, Werner, *World Exhibitions in the Nineteenth Century: Pageants of Social and Cultural Change*, Godesberg (1977).

Porter, A., 'Cambridge, Keswich and Late-Nineteenth Century Attitudes to Africa', *Journal of Imperial and Commonwealth History*, vol. V, no. 1 (1976), pp. 5–30.

Porter, A., 'Evangelical Enthusiasm, Missionary Motivation in West Africa in the Late Nineteenth Century: The Career of G.W. Brooks', *Journal of Imperial and Commonwealth History*, vol. VI, no. 1 (October 1977), pp. 23–46.

Porter, Bernard, *Critics of Empire: British Radical Attitudes to Colonialism in Africa, 1895–1914*, New York (1968).

Porter, Bernard, 'The Edwardians and Their Empire', in D. Read, ed. *Edwardian England*, London (1982), pp. 128–44.

Pratt, Mary Louise, *Imperial Eyes, Travel Writing and Transculturation*, London (1992).

Price, Richard, *An Imperial War and the British Working Class: Working-Class Attitudes and Reactions to the Boer War 1899–1902*, London (1972).

Prochaska, F.K., 'Little Vessels: Children in the Nineteenth Century English Missionary Movement', *Journal of Imperial and Commonwealth History*, vol. VI, no. 2 (January 1978), pp. 103–18.

Quiggin, A.H., *Haddon the Head-Hunter*, Cambridge (1942).

Ranger, Terence O., 'The Invention of Tradition in Colonial Africa', in E.J. Hobsbawm and T.O. Ranger, *The Invention of Tradition*, Cambridge (1983), pp. 211–62.

Rattray, Captain R.S., *Religion and Art in Ashanti*, Oxford (1927).

Read, D., ed., *Edwardian England*, London (1982).

Reynolds, F.H., *Some Notes About the History of Missionary Exhibitions*, London (1939).

Robinson, Ronald and John Gallagher, *Africa and the Victorians: the Official Mind of Imperialism*, Cambridge (1961).

Robb, J.H., *The Primrose League, 1883–1906*, London (1942).

Rose, Nikolas, 'The Psychological Complex: Mental Measurement and Social Administration', *Ideology and Consciousness*, no. 5 (Spring 1979), pp. 5–68.

Rosenstiel, Annette, 'Anthropology and the Missionary', *Journal of the Royal Anthropological Institute*, vol. 89 (1959), pp. 107–16.

Rotberg, R., *Christian Missionaries and the Creation of Northern Rhodesia*, Princeton (1965).

Rover, Constance, *Women's Suffrage and Party Politics in Britain 1866–1914*, London (1974).

Rowbotham, Sheila, *Hidden From History*, London (1973).

Royal Anthropological Institute, *Observers of Man*, Photographers' Gallery, March 1980, London (1980).

Rubin, William, *Primitivism in Twentieth Century Art*, 2 vols., New York (1985).

Rutherford, J., ed., *Identity: Community, Culture, Difference*, London (1990).

Rydell, Robert W., *All the World's a Fair, Visions of Empire at American International Expositions, 1876–1916*, Chicago and London (1984).

Ryder, A.F.C., "The Benin Mission', *Journal of the Historical Society of Nigeria*, vol. 2, no. 1 (1960), and vol. 2, no. 2 (1961).

Ryder, A.F.C., *Benin and the Europeans, 1485–1897*, London (1969 rev. ed., 1977).

Sagay, J.O.E., *History of the West African Peoples: Benin Kingdom and the British Invasion*, Cambridge (1970).

Said, Edward, W., *Orientalism*, London (1978).

Said, Edward, W., 'Representing the Colonised: Anthropology's Interlocutors', *Critical Inquiry*, 15 (1989), pp. 205–25.

Saxton, Alexander, 'Historical Explanations of Racial Inequality: A Review Essay', *Marxist Perspectives*, II (Summer 1979), pp. 146–68.

Sayer, Janet, *Biological Politics*, London (1982).

Sherer, Joanna Cohen, 'You Can't Believe Your Eyes: Inaccuracies in Photographs of North American Indians', *Studies in the Anthropology of Visual Communication*, vol. 2, no. 2 (Fall 1975), pp. 67–79.

Schneider, William H., 'Race and Empire: The Rise of Popular Ethnography in the Late Nineteenth Century', *Journal of Popular Culture*, vol. XI, no. 1 (Summer 1977), pp. 98–109.

Schneider, William H., *An Empire for the Masses: The French Popular Image of Africa, 1870–1900*, Westpoint and London (1982).

Schumpeter, Joseph, *Imperialism and Social Classes*, New York (1955, 1st ed., 1919).

Schwab, R., *La Renaissance Orientale*, Paris (1950).

Searle, G.R., *The Quest for National Efficiency*, Berkeley (1971).

Searle, G.R., *Eugenics and Politics in Britain, 1900–1914*, Leyden (1976).

Searle, G.R., 'Eugenics and Class', in Charles Webster, ed., *Biology, Medicine and Society, 1840–1940*, Cambridge (1981), pp. 217–42.

Seeley, J.R., *The Expansion of England*, London (1926).

Sekulla, Alan, *Photography Against the Grain*, Hlifax (1974).

Semmel, Bernard, *Imperialism and Social Reform: English Social-Imperial Thought 1895–1914*, London (1960).

Shattock, J., and M. Wolff, *The Victorian Periodical Press: Samplings and Soundings*, Leicester and Toronto (1982).

Shelley, H.C., *The British Museum: Its History and Treasures*, Boston (1911).

Sheehy, J., *The Rediscovery of Ireland's Past: The Celtic Revival 1830–1930*, London (1980).

Shepherd, Ben, 'Lobengula: A Royal Gentleman of Colour', *History Today*, vol. 34 (April 1984), pp. 36–41.

Shepherd, Ben, 'Showbiz Imperialism: The Case of Peter Lobengula', in John M. MacKenzie, ed., *Imperialism and Popular Culture*, Manchester (1986), pp. 94–112.

Shepperton, G.A., 'Church and Sect in Central Africa', *Rhodes-Livingstone Journal*, no. XXXIII (October 1963), pp. 83–95.

Shohat, Ella, 'Notes on the "Post-Colonial"', *Social Text*, 31/32, vol. 10 (1992), pp. 99–113.

Silverman, Deborah L., 'The 1889 Exposition: The Crisis of Bourgeois Individualism', *Oppositions*, no. 8 (Spring 1977), pp. 71–91.

Simon, Brian, *Education and the Labour Movement 1870–1920*, London (1965).

Sinclair, A., *The Savage: A History of Misunderstanding*, London (1977).

Slotkin, J.S., *Readings in Early Anthropology*, New York (1965).

Smith, Edwin W., 'Social Anthropology and Missionary Work', *International Review of Missions* (October 1924), pp. 518–53.

Solomon-Godeau, A., 'Going Native', *Art in America*, LXXVII (July 1989), pp. 118–29.

Southon, A.E., *Gold Coast Methodism, The First Hundred Years, 1835–1935*, Cape Coast and London (1934).

Spivak, Gayatri Chakravorti, 'The Rani of Sirmur', in eds., Barker, F. et al., *Europe and its Others*, vol. 1, Colchester (1985), pp. 128–51.

Spivak, Gayatri Chakravorty, *From Two Worlds*, London (1987).

Spivak, Gayatri Chakravorti, 'Can the Subaltern Speak?', in eds., Nelson, Cary and Lawrence Grossberg, *Marxism and the Interpretation of Culture*, Urbana (1988).

Spivak, Gayatri Chakravorty, 'Poststructuralism, Marginality, Postcoloniality and Value', in eds., Collier, P., and H. Geyer-Ryan, *Literary Theory Today*, London (1990).

Stanton, Gareth, 'The Oriental City: A North African Itinerary', *Third Text*, vol. 3/4 (Spring–Summer 1988), pp. 3–38.

Steadman, Philip, *The Evolution of Designs*, Cambridge (1979).

Stevenson, Catherine, 'Female Anger and African Politics: The Case of Two Victorian "Lady Travellers"', *Turn-of-the-Century Women*, vol. II, no. 1 (Summer 1985), pp. 7–17.

Stock, Eugene, *A History of the Church Missionary Society*, 3 vols., London (1899).

Stocking, George W. Jr., 'The Ethnographer's Magic: Fieldwork in British Anthropology from Tylor to Malinowski', in George W. Stocking, Jr., ed., *Observers Observed, Essays on Ethnographic Fieldwork*, Wisconsin (1983), pp. 70–120.

Stocking, George W. Jr., *Race, Culture, and Evolution: Essays in the History of Anthropology*, New York (1968).

Stocking George W. Jr., ed., *Observers Observed: Essays on Ethnographic Fieldwork*, Wisconsin (1983).

Stocking, George W. Jr., ed., *Objects and Others: Essays on Museums and Material Culture*, Wisconsin (1985).

Stocking, George W. Jr., 'What's in a Name? The Origins of the Royal Anthropological Institute (1837–71)', *Man*, vol. 6, no. 3 (September 1971), pp. 369–90.

Strayer, Robert W., *The Making of Mission Communities in East Africa*, London (1978).

Strayer, Robert W., Edwin I Steinhart and Robert M. Maxon, 'Protest Movements in Colonial East Africa: Aspects of Early African Response to European Rule', in *East African Studies*, XII, Syracuse (1973).

Street, Brian V., *The Savage in Literature: Representations of 'primitive' Society in English Fiction 1858–1920*, London, and Boston (1975).

Suvin, Darko, 'The Social Addressees of Victorian Fiction: A Preliminary Enquiry', *Literary History*, vol. 8, no, 1 (Spring 1982), pp. 11–40.

Symonds, R., *The British and Their Successors*, London (1966).

Tagg, J., *The Burden of Representation: Essays on Photographies and Histories*, London (1988).

Thompson, M.W., *A Catalogue of Correspondence and Papers of Pitt Rivers (A. Henry Lane Fox), 1855–1899*, Salisbury (1976).

Thompson, Paul, *The Edwardians; The Remaking of British Society*, London (1975).

Thomson, David, *England in the Nineteenth Century, 1818–1914*, Harmondsworth (1950).

Thorne, Susan Elizabeth, Protestant Ethics and the

Spirit of Imperialism: British Congregationalists and the London Missionary Society, 1795–1925, unpublished PhD. thesis, University of Michigan (1990).

Thornton, R., 'Narrative Ethnography in Africa, 1850–1920: The creation and Capture of an Appropriate Domain for Anthropology', *Man*, vol. 18, no. 3 (September 1983), pp. 502–20.

Tickner, Lisa, *The Spectacle of Women, Imagery of the Suffrage Campaign 1907–1914*, London (1987).

Torgovnick, M., *Gone Primitive, Savae Intellects, Modern Lives*, Chicago (1990).

Treichler, A., 'AIDS and HIV infection in the Third World: A First World Chronicle', in Kruger, B., and P. Mariani eds., *Remaking History*, Seattle (1989), pp. 31–86.

Trollope, Joanna, *Britannia's Daughters*, London (1983).

Tudor Jones, R., *Congregationalism in England 1662–1962*, London (1962).

United States Association for the Advancement of Science, *Fifty Years of Darwinism: Modern Aspects of Evolution; Centennial Addresses in Honor of C. Darwin Before the U.S. Association for the Advancement of Science*, New York (1909).

Urry, James, 'Notes and Queries on Anthropology' and the Development of Field Methods in British Anthropology 1870–1920', *Proceedings of the Royal Anthropological Institute* (1973), pp. 45–57.

Urry, James, 'Englishmen, Celts and Iberians, The Ethnographic Survey of the United Kingdom, 1892–1899', in Stocking, George, W. Jr., ed., *Functionalism Historicised, Essays on British Social Anthropology*, Madison (1984) pp. 83–105.

University of Liverpool, *Liverpool and Africa: An Exhibition on the Occasion of a Conference of the African Studies Association of the U.K.*, Liverpool (1974).

Vaneigem, Raoul, *The Revolution of Everyday Life*, London (1983, 1st ed., 1967).

Van Keuren, D.K., Human Science in Victorian Britain: Anthropology in Institutional and Disciplinary Formation, 1863–1908, unpublished Ph.D. thesis, University of Pennsylvania (1982).

Vaughan, William, 'The Englishness of British Art', *Oxford Art Journal*, vol. 13, no. 2 (1990), pp. 11–24.

Vinson, Adrian, 'The Edwardians and Poverty: Towards a Minimum Wage?' in D. Read, ed., *Edwardian England*, London (1982), pp. 75–92.

Waites, Bernard, Tony Bennett and Graham Martin, *Popular Culture: Past and Present*, London (1982).

Ward, Margaret, *Unmanageable Revolutionaries*, London (1983).

Ware, Vron, *Beyond the Pale, White Women, Racism and History*, London (1992).

Watney, Simon, *Policing Desire: Pornography, AIDS and the media*, Minneapolis (1987).

Watney, Simon, 'Missionary Positions: AIDS, "Africa", and Race', in R.Fergusson, M. Gever, T. Minh-ha, C.West, eds., *Out There: Marginalisation and Contemporary Cultures*, New York, Cambridge, Mass., and London (1990), pp. 89–103.

Webster, Charles, ed., *Biology, Medicine and Society, 1840–1940*, Cambridge (1981).

Weeks, Jeffrey, Sex, *Politics and Society: The Regulation of Sexuality Since 1800*, Harlow (1981).

West, Cornel, 'Black Culture and Postmodernism', in eds., Kruger, B. and Phil Mariani, *Remaking History*, Seattle (1989) pp. 87–96.

West, Cornel, 'The New politics of difference', in eds., Ferguson R. et al., *Out There, Marginalization and Contemporary Cultures*, New York (1990) pp. 19–36.

White, A., *Efficiency and Empire*, Brighton (1973).

Whitechapel Gallery, *From Two Worlds*, London (1986).

Wickham, E.R., *Church and People in an Industrial City*, London (1957).

Willett, Frank, *Primitive Art from the Manchester Museum*, Manchester (1952).

Willis, Anne-Marie and Tony Fry, 'Art as Ethnocide, the Case of Australia', *Third Text* (Winter 1988–9), pp. 3–21.

Wilson, David, *The British Museum: Purpose and Politics*, London (1984).

Wilson, Robin, 'Imperialism in Crisis: The "Irish Dimension"', in Mary Langan and Bill Schwarz, eds., *Crisis in the British State 1800–1930*, London (1985), pp. 151–78.

Wiltgen, R.M., *Gold Coast Mission History, 1471–1880*, Teclay, Ill. (1956).

Winks, Robin, ed., *British Imperialism; Gold, God and Glory*, New York (1963).

Wollen, Peter, 'Tourism, Language and Art', *New Formations*, No. 12 (Winter 1990), pp. 43–59.

Wright, Gwendolyn, *The Politics of Design in French Colonial Urbanism*, Chicago (1991).

Wright, Patrick, *On Living in an Old Country, The National Past in Contemporary Britain*, London (1985).

Yeo, Stephen, *Religion and Voluntary Organisations in Crisis*, London (1976).

Young, R.M., *Mind, Brain and Adaptation in The Nineteenth Century*, Oxford (1970).

Youngs, Tim, 'The Inscription of Self and Culture in British Narratives of Travel and Exploration in Africa 1850–1900,' unpublished PhD. thesis, Nottingham Polytechnic (1991).

INDEX